·Ol

*Mimesis, Masochism, & Mime*

# THEATER: Theory/Text/Performance

Enoch Brater, Series Editor
*University of Michigan*

# *Mimesis, Masochism, & Mime*

## The Politics of Theatricality in Contemporary French Thought

Edited by
Timothy Murray

Ann Arbor

THE UNIVERSITY OF MICHIGAN PRESS

2000   1999   1998   1997      4   3   2   1

A CIP catalog record for this book is available
from the British Library

Library of Congress Cataloging-in-Publication Data

Mimesis, masochism, & mime : the politics of theatricality in
   contemporary French thought / edited by Timothy Murray.
         p.   cm. — (Theater—theory/text/performance)
      Includes bibliographical references and index.
      ISBN 0-472-09635-4 (hardcover). — ISBN 0-472-06635-8 (paperback)
      1. Theater—Philosophy.   I. Murray, Timothy.   II. Series.
   PN2039.M52   1997
   792'.01—DC21                                                    97-601
                                                                   CIP

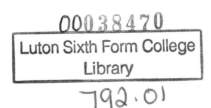

# Acknowledgments

The mise-en-scène of this collection reflects the high quality of contributions, suggestions, and support lent by Eliane dal Molin, Mitchell Greenberg, Verena Andermatt Conley, Christopher Pye, Elin Diamond, Sue-Ellen Case, Tom Conley, Herbert Blau, Marià Minich Brewer, Anne Berger, and Janice Price. Of course, the initial idea for this collection came from the writers it contains: I extend special thanks to Jean-François Lyotard and Jacques Derrida for their guidance and support over the years. I deeply regret that Louis Marin is not here to appreciate his contributions to the shape of this volume.

I am especially grateful to LeAnn Fields of the University of Michigan Press who took the collection under her wing and stuck by it during its many flights south. Indicative of the age in which it has been produced, the manuscript has been seen through production by Michigan's "Team X": I thank Kristen Lare and Mary Meade for their aid in production. Eve Trager and Joseph Cislo deserve special acknowledgment for their relentless tracking of permissions and the editor's aimless wanderings. At Cornell, Anne Mallory, Scott MacKenzie, and Burl Barr provided invaluable assistance in the preparation of the manuscript. I am indebted to Hope Mandeville's cheerful generosity, which allowed me to abandon my administrative duties for work on the volume.

I thank Renate Ferro for the welcome use of her cover photo, as well as for her tireless support, encouragement, and humor. Our children, Erin and Ashley, amused and distracted me when they sensed I needed it the most.

*Grateful acknowledgment is made to the following authors, publishers, and journals for permission to include essays previously published in the following sources.*

Louis Althusser, "The 'Piccolo Teatro': Bertolazzi and Brecht," trans. Ben Brewster, in *For Marx* (London: NLB, 1977), 131–51.

Hélène Cixous, "A Later Interview with Hélène Cixous," in Verena Andermatt Conley, *Hélène Cixous: Writing the Feminine* (Lincoln: University of Nebraska Press, 1991), 163–78.

Gilles Deleuze, "Un manifeste de moins," in Carmelo Bene, Gilles Deleuze, *Superpositions* (Paris: Minuit, 1979), 85–131.

Jacques Derrida, "The Theatre of Cruelty and the Closure of Representation," trans. Alan Bass, in *Writing and Difference* (Chicago: University of Chicago Press, 1978), 232–50.

Régis Durand, "The Disposition of the Voice," in *Performance in Postmodern Culture,* ed. Michel Benamou and Charles Caramello (Milwaukee: Century for Twentieth Century Studies, University of Wisconsin—Milwaukee; Madison: Coda Press, 1977), 99–110.

Frantz Fanon, "Algeria Unveiled," in *A Dying Colonialism,* trans. Haakon Chevalier (New York: Grove Press, 1967), 35–67. Copyright 1967 by Monthly Review Press. Reprinted by permission of Monthly Review Foundation.

Josette Féral, "Performance and Theatricality: The Subject Demystified," trans. Terese Lyons, in *Modern Drama* 25, no. 1 (March 1982): 170–81.

Michel Foucault, "Theatrum Philosophicum," trans. Donald F. Bouchard and Sherry Simon, in *Language, Counter-Memory, Practice,* ed. Donald F. Bouchard (Ithaca: Cornell University Press, 1977), 165–96.

René Girard, "From Mimetic Desire to the Monstrous Double," trans. Patrick Gregory, in *Violence and the Sacred* (Baltimore: Johns Hopkins University Press, 1977), 143–68.

André Green, "The Psycho-analytic Reading of Tragedy," trans. Alan Sheridan, in *The Tragic Effect: The Oedipus Complex in Tragedy* (Cambridge: Cambridge University Press, 1979), 1–34.

Luce Irigaray, "The Stage Setup," trans. Gillian C. Gill, in *Speculum of the Other Woman* (Ithaca: Cornell University Press, 1985), 243–68.

Julia Kristeva, "Modern Theatre Does Not Take (A) Place," trans. Alice Jardine and Thomas Gora, in *Sub-stance* 18, no. 19 (1977): 131–34.

Philippe Lacoue-Labarthe, "Theatrum Analyticum," trans. Robert Eisenhower, in *Glyph* 2 (Baltimore: Johns Hopkins University Press, 1977), 122–43.

Jean-François Lyotard, "The Tooth and the Palm," trans. Anne Knab and Michel Benamou, in *Sub-stance* 15 (1977): 105–10.

———. "The Unconscious as Mise-en-scène," trans. Joseph Maier, in *Performance in Postmodern Culture,* ed. Michel Benamou and Charles Caramello (Milwaukee: Center for Twentieth Century Studies, University of Wisconsin—Milwaukee; Madison: Coda Press, 1977), 87–98.

Louis Marin, "The Utopic Stage," trans. Robert A. Vollrath, *Utopics: Spatial Play* (Atlantic Highlands, N.J.: Humanities Press, 1984), 61–83.

*Every effort has been made to trace ownership of all copyrighted material in this book and to obtain permission for its use.*

# Contents

# Timothy Murray

## Introduction: The Mise-en-Scène of the Cultural

> *A new theatre or a new (non-Aristotelian) interpretation
> of the theatre; a theatre of multiplicities opposed in every
> respect to the theatre of representation, which leaves intact
> neither the identity of the thing represented, nor author,
> nor spectator, nor character, nor representation which,
> through vicissitudes of the play, can become the object of a
> production of knowledge or final recognition. Instead, a
> theatre of problems and always open questions which
> draws spectator, setting and characters into the real
> movement of an apprenticeship of the entire unconscious.*
> —Gilles Deleuze, *Difference and Repetition*

The past three decades have witnessed an explosive French dialogue regarding the role of theatricality in critical thought. Although some attention has been paid to avant-garde developments on the French stage, most discussion has focused on broader issues of representation. Regardless of the particular school or method being advanced, whether feminism, psychoanalysis, deconstruction, or ideology critique, French theoreticians invariably reflect on the structural and epistemological status of mimesis (imitation).

Primarily a philosophical and aesthetic concept, mimesis was initially outlined by Plato and Aristotle as the fundamental category of aesthetics and poetics. Whereas Plato turned to mimesis to explain the inferior status of the artistic imitation of "essence," Aristotle later recast mimesis in a positive light to account for the successful poetic representation of "ideal reality." It was Aristotle's notion that drama should portray a composite portrait of ideal virtue and moral action that dominated the theory and practice of Renaissance and neoclassical theatre. In the twentieth century, mimesis was lent a much wider literary significance, beyond the bounds of drama and epic poetry, by Eric Auerbach's influential 1946 study, *Mimesis: The Representation of Reality in Western Literature*. In this book, which helped to shape the discipline of comparative literature, Auerbach outlines a history of literature's thematic and stylistic representation of reality, from the "high style" focus of

classical epic poetry on a statuesque hero who represents the ideals of culture, to the nineteenth-century novel's realistic mode of elevating everyday individuals as the subjects of tragic representation. Auerbach's approach was particularly inventive in insisting on the modern novel's mixture of literary genres (tragedy, comedy, and romance) and styles (high, intermediate, low) to provide a realistic representation of the random universality of everyday life. Although different in emphasis, this specific literary goal of Auerbach's *Mimesis* is every bit as utopic as the differing philosophical aims of Plato's *Republic* or Aristotle's *Poetics:*

> The more numerous, varied, and simple the people are who appear as subjects of such random moments, the more effectively must what they have in common shine forth. In this unprejudiced and exploratory type of representation we cannot but see to what extent—below the surface conflicts—the differences between men's ways of life and forms of thought have already lessened. The strata of societies and their different ways of life have become inextricably linked. . . . It is still a long way to a common life of mankind on earth, but the goal now begins to be visible. And it is most concretely visible now in the unprejudiced, precise, interior and exterior representation of the random moment in the lives of different people.[1]

What remains unprejudiced, in Auerbach's terms, is the "unification" and "simplification" of mimesis and its ability to represent reality as an external and universal constant.

A radical questioning of what Michael Foucault terms "the original, the first time, resemblance, imitation, faithfulness" (220)[2] is precisely what led French poststructuralism to challenge the fundamental assumptions of such an endorsement of mimesis. The status of terms deriving from the philosophy and criticism of mimesis is at stake: nature, art, sameness, originality, genius, authority, sovereignty, patriarchy, teleology, understanding, and even pleasure. These terms are critiqued by French theory for sustaining not only the utopic notions of fiction and everyday life, but also the contemporary means of understanding these notions through the scaffoldings of structural linguistics, phenomenology, and psychoanalysis that shaped postwar French thought.

While wary of the uncritical endorsement of mimesis in theory and practice, these same French texts have turned insistently, as well as ambivalently, to the figure of theatricality as a self-reflexive supplement to the models of language and image that shape the untroubled binarisms of structural linguistics, poetics, and psychoanalysis. Theatricality is called upon by French theory as something of a third term through which "interpretation, explicitly or not, designates and frames its own practice as performance."[3] Theatricality is what performs and lays bare the mediating procedures of reflexivity that

give rise to thought, text, and image while proving false the utopic postwar notion of the unprejudiced. To Gilles Deleuze, for instance, theatricality is an unbalanced, nonrepresentative force that undermines the coherence of the subject through its compelling machineries. In stage terms, André Green theorizes theatricality as the means by which authors, players, and spectators are constituted as the dependent Other, not the masterful subject, of performance. Through such performance, the underlying subject/object dichotomy is destabilized, to follow Foucault, by the empty form of mime rather than revered by the mimetic paradigm "of a central and founding subject to which events occur while it deploys meaning around itself; and of an object that is a threshold and point of convergence for recognizable forms and the attributes we affirm" (224). Similarly, Philippe Lacoue-Labarthe turns to theatricality to figure the deconstruction of the procedures of absolutism and mastery over text and socius. Lacoue-Labarthe, like so many of the writers gathered in this collection, emphasizes "the political question" of the interpretational role of theatricality.

This political question has been raised with added force in recent work by American drama theorists, such as Herbert Blau, Marià Minich Brewer, Hollis Houston, Erik MacDonald, and Mohammed Kowsar, who dwell on poststructural theory's revolutionary impact on performance.[4] At stake in their critique of a universal mimesis are the implications of the kind of decentered theatrical performance that Foucault calls "thought *(la pensée)* as mime (repetition without a model)" (225). The vicissitudes of mime without a model, without an original essence, have been explored on a related political front by exciting work in the analysis of sexuality that situates mime, masquerade, and performance as cultural practices at odds with the identity politics of the phallocentric, heterosexual norm. Departing from work included here by Frantz Fanon, Jacques Derrida, Luce Irigaray, Julia Kristeva, Jean-François Lyotard, among others, theoreticians of sexual and gender identity have been exploring how to adopt the powers of representation by miming them against themselves and their institutional loci: the father, the family, the theater, the university, the state. While Elin Diamond and Sharon Willis revise strictly Oedipal norms with fluid psychoanalytic notions of identification, masquerade, and fantasy, Judith Butler, Teresa de Lauretis, Ed Cohen, Jill Dolan, and Sue-Ellen Case relate the mimicry of performance to the drag and camp of queer practice and identity politics.[5] Similar political questions are posed by critics as diverse as Kobena Mercer, Emily Apter, Homi K. Bhabha, Isaac Julien, Trinh T. Minh-ha, Tejumola Olaniyan, and myself regarding the promise of mime and performance for an understanding of postcolonial practice, improvisation, and resistance—practices that now are likely to be witnessed through the mixed media of screen, video, and stage.[6]

Texts mapping out the diverse terrain of Anglo-American performance theory are readily available in three unusually sophisticated collections: *Critical Theory and Performance,* edited by Janelle G. Reinelt and Joseph R. Roach, *Performing Feminisms: Feminist Critical Theory and Theatre,* edited by Sue-Ellen Case (a collection of essays published in *Theatre Journal* during the years Case and I served as its editors), and *Performance and Cultural Politics,* edited by Elin Diamond.[7] While French theoretical writings on theatricality are widely discussed and critiqued throughout these collections, those same French texts have not been readily accessible as a unit to the Anglo-American public. The aim of *Mimesis, Masochism and Mime* is to fill this gap by providing Anglo-American readers with a sorely needed sourcebook of French writings that reflect on theatricality's importance to the French conceptualization of mimesis, mime, and, as I will soon clarify, masochism.

With this end in mind, I have not included many authors, such as Anne Ubersfeld, Bernard Dort, and Patrice Pavis, whose work dwells more on specialized issues in French theater and dramatic theory than on the broader epistemological and ideological questions of French thought.[8] The difficulty and cost of obtaining translation and reprint permissions also have resulted in the unwanted exclusion of many texts by theoreticians whose work on theatricality has been pivotal in the transformation of French thought. My unfortunate need to exclude at the last minute essays by Roland Barthes, "Diderot, Brecht, Eisenstein," and Jacques Lacan, "Desire and the Interpretation of Desire in *Hamlet,*"[9] is compounded by the absence of a large number of essays by other influential writers whose texts on theatricality, performance, and fantasy have contributed to the diversity and depth of French thought, such as Jean-Luc Nancy, Sarah Kofman, Jean Laplanche, Christine Buci-Glucksmann, J.-B. Pontalis, Mikkel Borch-Jacobsen, Guy Rosolato, and Joyce McDougall.[10] But rather than apologize for these exclusions, I stress their magnitude as evidence of the wide impact of the theorization of theatricality on the conceptual development of French letters and culture.

## Theatricality or Reality: The Mise-en-Scène of the Cultural

This grouping of essays positions French poststructuralist thought within the context of its serious, and often overlooked, attentiveness to the cultural consequence of physical, plastic, and figural frameworks. This is an especially important consideration when related to poststructuralism's heedful suspicion of representation as well as the overdetermined privilege given by Anglo-American critics to its emphases on language, writing, graphics, and the literary. My stress here on theatricality thus functions to lend unprecedented

focus on French theorizations of the body, gender, sight, screen, voice, territoriality, otherness, and diversity. These reflections are framed by accounts of ideology, philosophy, and psychoanalysis as well as by specific linkages of the specular and aural concerns of the human sciences *(les sciences humaines)* to the contemporary work of performance, film, and video.

Readers also will note the importance of this volume's differing theorizations of theatricality to the discourse of cultural studies. I reflect with dismay on the relative silence of proponents of cultural studies regarding the theory and practice of theatricality, not to mention theatricality's significant inflection on fundamental notions of the cultural. To cite just one symptomatic example of the indifference of cultural studies to the politics of theatricality, the extensive bibliography of *Cultural Studies,* the 788-page Routledge reader edited by Lawrence Grossberg, Cary Nelson, and Paula Treichler, contains indirect reference to only one of the essays included in this collection, Irigaray's "The Stage Setup."[11] While *Cultural Studies* cites texts by Derrida, Lyotard, Deleuze, Fanon, and Althusser, its contributors refer to the more popular philosophical and literary analyses of these authors rather than emphasize their essays on theatricality, representation, and culture. This same volume ignores, moreover, many French theoreticians included here who have focused throughout their careers on the study of cultural representation: Marin, Cixous, Girard, Lacoue-Labarthe, Féral, and Durand. One might wonder how the British and American tradition of cultural studies can undertake a focused analysis of "the processes that have shaped modern and postwar society and culture"[12] without considering the extensive theorization of the politics of theatricality and representation that has garnered so much attention in France.

It is true that many proponents of cultural studies maintain an ambivalent relation to poststructural theory. Inside and outside circles of cultural, feminist, queer, and postcolonial studies, serious and troubling questions continue to surface regarding poststructuralism's attentiveness to formidable matters of diversity. Has poststructural theory, especially when conceptualized by male philosophers within France, been adequately attentive to the exigent questions of identity politics? Does the theory of the "split subject" contribute to or detract from the representation of "subject positions" whose inscriptions in the "identities" of gender, sexuality, race, class, and cultural difference might not have been overtly acknowledged by the French "fathers" of theory? Might not French feminism's focus on abstract, epistemological features of gender (writing, voice, hysteria, melancholia, gynocriticism, etc.) cloud its sensitivity to the more materialist and realistic matters of women's histories? Similarly, has the French theoretical notion of "difference" as a linguistic, textual, and discursive construct been so broadly philosophical,

structural, and formulaic as to occlude close analysis of historical realities that may well be more "diverse" and "divisive" than *different* and *differend*? Does not the rereading of psychoanalysis by "French Freud" remain inscribed in a logic of patriarchy and Oedipal, family drama that remains hostile to feminist, lesbian, and gay concerns? Similarly, has the French emphasis on "writing" and fantasy trained a blinding spotlight on "transcendental or essentialist qualities in contemporary theory"[13] in contrast to attentiveness to the more realistic, materialist issues of class, race, sexuality, ethnicity, and colonialism? In brief, has the French concern with the form and abstract matters of epistemology, the science of knowledge, blinded its theory to material and social differences, to the politics of the real? One could conclude such a litany of cautionary challenges by questioning whether Anglo-American poststructuralism's frequent privileging of the literary hasn't contributed to the academy's deep and, I would argue, continuing ambivalence about the study of mixed and "lower" forms of mass-cultural production, from popular theater, performance, and spectacle to video, television, and popular music.

Such challenges made in the era of cultural studies are not new to the critical arena. Similar criticisms have been prevalent on the Anglo-American scene since the broad translation of French poststructualism in the 1970s. At issue, then just as now, was the seeming incompatibility of French concerns with British and American ones, the apparent indifference of the broad philosophical and psychoanalytical questions of "theory" to the specifics of realist and cognitive approaches to literary and cultural history. In *Literature Against Itself,* for instance, Gerald Graff attacks structuralism for taking sides with modernism's politicized campaign against realism and for interrogating humanistic claims of literature's " 'mimetic' relation to the world."[14] In the 1980s, the politics of French theory was itself made the subject of dispute by American realist critics. In a provocative reading of Flaubert, "Rhetoric and Realism," Jonathan Arac contrasts deconstruction's rhetorical analysis and its demystification of internal and external binarism with a "realist criticism" based on the assertion, seemingly missing from French theory, "that culture is related to politics."[15] Similarly, in "The Reality of Theory," Daniel T. O'Hara attacks "French Freud" for distorting, even ignoring, reality: "their theoretical speculations are unanchored, really, to specific literary texts of our cultural moment, or to particular social groups, or to larger historical forces and movements in the world today."[16] Even Michael Taussig's recent exploration of the excesses of mimesis, *Mimesis and Alterity,* reverts to the same sort of antipoststructuralist chant: "mimesis has become that dreaded, absurd, and merely tiresome Other, that necessary strawman against whose feeble pretensions poststructuralists pace and strut. I, however, am taken in by mimesis precisely because, as the sensate skin of the real, it is the moment of know-

ing."[17] Curiously prevalent in Anglo-American criticism, now just as then, is a realist ambivalence about French theory. Such a realist stance would no doubt reproach the essays gathered here for engaging in dubious diversions of cultural criticism from the historical, political, and multicultural imperatives at hand.

It would only be fair to acknowledge that the American realist critics of poststructuralism are dead right about the French source of their disagreement. At the core of French literary and visual theory, philosophy, and psychoanalysis is a spirited critique of the complicity of the realist assumptions of language, philosophy, aesthetics, and psychology in sustaining a complex mimetic legacy that envelops metaphysics, consciousness, patriarchy, and absolutism. The point of this critique, however, is not to condemn realism but rather to deconstruct the European legacy of mimesis that brings realism into epistemological alignment with repressive mental and social practices, such as sexism, homophobia, and national absolutism, to which realism itself is by no means committed.

A patient reading of this collection, therefore, will reveal these and similar challenges to be the dialogical products of French theory itself rather than the Anglo-American realist means of the undoing of French thought. These essays addressing various aspects of the politics of theatricality pay close attention to theory's relation to the divisions of reality and to the figural representation of reality through text and image. With the possible exception of René Girard, these authors would unanimously endorse Foucault's suspicion of any critical project that aims to be "surrounded not by a marvelous multiplicity of differences, but by equivalences, ambiguities, the 'it all comes down to the same thing,' a leveling uniformity" (231). Readers of this collection will be struck, moreover, by its unqualified insistence that the understanding of reality and realism depends on the frame, window, or perspective of its mise-en-scène. Reality must be categorized, that is, by reflecting not merely on *what* is represented but also, and most significantly, on *how* it is shown or re-presented and *how* it is seen, read, or received. What is theorized or understood as "real" or "material" or even "historical" remains contingent on its mise-en-scène, that is, on the means with which it is represented as well as on the context of its reception.

This sensitivity to the conditions of mise-en-scène is exhibited in the diversity of style and argument in the essays to follow. One of the hallmarks of French theory is its experimentation with critical writing as a means of deliberately investigating the many forms, aspects, and manifestations of the cultural, not to mention theory itself as representation, as the performative mise-en-scène of writing. It should be stressed, moreover, that this attentiveness to form and representation forges political and ideological links to the

diverse cultural and material legacies of theater and theatricality that are outlined in this volume.

Reflecting its diverse critical and ideological terrain, these links are organized in this volume in four interrelated and overlapping sections generally concerned with *the philosophical, the psychoanalytical, the ideological,* and *the mimological.* Part 1, "Mimesis Imposed: Machineries of Representation," focuses on theatricality as a philosophical machinery of representation and provides differing accounts of its mimetic status. The section opens with a fascinating interview of Hélène Cixous, who reflects on the process of writing for the Théâtre du Soleil and the traumas of censorship, transference, and displacement that she lives along the way. In readings of Plato, Artaud, and Euripides that then follow, Jacques Derrida, Luce Irigaray, and René Girard differ over the status of theatrical authorship and its indebtedness to classical, feminist, and political accounts of mimesis. Part 2, "Tragedy and Masochism: Scene as Other," focuses on the masochistic role of tragedy on the scene of psychoanalysis and debates the psychopolitical implications of "the unconscious as mise-en-scène." The contributions by Louis Marin, André Green, Jean-François Lyotard, and Philippe Lacoue-Labarthe discuss the relationship of tragedy and masochism in French literary and psychoanalytic theory while simultaneously outlining significantly different approaches to Otherness, utopia, sight, reading, body, and fantasy as made manifest by psychoanalytically informed considerations of theatricality. These essays introduce readers to psychoanalytic terminology and approaches to theater while also engaging in debates over the finer distinctions of psychoanalytic theory. While Marin's essay traces positions of absence, lack, and suffering that are shared structurally by utopia and representation, Green, Lyotard, and Lacoue-Labarthe debate the masochistic condition of tragedy itself and its topological place in the unconscious. Part 3, "Staging Power: Transgressive Alterity," reflects on theatricality's role in foregrounding differing notions of ideology, power, and resistance. Louis Althusser, Michel Foucault, Gilles Deleuze, and Frantz Fanon relate the theatrical system of mimesis to historical practices of ethno- and Eurocentrism. In outlining ideological, theatrical, and revolutionary alternatives of diversity, nomadic singularities, and minority practice, these authors make their proposals in the context of close readings of philosophical, theatrical, and cultural examples: from Plato to Deleuze to the revolutionary mime of the veil in the Algerian War to more contemporary adaptations of "epic theater." Part 4, "Like a Film: Theatrical Dispositions," theorizes the conceptual and political radicality of contemporary theatrical experimentations on the Other scenes of film, video, and performance. These feminist and alternative practices are said to mime and undermine the hegemonically gendered histories of theatrical mimesis and masochism. What I term *mimology,* in this

context, is their mixed-media performance of the spaces and conventions of the symbolic Other. Through the mixture of form and content, these performances demystify the hegemonic dispositions of representation while reshaping them to portray complex positions of diversity.

These four sections can be read separately or in sequence. Readers knowledgeable of contemporary film and performance, for instance, may wish to begin with part 4 and then return to the earlier sections, which include essays dwelling on the theoretical context of later analyses by Féral and Durand. Likewise, those committed to ideology critique can turn first to part 3 before reading the philosophical and psychoanalytical essays to which these authors widely refer. Regardless of the order in which they engage these essays, readers are likely to appreciate how their arguments frequently dialogue with each other in weaving a complex narrative of the mimetic legacy, its masochistic alignment with patriarchal absolutism, and the performative appropriation of mimetic structure by alternative theater and political practice. Readers unfamiliar with poststructural approaches and vocabularies should be aided by the authors' helpful tendencies to situate their theoretical discussions in relation to widely known drama, from Shakespeare to Artaud, and in terms of more contemporary, experimental performance, from the Europeans, Marguerite Duras, Théâtre du Soleil, Carmelo Bene, and Giorgio Strehler, to the North Americans, Michael Snow, Mabou Mines, Robert Wilson, and Yvonne Rainer. Providing much more than a conceptual description of historical theater practice, these essays also display various strategies of the performance of writing itself through which the politics of interpretation takes center stage.

Rather than trivialize the diversity of these textual performances by summarizing their individual arguments in a uniform language and style, I wish to spend the remainder of this introduction in clarifying their overall relation to the mimetic legacy and its alignment with patriarchal absolutism. In rereading the contents of this volume, I am struck by the authors' insistence on three allegorical compounds around which Occidental theories of mimesis and performance (graphic and plastic) seem consistently to revolve: *nature and art, pleasure and pain, mime and disavowal.* My hope is that a brief overview of these compounds will provide readers with something like a topological map of their analyses in the essays to follow.

## Nature and Art

Deriving from Plato's *Republic* and Aristotle's *Poetics,* the Occidental theory of "the representation of reality" is based on the assumption that literature,

philosophy, and art provide mechanisms for the imitation (mimesis) of a metaphysical origin of truth. Book 10 of Plato's *Republic* critiques art for the inferiority of its representations. Plato warns the citizens of his republic that art produces mere copies of natural objects, which are in themselves but secondary imitations of true, ideal forms. Art is thus three removes from the pure form of reality; "the true" art produces mere *phantoms* of the *semblance* (nature) of the *exemplary* (form). Although a suspicious activity, art serves a social function by attesting, in its remove, to the presence of an ideal origin or center of truth that it can never replicate. Plato is thus ambivalent about the role of mimesis and its seductive phantoms. "On the one hand," in the words of Gunter Gebauer and Christoph Wulf, "he recognizes its significance; on the other, he fears its power, which is difficult to calculate."[18] For Aristotle, in contrast, the fables of fiction provide the positive ground not merely for representation of the ideal but also for the exhibition, if not the creation, of the general and the particular. The actions of state, family, and self provide the valuable material of mimesis by which metaphysical absence is made manifest as present and possible. It is through the literary embellishment of action and life that art heuristically aims to present its spectators with positive and negative models of human behavior and value that, in the *Poetics*, are best made manifest through expression of the feelings of happiness and misery.[19] Regardless of the difference of their attitudes toward mimesis, Plato and Aristotle share the critical assumption that works of art have a substitutive or vicarious relation to reality. Such a vicariousness is based, in the view of Jean-François Lyotard, on the scheme of "dramatization" or "scenic representation."[20] That is, mimesis stands for, signifies, and translates some other reality whose representation depends on the schematic binarisms of inside versus outside, nature versus copy, presence versus absence, truth versus mimesis, and signified versus signifier.

More recent lessons of modern philosophy and linguistics endow the individual subject, through the self-authorizing mechanisms of consciousness and language use, with the illusory ability to negotiate and oversee the closure of such representation, the fusion of art and reality. Such a confidently centered subjectivity is grounded by the modernist legacies of subject and object, sign and sight. The modern subject has been theorized by empiricism, cognitive philosophy, and phenomenology as being capable of positioning and locating itself through sight and language on the empirical borders of inside and outside. In this context, mimesis is not the product or copy of nature but the reproduction of the production of understanding through which subjects define themselves in specular and linguistic relation to objects. Described by Jacques Derrida, writing on Kant, as "anthropo-theological,"[21] this human act of mimesis, of making objects present with meaning, thus stands in for the

divine act of the production of meaning, and lays the groundwork for more contemporary notions of intersubjective thought, hermeneutic phenomenology, and universal communicability.[22]

In the 1954 essay "Science and Reflection," Martin Heidegger discusses the relation of the production of meaning as it takes place on the metaphysical scene of art and on the theoretical scene of science. Heidegger argues that the "reality" within which human subjects move and maintain themselves is determined to a large extent by the conceptual frameworks shared by art and science. To answer his question, "what is real in relation to theory," Heidegger situates theory as a theatrical procedure shared by theater and the science of phenomenological perception:

> The word "theory" stems from the Greek verb *theorein*. The noun belonging to it is *theoria*. Peculiar to these words is a lofty and mysterious meaning. The verb *theorein* grew out of the coalescing of two root words, *theatricality* and *horao*. *Theatricality* (cf. Theater) is the outward look, the aspect, in which something shows itself, the outward appearance in which it offers itself. Plato names this aspect in which what presences show what it is, *eidos*. To have seen this aspect, *eidenai* is to know [*wissen*]. The second root word in *theorein*, *harao*, means: to look at something attentively, to look it over, to view it closely. Thus it follows that *theorein* is *thean horan*, to look attentively on the outward appearance wherein what presences becomes visible and, through such sight—seeing—to linger with it.[23]

Even in the guise of a turn away from metaphysics, Heidegger positions the science of knowledge in relation to the theoretical procedures of visibility and the phenomenological conditions of perception. The theoretical subject is here authorized by procedures of perspective and specularity through which the subject stands as the ontological center, as the maker of the presence of absence, as the locus of meaning. Fundamental to modernist concepts of mimesis, I cannot stress too strongly, is this conflation of theater as outward appearance and of theatricality as the subjective performance of attentive gathering.

The gathering itself takes place through language. The phenomenological system depends heavily, for its conception of language use, on Ferdinand de Saussure's well-known divisions of the sign into the binaries of signifier/signified, sign/meaning, outside/inside.[24] The sign is construed by Saussure along the same binary nexus of appearance/essence that constitutes Heideggerian specularity, through which outside appearance remains in contrast with visibility or essence. So, whether through the theatrical mechanism of sight or sign, such a mimetic distinction between subject and object (which the Heideggerian project always seeks to unsettle) might be said to sustain not

only modern science and art but also the social formations they simultaneously inform and reflect.

The issue of social formation extends the terms of our discussion of modern conceptions of mimesis from self to society, from subject to subjugation. Crucial to so many of the texts in this collection is how the subject's production of representation and meaning through visibility mirrors the procedures of regulated perception that inscribe the subject in the ideological nexus of family, state, and nation. They stress how the governance of the modern socius is patterned after the early modern philosophical conventions of subject and mimesis (derived, as Heidegger indicates, from Plato and Aristotle) as well as on the conflation of metaphysics and social structure. Based on mimetic distinctions between inside and outside, inclusion and exclusion, self and other, the metaphorical heritage of patriarchy, family, and state is grounded in the early modern concepts of genius, authorship, and authority. The elaborate allegory of genius developed in the seventeenth century, for example, conflates the internal procedures of authorship (the imaginary) and the external force of authority (the symbolic) on numerous social registers: book, stage, ceremony, family, church, and state.[25] The extension of metaphors of personal prowess (the genius of cogito) into symbols of social power (the force of absolutism) prevails throughout the early modern period and continues to influence modern writings on philosophy and psychoanalysis. In this regard, Mitchell Greenberg provides an astute summary of the mimetic network of religious, economic, and metaphysical imperatives to be mimed by English, French, and Spanish viewers of seventeenth-century drama.

> The appeal of absolutist monarchy, the appeal to the leader, would be impossible without an underlying metaphorical structure that equated the king, the political/metaphysical "father" of his people, to the biological father of individual family units. All the political writers of the period fervently worked at reinforcing this metaphorical analogy between political and familial structures and power. From Bodin on, the basis of political power was shown "ab origine" to emanate from "primitive," i.e. Biblical, family units in which the father's preeminent position was seen both to reflect a God-given "natural order" and to serve as a model for all larger political groupings.[26]

Following this early modern logic, it can be said that the legacy of absolutism depends on the metaphorical conflation of the realist, natural, biological, empirical orders with the metaphysical, political order of divine origin. This conflation is gathered and represented through the ordering lens of patriarchal perspective and governance. Absolutism is thus the social and phallocentric corollary of the closure of representation.

The group of writers that coauthored the French collection *Mimesis desarticulations* maintains that such a legacy is sustained by "the ethics of Mimesis: it governs something—and somewhere—before the law . . . always in relation to an (un)certain anteriority."[27] Put similarly in the context of psychoanalysis, Jacques Lacan writes of *Hamlet* that "the order of the law can be conceived only on the basis of something more primordial."[28] The ethics of mimesis thus metaphorically encapsulates the excess, the somewhere or something more, of its own anteriority. Such an ordering of excessive anteriority and difference in the guise of presence, immediacy, and closure is precisely what positions the realist project in an awkward alignment with the legacy of the ethics of mimesis. While perhaps no longer strictly absolutist, this legacy bears the structural traces of the phallocentrism, ethnocentrism, and Eurocentrism that produced it. Its governance before the law of realism is based on something more universally primordial.

"One can say in total assurance," insisted Derrida as early as 1966, "that there is nothing fortuitous about the fact that the critique of ethnocentrism—the very condition of ethnology—should be systematically and historically contemporaneous with the destruction of the history of metaphysics. . . . The quality and the fecundity of a discourse are perhaps measured by the critical rigor with which this relationship to the history of metaphysics and to inherited concepts is thought."[29] In contrast to tautological assumptions about "the closure of the real," poststructuralism, even in its sharp differences, which are so strikingly evident in this collection, has been critical of the ethics of the realist project. In 1968, Derrida warns his readers that "the thing itself always escapes," even when subject to the most rigorous procedures of the phenomenological perception of the object and the linguistic regulation of the signifier. As constituted by *différance,* the thing or the signifier *differs* from everything else, and it *defers* any return to the same because of its difference from the nature to which it is added.[30] Before the law, then, the thing always stands in supplemental relation to an (un)certain anteriority and, thus, raises "a question of a critical relationship to the language of the human sciences and a question of a critical responsibility of the discourse."[31] So it follows that many of the essays gathered here stress and deconstruct the ills of any ethnocentric heritage (even that of "French thought" itself). Particular attention is paid to the demystification and critique of any Eurocentric reduction of difference and multiplicity to the same. Indeed, what is striking about these essays, many of which were penned in the sixties and seventies, is how seriously and carefully they outline theories of diversity, sexuality, gender, nomadism, and unresolved alterity whose psychophilosophical imperatives resound in the discourses of our multicultural age.

## Pleasure and Pain

How the politics of theatricality always already carries with it the negative valences of imitation can be understood in terms of the second conceptual compound important to this collection: pleasure and pain. The earliest reflections on aesthetics focus on the irony that the pleasure of mimesis derives from the spectator's attraction to physical and psychic suffering. Readers are familiar, no doubt, with Aristotle's prescription for the pleasure of tragedy: that it provoke in characters and viewers the suffering of pity and fear that, he feels, will be allayed by the comfort of purgation (catharsis). Stressing the pedagogical combination of pleasure, pain, and learning, Aristotle envelops the mimetic lesson in the pathos of masochism: "though the objects themselves may be painful to see, we delight to view the most realistic representations of them in art."[32]

The paradox of the pleasurable pain of mimesis claims the attention of almost all of the writers in this volume. Analyses of the tragic mimesis and contemplation of suffering provides the points of departure for essays by Girard, Marin, Green, Lacoue-Labarthe, and Fanon. In the fascinating interview opening this book, the feminist theoretician and writer Hélène Cixous speaks of her own writing for the theater as a painful experience of the complete dispossession and violent decomposition of self from which derives the pleasure of theatrical spectators. Writing about Antonin Artaud's program for a "Theater of Cruelty," Derrida situates theatrical cruelty, "its present inexistence and its implacable necessity," as a "historic question" touching on the limit of representation, "the nonrepresentable origin of representation" (41–42). This vast enigma of the repetition of negativity within representation is lent a more explicitly political context by the essays of Fanon, Althusser, Foucault, Deleuze, and Féral, among others, that stress the unresolved alterity of the socius. While Althusser encourages the explicit theatricalization of latent ideological meanings in order to affect spectators in spite of themselves, Deleuze dwells on the benefits of a "minority" theater through which the self is empowered as a stranger to the dull uniformity of its native language. Finally, getting to the heart of empiricism's debate over the merits of artistic masochism,[33] Féral privileges theatrical performances whose choric diversity and death drive enliven the feminist performer just as it haunts the unified, patriarchal subject. What lies at the heart of theatricality, then, whether as the scene of the nonrepresentational origin of representation or as the stage of unresolved social alterity, is the ambivalent pathos evoked by the divisions of mimesis and their profound turn of subject and socius against themselves. Put simply, *mimesis is the theatricalization of masochism.*

Regardless of the possible breadth with which masochism might be

represented, masochism's theatricalization tends to project it as a particularly sexualized dynamic of the family and of familial divisions, projections, and introjections. The domestic and absolutist economies of "pure blood" are situated by the authors of *Mimesis desarticulations,* for example, at the structural heart of mimesis and its ethics of anteriority.[34] That is, domesticity cannot occur without a certain masochistic inversion since the procedures of miming familial bloodlines depend on the loss of native blood through the ritual addition of foreign blood, the blood of the Other. The mimesis of familial anteriority, in other words, circulates blood that is always already as Other as it is natural, as foreign as it is pure, as strange as it is familiar, as different as it is the same. At stake in the inversion of familial purity is the erosion, let's call it "masochism-in-division," of related notions of essentialism. Any absolutist notions of ethnic, racial, gender, or even national purity are subject to the self-generated economies of mixture and pollution that resist the drive of the ethics of mimetic anteriority, as discussed above, to encapsulate the "something more" of its own difference.[35]

In addition to being constituted by a divisive economy of mixture, the familial site is marked frequently on the stage by an excessive spillage of blood. The family has been staged historically as the most complex locus of sexual representation, in which the theatrical pathos of sexuality and violence seems to increase exponentially when parents are involved. There can be little dispute that the family is the privileged site of pathos and its unfathomable masochism. The historical draw of the tragedies of Oedipus and Hamlet, of Jocasta and Gertrude, are most frequently cited in this collection as evidence of the family's complex chemistry and masochistic appeal. While stage conventions of exaggeration and embellishment obviously contribute to this intensity, theory has focused on the primal reverberations of spectatorial encounters with familial sexuality. That is, the family has appealed to theater as well as to theory as the violent locus of the earliest, imaginary experiences of sexuality and the pleasurable site of their symbolic resolution in the constitution of the subject.

It is a commonplace that Oedipal drama has provided psychoanalysis, for instance, with a controversial blueprint for mapping the subject's early development. André Green identifies the family as "the tragic space par excellence, no doubt, because in the family the knots of love—and therefore of hate—are not only the earliest, but also the most important ones" (142). On one level, the Oedipus complex is a model of the subject's complex identification with, desire for, and repulsion from the mother and the father. On another level, the negative and positive Oedipus complexes provide for entry into the respective horizons of the maternal imago and the law-of-the-father. Many of the liveliest debates inside and outside of French poststructuralist theory have

been catalyzed by disagreement over the mapping of subjectivity around the positive and negative Oedipal complexes and the potential of a concomitant sequestration of woman in the passive position of imago and man in the active thrust of phallic law.[36]

What adds fuel to this debate over the dramatic appeal of the Oedipal structure is its status as *myth* or *fantasy* within literature and psychoanalysis. Green emphasizes how tragedy stages familial relations more as projections and ideals than as historical realities, "not what has been but what might have been, as if it had occurred as the myths recount it" (143). The tragic fable lends itself to the theatricalization of a backward projection, a theatrical derealization, that blends personal reality with mythical identification. But rather than understand derealization as a mere device of the theater, the psychoanalytical tradition understands it to be a constitutive factor of subjective projection and identification. "In each case," writes Lacoue-Labarthe, "it is the ambivalence of *identification* that is at stake" (187). Faced with the tragic image and pathos of familial desire, writes Lacan, "the subject feels himself to be in an imaginary situation of otherness."[37]

Many of the essays included here refer to how the contemporary understanding of this process is indebted to Lacan's elaborate formula of desire revolving around his theory of the mirror stage. In the mirror stage, the infant is constituted by its narcissistic identification with a seemingly complete mirror image (gestalt) whose recognition is accompanied by the subject's realization of its inability to live up to this image.[38] On one level, the subject embraces the image as a salutory fiction, as an *introjection* of analogical correspondence to the self (on which the sexual drive depends). On another level, the image's seeming perfection alienates the subject, who subsequently confronts and aggresses the image as an interiorized rival. This second level, that of secondary narcissism derived from Freud, enables the subject to enter into language by bringing this image into alignment with the "admonitions of others" and the "awakening of his own critical judgment."[39] "What he projects before him as his ideal," writes Freud, "is the substitute for the lost narcissism of his childhood in which he was his own ideal."[40] Defined no longer in terms of plenitude and reflection (mirror image), but now in relation to lack and differentiation (distance, cut, joining, disjunction), the subject "identifies with the all powerful signifier of demand from which it is indistinguishable; but already unable to signify the lost unity except by repeating it as different, it fades before the signifier."[41] Lacan describes this structure of desire as a masochistic combination of knots that bind the subject to its "fading" before the signifier of its mournful relation to the loss of the idealized image or object of desire (*a*) (Lacan refers frequently to the *object petit a* or (*a*) as the signifier of the original lost object and the procedure of its loss).

Through this subsequent *projection of* an introjection, the image is re-viewed, as accompanied by speech and desire of the Other, in a way that allows the subject to position its complex libidinal relation to both the symbolic world and the introjections of the superego.[42] Such a conception of the "fading subject" has helped to generate two complementary discussions of the fundamental relation of masochism to theatricality. One pertains to the structures of libidinality per se, the other concerns the subject's relation to the social.

Regarding the first, Lacan emphasizes how "the pure negativity of the Real" marks the excessive failure of subjective representation on both the Imaginary and Symbolic registers. Sharply distinguishing the "fading subject" from realism's more confident, cognitive subject, Lacan defines the subject as what he terms the answer of the Real.[43] The Real signifies, in this context, an impossibility of the confident, cognitive recuperation of the Other on either the visual plane of the Imaginary or the linguistic register of the Symbolic. As such, it foregrounds both the interstices between the id, ego, and superego and, most importantly, the silent, unrepresentable work of the death drive that haunts the symbolic life emanating from Eros, the illusory source of what is real. The significance of new theatrical models sensitive to the "nonrepresentational" work of the drives is the subject of serious debate in the contributions by Lyotard, Green, and Lacoue-Labarthe. Lacoue-Labarthe argues that the dualism of the drives as split between libido (desire) and death results in the very ambivalence of identification that gives rise to the political imperative of the deconstruction of the representation of mastery (189). Thought itself is condemned, he argues, to the difference and deferral of representation rather than the plenitude of specular mimesis. In "The Unconscious as Mise-en-Scène," Lyotard turns his attention to the difference between a disguised mise-en-scène of wish and dream thoughts dependent on confident procedures of imitation and translation and the theatricality of the primary drives underlying the ego, id, and superego. The force of the drives, according to Lyotard, stages something that has no goal other than to make manifest its potentiality. As a result, the theatricality of desire eludes interpretation due to "its dischronisms, its polytopisms, and its paralogisms" (170). Green favors similar post-Freudian models of theatricality that acknowledge the antagonistic dominance of the life and death drives over the more realistic Aristotelian ones. The difference lies between a realist project of mimetic procedures of translation or recovery of "repressed" symbols and a radically psychoanalytic one that acknowledges how primary drives disturb the clear distinctions between the ego, id, and superego with a tendency toward discharge (spontaneity, cry, crisis), nontemporality (ubiquity of time and space), and contradiction (148–49).[44] Tracing such a split back to Nietzsche, Leo Bersani provides a helpful summary of its broader aesthetic implications in his daring book, *The Culture of Redemption:*

Psychoanalysis reformulates the Nietzschean tradition . . . between the Diony-sian and the Appollonian as the inevitable moment in the human subject between the self-shattering jouissance of the sexual and the desexualizing tracing of an ego's boundaries. But if the ego is originally constituted in order to be shattered, then the ego's consciousness of its boundaries may always include the possibility of a boundless self-interest that will explode boundaries. This interest is not a *desire* for something; it is a desire *to be* with an intensity that cannot be contained—held in or defined—by a self. In a sense, such desire is indeed characterized by a disinterestedness generally associated with art. But this disin-terestedness is the sign not of a lack of affect but rather of a drive so pure that it covets no objects.[45]

When critical attention shifts from the drives themselves to the related paralogisms of theatrical boundaries, the staging of the subject in relation to its fading can be said to align theatricality with the intensity and pleasure of masochism. Split between the image of plenitude and the signifier of lack, the subject who fades before the signifier of the lost object virtually conforms to the performative characteristics attributed by psychoanalysis to masochism. In "Masochism and Male Subjectivity," Kaja Silverman differentiates between two kinds of introjection through which the Freudian "superego" would here come into play. "Imaginary introjection" is the process through which once-loved objects are taken into the self to serve as subjective models. Through such introjection, the subject sees itself as it would like to be seen. "Symbolic introjection," in contrast, is the psychic process subordinating the subject to the Law and the Name-of-the-Father.[46] The result is a subject who is consti-tuted as split between the regulatory procedures of introjection. This is be-cause introjection leaves the subject torn between the awakening of critical judgment (through which the ego sees itself as it would like to be seen) and the admonition of others (subordinated to the Law). Silverman further aligns the introjections of post-Freudian subjectivity with the demonstrative fea-tures of moral (in contrast to simply "sexual") masochism, as outlined by Theodore Reik in *Masochism in Sex and Society*.[47] Functioning both as victim and victimizer in dispensing with the need for an external object, the moral masochist places a premium both on the self-display of exhibitionism and on the mirror staging that underpins subjectivity, "the 'I saw myself seeing my-self.'" To the masochist, an external audience is a structural necessity since the body is centrally on display, and a master tableau or group fantasy (the family drama of the paternal superego) lies behind all scenes.

It is crucial to note that the structural role of such a master tableau may carry varying weight for different subject positions. Frantz Fanon, for in-stance, understood such a position to be the only one available to the colo-nized subject, who is determined from without by the image and fantasy of

the white man's eyes.[48] That Fanon practiced psychoanalysis as a means of treating such cultural subjugation, a practice informing his essay included here, "Algeria Unveiled," underscores a point made by Silverman that moral masochism is frequently accompanied by "a strong heterocosmic impulse— the desire to remake the world in another image altogether, to forge a different cultural order."[49] It is just such an impulse, such a desire to forge a different cultural order acknowledging intensity, discharge, and contradiction, that readers of this collection may come to appreciate in two senses: first, as a structural feature of masochism itself, and second, as the result of any sustained critique of mimesis and its patriarchal inflections in the psychoanalytic construction of human subjects and their social relations.

## Mime and Disavowal

I wish to acknowledge the probable concern of many readers, especially "materialist feminist" ones, that such a heterocosmic impulse, the utopian need to forge a different cultural order, is contingent on the fact that Lacanian and masochistic identity are defined in relation to a phallic and heterosexual economy of lack or castration. This paradox hardly goes unnoticed by the majority of authors here assembled. Their political agendas are based, however, on an ambivalent understanding of lack and even castration as constructs of split subjectivity. Lack and castration are theorized as representational rather than biological constructs even though they are shared differently by subjects of both sexes (thus a source of deep ambivalence). What is contested is not so much the inscription of the subject in lack itself as the power and mastery that patriarchy falsely derives by excluding women, minorities, and "colonials" from economies of psychic recuperation and symbolic representation.[50] One of our essayists, Louis Marin, even situates utopian discourse itself on the fissured terrain of lack through which differences are totalized and historical contradictions are dissimulated and disavowed. The contradictory and ambivalent nature of disavowal is what provides the symbolic and utopian orders with their fictional stability and authority. It is true that the disavowal of fetishism ("yes, I know the subject is split [castrated], but nevertheless I'll carry on by pretending it to be otherwise") is perhaps the most significant procedure of stabilization traditionally theorized as being most available to male subjects. Yet confidence in just such stability is precisely what the essays in this volume contest vehemently, whether on philosophical, psychoanalytical, or ideological grounds. For it is in relation to the subject's revealing exhibition of such disavowal that masochism is understood to theatricalize the constitution of

the symbolic order in *différance* and to provide a representational means for forging this order differently by and for its Others.[51]

Two postures of disavowal receive the most attention in theoretical literature on the subject of masochism. One tendency is to focus on disavowal's devaluation of the symbolic order. Silverman highlights the male masochist's public refusal of the imitation of disavowal: "the male masochist magnifies the losses and divisions upon which cultural identity is based, refusing to be sutured or recompensed. In short, he radiates a negativity inimical to the social order."[52] In contrast is another tendency that locates disavowal and its mimicry at the heart of masochism and its heterocosmic impulse. Identified by Silverman as a heterocosmic trait of feminine masochism is the mimicry of the very procedures of fetishism that Gilles Deleuze, in "Coldness and Cruelty," isolates as the distinguishing feature of masochism. "Disavowal should perhaps be understood as the point of departure of an operation that consists neither in negating nor even destroying, but rather in radically contesting the validity of that which is: it suspends belief in and neutralizes the given in such a way that a new horizon opens up beyond the given and in place of it."[53] In this collection, theatrical mimesis is the given that is neutralized by masochistic disavowal for the opening up and miming of new ideological horizons. Yes, mimesis is lacking, but nevertheless it will be performed, in-difference.

Openly revealing and commenting on their own mimicry of the theatrical procedures of mimesis, the essays here included dwell on the political role played by theatricality in situating the subject in the desire of the Other and thereby accentuating the Otherness, the unresolved alterity, of spectacle and its heterocosmic impulses. Drawing upon Deleuze, Foucault writes of theatricality as the conceptual project of philosophy, as the "expanding domain of intangible objects that must be integrated into our thought: we must articulate a philosophy of the phantasm that cannot be reduced to a primordial fact through the intermediary of perception or an image, but that arises between surfaces . . . in the temporal oscillation that always makes it precede and follow itself—in short, in what Deleuze would perhaps not allow us to call its 'incorporeal materiality' " (218). Deleuze himself emphasizes that theater takes on a specific, political function only on the strength of the becoming of "minority consciousness" that "designates the power or weakness of a state . . . nothing regionalist, nor anything aristocratic, aesthetic, or mystical" (255). Similarly, Althusser appreciates, in the 1960s theatricality of Milan's Piccolo Teatro, the promise of laying bare the "internal balances and imbalances of forces" that sustain the societal divisions of capitalism. Fanon analyzes how mime and theatricality provided tactical means during the Algerian struggle for the reversal of disavowal itself: "What had been used to block the psychological or political offensives of the occupier became a means, an instru-

ment. . . . It is the necessities of combat that give rise in Algerian society to new attitudes, to new modes of action, to new ways" (272).

Other authors dwell on the ambivalent features of the theatrical model to detail the libidinal and political promise of recent experiments on stage and screen. In "The Tooth, the Palm," Lyotard returns to the figure of Artaud to discuss the model for an "energetic" theatricality that he also finds, in "The Unconscious as Mise-en-Scène," to be prominent in the cinema of Michael Snow, who sets up "perspectives of realities with an eye on enjoying heretofore unexperienced intensities" (174). Julia Kristeva argues, somewhat hopefully, that American experimental performances of the contestatory Other result in a return of the maternal repressed through which " 'feminist' theater, 'psychedelic' theater, 'black' theater . . . all draw from the same structure in order to effect a more directly social and political project" (280).⁵⁴ Citing what Deleuze theorizes in his contribution as the "nomadic" or "minority" promise of Carmelo Bene's theatricality, Régis Durand details Marguerite Duras's cinematic amplification and alteration of the politically charged relation between female sound and image. Finally, Josette Féral details how recent mixed-media experiments in performance offer an alternative to theater by making *différance* perceptible "in those extremely blurred junctures out of which the subject eventually emerges" (292).

What is striking to this reader sensitized by recent Anglo-American developments in the politics of identity, sexuality, and race is the uncanny prescience of so many of these earlier essays penned in the 1960s and 1970s. While their points of departure tend to be focused on the demystification of the many structural and specular assumptions of modern approaches to philosophy and literature, their diverse critiques of the ethnocentric assumptions of sameness, closure, patriarchy, and absolutism in politics, letters, and theory result in stunning outlines of alternative epistemological and ideological frameworks. What these essays also clarify is the investment of their theoretical authors in close analysis of specific textual and cultural instances of the politics of theatricality. Representation on page and stage is here shown to have imponderable social consequence.

It would be no exaggeration to suggest that these collected essays on theatricality provide theoretical sustenance and, even, justification for the more politicized claims of recent identity politics and multiculturalism, claims that often imagine themselves as running counter to the complex heritage addressed by French theory. What I here present is a gathering of theoretical work dedicated, as is the more politicized discourse of cultural studies, to the acknowledgment and analysis of the positive and negative valences of imitation. My hope is that the publication of such a grouping of essays on the politics of theatricality will provide a helpful historical context

and theoretical blueprint for future work in the cultural study of mimesis, masochism, and mime.

## NOTES

1. Eric Auerbach, *Mimesis: The Representation of Reality in Western Literature,* trans. Willard R. Trask (Princeton, N.J.: Princeton University Press, 1968), 552.

2. All page numbers cited in the body of the introduction refer to essays included in this collection.

3. Marià Minich Brewer, "Performing Theory," *Theatre Journal* 37, no. 1 (March 1985): 13–30.

4. See Herbert Blau, *To All Appearances: Ideology and Performance* (New York: Routledge, 1992); Hollis Huston, *The Actor's Instrument: Body, Theory, Stage* (Ann Arbor: University of Michigan Press, 1992); Brewer, "Performing Theory"; Erik Mac-Donald, *Theater at the Margins: Text and the Post-Structured Stage* (Ann Arbor: University of Michigan Press, 1993); Mohammed Kowsar, "Lacan's *Antigone:* A Case Study in Psychoanalytical Ethics," in *Critical Theory and Performance,* ed. Janelle G. Reinelt and Joseph R. Roach (Ann Arbor: University of Michigan Press, 1992), 399–412.

5. See Elin Diamond, "Mimesis, Mimicry, and the 'True-Real,' " *Modern Drama* 32, no. 1 (1989): 58–72; Sharon Willis, "Hélène Cixous's *Portrait de Dora:* The Unseen and the Un-scene," in *Performing Feminisms: Feminist Critical Theory and Theatre,* ed. Sue-Ellen Case (Baltimore: Johns Hopkins University Press, 1990), 77–91; Judith Butler, "Imitation and Gender Subordination," in *Inside/Out: Lesbian Theories, Gay Theories,* ed. Diana Fuss (New York: Routledge, 1991), 13–31, and "Performative Acts and Gender Constitution: An Essay in Phenomenology and Feminist Theory," in Case, *Performing Feminisms,* 270–82; Teresa de Lauretis, "Sexual Indifference and Lesbian Representation," in Case, *Performing Feminisms,* 17–39; Ed Cohen, "Posing the Question: Wilde, Wit, and the Ways of Men," in *Performance and Cultural Politics,* ed. Elin Diamond (London: Routledge, 1996); Jill Dolan, "Lesbian Subjectivity in Realism: Dragging at the Margins of Structure and Ideology," in Case, *Performing Feminisms,* 40–53; Sue-Ellen Case, "Toward a Butch-Femme Aesthetic," in *Making a Spectacle: Feminist Essays on Contemporary Theatre,* ed. Lynda Hart (Ann Arbor: University of Michigan Press, 1989).

6. Kobena Mercer, "Black Hair/Style Politics," in *Out There: Marginalization and Contemporary Cultures,* ed. Russell Ferguson, Martha Gever, Trinh T. Minh-ha, Cornel West (New York: New Museum of Contemporary Art; Cambridge, Mass.: MIT Press, 1990), 247–64; Emily Apter, "Acting Out Orientalism: Sapphic Theatricality in Turn-of-the-Century Paris," in Diamond, *Performance and Cultural Politics;* Homi K. Bhabha, *The Location of Culture* (London: Routledge, 1994); Trinh T. Minh-ha, *When the Moon Waxes Red: Representation, Gender, and Cultural Politics* (New York: Routledge, 1991); Tejumola Olaniyan, *Scars of Conquest/Masks of Resistance* (New York: Oxford University Press, 1995); Timothy Murray, "In Exile at Home: Tornado Breath and Unrighteous Fantasy in Robbie McCauley's *Indian Blood," Discourse* 16, no. 3 (spring 1994): 29–45, and *Drama Trauma: Specters of Race and Sexuality in Performance, Video, and Art* (London: Routledge, 1997).

7. J. Reinelt and J. Roach, *Critical Theory and Performance;* Case, *Performing Feminisms;* Diamond, *Performance and Cultural Politics.*

8. See Anne Ubersfeld, *Lire le théâtre* (Paris: Editions sociales, 1977); Bernard Dort, *Théâtre en jeu, 1970–1978: Essais de critique* (Paris: Seuil, 1979); Patrice Pavis, *Theatre at the Crossroads of Culture,* trans. Loren Kruger (London: 1992).

9. Roland Barthes, "Diderot, Brecht, Eisenstein," trans. Richard Howard, in *The Responsibility of Forms* (New York: Hill and Wang, 1985), 89–97; Jacques Lacan, "Desire and the Interpretation of Desire in *Hamlet,*" trans. James Hulbert, *Yale French Studies* 55–56 (1977): 11–52.

10. See Jean-Luc Nancy, "Larvatus Pro Deo," in *Glyph 2: Johns Hopkins Textual Studies* (Baltimore: Johns Hopkins University Press, 1977), 14–36; Sarah Kofman, "The Narcissistic Woman: Freud and Girard," *Diacritics* 10, no. 3 (fall 1980): 36–45; Jean Laplanche, *New Foundations for Psychoanalysis,* trans. David Macey (Oxford: Basil Blackwell, 1989); Christine Buci-Glucksmann, *Tragique de l'ombre: Shakespeare et le maniérisme* (Paris: Galilée, 1990); J.-B. Pontalis, *Perdre de vue* (Paris: Gallimard, 1988); Mikkel Borch-Jacobsen, *The Freudian Subject,* trans. Catherine Porter (Stanford: Stanford University Press, 1988); Guy Rosolato, *Eléments de l'interprétation* (Paris: Gallimard, 1985); Joyce McDougall, *Théâtre du je* (Paris: Gallimard, 1982).

11. Lawrence Grossberg, Cary Nelson, Paula Treichler, eds., *Cultural Studies* (New York: Routledge, 1992).

12. Ibid., 5.

13. Sue-Ellen Case, "Introduction," in *Performing Feminisms,* 8.

14. Gerald Graff, *Literature Against Itself: Literary Ideas in Modern Society* (Chicago: University of Chicago Press, 1979), 184. I discuss Graff's argument in more detail in "Terror and Judgment: Consenting with Hassan, Graff (and now Booth!), *Boundary 2,* 12, no. 3–13, no. 1 (spring–fall 1984): 215–34.

15. Jonathan Arac, "Rhetoric and Realism; or, Marxism, Deconstruction, and the Novel," in *Criticism without Boundaries: Directions and Crosscurrents in Postmodern Critical Theory,* ed. Joseph T. Buttigieg (Notre Dame: University of Notre Dame Press, 1987), 173.

16. Daniel T. O'Hara, "The Reality of Theory: Freud in His Critics," in Buttigieg, *Criticism without Boundaries,* 182.

17. Michael Taussig, *Mimesis and Alterity: A Particular History of the Senses* (New York: Routledge, 1993), 44.

18. Gunter Gebauer and Christoph Wulf, *Mimesis: Culture—Art—Society,* trans. Don Reneau (Berkeley and Los Angeles: University of California Press, 1995), 6.

19. See Gebauer and Wulf's helpful discussion of the differences between Plato and Aristotle in *Mimesis,* 25–59.

20. Jean-François Lyotard, "Beyond Representation," trans. Jonathan Culler, in *The Lyotard Reader,* ed. Andrew Benjamin (Oxford: Basil Blackwell, 1989), 163.

21. Jacques Derrida, "Economimesis," trans. Richard Klein, *Diacritics* 11, no. 2 (summer 1981): 9. This essay originally appeared in Sylviane Agacinski, Jacques Derrida, Sarah Kofman, Philippe Lacoue-Labarthe, Jean-Luc Nancy, Bernard Pautrat, *Mimesis desarticulations* (Paris: Aubier-Flammarion, 1975).

22. Very helpful overviews of hermeneutics and phenomenology are provided by Richard E. Palmer, *Hermeneutics* (Evanston, Ill.: Northwestern University Press, 1969); Don Ihde, *Hermeneutic Phenomenology: The Philosophy of Paul Ricoeur* (Evanston, Ill.: Northwestern University Press, 1971); Jacques Derrida, *Speech and Phenomena and*

*Other Essay's on Husserl's Theory of Signs,* trans. David B. Allison (Evanston, Ill.: Northwestern University Press, 1973).

23. Martin Heidegger, "Science and Reflection," in *The Question Concerning Technology and Other Essays,* trans. William Lovitt (New York: Harper, 1977), 163.

24. Ferdinand de Saussure, *Course in General Linguistics,* trans. Wade Baskin (New York: McGraw-Hill, 1959), 65–70.

25. See Timothy Murray, *Theatrical Legitimation: Allegories of Genius in Seventeenth-Century England and France* (New York: Oxford University Press, 1987).

26. Mitchell Greenberg, *Canonical States, Canonical Stages: Oedipus, Othering, and Seventeenth-Century Drama* (Minneapolis: University of Minnesota Press, 1994), xxi–xxii.

27. Agacinski et al. "Desarticulations de la mimeuse," in *Mimesis desarticulations,* 11. In a similar context, but from a different point of view, Paul Ricoeur writes, in *The Symbolism of Evil,* trans. Emerson Buchanan (Boston: Beacon, 1967), 311–12, of the anteriority of the sin committed in all men by Adam "through which the tragic myth is the depository of the Ineluctable implied in the very exercise of freedom."

28. Lacan, "Desire and the Interpretation of Desire in *Hamlet,*" 42.

29. Jacques Derrida, "Structure, Sign, and Play in the Discourse of the Human Sciences," in *The Structuralist Controversy: The Languages of Criticism and the Sciences of Man,* ed. Richard Macksey and Eugenio Donato (Baltimore: Johns Hopkins University Press, 1972), 251–52.

30. On *différance,* see Derrida, "Difference," in *Speech and Phenomena,* 129–60, also reprinted as "Différance," *Margins of Philosophy,* trans. Alan Bass (Chicago: University of Chicago Press, 1982), 1–27; and Derrida, *Positions,* trans. Alan Bass (Chicago: University of Chicago Press, 1981). For a helpful overview of Derridean deconstruction, see Jonathan Culler, *On Deconstruction* (Ithaca, N.Y.: Cornell University Press, 1982), 85–225.

31. Derrida, "Structure, Sign, and Play", 252.

32. Aristotle, *Art of Poetry,* ed. W. Hamilton Fyfe (Oxford: Clarendon Press, 1940), 9.

33. In theater studies, see Jeannie Forte: "Focus on the Body: Pain, Praxis, and Pleasure in Feminist Performance," in Reinelt and Roach, *Critical Theory and Performance,* 248–62; Jill Dolan, "Practicing Cultural Disruptions: Gay and Lesbian Representation and Sexuality," in Reinelt and Roach, *Critical Theory and Performance,* 263–75; Elin Diamond, "The Violence of 'We': Politicizing Identification," in Reinelt and Roach, *Critical Theory and Performance,* 390–98. The most extensive and productive site of this debate has been in film theory. See Laura Mulvey, *Visual and Other Pleasures* (Bloomington: Indiana University Press, 1989), 14–26; D. N. Rodowick, *The Difficulty of Difference: Psychoanalysis, Sexual Difference, and Film Theory* (New York: Routledge, 1991), 1–17, 66–94; Kaja Silverman, *Male Subjectivity at the Margins* (New York: Routledge, 1992); Linda Williams, *Hard Core: Power, Pleasure, and the 'Frenzy of the Visible'* (Berkeley and Los Angeles: University of California Press, 1989), 184–288; Gaylyn Studlar, *In the Realm of Pleasure: Von Sternberg, Dietrich, and the Masochistic Aesthetic* (New York: Columbia University Press, 1988); Mary Ann Doane, *Femmes Fatales: Feminism, Film Theory, Psychoanalysis* (New York: Routledge, 1991), 17–43; Timothy Murray, *Like a Film: Ideological Fantasy on Screen, Camera, and Canvas* (London: Routledge, 1993), 25–64; Teresa de Lauretis, "Film and the Visible," in *How Do I Look? Queer Film and Video,* ed. Bad Object Choices (Seattle: Bay Press, 1991), 223–84.

34. Agacinski et al. "Desarticulations de la mimeuse," 12.

35. In "In a Word, *Interview*" with Ellen Rooney, *Differences 1*, no. 2 (summer 1989): 124–56, Gayatri Chakravorty Spivak engages in a fascinating discussion of the nuances of essentialism. Also on this subject, see Derrida's extremely significant essay, "*Geschlecht:* Différence sexuelle, différence ontologique," in *Psyche: Inventions de l'autre* (Paris: Galilée, 1987), 395–414.

36. In *The Acoustic Mirror: The Female Voice in Psychoanalysis and Cinema* (Bloomington: Indiana University Press, 1988), Kaja Silverman provides a fascinating proposal for a feminist appropriation of the Oedipus complex. Also see my discussion of Silverman in *Like a Film*, 25–64.

37. In addition, readers should consult the especially influential theory of fantasy written by Jean Laplanche and J.-B. Pontalis, "Fantasy and the Origins of Sexuality," in *Formations of Fantasy*, ed. Victor Burgin, James Donald, and Cora Kaplan (London: Routledge, 1989), 5–34.

38. See Lacan, "The Mirror Stage as Formative of the Function of the I," in *Ecrits: A Selection*, trans. Alan Sheridan (New York: Norton, 1977), 1–7.

39. Sigmund Freud, "On Narcissism," in *The Standard Edition of the Complete Psychological Works*, ed. and trans. James Strachey (London: Hogarth Press and the Institute of Psychoanalysis, 1953–74), 14:94.

40. Ibid.

41. Jacqueline Rose, *Sexuality in the Field of Vision* (London: Verso, 1986), 185.

42. The most helpful summary of Lacan's understanding of this process is Jacqueline Rose, "The Imaginary," in *Sexuality*, 167–97. A superb account of Lacan's reading of *Hamlet* is provided by Julia Reinhard Lupton and Kenneth Reinhard, *After Oedipus: Shakespeare in Psychoanalysis* (Ithaca, N.Y.: Cornell University Press, 1993), 11–118.

43. In *The Sublime Object of Ideology* (London: Verso, 1989), 173, Slavoj Žižek marks the difference between the Lacanian Real and the cognitive real: "the Real is not a transcendent positive entity, persisting somewhere beyond the symbolic order like a hard kernal inaccessible to it, some kind of Kantian 'Thing-in-itself'—in itself it is nothing at all, just a void, an emptiness in a symbolic structure marking some central impossibility. It is in this sense that the enigmatic Lacanian phrase defining the subject as an 'answer of the Real' is to be understood: we can inscribe, encircle the void place of the subject through the failure of his symbolization, because the subject is nothing but the failure point of the process of his symbolic representation. In the Lacanian perspective, the object as real is then, in the final analysis, just a certain limit: we can overtake it, leave it behind us, but we cannot reach it . . . but on the other hand we cannot escape it" (173).

44. In *The Culture of Redemption* (Cambridge, Mass.: Harvard University Press 1990), 45, Leo Bersani situates this difference in relation to varying concepts of masochism: "It has apparently been more acceptable to treat the achievements of culture as ambiguously successful reparative repetitions of developmental disturbances than to think of those achievements as sustained by the uncommunicable and uninterpretable intensities of a masochistic jouissance."

45. Ibid., 100–101.

46. Silverman, *Male Subjectivity*, 192.

47. Ibid., 185–213.

48. Frantz Fanon, *Black Skin, White Masks*, trans. Charles Lam Markmann (London: Pluto, 1986). See Homi K. Bhabha's helpful analysis of Fanon's position in

"Remembering Fanon: Self, Psyche, and the Colonial Condition," in *Remaking History,* ed. Barbara Kruger and Phil Mariani (Seattle: Bay Press, 1989), 131–48; see also Diana Fuss's analysis of the Fanon piece included here, "Interior Colonies: Frantz Fanon and the Politics of Identification," *Diacritics* 24, nos. 2–3 (summer–fall 1994): 20–42.

49. Silverman, *Male Subjectivity,* 198.

50. "Colonials" in the sense employed by Homi K. Bhabha in *The Location of Culture.*

51. Bhabha, *The Location of Culture,* 66–92, and Rodowick, *The Difficulty of Difference,* 84–94, relate the procedures of disavowal to the praxis of minority and colonial politics.

52. Silverman, *Male Subjectivity,* 206.

53. Gilles Deleuze, *Masochism: "Coldness and Cruelty,"* trans. Jean McNeil, published with *Venus in Furs* by Leopold von Sacher-Masoch (New York: Zone Books, 1989), 31. "In masochism," Deleuze elaborates, "we find a progression from disavowal to suspense, from disavowal as a process of liberation from the pressures of the superego to suspense as an incarnation of the ideal. Disavowal is a qualitative process that transfers to the oral mother the possession and privileges of the phallus. Suspense points to the new status of the ego and to the ideal of rebirth through the agency of the maternal phallus. From the interplay of disavowal and suspense there arises in the ego a qualitative relation of imagination, which is very different from the quantitative relation of thought in the superego. Disavowal is a reaction of the imagination, as negation is an operation of the intellect or of thought. Disavowal challenges the superego and entrusts the mother with the power to give birth to an 'ideal ego' which is pure, autonomous and independent of the superego. The process of disavowal is linked to castration not contingently but essentially and originally; the expression of fetishistic disavowal, 'No, the mother does not lack a phallus,' is not one particular form of disavowal among others, but formulates the very principle from which the other manifestations of disavowal derive, namely the abolition of the father and the rejection of sexuality. Nor is disavowal in general just a form of imagination; it is nothing less than the foundation of imagination, which suspends reality and establishes the ideal in the suspended world. Disavowal and suspense are thus the very essence of imagination, and determine its specific object: the ideal" (*Masochism,* 127–28).

54. In this context, see Elin Diamond's excellent essay on Kristeva, Irigaray, and Adrienne Kennedy, "Mimesis, Mimicry, and the 'True-Real,' " in which she elaborates on the feminist implications of many of the issues I raise in this introduction.

Part 1

# *Mimesis Imposed*

## Machineries of Representation

# Hélène Cixous
## Hors Cadre Interview

At the moment of updating an exchange with Hélène Cixous done in 1984, I received this lengthy interview conducted by the editors of *Hors Cadre,* a review dedicated to the relation of cinema to work across various disciplines. Most questions that were to be asked are developed in it. The interview, somewhat abbreviated here, provides most recent information about Cixous's thoughts on the state of the author. In the process, we learn about her shift to theater, how she approaches various types of writing, her reaction to the media and culture. The critics conducting the interview, working a French context, are in the generation of Cixous, and do not dwell on some of the problematic issues that could have been explored. This most recent, and critically acute interview, reveals some of the principal differences between the two continents, Europe and America, in respect to what it is to live and write. We tend to forget that many somatic differences mark a gap between the two worlds. The ways American and French people deal with their work cannot fail to include a vastly different register of everyday experience, including somatic differences: in France, one rides a slow subway, one dialectizes one's work with others in a café by conversing, eating and drinking together. Contact is established easily and with space of intimacy. Political issues in Europe tend to be of a broad scope. Intellectual exchange of this kind is almost impossible in North America where—similar to what Cixous notices for the stage—problems of space, of number, and of transmission are broader. Electronic means are used to reach others. Technology is omnipresent in our daily routine. Much of the divergences may revolve around questions of cultural speed. Not only the state of the author, but also that of the critic may have changed more over the past twenty years on this side of the Atlantic than in France. In this interview conducted in a French context, Cixous is allowed to develop what she clearly most enjoys, that is, the act of writing itself.

—TRANS.

CIXOUS: I had better try to tell something like the story of my theatrical writing.

A story: because I do not theorize, except for certain traits of which I will speak, for example, the question of characters which, for me, is essential.

The fact is, that writing remains solitary. When I write for the theater, I write in my corner, as for fiction, with, as starting point, a difference in position in relation to the text that is prepared for the Théâtre du Soleil.[1] Specifically my relation to the Théâtre du Soleil, not to theater in general is what counts. For example, this year I wrote a play, destined to X. There, I was the one who was in "charge," it was my phantasm, my desire, it did not depend on anyone else except for me. It is a play for five women. With the Théâtre du Soleil, it is completely different because a work had been requested.

The request already dictates certain traits, not of writing itself, but of the economy of the play. For example, a certain space, a certain duration, a certain style and a certain quantity. There are twenty-five or thirty comedians in the Théâtre du Soleil. I do not write *in order* to hire them, but I know that there must be a space and a great number because twenty-five is not only twenty-five, it is twenty-five multiplied, and of course, this touches on everything I want to do. In the beginning it was form (but I think it continues to be), a challenge. To stretch my imagination to those dimensions is for me the most difficult exercise. One realizes that a brain that imagines is just like a uterus, that is, it cannot carry more than a certain quantity. That is a very human issue. I can conceive a work of five, six creatures but I stop there. For the *Indiade,* for example, I had a lot of problems because I had to conceive scenes with about twenty to twenty-five players. I was never able to do it all at once, I mean in a way that remains corporeal and creative. There was no artifice but a mechanism; I knew that at a certain time I needed a scene that would bring twenty characters on stage; in my head there was no room for twenty characters. So I had to take this scene up again, to put genesis repeatedly into play. I had to relive this scene piece by piece. Then, there is another problem: the time of creation is no longer the same. I need twenty days, but at the same time I need at least four pregnancies. There is a problem of maturation and of a time lag between what should be twins.

HC: Does this kind of retake in time, of fragmentation, lead to a transformation? and to variables of conception?

CIXOUS: I have to be careful about that. There are different types of maturation, there are states, precisely; my own state is not the same at one or two weeks' interval, something that requires an additional creative effort on my part. I have to get in touch with a past state, to bring it up to the present; I describe this as a difficulty that has nothing to do with the act of writing itself. It is not the hand, it is not language, it is one's state that is put in question.

HC: That is the state of the author.

CIXOUS: That is precisely what I would say. Because I think that the terms and the metaphors of pregnancy, etc., are completely applicable in this case.

I come back to what I said initially. While I am writing, while I am elaborating, I am alone. But with the Théâtre du Soleil there is an initial contract, an agreement between Ariane and myself on the subject. On the subject, without specifics, on the general nature of the subject, not obviously, on the story. For example, right now, I am writing on the Resistance. The subject upon which we agreed is: the Resistance in France. Then, one has to specify, because resistance in France includes a thousand subjects, a thousand possibilities. And the way in which it is going to be told, the choice, the definition of the plot, of the characters, all that is up to me, just as with the *Indiade*. That is where I am working from, with constraints coming from the other that qualify space and number; I say a constraint, but it is also a kind of freedom. For an overflowing, prodigious imagination, it would be an unlimited "permit for the unlimited." The Théâtre du Soleil has no theatrical "limits" so to speak. However, for me, this freedom requires a supplementary effort. While I have no difficulty in writing a play with five or six characters, I do with writing for twenty-five, thirty or fifty characters. Someone quick as lightning could produce a scene with twenty-five characters all at once. I cannot do it.

So, I work at length (that is, "for quite some time," something that cannot be measured) in my corner. Then comes the moment of relay, the moment when the troupe starts its rehearsals. There is a text, a story, characters, then come the adventures. And they vary a great deal. I am telling you a naive story, the chronicle of creation in the first degree, but afterward, I will complicate this story somewhat. What happens when the Company begins to work? First of all, no one ever touches the writing. There are two dimensions, two working registers: what I call writing, that is, the style, all that is never touched or brushed against by the world of the Company. Now, I do not say that there are no interventions at the level of the unconscious. It is not impossible that unconsciously, knowing precisely the destination, I do not write in a certain way, but I cannot account for that. It is not impossible that what I know about the Théâtre du Soleil, of its memory, alters something of my own writing project. The interlocutor always intervenes. Similarly, when I am giving a seminar, I speak to . . . and in a certain language. It becomes interesting when we think of the nature of a fictional text. When I write a fictional text, who is my interlocutor? To whom do I write? I cannot name the instance which then works on the unconscious of my language. It must be a mixture of myself, of God, of the absolute, etc.—since the public has neither a face nor a presence. There is also a part of censorship of which I am conscious. I felt over the years that I was threatened inside by effects of censorship.

HC: Which belong to theater?

CIXOUS: No, in the fictional text. Of course, I resist it with all my

strength, but I know that when I started to write, I ignored the drama of reception. I was in a kind of primitive freedom; afterward, the world—never work done at the university but all that pertains to mass media—sent me back the image of an interdiction, and I rejected and reinscribed this interdiction. I feel that I vibrate and that sometimes in my own text I inscribe a protest against interdiction.

HC: What kind of interdiction?

Cixous: Always the same accusation: hermeticism, unreadability, incomprehensibility, difficulty; this kind of "critical vocabulary" has been resonating for twenty-five years, I hear it all the time, sometimes even with an intimidated, non-hostile connotation.

HC: Did the passage to the theater represent for you a concern of greater perceptibility, readability, or of more direct reception? You spoke of spatial constraints and of numbers, leaving in the dark the face of the receiver (addressee); but in relation to this problem of unreadability that you point out, does theatrical exigency presuppose—and it would have nothing to do with censorship—that something can be perceived more directly?

Cixous: Yes, necessarily.

HC: So it brings about changes in writing.

Cixous: Absolutely. But I do not perceive it as a constraint. It is another contract. And that is why I spoke of my seminars. In the seminar, I have another language, I have my seminar language which is very free, but which is, of course, linear. It is oral, and the effects of writing are necessarily reduced. However, it is a rather elaborated language that "I speak to myself"; that I do not speak, for example when I give lectures abroad, because I lower it by a tone and I change it. For the theater, it is true that a certain language, in any event, is not even determined by the public, but by the characters themselves. I do not see how my characters would speak *my* language, one of my languages . . . no. I try to hear their other languages. So, of course, it is a mixture, their languages mixed in with my language, there is a formidable displacement.

So, that is where it begins. For the *Indiade,* I had a problem that I solved *in extremis:* at some point I even thought I would not write the play. It was the musical partition, so to speak, of the people that escaped me. I did not know how common Indians spoke; and I could not imagine it, I could not do it. So, you will tell me, how could I know how non-common Indians spoke? They left traces: there is an enormous quantity of texts by Ghandi, Nehru, and all the known characters. And I read them. So I do not imitate Nehru or Ghandi's language, but on the other hand I can hear something of their imaginary, of their musical, world, a secret ground from which I plant and graft something. I plug in, it is a reading, simply put. And from the reading

that I am doing, including the unconscious effects, I can orient myself toward the creation of a language that is going to resemble, at least so I hope, what their own body would produce. It is not intellectual of course, it is affective. But with the people, there is no source whatsoever! I had to take another trip to India, and I finally found some mediations allowing me to hear how a village woman or an artisan felt, vibrated, cried and trembled, and to throw myself into this redoubtable adventure that is, since it can be pure treason, the engendering of idiolects. And if I had not been able to find the mediations during a second trip, the play would not have existed. So it is the first step already of this displacement of language, it is character.

HC: Not the public, but the character. You construct him in a dialogue as if you were dialoguing with him . . .

Cixous: I identify with the character. It is truly an organ graft. It is the graft of a heart. I say the heart because that is really where it is taking place, and if I cannot graft this second heart, nothing happens. I don't succeed evenly. Sometimes the graft is rejected. When I find someone profoundly dislikable, I might have problems. I have to find the heart of the traitor, that is, to feel in me the heart of a traitor. But it is interesting, because the traitor has his reasons: it is up to me to find the right pitch of the passion, its sincerity, that is, a suffering. However, there are traitors I will not be able to put on stage, I have always known that.

HC: It must be a problem for the Resistance.

Cixous: It is a problem for Hitler, but I do not try. I think about it a lot. It is painful and it is on the side of the repulsive, but after all . . . maybe that is also a lesson: I do not think that I have the nature of a traitor but there is certainly a point where, humanly, in the texture that constitutes me, a traitor is understood.

HC: If I understand you well, the test of the characters allows you to become you (you speak of sympathy, of the necessity of the graft and of identification) but by going through alteration. The exigency of the characters provokes the plurality of voices, obliges you to multiply your ears, imposes an intellectual work that you carry on like a systematic project. There is a play on alteration that I find interesting.

Cixous: Alteration is vital. While I work, I am not at all intellectual. I do not elaborate anything, I do not theorize anything and I think nothing. But afterward, because I nevertheless have myself that function (intellectual, pedagogical, etc.) afterward, it is really when I begin to ask myself about the effects. So alteration, yes, it is indispensable to let oneself be altered. But how, by whom? For example, if I had to stage, if I had to write Pétain (I have not tried, so I am virgin), at that moment, I am just like you in front of Pétain, and in an intersubjectivity that is, in fact, limited; no interiorisation, in fact,

we entail rejection; and besides we give ourselves over to the pleasure of antipathy.

(. . .) There are characters who give themselves to me, who are accessible to me, very quickly, or rather quite quickly, compared to the difficulties I have with others. Probably because there are resemblances, a system of emotions that I perceive right away, affects familiar to me, and that probably means that I find myself in the space of love, it must be the space where one loves someone. I would not say that it is narcissistic, because that would be too simple, but it is good, it does not hurt, there is some ideal of the self. Some characters I am looking for I take a very long time to find and when I miss them, it is as if I missed a certain level; I feel them pass, and in the end, they may remain in this zone that is the zone of the insignificant or indifferent encounter, the kind we have with most people we meet. It is neither true nor false, there is no depth, there is not what is going to be the source of a whole life, and a whole destiny. So I realize this, because what I am writing is flat; I did not find what will provide depth, the heart of a text that, in writing, is manifested through metaphors. And I did not find the source of metaphors, that is, the translation of the soul, or of the body, etc., into metaphors. This is a sign of alarm. At that moment, I continue to search.

HC: Can we develop this? This kind of multiple movement is precious for us. What you are saying is that there is no soul in writing when there is no sympathy, when there is no possibility of sympathy or empathy; but that this source of writing is metaphor because it produces displacement. There is, once again, a movement of coming and going and a passage and in a certain way a rejection, a taking and leaving, that itself is multiple, isn't that so?

CIXOUS: Quite so.

HC: What is the use of metaphor? It is not only an index of writing; what does it let pass in the body of the other, in the character, and that goes through you?

CIXOUS: That is theater or theatricality. It is obviously—I am not going to say "the other scene"—what makes that a character becomes, *is*, worthy of theater. For me the supreme example is Shakespeare. All of Shakespeare's characters are like that, every one of them is already his own little theater. Every one of them gets up on his own stage. Every one of Shakespeare's individuals has his little kingdom, his micro-kingdom. We could say that each inhabitant (let us not say character) of Shakespeare is exceptional; he is rich, he affects us, he fascinates us, he is not a person without a kingdom whom we may cross in the street. There are many people without a kingdom. It must be said that if we put those in the theater, the theater fades away. At last, in the theater the way I see and like it, because there is also a flat theater. There are many false scenes, those of television, for example—which bring us nothing, because they have

no inner universe and because they do not produce a sign, while one can, on television, see all of a sudden, and exceptionally, a person who is worthy of theater. It is never a speaker . . . one person moved me: I saw her two years ago, she happened to be a cook, a female chef, and who was talking about how she was cooking. She had a rich language—she delved into the roots of human beings. What she said was worthy of any book of psychoanalysis, but it was richer, more substantial, magnificent. Put this woman on the stage and it is ready. Why? Because she has substance. She knows everything about life. And she knows how to communicate this knowledge on the scene of language.(. . .)

HC: We spoke a lot about the relation to the actors, to incorporation but little about the relation to Mnouchkine. You spoke of the request made by Mnouchkine concerning the subject, and you said nothing—may be there is nothing to say—of the relation of accompaniment or absence of Mnouchkine herself during the time of writing.

CIXOUS: Precisely, I could not make rules or laws, that is very variable. What can I say? Those are questions of maturation. For example, I have no exchange with her about the mise en scène, I do not even know when she begins to imagine it, nor what she does. Nothing is said about it. At some point, I might write a certain number of scenes that I want to show her. There are variants on this. That is to say, there are moments that cannot be programmed, that depend on what she does, when it is possible for me to say something and when it is not possible. Of course, I present her with something rather finished. Before she starts rehearsing, the material for the work is there. Even if I am not done. Rehearsals begin each time before I finish the work. I go on during rehearsals.

HC: So, some rehearsals accompany . . .

CIXOUS: The problem is not related to art but to an economic constraint. It so happens that three times—since it is the third time that I work for the Théâtre du Soleil—the troupe is unemployed. So there is an economic problem of life; and the problem of taking up work again is solely determined by questions of money. There is a limit beyond which we cannot go. One has to begin working at a certain moment because the actors have to live. . . . It is a long story. If this were not the case, if we could wait, I would be done before rehearsals.

HC: But there is no return, that is, there are no constraints imposed by the rehearsals on the finishing of the writing itself?

CIXOUS: Yes, because while they are rehearsing, it may happen that they come up against a scene that comes back to me and of which I need to take charge . . .

HC: . . . and which is modified right away? That is the question I asked. That you modify the scene, that, I understood quite well but . . .

CIXOUS: It does not modify what comes afterward, not necessarily. Because, nevertheless, I have the story in my head. I begin to write it with an unfinished story. Generally, it is the end that remains the surprise, exactly as with a text of fiction.(. . .)

HC: But it is the side of a personal writing?

CIXOUS: Yes, it is not in rehearsal.

HC: What part does representation play? I use the term to question a possible transference of the scene and the scenic act on the operation of writing which would be reflected scenically as it comes into being. To know if, precisely, the figure of the theater that you are describing intervenes like a mirror for writing in the course of writing.

CIXOUS: Without it being conscious. What happens is that I see afterward, and it is not calculation, that theater writing condenses much more. . . . I think that I have to develop more at length and in detail than what the theater allows me to do. The theater gathers. It is almost of the order of the poetic: it would be the literal translation of something that I take much more time to think that discourse takes much more time to present.

HC: Theater is an accelerator, a multiplier of writing.

CIXOUS: Absolutely.(. . .) I come back to my collaboration with Ariane because I try to think it. There are three cases. First when she tells me, "This scene is not going to work, but I do not know, this scene will work but I do not know." She never knows. There is also the case of the figure where she says to me in advance, "here, you are not in the theater, here it is a text, it is not theater." If she is absolutely sure, I redo it right away, it never gets to the rehearsal. I trust her because first there is something non-verifiable, and especially because I never know what I am doing. What I am doing is very deceiving and strange, as far as theater or the theatrical genre are concerned, I do not have a critical instance in me.

HC: And you have it for fiction?

CIXOUS: I think I have it more, but perhaps I do not. In any event, I do not have the feeling of uncertainty that I have with the theater. Really, when I write for the theater, I do not have confidence. Because it is less tied to me. Because I had moments of intense satisfaction with a scene that turned out to be impossible. There is the bad fairy hidden in writing that can deceive me. I can have satisfactions which are of the order of writing and that represent a screen. I can be wrong about the scene, writing, the genre.

HC: So bring about another writing?(. . .)

CIXOUS: Yes, certainly. To write for the theater is a passionate, but painful experience. I am not even ashamed of saying that at the beginning I was a bit bothered because I did not recognize myself; personally I am being destructured, I my own being, I am being decomposed in a violent way.

When I write, I always tell those close to me that in the evening they should not approach me, I am like a mad woman. I am lost. I do not sit down in front of my paper saying to myself "now lose yourself," but this operation, of identification, breaks down my own identification with myself and is of such violence that I am truly outside of myself when night falls.

HC: Is this a test?

CIXOUS: It is a test because I have to socialize myself again. I should go and sleep somewhere else, until this goes away and that I come back. The problem occurs when you have to speak to someone. And you are not there. Hence the precautions I take: the days where I write for the theater I cut everything, I take care not to have the least rendez-vous in the evening because I am not there.

HC: And it is not the same for the writing of fiction or of an essay?

CIXOUS: Not like that. It is like an effect of madness. First, I am haunted by others. I am all the others. I am not myself. This leads to real fainting spells. The first time this happened to me, I was afraid. Now I am used to it, I do not care, I understand. But one is so much the other that it is a complete dispossession.

That is why I have no judgment. Because it is so much not me . . . For the text I am in a state of tension or of travel, but it is nevertheless I who am travelling. There is some self left. How can one tell the pain, the fear that I can feel in these moments because, with the Resistance, in any case now, I am in a plurality of worlds; in fact, the story of the Resistance is like that. These worlds did not communicate. And when I am in a world, I live it, absolutely, so I lose myself, and not only I lose myself but I lose all the other worlds. And that is how I go down into the well so deeply . . . so, I am going to take a metaphor: it is as if I were so much down in the bottom of the well of France that England, the United States, China, that all that no longer exists. It destroys, it radiates in a destructive manner. And that is terrible, because it provokes amnesia. The world around me is reduced to nought.

HC: Is the return to the text then a refuge?

CIXOUS: I know that I could not live without text. I know that I will never only be an author of theater, that these two gestures which are very different are complementary and that complementarity is in any case always an enrichment for me. Difference, the differential, is, of course, enrichment.

HC: You maintain the difference.

CIXOUS: Oh, yes. There is a difference, almost term by term, of all the attitude of writing, of all the relations . . . For the text I have none of the anxieties that I harbor for the theater. Now, the text does not give me the kind of pleasure the theater does, afterward, of course. I am going to say something banal: the text is written in solitude and is also read in solitude. That is

to say that the return is deferred so much, so much . . . There is no return to the text. The author has no return. There is reading, we know that it exists, but it does not come back. Even the most attentive readers and the closest do not give you a return, an echo. The text remains silent. And an author is used to it. Everything is different with the theater, with a public that provides an echo, that is, a way of sharing. True, ceremony of theater is one of the most beautiful things in the world. And it is part of what I think I am part: of a very great combat for culture. There is something necessary and gratifying in the encounter with the audience. I think we are part of a small army that defends a certain number of values, and pleasure is provided when that is verified: it is beneficial at all levels.

There is also the communal experience of this kind of extraordinary vessel that is the theater, with the whole troupe working. But there too, this belongs specifically to the Théâtre du Soleil; it is something happy, it could not be that. It is a collective adventure and we have few, it is also a metaphor, because in the world where sixty people work, there is everything. Sixty people is already a society, with all that can happen in society: love, war, the cause to be defended. I metaphorize it as an army of knights that defend a cause, something quite noble, so in itself it represents more than the theater.

The reward of theatrical writing is in the moment when it translates into many people working together.

HC: It is a collective object, but the author does not feel at all dispossessed.

CIXOUS: Not I, in any case.

HC: But the disappropriation you spoke of at the moment of writing?

CIXOUS: I accept it, because it is the text of the experience of theater in the extreme. I like all things extreme, it makes me discover things. I feel moral anguish one does not feel with the fictional text and because precisely something attends from the other side. I much more have the feeling that it is never good enough with the theater than with a text. Why? I am certainly more uneven because of this division into several characters.

The return of the theater in the text, that is what happened with *Manne:* in the text little by little I dare to introduce something I did not used to do, that is, characters—I talk about real people—and to introduce the third person. Here, there are five. It still remains within my register, it is not the traditional novelistic narrative, but there is nevertheless some third person. It is not a third person without thread, as in the theater; there is some thread, there remains the "I," the umbilical cord. Right away the problem I do not encounter in the theater comes back, the problem of the body. In the theater, I do not deal with what for me is very important, that is, sexual difference. In the theater, sexual difference is treated by the theater itself. I always say that in

my fictional texts I write with the body of a woman and that I cannot put myself in the place of a man. I can only deal with one kind of pleasure that I know and I cannot deal in the first person with masculine pleasure. And this is the only way I write, while having pleasure. But in the theater, I do not have this problem. I can put men in the theater because there the body is given over to it by an actor. The actor makes the link with his sexed body, so it is not my problem. But in the text, it is my problem: I found it again while writing *Manne,* since I do not have the body of a comedian, it is mine that makes body with all the bodies, and that is my limit. I can go as far as possible in the identification of the other, even in the masculine, except where pleasure or sexuality are concerned. I did what I could, I went as far as possible, toward the body of a man, or, since there is a sexual exchange in these dialogues, toward what I as a woman can perceive of masculine sexuality and what I can perceive of what masculine sexuality can perceive of feminine sexuality, I, as woman, being in relation with feminine sexuality. Beyond, there is my limit. I think that it cannot be surpassed. While writing *Manne,* I was able, up to a certain point, to feed it with my first person. Up to the point where I began to lie. I began to be too far from myself and it became, something I do not like . . . what should I call this? I had no guarantee. What I was writing was not lived. It is as if I had, to give me assurance in writing, this cover, this absolute referent that is my own body, not only sexed, but with affect. If I feel no affect, it is a lie, it is all over. It is true that by going too far in the third person the affect is taken away. And that is where I stop. I am going to produce philosophy or I know not what, but it will no longer be text.

NOTES

Edited and translated by Verena Andermatt Conley.

1. Théâtre du Soleil is a French performance collective founded by Ariane Mnouchkine in 1964. Its productions have ranged from adaptations of Shakespeare to the performance of scripts written by Cixous for the company.—Ed.

# Jacques Derrida

## The Theater of Cruelty and the Closure of Representation

*for Paule Thévenin*

> *Unique fois au monde, parce qu'en raison d'un*
> *événement toujours que j'expliquerai, il n'est pas de*
> *Présent, non—un présent n'existe pas.*
> —Mallarmé, *Quant au livre*

> *. . . as for my forces, they are only a supplement,*
> *the supplement of an acutal state,*
> *it is that there has never been an origin.*
> —Artaud, 6 June 1947

"Dance / and consequently the theater / have not yet begun to exist." This is what one reads in one of Antonin Artaud's last writings (*Le théâtre de la cruauté,* in *84,* 1948). And in the same text, a little earlier, the theater of cruelty is defined as "the affirmation / of a terrible / and, moreover, implacable necessity." Artaud, therefore, does not call for destruction, for a new manifestation of negativity. Despite everything that it must ravage in its wake, "the theater of cruelty / is not the symbol of an absent void." It *affirms,* it produces affirmation itself in its full and necessary rigor. But also in its most hidden sense, the sense most often buried, most often diverted from itself: "implacable" as it is, this affirmation has "not yet begun to exist."

It is still to be born. Now a necessary affirmation can be born only by being reborn to itself. For Artaud, the future of the theater—thus, the future in general—is opened only by the anaphora which dates from the eve prior to birth. Theatricality must traverse and restore "existence" and "flesh" in each of their aspects. Thus, whatever can be said of the body can be said of the theater. As we know, Artaud lived the morrow of a dispossession: his proper body, the property and propriety of his body, had been stolen from him at birth by the thieving god who was born in order "to pass himself off / as me."[1] Rebirth doubtless occurs through—Artaud recalls this often—a kind of reeducation of the organs. But this reeducation permits the access to a life before birth and after death ("through dying / I have finally achieved real

immortality," p. 110), and not to a death before birth and after life. This is what distinguishes the affirmation of cruelty from romantic negativity; the difference is slight and yet decisive. Lichtenberger: "I cannot rid myself of this idea that I was *dead* before I was born, and that through death I will return to this very state. . . . To die and to be reborn with the memory of one's former existence is called fainting; to awaken with other organs which must first be reeducated is called birth." For Artaud, the primary concern is not to die in dying, not to let the thieving god divest him of his life. "And I believe that there is always someone else, at the extreme moment of death, to strip us of our own lives."[2]

Similarly, Western theater has been separated from the force of its essence, removed from its *affirmative* essence, its *vis affirmativa*. And this dispossession occurred from the origin on, is the very movement of origin, of birth as death.

This is why a "place" is "left on all the stages of stillborn theater" ("Le théâtre et l'anatomie," in *La rue,* July 1946). The theater is born in its own disappearance, and the offspring of this movement has a name: man. The theater of cruelty is to be born by separating death from birth and by erasing the name of man. The theater has always been made to do that for which it was not made: "The last word on man has not been said. . . . The theater was never made to describe man and what he does. . . . *Et le théâtre est ce patin dégin-gandé, qui musique de troncs par barbes métalliques de barbelés nous maintient en état de guerre contre l'homme qui nous corsetait.* . . . Man is quite ill in Aeschylus, but still thinks of himself somewhat as a god and does not want to enter the membrane, and in Euripides, finally, he splashes about in the membrane, forgetting where and when he was a god" (ibid.).

Indeed, the eve of the origin of this declining, decadent, and negative Western theater must be reawakened and reconstituted in order to revive the implacable necessity of affirmation on its Eastern horizon. This is the implacable necessity of an as yet inexistent stage, certainly, but the affirmation is not to be elaborated *tomorrow,* in some "new theater." Its implacable necessity operates as a permanent force. Cruelty is always at work. The void, the place that is empty and waiting for this theater which has not yet "begun to exist," thus measures only the strange distance which separates us from implacable necessity, from the *present* (or rather the contemporary, *active*) work of affirmation. Within the space of the unique opening of this distance, the stage of cruelty rears its enigma for us. And it is into this opening that we wish to enter here.

If throughout the world today—and so many examples bear witness to this in the most striking fashion—all theatrical audacity declares its fidelity to Artaud (correctly or incorrectly, but with increasing insistency), then the

question of the theater of cruelty, of its present inexistence and its implacable necessity, has the value of a *historic* question. A historic question not because it could be inscribed within what is called the history of theater, not because it would be epoch-making within the becoming of theatrical forms, or because it would occupy a position within the succession of models of theatrical representation. This question is historic in an absolute and radical sense. It announces the limit of representation.

The theater of cruelty is not a *representation*. It is life itself, in the extent to which life is unrepresentable. Life is the nonrepresentable origin of representation. "I have therefore said 'cruelty' as I might have said 'life.' "³ This life carries man along with it, but is not primarily the life of man. The latter is only a representation of life, and such is the limit—the humanist limit—of the metaphysics of classical theater. "The theater as we practice it can therefore be reproached with a terrible lack of imagination. The theater must make itself the equal of life—not an individual life, that individual aspect of life in which *characters* triumph, but the sort of liberated life which sweeps away human individuality and in which man is only a reflection" (*TD*, 116).

Is not the most naïve form of representation *mimesis*? Like Nietzsche— and the affinities do not end there—Artaud wants to have done with the *imitative* concept of art, with the Aristotelean aesthetics⁴ in which the metaphysics of Western art comes into its own. "Art is not the imitation of life, but life is the imitation of a transcendental principle which art puts us into communication with once again."⁵

Theatrical art should be the primordial and privileged site of this destruction of imitation: more than any other art, it has been marked by the labor of total representation in which the affirmation of life lets itself be doubled and emptied by negation. This representation, whose structure is imprinted not only on the art, but on the entire culture of the West (its religions, philosophies, politics), therefore designates more than just a particular type of theatrical construction. This is why the question put to us today by far exceeds the bounds of theatrical technology. Such is Artaud's most obstinate affirmation: technical or theatrological reflection is not to be treated marginally. The decline of the theater doubtless begins with the possibility of such a dissociation. This can be emphasized without weakening the importance or interest of theatrological problems, or of the revolutions which may occur within the limits of theatrological problems, or of the revolutions which may occur within the limits of theatrical technique. But Artaud's intention indicates these limits. For as long as these technical and intratheatrical revolutions do not penetrate the very foundation of Western theater, they will belong to the history and to the stage that Antonin Artaud wanted to explode.

What does it mean to break this structure of belonging? Is it possible to

do so? Under what conditions can a theater today legitimately invoke Artaud's name? It is only a fact that so many directors wish to be acknowledged as Artaud's heirs, that is (as has been written), his "illegitimate sons." The question of justification and legality must also be raised. With what criteria can such a claim be recognized as unfounded? Under what conditions could an authentic "theater of cruelty" "begin to exist"? These simultaneously technical and "metaphysical" questions (metaphysical in the sense understood by Artaud), arise spontaneously from the reading of all the texts in *The Theater and Its Double,* for these texts are more *solicitations* than a sum of precepts, more a system of critiques *shaking the entirety* of Occidental history than a treatise on theatrical practice.

The theater of cruelty expulses God from the stage. It does not put a new atheist discourse on stage, or give atheism a platform, or give over theatrical space to a philosophizing logic that would once more, to our greater lassitude, proclaim the death of God. The theatrical practice of cruelty, in its action and structure, inhabits or rather *produces* a nontheological space.

The stage is theological for as long as it is dominated by speech, by a will to speech, by the layout of a primary logos which does not belong to the theatrical site and governs it from a distance. The stage is theological for as long as its structure, following the entirety of tradition, comports the following elements: an author-creator who, absent and from afar, is armed with a text and keeps watch over, assembles, regulates the time or the meaning of representation, letting this latter *represent* him as concerns what is called the content of his thoughts, his intentions, his ideas. He lets representation represent him through representatives, directors or actors, enslaved interpreters who represent characters who, primarily through what they say, more or less directly represent the thought of the "creator." Interpretive slaves who faithfully execute the providential designs of the "master." Who moreover—and this is the ironic rule of the representative structure which organizes all these relationships—creates nothing, has only the illusion of having created, because he only transcribes and makes available for reading a text whose nature is itself necessarily representative; and this representative text maintains with what is called the "real" (the existing real, the "reality" about which Artaud said, in the "Avertissement" to *Le moine,* that it is an "excrement of the mind") an imitative and reproductive relationship. Finally, the theological stage comports a passive, seated public, a public of spectators, of consumers, of "enjoyers"—as Nietzsche and Artaud both say—attending a production that lacks true volume or depth, a production that is level, offered to their voyeuristic scrutiny. (In the theater of cruelty, pure visibility is not exposed to voyeurism.) This general structure in which each agency is linked to all the

others by representation, in which the irrepresentability of the living present is dissimulated or dissolved, suppressed or deported within the infinite chain of representations—this structure has never been modified. All revolutions have maintained it intact, and most often have tended to protect or restore it. And it is the phonetic text, speech, transmitted discourse—eventually transmitted by the prompter whose hole is the hidden but indispensable center of representative structure—which ensures the movement of representation. Whatever their importance, all the pictorial, musical, and even gesticular forms introduced into Western theater can only, in the best of cases, illustrate, accompany, serve, or decorate a text, a verbal fabric, a logos which *is said* in the beginning. "If then, the author is the man who arranges the language of speech and the director is his slave, there is merely a question of words. There is here a confusion over terms, stemming from the fact that, for us, and according to the sense generally attributed to the word *director,* this man is merely an artisan, an adapter, a kind of translator eternally devoted to making a dramatic work pass from one language into another; this confusion will be possible and the director will be forced to play second fiddle to the author only so long as there is a tacit agreement that the language of words is superior to others and that the theater admits none other than this one language" (*TD,* 119). This does not imply, of course, that to be faithful to Artaud it suffices to give a great deal of importance and responsibility to the "director" while maintaining the classical structure.

By virtue of the word (or rather the unity of the word and the concept, as we will say later—and this specification will be important) and beneath the theological ascendancy both of the "verb [which] is the measure of our impotency" (*OC* 4:277) and of our fear, it is indeed the stage which finds itself threatened throughout the Western tradition. The Occident—and such is the energy of its essence—has worked only for the erasure of the stage. For a stage which does nothing but illustrate a discourse is no longer entirely a stage. Its relation to speech is its malady, and "we repeat that the epoch is sick" (*OC* 4:280). To reconstitute the stage, finally to put on stage and to overthrow the tyranny of the text is thus one and the same gesture. "The triumph of pure mise en scène (*OC* 4:305).

This classical forgetting of the stage is then confused with the history of theater and with all of Western culture; indeed, it even guaranteed their unfolding. And yet, despite this "forgetting," the theater and its arts have lived richly for over twenty-five centuries: an experience of mutations and perturbations which cannot be set aside, despite the peaceful and impassive immobility of the fundamental structures. Thus, in question is not only a forgetting or a simple surface concealment. A certain stage has maintained with the "forgotten," but, in truth, violently erased, stage a secret communica-

tion, a certain relationship of *betrayal,* if to betray is at once to denature through infidelity, but also to let oneself be evinced despite oneself, and to manifest the foundation of force. This explains why classical theater, in Artaud's eyes, is not simply the absence, negation, or forgetting of theater, is not a nontheater: it is a mark of cancellation that lets what it covers be read; and it is corruption also, a "perversion," a *seduction,* the margin of an aberration whose meaning and measure are visible only beyond birth, at the eve of theatrical representation, at the origin of tragedy. Or, for example, in the realm of the "Orphic Mysteries which subjugated Plato," or the "Mysteries of Eleusis" stripped of the interpretations with which they have been covered, or the "pure beauty of which Plato, at least once in this world, must have found the complete, sonorous, streaming naked realization" (*TD,* 52). Artaud is indeed speaking of perversion and not of forgetting, for example, in this letter to Benjamin Crémieux:

> The theater, an independent and autonomous art, must, in order to *revive or simply to live,* realize what differentiates it from text, pure speech, literature and all other fixed and written means. We can perfectly well continue to conceive of a theater based upon the authority of the text, and on a text more and more wordy, diffuse, and boring, to which the esthetics of the stage would be subject. But this conception of theater, which consists of having people sit on a certain number of straight-backed or overstuffed chairs placed in a row and tell each other stories, however marvelous, is, if not the absolute negation of theater—which does not absolutely require movement in order to be what it should—certainly its *perversion.* (*TD,* 106; *my italics*).

Released from the text and the author-god, mise-en-scène would be returned to its creative and founding freedom. The director and the participants (who would no longer be actors *or* spectators) would cease to be the instruments and organs of representation. Is this to say that Artaud would have refused the name *representation* for the theater of cruelty? No, provided that we clarify the difficult and equivocal meaning of this notion. Here, we would have to be able to play upon all the German words that we indistinctly translate with the unique word representation. The stage, certainly, *will no longer represent,* since it will not operate as an addition, as the sensory illustration of a text already written, thought, or lived outside the stage, which the stage would then only repeat but whose fabric it would not constitute. The stage will no longer operate as the repetition of *present,* will no longer *re*-present a present that would exist elsewhere and prior to it, a present that would exist elsewhere and prior to it, a present whose plenitude would be older than it, absent from it, and rightfully capable of doing without it: the being-present-to-itself of the absolute Logos, the living present of God. Nor will the stage be a

representation, if representation means the surface of a spectacle displayed for spectators. It will not even offer the presentation of present, if present signifies that which is maintained *in front* of me. Cruel representation must permeate me. And nonrepresentation is, thus, original representation if representation signifies, also, the unfolding of a volume, a multidimensional milieu, an experience which produces its own space. *Spacing [espacement]*, that is to say, the production of a space that no speech could condense or comprehend (since speech primarily presupposes this spacing), thereby appeals to a time that is no longer that of so-called phonic linearity, appeals to "a new notion of space" and "a specific idea of time" (*TD,* 124). "We intend to base the theater upon spectacle before everything else, and we shall introduce into the spectacle a new notion of space utilized on all possible levels and in all degrees of perspective in depth and height, and within this notion a specific idea of time will be added to that of movement. . . . Thus, theater space will be utilized not only in its dimensions and volume but, so to speak, in its undersides *(dans ses dessous)*" (*TD,* 124).

Thus, the closure of classical representation, but also the reconstitution of a closed space of original representation, the archi-manifestation of force or of life. A closed space, that is to say a space produced from within itself and no longer organized from the vantage of an other absent site, an illocality, an alibi or invisible utopia. The end of representation, but also original representation; the end of interpretation, but also an original interpretation that no master-speech, no project of mastery will have permeated and leveled in advance. A visible representation, certainly, directed against the speech which eludes sight—and Artaud insists upon the productive images without which there would be no theater *(theaomai)*—but whose visibility does not consist of a spectacle mounted by the discourse of the master. Representation, then, as the autopresentation of pure visibility and even pure sensibility.[6]

It is this extreme and difficult sense of spectacular representation that another passage from the same letter attempts to delimit: "So long as the *mise en scène* remains, even in the minds of the boldest directors, a simple means of presentation, an accessory mode of expressing the work, a sort of spectacular intermediary with no significance of its own, it will be valuable only to the degree it succeeds in hiding itself behind the works it is pretending to serve. And this will continue as long as the major interest in a performed work is in its text, as long as literature takes precedence over the kind of performance improperly called spectacle, with everything pejorative, accessory, ephemeral and external that that term carries with it" (*TD,* 105–6). Such, on the stage of cruelty, would be "spectacle acting not as reflection, but as force" (*OC* 4:297). The return to original representation thus implies, not simply but above all, that theater or life must cease to "represent" an other language, must cease to

let themselves be derived from an other art, from literature, for example, be it poetic literature. For in poetry, as in literature, verbal representation purloins scenic representation. Poetry can escape Western "illness" only by becoming theater. "We think, precisely, that there is a notion of poetry to be dissociated, extracted from the forms of written poetry in which an epoch at the height of disorder and illness wants to keep all poetry. And when I say that the epoch wants, I am exaggerating, for in reality it is incapable of wanting anything; it is the victim of a formal habit which it absolutely cannot shake. It seems to us that the kind of diffuse poetry which we identify with natural and spontaneous energy (but all natural energies are not poetic) must find its integral expression, its purest, sharpest and most truly separated expression, in the theater" (*OC,* 4:280).

Thus, we can distinguish the sense of *cruelty* as *necessity* and *rigor.* Artaud certainly invites us to think only of "rigor, implacable intention and decision," and of "irreversible and absolute determination" (*TD,* 101), of "determinism," "submission to necessity" (*TD,* 102), etc., under the heading of cruelty, and not necessarily of "sadism," "horror," "bloodshed," "crucified enemies" (ibid.), etc. (And certain productions today inscribed under Artaud's name are perhaps violent, even bloody, but are not, for all that, cruel.) Nevertheless, there is always a murder at the origin of cruelty, of the necessity named cruelty. And, first of all, a parricide. The origin of theater, such as it must be restored, is the hand lifted against the abusive wielder of the logos, against the father, against the God of a stage subjugated to the power of speech and text.[7]

> In my view no one has the right to call himself author, that is to say creator, except the person who controls the direct handling of the stage. And exactly here is the vulnerable point of the theater as it is thought of not only in France but in Europe and even in the Occident as a whole: Occidental theater recognizes as language, assigns the faculties and powers of a language, permits to be called language (with that particular intellectual dignity generally ascribed to this word) only articulated language, grammatically articulated language, i.e., the language of speech, and of written speech, speech which, pronounced or unpronounced, has no greater value than if it is merely written. In the theater as we conceive it, the text is everything. (*TD,* 117)

What will speech become, henceforth, in the theater of cruelty? Will it simply have to silence itself or disappear?

In no way. Speech will cease to govern the stage, but will be present upon it. Speech will occupy a rigorously delimited place, will have a function within a system to which it will be coordinated. For it is known that the representations of the theater of cruelty had to be painstakingly determined in advance. The absence of an author and his text does not abandon the stage to

dereliction. The stage is not forsaken, given over to improvisatory anarchy, to "chance vaticination" (*OC* 4:234), to "Copeau's improvisations" (*TD*, 109), to "Surrealist empiricism" (*OC* 4:313), to commedia dell' arte, or to "the capriciousness of untrained inspiration" (ibid.). Everything, thus, will be *prescribed* in a writing and a text whose fabric will no longer resemble the model of classical representation. To what place, then, will speech be assigned by this necessary prescription called for by cruelty itself?

Speech and its notation—phonetic speech, an element of classical theater—speech and *its* writing will be erased on the stage of cruelty only in the extent to which they were allegedly *dictation:* at once citations or recitations and orders. The director and the actor will no longer take dictation: "Thus we shall renounce the theatrical superstition of the text and the dictatorship of the writer" (*TD,* 124). This is also the end of the *diction* which made theater into an exercise of reading. The end of the fact that for "certain theatrical amateurs this means that a play read affords just as definite and as great a satisfaction as the same play performed" (*TD,* 118).

How will speech and writing function then? They will once more become *gestures;* and the *logical* and discursive intentions which speech ordinarily uses in order to ensure its rational transparency, and in order to purloin its body in the direction of meaning, will be reduced or subordinated. And since this theft of the body by itself is indeed that which leaves the body to be strangely concealed by the very thing that constitutes it as diaphanousness, then the deconstitution of diaphanousness lays bare the flesh of the word, lays bare the word's sonority, intonation, intensity—the shout that the articulations of language and logic have not yet entirely frozen, that is, the aspect of oppressed gesture which remains in all speech, the unique and irreplaceable movement which the generalities of concept and repetition have never finished rejecting. We know what value Artaud attributed to what is called—in the present case, quite incorrectly—onomatopoeia. Glossopoeia, which is neither an imitative language nor a creation of names, takes us back to the borderline of the moment when the word has not yet been born, when articulation is no longer a shout but not yet discourse, when repetition is *almost* impossible, and along with it, language in general: the separation of concept and sound, of signified and signifier, of the pneumatical and the grammatical, the freedom of translation and tradition, the movement of interpretation, the difference between the soul and the body, the master and the slave, God and man, author and actor. This is the eve of the origin of languages, and of the dialogue between theology and humanism whose inextinguishable reoccurrence has never not been maintained by the metaphysics of Western theater.[8]

Thus, it is less a question of constructing a mute stage than of construct-

ing a stage whose clamor has not yet been pacified into words. The word is the cadaver of psychic speech, and along with the language of life itself the "speech before words"[9] must be found again. Gesture and speech have not yet been separated by the logic of representation. "I am adding another language to the spoken language, and I am trying to restore to the language of speech its old magic, its essential spellbinding power, for its mysterious possibilities have been forgotten. When I say I will perform no written play, I mean that I will perform no play based on writing and speech, that in the spectacles I produce there will be a preponderant physical share which could not be captured and written down in the customary language of words, and that even the spoken and written portions will be spoken and written in a new sense" (*TD*, 111).

What of this "new sense"? And first, what of this new theatrical writing? This latter will no longer occupy the limited position of simply being the notation of words, but will cover the entire range of this new language: not only phonetic writing and the transcription of speech, but also hieroglyphic writing, the writing in which phonetic elements are coordinated to visual, pictorial, and plastic elements. The notion of hieroglyphics is at the center of the *First Manifesto:* "Once aware of this language in space, language of sounds, cries, lights, onomatopoeia, the theater must organize it into veritable hieroglyphs, with the help of characters and objects, and make use of their symbolism and interconnections in relation to all organs and on all levels" (*TD*, 90).

On the stage of the dream, as described by Freud, speech has the same status. This analogy requires patient meditation. In *The Interpretation of Dreams* and in the *Metapsychological Supplement to the Theory of Dreams* the place and functioning of writing are delimited. Present in dreams, speech can only behave as an element among others, sometimes like a "thing" which the primary process manipulates according to its own economy. "In this process thoughts are transformed into images, mainly of a visual sort; that is to say, word presentations are taken back to the thing-presentations which correspond to them, as if, in general the process were dominated by considerations of *representability (Darstellbarkeit)*." "It is very noteworthy how little the dream-work keeps to word-presentations; it is always ready to exchange one word for another till it finds the expression which is most handy for plastic representation."[10] Artaud too, speaks of a "visual and plastic materialization of speech" (*TD*, 69) and of making use of speech "in a concrete and spatial sense" in order to "manipulate it like a solid object, one which overturns and disturbs things" (*TD*, 72). And when Freud, speaking of dreams, invokes sculpture and painting, or the primitive painter who, in the fashion of the authors of comic strips, hung "small labels . . . from the mouths of the

persons represented, containing in written characters the speeches which the artist despaired of representing pictorially" (*SE* 4:312), we understand what speech can become when it is but an element, a circumscribed site, a circumvented writing within both general writing and the space of representation. This is the structure of the rebus or the hieroglyphic. "The dream-content, on the other hand, is expressed as it were in a pictographic script" (*SE* 4:227). And in an article from 1913: "For in what follows 'speech' must be understood not merely to mean the expression of thought in words but to include the speech of gesture and every other method, such, for instance, as writing, by which mental activity can be expressed. . . . If we reflect that the means of representation in dreams are principally visual images and not words, we shall see that it is even more appropriate to compare dreams with a system of writing than with a language. In fact the interpretation of dreams is completely analogous to the decipherment of an ancient pictographic script such as Egyptian hieroglyphs" (*SE* 13:176–77).[11]

It is difficult to know the extent to which Artaud, who often referred to psychoanalysis, had approached the text of Freud. It is in any event remarkable that he describes the play of speech and of writing on the stage of cruelty according to Freud's very terms, a Freud who at the time was hardly elucidated. Already in the *First Manifesto*:

> *The language of the stage:* It is not a question of suppressing the spoken language, but of giving words approximately the importance they have in dreams. Meanwhile new means of recording this language must be found, whether these means belong to musical transcription or to some kind of code. As for ordinary objects, or even the human body, raised to the dignity of signs, it is evident that one can draw one's inspiration from hieroglyphic characters [*TD*, 94]. . . . Eternal laws, those of all poetry and all viable language, and, among other things, of Chinese ideograms and ancient Egyptian hieroglyphs. Hence, far from restricting the possibilities of theater and language, on the pretext that I will not perform written plays, I extend the language of the stage and multiply its possibilities. (*TD*, 111)

As concerns psychoanalysis and especially psychoanalysts, Artaud was no less careful to indicate his distance from those who believe that they can retain discourse with the aid of psychoanalysis, and thereby can wield its initiative and powers of initiation.

For the theater of cruelty is indeed a theater of dreams, but of *cruel* dreams, that is to say, absolutely necessary and determined dreams, dreams calculated and given direction, as opposed to what Artaud believed to be the empirical disorder of spontaneous dreams. The ways and figures of dreams can be mastered. The surrealists read Hervey de Saint-Denys.[12] In this theatri-

cal treatment of dreams, "poetry and science must henceforth be identical" (*TD*, 140). To make them such, it is certainly necessary to proceed according to the modern magic that is psychoanalysis. "I propose to bring back into the theater this elementary magic idea, taken up by modern psychoanalysis." (*TD*, 80). But no concession must be made to what Artaud believes to be the faltering of dreams and of the unconscious. It is the *law* of dreams that must be produced or reproduced: "I propose to renounce our empiricism of imagery, in which the unconscious furnishes images at random, and which the poet arranges at random too" (ibid.).

Because he wants "to see sparkle and triumph on stage" "whatever is part of the illegibility and magnetic fascination of dreams" (*CW* 2:23), Artaud therefore rejects the psychoanalyst as interpreter, second-remove commentator, hermeneut, or theoretician. He would have rejected a psychoanalytic theater with as much rigor as he condemned psychological theater. And for the same reasons: his rejection of any secret interiority, of the reader, of directive interpretations or of psychodramaturgy. "The *subconscious* will not play any true role on stage. We've had enough of the confusion engendered between author and audience through the medium of producers and actors. Too bad for analysts, students of the soul and surrealists. . . . We are determined to safeguard the plays we put on against any secret commentary" (*CW* 2:39).[13] By virtue of his situation and his status, the psychoanalyst would belong to the structure of the classical stage, to its societal form, its metaphysics, its religion, etc.

The theater of cruelty thus would not be a theater of the unconscious. Almost the contrary. Cruelty is consciousness, is exposed lucidity. "There is no cruelty without consciousness and without the application of consciousness" (*TD*, 102). And this consciousness indeed lives upon a murder, is the consciousness of this murder, as we suggested above. Artaud says this in "The First Letter on Cruelty": "It is consciousness that gives to the exercise of every act of life its blood-red color, its cruel nuance, since it is understood that life is always someone's death" (*TD*, 102).

Perhaps Artaud is also protesting against a certain Freudian description of dreams as the substitutive fulfillment of desire, as the function of vicariousness: through the theater, Artaud wants to return their dignity to dreams and to make of them something more original, more free, more *affirmative* than an activity of displacement. It is perhaps against a certain image of Freudian thought that he writes in the *First Manifesto:* "To consider the theater as a second-hand psychological or moral function, and to believe that dreams themselves have only a substitute function, is to diminish the profound poetic bearing of dreams as well as of the theater" (*TD*, 92).

Finally, a psychoanalytic theater would risk being a desacralizing theater,

and thereby would confirm the West in its project and its trajectory. The theater of cruelty is a hieratic theater. Regression toward the unconscious (cf. *TD*, 47) fails if it does not reawaken the sacred, if it is not both the "mystic" experience of "revelation" and the manifestation of life in their first emergence (*TD*, 46–47, 60). We have seen the reasons why hieroglyphics had to be substituted for purely phonic signs. It must be added that the latter communicate less than the former with the imagination of the sacred. "And through the hieroglyph of a breath I am able to recover an idea of the sacred theater" (*TD*, 141). A new epiphany of the supernatural and the divine must occur within cruelty. And not despite but thanks to the eviction of God and the destruction of the theater's theological machinery. The divine has been ruined by God. That is to say, by man, who in permitting himself to be separated from Life by God, in permitting himself to be usurped from his own birth, became man by polluting the divinity of the divine. "For far from believing that man invented the supernatural and the divine, I think it is man's age-old intervention which has ultimately corrupted the divine within him" (*TD*, 8). The restoration of divine cruelty, hence, must traverse the murder of God, that is to say, primarily the murder of the man-God.[14]

Perhaps we now can ask, not about the conditions under which a modern theater could be faithful to Artaud, but in what cases it is surely unfaithful to him. What might the themes of infidelity be, even among those who invoke Artaud in the militant and noisy fashion we all know? We will content ourselves with naming these themes. Without a doubt, foreign to the theater of cruelty are:

1. All non-sacred theater.

2. All theater that privileges speech or rather the verb, all theater of words, even if this privilege becomes that of a speech which is self-destructive, which once more becomes gesture of hopeless reoccurrence, a *negative* relation of speech to itself, theatrical nihilism, what is still called the theater of the absurd. Such a theater would not only be consumed by speech, and would not destroy the functioning of the classical stage, but it also would not be, in the sense understood by Artaud (and doubtless by Nietzsche), an *affirmation*.

3. All *abstract* theater which excludes something from the totality of art, and thus, from the totality of life and its resources of signification: dance, music, volume, depth of plasticity, visible images, sonority, phonicity, etc. An abstract theater is a theater in which the totality of sense and the senses is not consumed. One would incorrectly conclude from this that it suffices to accumulate or to juxtapose all the arts in order to create a total theater addressed to the "total man"[15] (cf. *TD*, 123). Nothing could be further from addressing total man than an assembled totality, an artificial and exterior mimicry. Inversely, certain apparent exhaustions of stage technique sometimes more rigor-

ously pursue Artaud's trajectory. Assuming, which we do not, that there is some sense in speaking of a fidelity to Artaud, to something like his "message" (this notion already betrays him), then a rigorous, painstaking, patient, and implacable sobriety in the work of destruction, and an economical acuity aiming at the master parts of a still quite solid machine, are more surely imperative, today, than the general mobilization of art and artists, than turbulence or improvised agitation under the mocking and tranquil eyes of the police.

4. All theater of alienation. Alienation only consecrates, with didactic insistence and systematic heaviness, the nonparticipation of spectators (and even of directors and actors) in the creative act, in the irruptive force fissuring the space of the stage. The *Verfremdungseffekt*[16] remains the prisoner of a classical paradox and of "the European ideal of art" which "attempts to cast the mind into an attitude distinct from force but addicted to exaltation" (*TD*, 10). Since "in the 'theater of cruelty' the spectator is in the center and the spectacle surrounds him" (*TD*, 81), the distance of vision is no longer pure, cannot be abstracted from the totality of the sensory milieu; the infused spectator can no longer *constitute* his spectacle and provide himself with its object. There is no longer spectator or spectacle, but *festival* (cf. *TD*, 85). All the limits furrowing classical theatricality (represented/representer, signified/signifier, author/director/actors/spectators, stage/audience, text/interpretation, etc.) were ethicometaphysical prohibitions, wrinkles, grimaces, rictuses—the symptoms of fear before the dangers of the festival. Within the space of the festival opened by transgression, the distance of representation should no longer be extendable. The festival of cruelty lifts all footlights and protective barriers before the "absolute danger" which is "without foundation": "I must have actors who are first of all beings, that is to say, who on stage are not afraid of the true sensation of the touch of a knife and the convulsions—*absolutely* real for them—of a supposed birth. Mounet-Sully believes in what he does and gives the illusion of it, but he knows that he is behind a protective barrier, me—I suppress the protective barrier" (letter to Roger Blin, September 1945). As regards the festival, as invoked by Artaud, and the menace of that which is "without foundation," the "happening" can only make us smile: it is to the theater of cruelty what the carnival of Nice might be to the mysteries of Eleusis. This is particularly so due to the fact that the happening substitutes political agitation for the total revolution prescribed by Artaud. The festival must be a political *act*. And the *act* of political revolution is *theatrical*.

5. All nonpolitical theater. We have indeed said that the festival must be a political *act* and not the more or less eloquent, pedagogical, and superintended transmission of a concept or a politico-moral vision of the world. To reflect—which we cannot do here—the political sense of this act and this

festival, and the image of society which fascinates Artaud's desire, one should come to invoke (in order to note the greatest difference within the greatest affinity) all the elements in Rousseau which establish communication between the critique of the classical spectacle, the suspect quality of *articulation* in language, the ideal of a public festival substituted for representation, and a certain model of society perfectly present to itself in small communities which render both useless and nefarious all recourse to *representation* at the decisive moments of social life. That is, all recourse to political as well as to theatrical representation, replacement, or delegation. It very precisely could be shown that it is the "representer" that Rousseau suspects in *The Social Contract*, as well as in the *Letter to M. d'Alembert*, where he proposes the replacement of theatrical representations with public festivals lacking all exhibition and spectacle, festivals without "anything to see" in which the spectators themselves would become actors: "But what then will be the objects of these entertainments? . . . Nothing, if you please. . . . Plant a stake crowned with flowers in the middle of a square; gather the people together there, and you will have a festival. Do better yet; let the spectators become an entertainment to themselves; make them actors themselves."[17]

6. All ideological theater, all cultural theater, all communicative, *interpretive* (in the popular and not the Nietzschean sense, of course) theater seeking to transmit a content, or to deliver a message (of whatever nature: political, religious, psychological, metaphysical, etc.) that would make a discourse's meaning intelligible for its listeners;[18] a message that would not be totally exhausted in the *act* and *present tense* of the stage, that would not coincide with the stage, that could be repeated without it. Here we touch upon what seems to be the profound essence of Artaud's project, his historico-metaphysical decision. *Artaud wanted to erase repetition in general.*[19] For him, repetition was evil, and one could doubtless organize an entire reading of his texts around this center. Repetition separates force, presence, and life from themselves. This separation is the economical and calculating gesture of that which defers itself in order to maintain itself, that which reserves expenditure and surrenders to fear. This power of repetition governed everything that Artaud wished to destroy, and it has several names: God, Being, Dialectics. God is the eternity whose death goes on indefinitely, whose death, as difference and repetition within life, has never ceased to menace life. It is not the living God, but the Death-God that we should fear. God is Death. "For even the infinite is dead, / infinite is the name of a dead man / who is not dead" (*84*). As soon as there is repetition, God is there, the present holds on to itself and reserves itself, that is to say, eludes itself. "The absolute is not a being and will never be one, for there can be no being without a crime committed against myself, that is to say, without taking from me a being who wanted one

day to be god when this is not possible, God being able to manifest himself only all at once, given that he manifests himself an infinite number of times during all the times of eternity as the infinity of times and eternity, which creates perpetuity" (September 1945). Another name of repetition: Being. Being is the form in which the infinite diversity of the forms and forces of life and death can indefinitely merge and be repeated in the word. For there is no word, nor in general a sign, which is not constituted by the possibility of repeating itself. A sign which does not repeat itself, which is not already divided by repetition in its "first time," is not a sign. The signifying referral therefore must be ideal— and ideality is but the assured power of repetition—in order to refer to the same thing each time. This is why Being is the key word of eternal repetition, the victory of God and of Death over life. Like Nietzsche (for example in *The Birth of Philosophy*), Artaud refuses to subsume Life to Being, and inverses the genealogical order: "First to live and to be according to one's soul; the problem of being is only their consequence" (September 1945); "There is no greater enemy of the human body than being" (September 1947). Certain other unpublished texts valorize what Artaud properly calls "the beyond of being" (February 1947), manipulating this expression of Plato's (whom Artaud did not fail to read) in a Nietzschean style. Finally, Dialectics is the movement through which expenditure is reappropriated into presence—it is the economy of repetition. The economy of truth. Repetition *summarizes* negativity, gathers and maintains the past present as truth, as ideality. The truth is always that which can be repeated. Nonrepetition, expenditure that is resolute and without return in the unique time consuming the present, must put an end to fearful discursiveness, to unskirtable ontology, to dialectics, "dialectics [a certain dialectics] being that which finished me" (September 1945).[20]

Dialectics is always that which has finished us, because it is always that which *takes into account* our rejection of it. As it does our affirmation. To reject death as repetition is to affirm death as a present expenditure without return. And inversely. This is a schema that hovers around Nietzsche's repetition of affirmation. Pure expenditure, absolute generosity offering the unicity of the present to death in order to make the present appear *as such*, has already begun to want to maintain the presence of the present, has already opened the book and memory, the thinking of Being as memory. Not to want to maintain the present is to want to preserve that which constitutes its irreplaceable and mortal presence, that within it which cannot be repeated. To consume pure difference with pleasure. Such, reduced to its bloodless framework, is the matrix of the history of thought conceptualizing itself since Hegel.[21]

The possibility of the theater is the obligatory focal point of this thought which reflects tragedy as repetition. The menace of repetition is nowhere else as well organized as in the theater. Nowhere else is one so close to the stage as

the origin of repetition, so close to the primitive repetition which would have to be erased, and only by detaching it from itself as if from its double. Not in the sense in which Artaud spoke of *The Theater and its Double*,[22] but as designating the fold, the interior duplication which steals the simple presence of its present act from the theater, from life, etc., in the irrepressible movement of repetition. "One time" is the enigma of that which has no meaning, no presence, no legibility. Now, for Artaud, the festival of cruelty could take place only *one time:* "Let us leave textual criticism to graduate students, formal criticism to esthetes, and recognize that what has been said is not still to be said; that an expression does not have the same value twice, does not live two lives; that all words, once spoken, are dead and function only at the moment when they are uttered, that a form, once it has served, cannot be used again and asks only to be replaced by another, and that the theater is the only place in the world where a gesture, once made, can never be made the same way twice" (*TD,* 75). This is indeed how things appear: theatrical representation is finite, and leaves behind it, behind its actual presence, no trace, no object to carry off. It is neither a book nor a work, but an energy, and in this sense it is the only art of life. "The theater teaches precisely the uselessness of the action which, once done, is not to be done, and the superior use of the state unused by the action and which, *restored,* produces a purification" (*TD,* 82). In this sense the theater of cruelty would be the art of difference and of expenditure without economy, without reserve, without return, without history. Pure presence as pure difference. Its act must be forgotten, actively forgotten. Here, one must practice the *aktive Vergesslichkeit* which is spoken of in the second dissertation of *The Genealogy of Morals,* which also explicates "festivity" and "cruelty" (*Grausamkeit*).

Artaud's disgust with nontheatrical writing has the same sense. What inspires this disgust is not, as in the *Phaedrus,* the gesture of the body, the sensory and mnemonic, the hypomnesiac mark exterior to the inscription of truth in the soul, but, on the contrary, writing as the site of the inscription of truth, the other of the living body, writing as ideality, repetition. Plato criticizes writing as a body; Artaud criticizes it as the erasure of the body, of the living gesture which takes place only once. Writing is space itself and the possibility of repetition in general. This is why "We should get rid of our superstitious valuation of texts and written poetry. Written poetry is worth reading once, and then should be destroyed" (*TD,* 78).

In thus enumerating the themes of infidelity, one comes to understand very quickly that fidelity is impossible. There is no theater in the world today which fulfills Artaud's desire. And there would be no exception to be made for the attempts made by Artaud himself. He knew this better than any other:

the "grammar" of the theater of cruelty, of which he said that it is "to be found," will always remain the inaccessible limit of a representation which is not repetition, of a *re*-presentation which is full presence, which does not carry its double within itself as its death, of a present which does not repeat itself, that is, of a present outside time, a nonpresent. The present offers itself as such, appears, presents itself, opens the stage of time or the time of the stage only by harboring its own intestine difference, and only in the interior fold of its original repetition, in representation. In dialectics.

Artaud knew this well: "a certain dialectics . . . " For if one appropriately conceives the *horizon* of dialectics—outside a conventional Hegelianism—one understands, perhaps, that dialectics is the indefinite movement of finitude, of the unity of life and death, of difference, of original repetition, that is, of the origin of tragedy as the absence of a simple origin. In this sense, dialectics is tragedy, the only possible affirmation to be made against the philosophical or Christian idea of pure origin, against "the spirit of beginnings": "But the spirit of beginnings has not ceased to make me commit idiocies, and I have not ceased to dissociate myself from the spirit of beginnings which is the Christian spirit" (September 1945). What is tragic is not the impossibility but the necessity of repetition.

Artaud knew that the theater of cruelty neither begins nor is completed within the purity of simple presence, but rather is already within representation, in the "second time of Creation," in the conflict of forces which could not be that of a simple origin. Doubtless, cruelty could begin to be practiced within this conflict, but thereby it must also let itself be *penetrated*. The origin is always *penetrated*. Such is the alchemy of the theater.

> Perhaps before proceeding further I shall be asked to define what I mean by the archetypal, primitive theater. And we shall thereby approach the very heart of the matter. If in fact we raise the question of the origins and *raison d'être* (or primordial necessity) of the theater, we find, metaphysically, the materialization or rather the exteriorization of a kind of essential drama, already *disposed* and *divided*, not so much as to lose their character as principles, but enough to comprise, in a substantial and active fashion (i.e. resonantly), an infinite perspective of conflicts. To analyze such a drama philosophically is impossible; only poetically. . . . And this essential drama, we come to realize, exists, and in the image of something subtler than Creation itself, something which must be represented as the result of one Will alone—and *without conflict*. We must believe that the essential drama, the one at the root of all the Great Mysteries, is associated with the second phase of Creation, that of difficulty and of the Double, that of matter and the materialization of the idea. It seems indeed that where simplicity and order reign, there can be no theater nor drama, and the true theater, like poetry as well, though by other means, is born out of a kind of organized anarchy. (*TD,* 50–51).

Primitive theater and cruelty thus also begin by repetition. But if the idea of a theater without representation, the idea of the impossible, does not help us to regulate theatrical practice, it does, perhaps, permit us to conceive its origin, eve and limit, and the horizon of its death. The energy of Western theater thus lets itself be encompassed within its own possibility, which is not accidental and serves as a constitutive center and structuring locus for the entire history of the West. But repetition steals the center and the locus, and what we have just said of its possibility should prohibit us from speaking both of death as a horizon and of birth as a past *opening*.

Artaud kept himself as close as possible to the limit: the possibility and impossibility of pure theater. Presence, in order to be presence and self-presence, has always already begun to represent itself, has always already been penetrated. Affirmation itself must be penetrated in repeating itself. Which means that the murder of the father which opens the history of representation and the space of tragedy, the murder of the father that Artaud, in sum, wants to repeat at the greatest proximity to its origin but *only a single time*—this murder is endless and is repeated indefinitely. It begins by penetrating its own commentary and is accompanied by its own representation. In which it erases itself and confirms the transgressed law. To do so, it suffices that there be a sign, that is to say, a repetition.

Underneath this side of the limit, and in the extent to which he wanted to save the purity of a presence without interior difference and without repetition (or paradoxically amounting to the same thing, the purity of a pure difference),[23] Artaud also desired the impossibility of the theater, wanted to erase the stage, no longer wanted to see what transpires in a locality always inhabited or haunted by the father and subjected to the repetition of murder. Is it not Artaud who wants to reduce the archi-stage when he writes in the *Here-lies:* "I Antonin Artaud, am my son, / my father, my mother, / and myself" (*AA,* 238)?

That he thereby kept himself at the limit of theatrical possibility, and that he simultaneously wanted to produce and to annihilate the stage, is what he knew in the most extreme way. December 1946:

And now I am going to say something which, perhaps,
is going to stupify many people.
I am the enemy
of theater.
I have always been.
As much as I love the theater,
I am, for this very reason, equally its enemy.

We see him immediately afterward: he cannot resign himself to theater as repetition, and cannot renounce theater as nonrepetition:

> The theater is a passionate overflowing
> a frightful transfer of forces
>     from body
>     to body.
> This transfer cannot be reproduced twice.
> Nothing more impious than the system of the Balinese which consists,
> after having produced this transfer one time,
> instead of seeking another,
> in resorting to a system of particular enchantments
> in order to deprive astral photography of the gestures thus obtained.

Theater as repetition of that which does not repeat itself, theater as the original repetition of difference within the conflict of forces in which "evil is the permanent law, and what is good is an effort and already a cruelty added to the other cruelty"—such is the fatal limit of a cruelty which begins with its own representation.

Because it has always already begun, representation therefore has no end. But one can conceive of the closure of that which is without end. Closure is the circular limit within which the repetition of difference infinitely repeats itself. That is to say, closure is its *playing* space. This movement is the movement of the world as play. "And for the absolute life itself is a game" (*OC* 4:282). This play is cruelty as the unity of necessity and chance. "It is chance that is infinite, not god" *(Fragmentations)*. This play of life is artistic.[24]

To think the closure of representation is thus to think the cruel powers of death and play which permit presence to be born to itself, and pleasurably to consume itself through the representation in which it eludes itself in its deferral. To think the closure of representation is to think the tragic: not as the representation of fate, but as the fate of representation. Its gratuitous and baseless necessity.

And it is to think why it is *fatal* that, in its closure, representation continues.

## NOTES

Translated by Alan Bass.
   1. "Le théâtre de la cruauté," 84, 5–6 (1948): 109.

2. Antonin Artaud, *Antonin Artaud Anthology,* ed. Jack Hirschman (San Francisco: City Light Books, 1965), 162.

3. Antonin Artaud, *The Theater and Its Double,* trans. Mary Caroline Richards (New York: Grove Press, 1958), 114. Subsequent references appear in the text, abbreviated *TD.*

4. "The psychology of orgiasm conceived as the feeling of a superabundance of vitality and strength, within the scope of which even pain acts as a *stimulus,* gave me the key to the concept of *tragic* feeling, which has been misunderstood not only by Aristotle, but also even more by our pessimists" (Friedrich Nietzche, *The Twilight of the Idols,* trans. Anthony Ludovici [New York: Russell and Russell, 1964], 119). Art, as the imitation of nature, communicates in an essential way with the theme of catharsis. "Not in order to escape from terror and pity, not to purify one's self of a dangerous passion by discharging it with vehemence—this is how Aristotle understood it—but to be far beyond terror and pity and to be the eternal lust of becoming itself—that lust which also involves the *lust of destruction.* And with this I once more come into touch with the spot from which I once set out—the 'Birth of Tragedy' was my first transvaluation of all values: with this again I take my stand upon the soil from out of which my will and my capacity spring—I, the last disciple of the philosopher Dionysus—I, the prophet of eternal recurrence" (ibid., 120).

5. Antonin Artaud, *Oeuvres complètes,* (Paris: Gallimard, 1956), 4:310. Subsequent references appear in the text, abbreviated *OC.*

6. That *re*presentation is the auto-presentation of pure visibility and pure sensibility, amounts to postulating that presence is an effect of repetition.—TRANS.

7. On the question of parricide and the "father of the Logos," cf. "Plato's Pharmacy," in *Dissemination,* trans. Barbara Johnson (Chicago: University of Chicago Press, 1981), 61–171.—TRANS.

8. *The Theater and Its Double* would have to be confronted with *The Essay on the Origin of Languages, The Birth of Tragedy,* and all the connected texts of Rousseau and Nietzsche: the *System* of their analogies and oppositions would have to be reconstituted.

9. *TD,* 60, 110. In this sense the word is a sign, a symptom of living speech's fatigue, of life's disease. The word, as clear speech subjected to transmission and to repetition, is death in language. "One could say that the mind, able to go on no longer, resigned itself to the clarities of speech" (*Collected Works,* trans. Victor Corti, 4 vols. [London: Calder and Boyars, 1968–74], 4:289). Subsequent references appear in the text, abbreviated *CW.* On why it is necessary to "change the role of speech in the theater," cf. *TD,* 72–73, 94–95.

10. *The Standard Edition of the Complete Psychological Works of Sigmund Freud,* ed. and trans. James Strachey, 23 vols., (London: Hogarth Press and the Institute of Psychoanalysis, 1953–74), 14:228. Subsequent references appear in the text, abbreviated *SE.*

11. On these questions, cf. "Freud and the Scene of Writing," in *Writing and Difference,* trans. Alan Bass (Chicago: University of Chicago Press, 1978) 196–231 n. 12.—TRANS.

12. *Les Rêves et les moyens de les diriger* (1867) is invoked at the opening of André Breton's *Communicating Vessels,* trans. Mary Ann Caws and Geoffrey T. Harris (Lincoln: University of Nebraska Press, 1990).

13. "Miserable, improbable psyche that the cartel of psychological presuppositions has never ceased pinning into the muscles of humanity" (letter written from Espalion to Roger Blin, 25 March 1946 [texts referred to by date are unpublished]).

"Only a very few highly contestable documents on the Mysteries of the Middle Ages remain. It is certain that they had, from the purely scenic point of view, resources that the theater has not contained for centuries, but one could also find on the repressed debates of the soul a science that modern psychoanalysis has barely rediscovered and in a much less efficacious and morally less fruitful sense than in the mystical dramas played on the parvis" (February 1945). This fragment multiplies aggressions against psychoanalysis.

14. Against the pact of fear which gives birth to man and to God must be restored the unity of evil and life, of the Satanic and the divine: "I, M. Antonin Artaud, born in Marseilles 4 September 1896, I am Satan and I am God and I do not want anything to do with the Holy Virgin" (written from Rodez, September 1945).

15. On the integral spectacle, cf. *CW* 2:31. This theme is often accompanied by allusions to participation in an "interested emotion": the critique of aesthetic experience as disinterestedness. It recalls Nietzsche's critique of Kant's philosophy of art. No more in Nietzsche than in Artaud must this theme contradict the value of gratuitous play in artistic creation. Quite to the contrary.

16. Brecht is the major representative of the theater of alienation.—TRANS.

17. *Letter to M. d'Alembert,* trans. Allan Bloom (Glencoe: Free Press, 1960), 126. [These questions receive an extended treatment in *Of Grammatology,* trans. Gayatri Chakravorty Spivak (Baltimore: Johns Hopkins University Press, 1974), 165ff.—TRANS.]

18. The theater of cruelty is not only a spectacle without spectators, it is speech without listeners. Nietzsche: "The man in a state of Dionysean excitement has a listener just as little as the orgiastic crowd, a listener to whom he might have something to communicate, a listener which the epic narrator, and generally speaking the Apollonian artist, to be sure, presupposes. It is rather in the nature of the Dionysean art, that it has no consideration for the listener: the inspired servant of Dionysus is, as I said in a former place, understood only by his compeers. But if we now imagine a listener at those endemic outbursts of Dionysean excitement then we shall have to prophesy for him a fate similar to that which Pentheus the discovered eavesdropper suffered, namely, to be torn to pieces by the Maenads. . . . But now the *opera* begins, according to the clearest testimonies, with the *demand of the listener to understand a word.* What? The listener *demands?* The word is to be understood?" ("On Music and Words," in *Early Greek Philosophy,* trans. Maximilian Mugge [New York: Russell and Russell, 1964], 40–41).

19. *Répétition* also means "rehearsal" in French.—TRANS.

20. On the economy of dialectics, cf. "From Restricted to General Economy," in *Writing and Difference,* 251–77. On truth, repetition, and the beyond of being, cf. "Plato's Pharmacy."—TRANS.

21. Derrida seems to be making a point here which is developed more fully in "From Restricted to General Economy." He seems to be referring, if rather elliptically, to the Hegelian dialectic of the master and the slave, in which the master, who both risks death and *consumes* with pleasure, does not *maintain* the *present.* The slave is the truth of the master because he maintains the present through his relation to work, his deferred consumption of the present. Thus he is also the embodiment of the dialectical "memory"—*Erinnerung.* Both master and slave are possibilities of metaphysics, of *presence,* and to confirm the one or the other—as happens inevitably—is to repeat a metaphysical gesture.—TRANS.

22. Letter to Jean Paulhan, 25 January 1936: "I think I have a suitable title for my book. It will be *The Theater and Its Double,* for if theater doubles life, life doubles true theater. . . . This title corresponds to all the doubles of the theater that I believe to have found over the course of so many years: metaphysics, the plague, cruelty. . . . It is on the stage that the union of thought, gesture, and act is reconstituted" (*CW* 5:272–73).

23. To attempt to reintroduce a purity into the concept of difference, one returns it to nondifference and full presence. This movement is fraught with consequences for any attempt opposing itself to an indicative anti-Hegelianism. One escapes from it, apparently, only by conceiving difference outside the determination of Being as presence, outside the alternatives of presence and absence and everything they govern, and only by conceiving difference as original impurity, that is to say as *différance* in the finite economy of the same.

24. Nietzsche again. These texts are well-known. Thus, for example, in the wake of Heraclitus: "And similarly, just as the child and the artist play, the eternally living fire plays, builds up and destroys, in innocence—and this game the *aeon* plays with himself. . . . The child throws away his toys: but soon he starts again in an innocent frame of mind. As soon however as the child builds he connects, joins and forms lawfully and according to an innate sense of order. Thus only is the world contemplated by the aesthetic man, who has learned from the artist and the genesis of the latter's work, how the struggle of plurality can yet bear within itself law and justice, how the artist stands contemplative above, and working within the work of art, how necessity and play, antagonism and harmony must pair themselves for the procreation of the work of art" ("Philosophy during the Tragic Age of the Greeks," in *Early Greek Philosophy,* 108).

# Luce Irigaray
## The Stage Setup

The myth of the cave, for example, or as an example, is a good place to start.[1] Read it this time as a metaphor of the inner space, of the den, the womb or *hystera,* sometimes of the earth—though we shall see that the text inscribes the metaphor as, strictly speaking, impossible. Here is an attempt at making metaphor, at trying out detours, which not only is a silent prescription for Western metaphysics but also, more explicitly, proclaims (itself as) everything publicly designated as metaphysics, its fulfillment, and its interpretation.

### The Stage Setup

So let us make reading the myth of the cave our point of departure. Socrates tells us that men—*hoi anthrōpoi,* sex unspecified—live *underground,* in a *dwelling formed* like a *cave.* Ground, dwelling, cave, and even, in a different way, form—all these terms can be read more or less as equivalents of the *hystera.* Similar associations could in fact be made for *living, dwelling* for a certain time or even for all time, in the *same place,* in the *same habitat.*

As the story goes, then, men—with no specification of sex—are living in one, same, place. A place shaped like a cave or a womb.[2]

### Turned Upside-Down and Back-to-Front

The entrance to the cave takes the form of a long passage, corridor, neck, conduit, leading upward, toward the light or the *sight of day,* and the whole of the cave is oriented in relation to this opening. Upward—this notation indicates from the very start that the Platonic cave functions as an attempt to give an orientation to the reproduction and representation of something that is always already there in the den. The orientation functions by turning everything over, by reversing, and by pivoting around axes of symmetry. From high to low, from low to high, from back to front, from anterior to opposite, but in all cases from a point of view in front of or behind something in this cave, situated in the back. *Symmetry plays a decisive part here*—as projection, reflection, inversion, retroversion—and you will always already have lost your bearings as soon as you set foot in the cave; it will turn your head, set you walking on your hands, though Socrates never breathes a word about the

whole mystification, of course. This theatrical trick is unavoidable if you are to enter into the functioning of representation.

So men have lived in this cave since their childhood. Since time began. They have never left this space, or place, or topography, or topology, of the cave. The swing around the axes of symmetry necessarily determines how they live, but they are unaware of this. Chained by the neck and thighs, they are fixed with their heads and genitals facing *front, opposite*—which in Socrates' tale, is the direction toward the back of the cave. The cave is the representation of something always already there, of the original matrix/womb which these men cannot represent since they are held down by chains that prevent them from turning their heads or their genitals toward the daylight. They cannot turn toward what is more primary, toward the *proteron* which is in fact the *hystera*. Chains restrain them from turning toward the origin but/and they are prisoners in the space-time of the pro-ject of its representation. Head and genitals are kept turned to the front of the representational project and pro-cess of the *hystera*. To the *hystera protera* that is apparently resorbed, blended into the movement of *hysteron proteron*. For *hysteron*, defined as what is be-hind, is also the last, the hereafter, the ultimate. *Proteron*, defined as what is in front, is also the earlier, the previous. There is a fault in the *hysterein* which is maintained by the *proterein*, or more exactly here by the *prosō*, the forward, the *prosōpon*, the opposite, the face, the visage, the physiognomy, the *blepein eis prosōpon*, or even the *protasis*—maintained by links, by chains that are, as it were, invisible. Thus keeping up the illusion that the origin might become fully visible if only one could turn around, bring it into one's field of vision, facing one's face, if only it were not artificially turned away. One is able only to look ahead and stretch forward. Chains, lines, perspectives oriented straight ahead—all maintain the illusion of constant motion in one direction. Forward. The cave cannot be explored in the round, walked around, mea-sured in the round. Which means that the men all stay there in the same spot—same place, same time—in the same *circle*, or circus ring, the *theatrical arena* of that representation.

### Special Status for the Side Opposite

And the only thing they can still do is to look at whatever presents itself before their eyes. Paralyzed, unable to *turn round or return* toward the origin, toward the *hystera protera,* they are condemned to look ahead at the wall opposite, toward the back wall of the cave—the back which is also the front, the fore—toward the metaphorical project of the back of the cave, which will serve as a *backcloth* for all the representations to come. Heads forward, eyes

front, genitals aligned, fixed in a straight direction and always straining forward, in a straight line. A phallic direction, a phallic line, a phallic time, backs turned on origin.

This project, or process, by which the *hystera* is displaced, transposed, transferred, metaphorized, always already holds them captive. The transposition of the anterior to the posterior, of the origin to the end, the horizon, the *telos*, envelops and encircles them; it is never susceptible of representation, but produces, facilitates, permits all representations since all are always already marked, or re-marked, in the incessant repetition of this same work of projection. Which yet is impossible, or cannot be completed at least. The *hystera*, faceless, unseen, will never be presented, represented as such. But the representational scheme and sketch for the *hystera*—which can never be fulfilled—sub-tends, englobes, encircles, connotes, overdetermines every sight, every sighting, face, feature, figure, form, presentification, presence. Blindly.

Certain men, then—sex undetermined (?)—are chained up in/by this transposition of the *hystera*. In no position to turn their heads, or anything else. Unable to turn, turn around, or return.

## A Fire in the Image of a Sun

They have been given a *light*, however. It comes from a *fire* burning at a distance, behind and above them. A light indeed, but artificial and earthly. A weak light, and one that offers the eyes poor visibility, far from ideal conditions for seeing and being seen. Its distance and particularly its position in relation to the prisoners control the play of shadow in a specific way. It is a light that gives little light. That produces only shadows, reflections, fantasies, all of which are bigger than the *objects* figured in this way. Given the light's situation in relation to these objects, to the prisoners, to their gaze. And given the light's exposure in the earth. A fire, then, burns at a distance, behind the men and above them. *Like* the natural daylight, sunlight—afar, behind, above (at least in this place)—but meant to be only an artificial, artful reproduction of sunlight *inside* this translation, reversal, projection of the *hystera*. A fire lighted by the *hand of man* in the "image" of the sun. A *topographic mime*, but one whose process of repetition, reproduction, is always already multiply doubled up, divided, scaled down, demented, with no possible recourse to a first time, a first model. For if the cave is made in the image of the world, the world—as we shall see—is equally made in the image of the cave. In cave or "world" all is but the image of an image. For this cave is always already an attempt to re-present another cave, the *hystera*, the mold which silently dictates all replicas, all possible forms, all possible relation of forms and between forms, of any replica.

## The Forgotten Path

Thus, in that cave, inside that cave, burns *a* fire "in the image of " *a* sun. But there is also a *path,* no doubt made in the image of the conduit, neck, passage, corridor which goes up (or rather would go down) out of the cave toward the light of day, toward the sight of day. Gallery, sheath, envelope-passage, enveloped, going from the daylight to the underground grotto and its fire. A conduit which is taken up and reproduced *inside* the cave. A repetition, representation, figuration reenacted within the cave of that passage which we are told leads in and out of it. Of the path *in between.* Of the "go-between" path that links two "worlds," two modes, two methods, two measures of replicating, representing, viewing, in particular the sun, the fire, the light, the "objects," and the cave. Of this passage that is neither outside nor inside, that is between the way out and the way in, between access and egress. This is a key passage, even when it is neglected, or even especially when it is neglected, for when the passage is forgotten, by the very fact of its being reenacted *in* the cave, it will found, subtend, sustain the hardening of all dichotomies, categorical differences, clear-cut distinctions, absolute discontinuities, all the confrontations of irreconcilable representations. Between the "world outside" and the "world inside," between the "world above" and the "world below." Between the light of the sky and the fire of the earth. Between the gaze of the man who has left the cave and that of the prisoner. Between truth and shadow, between truth and fantasy, between "truth" and whatever "veils" the truth. Between reality and dream. Between . . . Between . . . Between the intelligible and the sensible. Between good and evil. The One and the many. Between anything you like. All oppositions that assume the *leap* from a worse to a better. An ascent, a displacement (?) upward, a progression along a line. Vertical. Phallic even? But what has been forgotten in all these oppositions, and with good reason, is how to pass through the passage, how to negotiate it—the forgotten transition. The corridor, the narrow pass, the neck.

*Forgotten vagina.* The passage that is missing, left on the shelf, between the outside and the inside, between the plus and the minus. With the result that all divergencies will finally be proportions, functions, relations that can be referred back to *sameness.* Inscribed, postulated in/by *one, same unit(y),* synthesis or syntax. Dictating silently, invisibly, all the *filial* resemblances or differences. Even if it seems possible to name what articulates them, or see it represented: sun, for example. Or truth. Or good. Or father. Or phallus? For examples. Thus pointing to the so-called spring, or source, at the heart of difference? or at its womb? which would theoretically guarantee its action, especially its action as quite other. Or Other. But whatever assures the functioning of difference in this way is always already foreign to the multiple action of difference, or rather differences, because it will always already have been wrapped away in verisimili-

tude, once the neck, the corridor, the passage has been forgotten. License to operate is only granted to the (so-called) play of those differences that are measured in terms of *sameness* or that kowtow to analogy, of different analogies re-marked in the unrepresentable, invisible process of translating the *hystera*. It is within the project encircling, limiting the horizon in which the *hystera* is made metaphor, that this dance of difference is played out, whatever points of reference outside the system and the self are afforded for relating them one to another, bringing them together, making them metaphor. For metaphor—that transport, displacement of the fact that passage, neck, transition have been obliterated—is reinscribed in a matrix of resemblance, family likeness. Inevitably so. Likeness of the cave, likeness(es) within the cave, likeness(es) of the transfer of the cave. Likeness(es) of copies and reflections that have a part to play in the cave. Where man, *ho anthrōpos*—sex unspecified, neuter if you will *(to genos?)* but turned to face only straight ahead—cannot escape a process of likeness, even though he re-presents or re-produces himself *as* like. He is always already a captive of repetition. Everything is acted out between rehearsal and performance, repetition and representation, or reproduction. Particularly since the representation designated as presence, or the presence making an appearance as representation, makes men forget, in an other or like act of forgetting, the foundation it rises out of. And unveiling so-called presence is merely entering into another *dream*. Which is always the same, even when it finds support in the visible, even if it pursues itself, with eyes wide open, in broad daylight, backed up with proofs of objectivity. This dream of sameness will end up in the fancy—or the inference, or indeed the deduction—that the neck, passage, conduit, that has been obliterated and forgotten, can be nothing but the one, the same, penis. Simply *turned inside out,* or *truncated.* For examples. One supposition is not explored: that it might possibly be a matter of a mirror both like and unlike. A concave mirror perhaps? Made to reflect a mirror both like and unlike. Let us say a convex mirror? But suppositions like that would certainly raise a few problems. With regard to the "object" of reflection, angles of divergence, and unforeseen error in focusing. These obviously could be played with to produce new differences, still within the pursuit of an old dream of symmetry that would in turn be complicated if it began to calculate and predict their effects. All through the re-intervention of the mirror or mirrors which, we must remember, is only one means of repetition among many. This is one representation of repetition, though a privileged one no doubt, and interpretation has still to get to the bottom of it, to see behind its mask of an unrepresentable desire for likeness.

But we're getting ahead of ourselves, and ahead of the story that Socrates has already put together so that things unfold in the right order. He guides you

surefootedly along a well-blazed trail, according to a tried and true method. No surprises, no cracks are to be feared. He plays it all back *in reverse,* as it were, and with a certain irony, retracing his steps, confident of the destination, skirting all obstacles. The only risk you run is of finding yourselves at the end more cunningly enslaved than at the outset. Understudies in a mime that you yourselves confirm.

### Paraphragm/Diaphragm

A path in this cavern runs *between* the fire and the prisoners. Reeneactment *on the inside* of this scene of the conduit, passage, neck, leading to the sight of day. This path conforms to the topography of the other path, and a fire in the image of the sun or a sun hangs over it. Now it seems that along this similarly sloping track, a *little wall, teikhion,* is raised, barring the road, the way, the passage. A small wall, a wall-ette, *built* by man, that cannot be crossed or breached, that separates and divides without any possibility of access from the *other side.* The diminutive, "i," in the word *teikhion* is usually translated by little, or low, but it could also be rendered as thin, light, wholly unrelated to the massive walls around a city, for example. The wall of a private house or home: *teikhion.* A wall that Plato in fact compares to a *curtain,* or *veil, hōsper ta paraphragmata.* A little wall "like" a curtain, or a curtain "like" a little wall? Which referent is primary in this analogy? No simple decision can be arrived at. This wallcurtain swallows up the conjuror's sleight of hand; this wallcurtain stands in the way, barring the path, by/for artifice. It is artfully, artificially fashioned by human hand. This wallcurtain or restraining wall or balustrade prevents the men who have raised it from having access to the back of the cave. Here the backcloth of representation.

*Inside* Plato's—or Socrates'—cave, an artificial wall curtain—reenactment, reprise, representation of a *hymen that has elsewhere been stealthily taken away,* is never, ever, crossed, opened, penetrated, pierced, or torn. Neither is it always already half open. The fragility, the tenuousness, or even transparence evoked by the diminutive—*teikhion*—and perhaps by the curtain comparison, relies upon the wholeness of this partition—an *inner* facade that not only reduces the opposition of inner and outer in scale as far as possible, but also reverses them—without any retrospective effects or pro-jects.

On one side, then, men pass, move about freely, we are led to believe, they are led to believe, restricted only by the ban on advancing further into the cave. On the other side, prisoners are chained up facing the back of the cave—a hollow space that is just as *closed off* as the wall curtain will remain *intact*—backs to the fire, to the balustrade, to the men moving about behind it, and to the instruments of their prestige. Their backs are also turned, of course, to the origin, the *hystera,* of which this cave is a mere reversal, a

project of figuration. Without cracks. A prison that these men can have no measure of, take no measures against, since they are restrained by other, or like, chains or images of chains from turning back to the opening of this grotto, from walking around to examine its topography, its deceptive pro-ject of symmetry. The a priori condition of the illusion governing and structuring this drama in mime. Fictive representation of the repetition that leads, and can only lead, to the contemplation of the Idea. Eternally fixed.

Chains, then, prevent the prisoners from turning around toward the entrance to the cave, as well as toward the origin. And toward the sun, the fire, the path running up to it, the wall curtain, the men moving about behind it and the "objects" they use in their tricks. Behind them is all this, and they are forbidden not only to look at it but to move toward it. And this makes possible a certain number of *permutations* as well *as confusions as to the function,* the functioning, *of what is behind,* and what behind is. Invisible.

### The Magic Show

Behind them are men. And they are doubly behind: behind them and behind the partition. But this *twofold* distance can in no way be unfolded into twice one is two, for the division operated by the partition *within* the cave is never transgressed.

Between the prisoners and those men who are situated *behind,* some kind of show will be put on provided one accepts that the "little wall" or "curtain" that in other instances cannot be crossed may be leaned over, looked over. Sublimated perhaps? The show will take place over the wall, if the "objects" are *raised high enough.* But this wall is not supposed to be very high. At least it has been usual to translate thus in terms of verticality the "i" diminutive in *teikhion* and perhaps the *hōsper ta paraphragmata.* So the wall will be got over. But not really. It won't be climbed or leaped. The men, the men's "bodies," will remain behind this screen. But by thrusting their bodies *high enough,* the men will succeed in getting across the screen some symbol, reproduction, fetish of their "bodies" or those of other living animals. It is this erected effigy of their bodies whose shadow, produced by the fire burning behind and above, will appear in profile upon the posterior side of the cave, in its new role as projection screen. Between these *two screens* that are not twice one— the screen that reproduces and multiplies cannot be added up with the screen that subtracts and divides—the chained men are on show/at the show.

Their eyes are dim, it is true, but if they were not looking, fascinated, rapt in fascination with what they see opposite them, then the projected shadows, the reflections, phantoms, would lose the attraction of their appearances, the reality of their phantasmic power. Those shadows come from the

interception of the firelight by the effigied emblem—immortalized in its deathly duplication—of men whose ancestor seems successfully to have raised *above a screen-horizon* this prestigious fake, *this lasting morphological impress.*[3] What cunning and utterly convincing necromancers these are who sacrifice (even themselves) to the greatness of their specters and thereby rob, rape, and rig the perspicacity of their public, blinding it with their exhibitions. Here are stealthy sandmen, working in the half-light of mid-night. Solar masks. But they are cut off from the stage by a curtain that, here, is opaque. Hidden from the eyes they charm but equally kept away from seeing their own show, the effects of their own sorcery. Their clearsightedness is busy in the wings with modeling the form of their replica(s) into the very fiction of verisimilitude. They form artful attributes, eclipsing the light of the fire—the sun's image?— which etches their shadows on the back of the cave. Copy cats copied in their turn by reflections that steal out of reach of the miracle workers.

The deception, the make-believe, works on at least *three* levels here. Let us for a moment (pretend to) fix our attention upon that number. Obviously this three cannot be interpreted as three times one. The magician, whose position behind and/or in front already cries out to be analyzed in terms of *doubling-back*, substitutes for himself the instruments of his power, which are deceptive because they claim to be such perfect copies. Already a man's gaze is lost in them. By intercepting light that allows for clear vision, these deceptive figures are doubled by their own shadows. Fiction engenders fiction. Projections, reflections, fantasies. But of whom? of what? Of the prisoners too, between the fire and the surface that reproduces the images? The wall face works all too well. It multiplies all by itself. The protagonists don't understand what is going on. No one knows any longer who is the deceiver and who the deceived. How are the parts being cast? To whom or what is the projection to be attributed? All aid and abet a simulation that continues unaided and whose cause always already goes back earlier, ever backward into the cloud-filled future past of ever darkening projects.

Meanwhile, on that set-up stage of men's representation, we find a *minimum of two men:* the two only seem to be the product of an addition—and/or one or the other of them is half—but which half? half of what? since the whole business is based on indivision—effigied, half-blinded, half robbed-raped, half cut in on the deal. These two men, twice two halves of men to the nth power (or power renounced?) *uphold the process of mimēsis* from each side of a wall curtain in which their stratagems are lost in infinite regression. This facade doubles, redoubles, infinitely reverses the opposition of inner and outer, all within the symmetrical closure of this theater.

Such operations of division can always be played with and played back to

provide some stake in this game that is always already rigged. Endlessly giving the game away. Betting, on nothing, till kingdom come. Mortgaging into insolvency this twisted cave of Plato's—or Socrates'. And no one will take his cave away from him, even counting with imaginary numbers. For in this cavern the tricks are many and can never be reduced or added up or multiplied simply together, although the numerous different parts being played advance the size and authority of the effects in effect. Each time in these plural operations of deception, the passage from imitating to imitated, from present to past, is withheld. Dazzling trompe-l'oeil!

### A Waste of Time?

The show is also a pass-time. Thus, the repetition of origin, or the origin of repetition, only gives an illusion of being arrested in its symmetrical reproduction—Plato's *hystera*. Representation only stops repetition by extrapolation. Sameness is prescribed and reenacted therein, but it is also held in reserve and lives on in a primordial presence that will determine all replicas but will never be exhausted. There is always some *to spare*. Over and above— *auxiliary to being*—any withdrawal that will be made. In the meantime, between time.

But time is still there all the same, held in suspense. The fiction that man and his copy are equivalent immortalizes time's attributes. Thereby putting the sun in eclipse, though the sun provides the rhythm of the calendar too: day/night, seasons, years. Like and unlike, like returning as unlike. Fetishes and ghosts will thus argue over dead time. And penumbra. O! *Impoverished present, copula in effigy only, statement in a state of rigor mortis.* Who can parse subject and predicate, or their doubles, when all are doubly dead? This makes for no deed of title, of course, since the doubling up is obviously not twice one death, but perhaps an attempt to share out what is commonly known as death. The fission of one between two deaths, the spacing out of one dead between two. The effraction within a death cave. And the operation is necessarily one of indivision.

This is not all. The reenactment within the cave of the path which might lead in, out of, or back to it, that access and egress from the cave, condemns the two-way movement of its use, the beat of its opening/closing. A ban on pulsations, rhythmic intervals that are unlike and yet again the same. The artifact of the path, and the partition *within* the grotto cannot, of course, take over this function. The partial, man-made opening of a division/ multiplication merely perpetuates and indeed lends credit, ad infinitum, to the cave's reversing operation and thus sustains the snare constituted by its symmetrical pro-ject and the closure of its representation. It always operates *inside* the cave. It re-marks the breaking into fractions, speculates on its

potency, tries to anticipate the split, the bar, and to take advantage of it. Sometimes by breaking and entering. But always *inside*. All such interventions *defer penetration*. They contract to penetrate, but never in fact come through. For the wall curtain remains impregnable. And never will the *paraphragma* offer a sure replacement for a certain *diaphragma*.

We are really wasting our time with this show, which is intended as a preliminary education in reminiscence. There is the odd hitch in the system, of course. For the holes, cracks, tears—in the *diaphragma* for example—or the faults and failings of the *hysterein* must, in their turn, be re-marked, re-inscribed. Particularly in the memory. Which is not to say that they will or can be represented, but that by their very elimination, their very reserve, they will set up the economy of that representation. Even in the term used to designate its goal, its ultimate profit—*a-lē-theia*—not forgotten, without the veil of forgetfulness. The *negative and negating* constituent of *alētheia* must not be left out of consideration. Thus the outlawed element—called the slave and the repressed in other symbolic systems—rules without appeal or recall the very text that outlaws it. This becomes clear if we question its overdetermination, and unmask the figures, forms, signs, that ensure its present coherence.

## A Specular Cave

Such an enterprise is never simple, but it will be simpler here than elsewhere because of the plural relationship this scene has to origin. Here is theater, text, that has yet to reflect or reflect upon its perspective. Here the properties of the eye, of mirrors—and indeed of spacing, of space-time, of time—are dislocated, disarticulated, disjointed, and only later brought back to the perspective-free contemplation of the truth of the Idea. Idea eternally present, postulated by the separation, the dismembering of, on the one hand, the "amorphous" but insistent anteriority of the *hystera*, that unrepresentable origin of all forms and all morphology, and, on the other hand, the dazzling fascination of the Sun—image of Good—who must be there across the way if we are to see good/well. *Eidos*, ever identical to itself, like unto itself, ensuring the identity of repetition, ensuring that what may be repeated is, while at the same time, in a dialectical trick we must come back to, constituting itself as matrix—in front, turned inside out and backward—origin in its turn, as well as cause, invisible, of all proper visibility. Outside the perception of the mortal eye, positioned opposite and above, vertically (is this phallicism squared?), here is the light of evidence by which all vision will have to be polarized if it is to remain clear, in a right appreciation of "beings," in a straight and true direction: *orthotēs*. Harmonious conjunction and in fact confusion of the *hystera* and the sun in an *ecstasy of copula*. Invisible and indivisible ideality—

whose distinct parts can never be seen (again) on inspection—cause and pole, whether inverted or not, of the straightness of vision. Being, one, simple, unalterable, beyond analysis, permanent. Is this the extrapolated—or even sublimated?—replica of an *insoluble primal scene*?

But there, in the *apaideusia* of the cave, Being is tested by being split up into offspring, copies, and fakes. These disperse and miniaturize the potency of the gaze. Of mirrors. Of eyes "like" mirrors, that are not, always already, broken and articulating the break, but rather are artificially disjointed and divided into properties offering an illusion of analysis, and addition, and multiplication, up to the highest power. The unit!

Thus a bony cavernous socket encloses the eye. An inside-out socket, in this case, in which the gaze is swallowed up in a vault. Projection sphere for the *hystera protera*: the *hystera* that has been inverted and turned backward by Plato. An enclosure, veil-wrapping of the originary blind incarceration, which has been turned over to become the circus and backdrop of representation. A motionless retina, a reticulum without nerves, a mere concave surface, reflecting light and shadows. An opaque rearview mirror. *Light off.* A horizon that blocks light, and sight into the bargain. Limiting the view but ensuring the reproduction by *reflection* of what is claimed to take place behind. The painted figure, the fake, the seductive fantasy will serve to intercept retroactive effects whose twists and turns will be kept not only from the men chained up, staring in captive fascination at the wall opposite them, but also from the magicians, eternally hidden by the screen from their own stratagems. That screen is not even unsilvered glass. It is better thought of as the back of the mirror(s). Or as a *water-tight* bulkhead, as a *paraphragma* impervious to all blows, even in retrospect. A fiction, a fictive fission both before and after the fact. An attempt to master the blow in its division and duplication. Cutting, dismemberment. An operation with an excess of terms and *remainders*. Indefinitely. The protection screen is fit to engender (only) the replica, the replica of the replica. Indefinitely. The screen that subtracts, divides and defends, sends back phantasmatic offspring by projection—as remainders, over and above— onto the screen that reproduces and multiplies. Such products are good enough for blind eyes to gape at. Clearsightedness works on the sly, from the wings. There are twice two half-gazes. A wide-eyed gaze, an averted gaze.

The *paraphragma* is also an eyelid. Built of stone. A veil permanently drawn, never open by so much as a crack. An inorganic, mineral membrane. A dead tissue, dead like the others delimiting or dividing this scene; and they *organize* this representation artfully. Stiff, rigid membranes, *frozen* by the "likes" or "as ifs" of evocation and figuration that have always already got in

the way. Consisting in/by the inter-position of a certain *speculum* which, *naturally* has already been enveloped. Everything on the inside here is already re-silvered. Closed up, folded back upon some kind of specular intuition. *A specularity of intuition that has yet to reflect its perspective and has yet to be interpreted into an intuition of specularity.* No mirror offers itself to be seen and read in this speleology. And the truth of what we see depends on this.

*But this cave is already, and ipso facto, a speculum.* An inner space of reflection. Polished, and polishing, fake offspring. Opening, enlarging, contriving the scene of representation, the world as representation. All is organized into cavities, spheres, sockets, chambers, enclosures, simply because the speculum is put in the way. The operation is abortive—naturally—since only reflection is safe and spawns misbegotten freaks, abortive products before and after the fact. This cave intercepts the games of copula in a miming of reproduction and in each figuration of the inner space the image of the Sun engenders sham offspring. This mime simulates offspring beyond appeal and recall, pretends to defer them by/for some kind of anamnesia. Irretrievably. For has reminiscence not always already engaged in rapturous contemplation of the Idea? The eternally present Idea? Target, or vanishing point, and death, that dominates this preliminary education. Existence from the beginning but devoid of any family context. A margin outside inscription which like a star both guides and at the same time strikes to the ground, frames and freezes all forms of replicas, all possible relation between the forms of replicas. Limning and limiting the show, the dialogue, the language outside time or place in its extrapolation of light. Or else stealthily opening it up into an abyss of blinding whiteness at every step, or letter, or look. *Matrix. Or given the name of matrix. Yet virgin of presence.* Ravishing anything which has yet to be targeted and measured. Or which seems that way, at least. The projection screen is a mirage that conceals the part played by the mirrors that have always already produced and framed it "as such."

This accounts for the fact that they all remain motionless in that enclosure, fixed in the being-prisoners attitude they have been cast for, *frozen* by the effects of symmetry that they do not realize are directing this theater of remembrance. The prison that holds them is the illusion that the evocation and the repetition (of origin) are equivalent. They sit riveted by the fascination of what they see opposite. By the semblance of what is apparently taking place behind and by its projection which, by pretending to be immediate presence, presentation, steals the economy of both before and after the fact. Foils the interaction of relationships between repetition and representation, or reproduction, and perverts its prescriptions and balances. The end, the unrepresentable Idea, guarantees that replicas and copies are engendered and

conform, and the fiction of the being-present masks the ancestry of its reproduction-production, with repetition left over and to spare. Time, space-time are side-tracked by a symmetrical process ordering representation else-where, or correlatively, are seduced, captivated, caught, in the lustrous glow of the Idea, of the Sun. *Brilliance of silver-backing in suspension.* Surety—of daylight?—put up and never paid back. Preventing metaphor and phony analogies from drifting away. *Sun, anchor of origin.* Closing off and arresting the cycle of phallic scenography and its system of light metaphors in an *unreflected* glare. Everything in this circus will sustain the blinding snare. Fetish-objects, wall curtain, screens, veils, eyelids, images, shadows, fantasies are all so many barriers to intercept, filter, sift the all-powerful incandescence, to charm and shield the eyes while at the same time displaying and recalling, even from behind such masks, its own cause and goal. The gaze is ringed by a luminous, infinitely reverberating blindness. By a dazzling orbit.

## The Dialogues

### One Speaks, the Others Are Silent

"While carrying their burdens, some of them, as you would expect, are talking, others silent." As you would expect. Really and truly? Yes, you would expect it, given the systems of duplication, the rules of duplicity, that organize this cave. For if everyone talked, and talked at once, the background noise would make it difficult or even impossible for the doubling process known as an echo to occur. The reflection of sound would be *spoiled* if different speakers uttered different things at the same time. Sounds would thereby become ill defined, fuzzy, inchoate, indistinct, devoid of figures that can be reflected and reproduced. If everyone spoke, and spoke at once, the silence of the others would no longer form the *background* necessary to highlight or outline the words of some, or of one. Silence or blanks function here in two ways to allow replication. *Of likeness.* (Note that these two ways cannot be analyzed into twice once; the silence of the magicians cannot simply be added to that of the back of the cave.)

And moreover the *echo*—which mythology has linked to a woman who dies a virgin for love of Narcissus—would be hindered by the fact that these enchanters talked to each other. The interference of speech, of what goes on and gets across in conversation, could no longer be reduced to that *neutral* blank, that *neutral* silence which allows words and their repetition to be discriminated and separated out and framed. This is how the illusion is sustained that there are specific terms for each thing and each one, which can be reproduced as such. Thus, the present of production-reproduction would be

destroyed not just because the effects of retroaction had become so complex but even more because of the part played in the drama of interventions by factors of pluridetermination and overdetermination. This would apply in the hiatus, the supposed break and joint between a present and a past—an imitating and an imitated, a signifier and a signified—whereby the present takes up, repeats, *specularizes,* the past which is defined as a present that has taken place. But it would equally work to open up this present or past, spread it out, unfold it in the suspense of insoluble, unresolvable correlations, between a preterit and a future perfect tense, as well as between a future perfect and a preterit. If these "men carrying burdens" talked to each other, at least at this point in Socrates' tale, they would interpret and unmask the mimetic function that organizes the cave.

So some speak and others are silent. Someone or other speaks, the others do not. Thus the possibility of the replica is set up. Unless, that is, the silent offer that possibility by taking the place of a reflecting screen.

And so it goes in Plato's *Dialogues,* even the ones that mimic a conversation on mimesis. As you might have expected. Naturally. The phrase *hoion eikos* immediately translates, betrays, and conceals the question of a mimicry of sound and language within the economy of exchanges, notably verbal exchanges. And it will be a long time before the backing behind this apparent "naturalness" begins to be questioned, before the problem is raised about the relationships between mimicry, representation and communication. But the hysteric—derived from *hystera,* as you might have expected—will deceptively, covertly, bring up the forgotten dilemma.

"You have shown me a strange image, and they are strange prisoners," he says. Here the "image" previously *described* is reframed as image. The summary, somewhat in the manner of a retort, gives support for belief in a "good" mimesis in language. And inscribes, furtively, surreptitiously, silently, through the indirection of a so-called fanciful reproduction, through the credibility of equivalence vested in that repeat, the place, the illusion of a place, the delusion of a place of transcendental significance. Working out of sight and, perhaps, out of speech, this place is claimed to dominate, exceed, and guarantee discourse. Glowing bright and white, the "truth" of the Idea therein reserves itself, keeps itself in reserve, in store, as the—extrapolated—source of sight. Of night. Of the economy of relationships between white and black, as well as between white and white, black and black. Between whites, blacks, and sight. What we define "as" meaning is made possible in this way, as are the signs that seem to mark it in a privileged way and to (re)produce it. The system is an extrapolation of the *white* light that cannot be seen as such but

allows us to see and gives us an awareness of the black. Black plays no further part; its guarantee is suspended; or rather has always already been staked elsewhere in the writing of the text that will neither be seen nor mimed, *in truth.*

## Like Ourselves They Submit to a Like Principle of Identity

"They are like ourselves," he replied. As you might have expected. Naturally. Why should the process of likeness stop or be contradicted here? Why should those telling, representing the scene, not be equated with those they are talking about? Why should they not serve to endorse the conformity of their words? Unless it is that they have been set up as equivalents by the identity, the principle of identity, governing their discourse. Or that they come by this "likeness"—they who are like ourselves who are ourselves alike—through a regulated alternation of replicas in which interference and the background noise of the conversation are turned down, right from the start. The "we" and the "I replied" would have no other strategic aim than to disguise and sustain at one and the same time the priority or the apriorism of sameness.

"They are like ourselves," I replied. And just as we believe that mime, even if indirectly, can take us back into reality and imagine that we evoke and recall it even in the language of figures, so also have they failed to take the measure of that fiction constituted by the reversing projection of the *hystera protera* or to take measures against it. Yet this project prescribes and overdetermines, in silence, the whole system of metaphor. Shutting it in, like the "prisoners" in Plato's cave. Chained up like ourselves—I might say—backs to the origin, staring forward. Chained up more specifically by the effects of a certain language, of certain norms of language that are sometimes called *concatenation,* or chain of propositions, for example.

"Do you think they"—any more than ourselves?—"have seen anything of themselves and of one another, except the shadows which the fire throws on the opposite wall of the cave?" Never have these "prisoners" *envisaged* anything but the reflections, shadows, fancies of objects that are (always already) made, represented-reproduced (always already) behind them. And this thanks to the light of a fire burning not only behind them, but also (always already) behind the "objects" that are manufactured and produced by the magicians. The fire is said to be artificial, a firework in the image of the sun. That is also behind. This setup in which the *hystera* is reversed fuels the confusion between a certain origin defying representation and the daylight, the good clear light of representation. The confusion between fire and light, the fire of the origin and the light of day. Fire comes in only as light, lit in the image of the

sun. There is *one* fire, *one* sun, and moreover the one somehow comes out of the other. The sun sires fire, as a bastard son, in an artful retroversion of genealogy. Seeing (daylight) would become the single cause of origin. Forgotten is the force used to pivot the scene around axes of symmetry, ignored is that fission, that split—or pseudo-split—that duplicity which is already ahead of the game and in which the Sun would theoretically be Father, God, procreator of all. Or at least everything acted out on this stage. The other, and the move from the female one to the other, are forgotten upon this theater of representation where light, which lets us see, holds center stage. And the scene *incurs a debt* when it reproduces the other scene, and the passage, corridor, neck, leading in and out of it. That passage joins the two scenes together, but not, of course, by merely swiveling around axes of symmetry.

### Provided They Have a Head, Turned in the Right Direction

In Plato's cave, men—sex unspecified—gaze at shadows projected opposite them on the back of the cave. The fire behind produces nothing but shadows and gazes fascinated by shadows. And whether it be through their own eyes or through the eyes of their companions, the men can see only the projection of the light of the fire striking "objects," "figures," that are always already manufactured. Behind.

What else could they see, considering that every one of them is kept in that same position? They are seated, looking fixedly across from them, backs to a supposedly like origin, one and the same, and to the path reenacted within the cave, to its partition, to the magicians, to the instruments of their prestige, and to their spells. Which are of course always the same. Thus the men can *see* the same images, shadows, fancies, through the eyes of others. Within this *twisted* cave of Plato's, all are identical to, identified with, prisoners who are the same and other. The community of men is caught in the snare of a symmetrical project that they could only glimpse by turning their heads. But these men are chained above all by the intractability of repetition, by the overdetermination of the one by the other, which both fascinates and escapes them. No sun will ever reduce this overdetermination to an exact truth of perception, to a "nature" clearly seen.

The most striking effect of their being thus forced to keep their heads still all their lives seems to be to set up the scene of representation, since this depends upon the side, the face, the figure, the gaze being turned in the right direction around some axis or pivot. And the confusion about position and orientation, of opposite and behind, front and back, seems to breed fakes and fancies that *good sense and proper orientation* could clear up. What is more, the head has to be correctly turned, and modeled (for that turn), and styled, moved in the

right way—which is the wrong way. The head is turned around to suit the illusion *on the opposite side* that the prisoners stare at. It would take a general, comprehensive survey to get back to the true, to remember the truth that we have been artificially led away from. You would have to have completed the whole circuit, by in fact doing two half-circuits, or circles. For it is an illusion that you can close the circle, return to the same point, the same "truth." The truth of sameness, which has always already artfully prescribed the detour needed for its re-cognition. Yet it takes advanced gymnastics to reduce the turn away from origin and back to the sun and come up with a propaedeutic that puts a ring around the truth. And when difference dodges and twirls between two poles, process and project plunge down, destroying a truth that orders them. Viciously. The axis authorizing this pirouette, dominated in the vertical plane by the sun, dazzles us into neglecting the break effected by that volte-face, and the reduction of its ellipse.

Thus there is *one single upright,* standing straight and erect, with the stage pivoting around it, and its relation to the sun, the solar tropism, apparently determines the correct orientation. *One* spindle *only* rises toward *one* sun, but it has always already been tricked and truncated by the duplicity of a project that relies upon its function and its functioning, as such. *One single spindle,* but one that always runs the risk of being fractured should the foundation collapse under some dream of symmetry that has artificially struck its joints together and disguised its piecemeal construction. For taking the detour that includes the back of the cave, the road out of the cave and the (so-called) return to the sun also involves taking a few other lines, routes, tracks that cannot be traced back to the unit(y) without incurring liabilities. Even if the unit(y) were that of a direct route, or of a correct orientation. The end of the story will show this.

### What Is = What They See, and Vice Versa
"Then, if these prisoners were able to talk to each other—*dialegesthai*—about what they see, don't you think that they would call—*nomizein*—what they see what is—*ta onta*—?" "Inevitably." *Ananke.* The peremptory affirmation of this inevitability attests to another vicious circle (other and yet the same) that supports and confirms the maneuverings to get around its aporias. And just as it was natural, probable that among the magicians certain should speak—or a certain one should speak—and others be silent, so it is essential to re-mark, reduplicate, replicate the necessity of the relationship between, on the one hand, the possibility of talking to each other and, on the other, of giving the name "beings" to what one sees as beings. It has been demonstrated earlier that sight is the same for all the men in chains, and in fact for all of us who are identical to them as they are to each other.

A whole conception of language here halts—or runs up against—the illusion of a system of metaphor, a meta-metaphor, postulated by the preexistence of the truth that *decides* in advance how conversation, interventions, will develop. These "inters" are dictated by a specular genealogy, by a process of images, reflections, reduplications which are rated in terms of their conformity, equivalence, and appropriateness to the true that is meant to be uncovered. These "inters" can be calculated or combined as proportions of a more or less correct relation to the sameness (of the Idea); they are always cross-referenced with the ideal of truth which determines their enumeration, their measure, their analogic and dialectical pertinence and, as a consequence, the order, the hierarchy, the subordination of the interventions by which differences are regulated and declinable as more or less "good" copies. Copies, that is, of the same, the identical, the one, the permanent, the unalterable, the undecomposable. The Being. Whose names, representations, and figures—along with their differences, their intervals, their syntax and dialogic—remark, signpost, stagger the divisions of the *gap,* which is always to be *reduced,* between the appearance of truth and the truth that it veils.

## The A-lētheia, a Necessary Denegation among Men

Once the possibility of a conversation has been framed and unalterably fixed in position then the *alētheia* that has secretly helped to set all this up will soon put in an appearance, in the dialogue at least, and be named a pawn in a game and on a chessboard. In fact, of course, *alētheia* not only is the game's main stake but also determines its layout, its principles, and its modus operandi. *Alētheia* will come into play when *denomination* occurs but in fact, silently, it has determined the whole functioning of the language, its terminology, its syntax, its dramatization. Yet this exorbitant power is hidden in the fact that it is *also* used as metaphor and evoked and recalled. Not without the assistance of a (de)negation: the word is *a-lētheia.*

When the thing that determines all the logic and affirmation of discourse can successfully be expressed therein by means of *a (de)negation,* this enormously enlarges the scope of the game underway. As long as the efficacy of that operation is never queried. As long as no one seeks to interpret how equivocal is the *formality* by which veils are theoretically lifted, notably the veils of oblivion, error, and mendacity. Of fantasy. As long as no measure is taken of the fact that using representations in utterance (even if it be) by means of negation/denial, in order to repeat what tacitly determines them, does not undermine that domination but in fact increases its weight and reinforces its status. Such repetition entails the interminable developments of a discourse that is predicted, enveloped, rolled up in its project, and whose modes of exposition, demonstration, and transformation will be nothing but

different versions of its deeds of credit. But their function as *simulations* will itself never be unveiled as *cause,* even, or especially, if it is designated by the term *unveiling.*

The economy of this optical jiggery-pokery now demands that the *alētheia* be named. We will have to wait only for the next trick of deduction, or the next paragraph. But this particular paragraph is really worth its weight in *gold,* for it under-lies the whole Socratic dialectic: nothing can be named as "beings" except those same things which all the same men see in the same way in a setup that does not allow them to see other things and which they will designate by the same names, on the basis of the conversation between them. Whichever way up you turn these premises, you always come back to *sameness.*

### Even Her Voice Is Taken Away from Echo

"And suppose further that the prison had an echo which came from the other side." From the wall facing them, blocking their view, circumscribing the gaze, the show, the scene. What if the back of the cavern, that project reversing the unrepresentable origin, that backcloth for all representations, had, moreover, an echo? The fantasies it would permit—to which it would offer its reflecting screen, the polished whiteness of its surface—would emit sounds, the words pronounced by the magicians. By those men who carry effigies, placed between the opening of the cave, its fire, its path on the one hand and the partition, the prisoners, the back of the cave, on the other hand. The shadow-reflections of their marvelous tricks, which trace and outline both themselves and the *silent virginity* of the back of the cave, begin to speak, we are told, eclipsing the staggered artificial system of their productions-reproductions. Shadows of statues, of fetish-objects, these and none other would henceforth be named truth—*to aléthes*—by the men in chains. Projections of symbols for men's bodies, raised high enough so that they show over the top of the little wall so as to dominate and sublimate it—though the wall has been raised in the cave artificially—would, theoretically, be the only possible representation of the truth for the prisoners because they provide, in addition, the echo of the words pronounced by the same men. The echo is possible because of the reflecting property, the so-called *virginity and muteness of that back of the matrix/womb* which a man, an *obstetrician,* turned round, backward and upside down in order to make it into the stage, the chamber, the stronghold of representation.

In all events, the womb has been played with, made metaphor and mockery of by men. At least *three* men, if this time you count the stage director. But this three is only apparently a sum. And the one nearest the back of the cave, the one with the heaviest chains, the one bound with the strongest fascination to the depths of that crypt, will be so strongly persuaded that

the shenanigans of the other are the truth that he will lose all the senses that the "others" pretend still to control. But at this point in the drama, as quite often in fact, it is hard to decide who is weaving the web of illusion and who is caught in it.

But before everything goes mad in this cave, to a point where a possible resumption of the dialectic would demand that the way out of it be considered, at least for an exemplary prisoner, there is this: The projections of the statufied emblems of men's bodies will be designated by the term *truth* only if they can be lent voices, *echoes* of the words pronounced by the magician-imagemakers. Thus, to state everything quite clearly, only the effigies of men's bodies, the words of men, the gaze of men—whose sex is no doubt undetermined, except in the formalization of their gender?—will be available to decide on what is true and false and to make the question of the *parousia* of truth unavoidable. All of this demands, of course, that both a *paraphragm* and the *back* serve as virginal and mute screens and thus keep the strategies operating successfully. It is indispensable to keep magicians and prisoners permanently separated by means of an impenetrable partition, and to offer fantasies and voices the reliable assistance of the furthest wall of the cave. These two screens must come into play, must figure between the (at least two, two halves of) men if the relation acted out between them is to include the question of truth, is to allow truth to make an appearance.

But of necessity—*pollē anankē*—truth will be unequivocally obvious only if the emission of sounds is made an attribute of the fantasies. Sound (*phōnē*) gives fantasies a character of pure and immediate presence that masks the artificial mechanisms, the reduplications, the repetition-reproduction procedures, to say nothing of the obliterations that *contrive* their elaboration. If it speaks, the semblance will represent truth, even if everything was excluded. Sound—taken away from Echo here or elsewhere—indicates the presence of truth, which requires the privilege enjoyed by the *phōnē*. Truth and *phōnē* sustain and determine their mutual domination, at least when it is a matter of ensuring the present existence, the presence of the existence of the *alētheia*. Of establishing once and for all the *parousia* of the idea (of) truth, of the ideal of truth. Given that this is so, some concession, some appeal in fact, must be made to that *elementary matter, the air.* At least to the extent to which the element will already be disturbed, subjected to rhythm, number, and harmony, already altered mimetically. Trans-formed into sounds which, once elaborated into language—whether in lexicon or syntax—will immediately be enslaved to the idea of verisimilitude. Thus sound's only prerogative is to function as a relay station, a detour that is indispensable in guaranteeing the

previous existence of the *alētheia,* which will henceforth take command of all "beings," including voices. Once founded and named, the power of truth will enslave and eclipse the instrument that established its authority. Truth will exist, an eternal presence, without that material element, reduced to the medium of one of its manifestations: the realization of voice.

## A Double Topographic Error, Its Consequences

Now, in that cave, let us not forget that this *parousia* rests on the indirect authority of men's words, heard by men and lent to fantasies which men produce and see. Moreover, it is men who lend credit to the *parousia* as such, specifically when they name it. This is how the system and the transactions of the recognition of truth operate. And, let us note, its justification is to sanction, organize, regulate, and arbitrate the relationships between men, particularly by means of theorization. And this is so in the *polis* as well as in the cave. An ideal of truth is in fact necessary to underlie and legitimize the metaphors, the figures used to represent the role of women, without voice, without presence. The feminine, the maternal are instantly *frozen* by the "like," the "as if" of that masculine representation dominated by truth, light, resemblance, identity. By some dream of symmetry that itself is never ever unveiled. The maternal, the feminine serve (only) to keep up the reproduction-production of doubles, copies, fakes, while any hint of their material elements, of the womb, is turned into scenery to make the show more realistic. The *womb,* unformed, "amorphous" origin of all morphology, is transmuted by/for analogy into a circus and a projection screen, a theater of/for fantasies. The little wall, the *paraphragm*—a replica within the cave of a diaphragm that has been secretly eliminated elsewhere—enables, perpetuates, gives added range and relief to representation by artificially opening up a division/multiplication *within* the cave, by infinitely scaling down the opposition of external/internal as well as by resorting to the theurgic, astrological device of putting them into infinite regression, in order to keep up the attractions of the shows parading past the wall. Like an impenetrable eyelid, this paraphragm makes magicians and darkroom disappear. It is a veil that will not tear, will certainly never open but will distract the eye from its function. *A screen that sets men gazing in different directions*—some gazing "off," into the wings/some gazing in fascination—preventing them from glimpsing each other, from mingling, taking each other's measure, except by means of the *interposed object-fetish* that captures and hides the light. Twice two half—or halved?—gazes are blinded so as to give infinite scope to the show.

As for the *path,* that reproduction *within* the cave of the passage, conduit, neck that rises—or should, rather, descend—out of the crypt toward the light

of day, toward the sight of day, if that path is given a metaphor or a name, it remains nonetheless in the very back, *shrinking away* from the scene being played out. It has been led astray once again. *Forgotten, set back, and then set further back again,* both included within and excluded from the cave. Serving, of course, by its slope to ensure the fire's glow but seeing very little traffic up to now. It is just possible to envisage, or deduce, that the path has been occasionally trodden by the magicians. But the attention of the protagonists is not directed toward it, is in fact turned away from it. Indeed the path's position in the cave between a *double error, a double faux-pas,* on the part of the play's director, despite all his expertise in mimicry. So we are forced to understand, and conclude, that the error is a necessary part of the *parousia* of truth, which relies on *this path's being included within the theater* of representation and at the same time *thrown back onto the other side of the paraphragm.* As a result of some ill-placed mimetic scruple or of some fallacious exhaustion contributing to the scene's closure, the path must have its appropriate copy *within* the cave, but it must have neither access to nor function in the process of reproduction-production that takes place on that scene. It seems clear that this path is not the way out to daylight and that the journey to the presence of truth takes advantage of topographic gaps which will never be taken into consideration.

Equally unaccounted for is the whole sexual scenography of which the gaps are a privileged symptom. And no explicit terms will be used to make the prisoners understand that they are taking the false for the true, like untutored children. The objection that will be raised to counter their "opinions" is never traced back to its premises or related to the sexual economy which it simultaneously conceals and upholds. That objection will be based upon a failure to differentiate between a "good" and a "bad" mimesis, between a "faithful" reproduction of the truth—a copy that allows truth to appear underneath the mask—and the fantasies, fakes, shadows, copies of copies of objects which are already artificially fabricated, mimed, and merely to contemplate which leads to madness. The madness of the "men in chains," for example. Such men are not even in a position to take the measure of their insanity—*aphrosunē*—since they are under the spell of magic tricks and have nothing to oppose or compare to them, no "other" truth, nothing truer, no "vision" of truth. They are still in that state of *apaideusia* which does not allow fakes and copies, reduplications of the truth, to be distinguished from truth itself.

But this truth, which it is madness to fail to recognize—madness being a kind of excess, of drifting away from all relation to truth, unpegged to truth's standard—would always already have covered over, erased (or subli-

mated?) the scene of another, forgotten, "truth" or "reality," whose fate is secured and sealed by the discourse of Socrates. The *alētheia* in the very negation/denial that it speaks, may be interpreted as the affirmation of a possibility of reviewing what has been forgotten within an economy of representation that prescribes its neglect. The *a-lētheia* would theoretically function henceforth as *the bond offered as security for what has been forgotten* in the Socratic dialectic from the dawn of Western photological systematics, as the representation of representation which keeps the sun from the place(s) of its tropical beat(s). Forcing the sun in some manner to spin around, to turn eternally in its own orbit, forever to return to the same point in the circle where it would always already have been placed in order to keep every system in order, including, paradoxically, its own. The sun is fixed, frozen, the keystone supporting the whole—phallic—edifice of representation that it dominates, illumines, warms, makes fertile, and regulates by scattering its beams everywhere. No return is possible. No reverberation is powerful enough to bend the sun in its course, modify the autarchy of its fire. And the sun itself is assumed to have no other need or desire than to move in a circle, to come back upon itself, whatever heliotropism it has produced elsewhere. Attracting everything to itself, never deviating from its path. Indefinitely circumscribing the earth, offering the rhythm of days and nights, seasons, years. Of time, which always comes back to the same thing. At least for those things that are supposed to measure time, to record it, repeat it, close the cycle. Immutable periodicity of sameness. Background against which differences will be marked, and referred back inevitably to sameness. Separations can be measured by the inevitable return of the same. The sun is caught in an *eternal pendular isolation* as it describes the orb of the representable, the visible world, and distinguishes ideas from copies, from fakes. And also as it determines what is proscribed in the theater of representation.

## NOTES

Translated by Gillian C. Gill. The notes are the translator's.

1. All translations from Plato are from *The Dialogues of Plato,* trans. Benjamin Jowett (Oxford: Oxford University Press, 1953). Because the passage under consideration, *Republic* 7, 514–517a, is brief, I have given section references only when confusion seemed likely.

2. Throughout this essay, LI weaves a sequence of puns based on homonyms and rhymes of the word *antre*—cave, or den. The most prominent rhyme is *ventre*—womb. Another important one is *entre*—between, which gives the complex pun

*antr-ouverture,* used at times by LI instead of *entr-ouverture*—gap or half-opening. Unfortunately this sequence of word-plays has no simple equivalent in English.

3. In translating *simulacre* I have preferred "fake" to the usual "simulacrum" because "fake" seems to convey that note of moral condemnation Plato has when talking of the life of the body. The word "impress" translates *estampage,* a pun meaning both branding, stamping (the male form places a stamp upon the female matter) and also swindling, fleecing.

# René Girard

## From Mimetic Desire
## to the Monstrous Double

In *The Bacchae* the intervention of the god coincides with the loss of genera-
tive unanimity and the inevitable slide into reciprocal violence. When the
transcendental element descends to the human sphere it is reduced to imma-
nence, transformed back into mimetic fascination. Reciprocal violence now
demolishes everything that unanimous violence had erected. And as the insti-
tutions and interdictions based on generative unanimity perish, violence
roams at will, unchallenged and unchecked. The god who has appeared mal-
leable and complaisant, a willing servant of mankind, always manages to slip
away at the last moment, leaving destruction in his wake. Then the men who
sought to bend him to their uses turn on one another with murderous intent.

In *Oedipus the King* the tragic conflict still centers, at least in appearance,
on specific concerns: the throne of Thebes and the queen who is both mother
and wife. In *The Bacchae,* by contrast, Dionysus and Pentheus have nothing
concrete to fight over. Their rivalry centers on divinity itself; but behind that
divinity there lies only violence. To compete for divinity is to compete for a
chimera, because the reality of the divine rests in its transcendental absence. It
is not the hysterical rivalry of men that will engender gods—only unanimous
violence can accomplish that. Insofar as divinity is real, it cannot serve as a
prize to be won in a contest. Insofar as it is regarded as a prize, it is merely a
phantom that will invariably escape man's grasp and turn to violence.

Every tragic protagonist is fated to pursue this phantom. And as soon as
one individual attempts to incarnate divine violence, rivalries spring up. The
violence remains reciprocal; there is no profit to anyone when only blows are
traded. The chorus perceives the train of events and scrupulously avoids
involving itself in the tragic action.

We must take care not to view the tragic conflict in terms of its immedi-
ate goals, even when they are objects of such consequence as a throne or a
queen. *The Bacchae* teaches us that we must invert the usual order of things in
order to appreciate the import of tragic rivalry. In the traditional view the
object comes first, followed by human desires that converge independently on
this object. Last of all comes violence, a fortuitous consequence of the conver-
gence. As the sacrificial conflict increases in intensity, so too does the vio-
lence. It is no longer the intrinsic value of the object that inspires the struggle;

rather, it is the violence itself that bestows value on the objects, which are only pretexts for a conflict. From this point on it is violence that calls the tune. Violence is the divine force that everyone tries to use for his own purposes and that ends by using everyone for its own—the Dionysus of *The Bacchae*.

In the light of this knowledge even the preliminary stages of the sacrificial crisis can be seen to reveal the dominant influence of violence. Certain scenes of *Oedipus the King*, while less explicit in their violence than those of *The Bacchae*, gain intensity and significance when viewed with the lessons of *The Bacchae* in mind. When Oedipus and Laius meet at the crossroads, the father/son and king/subject relationship is not initially in question. Their encounter begins with a stranger's menacing gesture, the older man barring the road to the younger one. Oedipus's reaction is to strike out at the stranger then at his throne, then at his wife; that is, to strike at the objects belonging to the initiator of violence. Only in the end is the aggressor identified as father and king. In other words, it is violence that bestows value on the violent man's possessions. Laius is not violent because he is a father; rather, it is because of his violence that he passes as a father and a king. Is that not what Heraclitus had in mind when he proclaimed that "violence is the father and king of all"?

Nothing, perhaps, could be more banal than the role of violence in awakening desire. Our modern terms for this phenomenon are *sadism* or *masochism,* depending on its manifestations; we regard it as a pathological deviation from the norm. We believe that the normal form of desire is nonviolent and that this nonviolent form is characteristic of the generality of mankind.

But if the sacrificial crisis is a universal phenomenon, this hopeful belief is clearly without foundation. At the very height of the crisis violence becomes simultaneously the instrument, object, and all-inclusive subject of desire. This is why social coexistence would be impossible if no surrogate victim existed, if violence persisted beyond a certain threshold and failed to be transmuted into culture. It is only at this point that the vicious circle of reciprocal violence, wholly destructive in nature, is replaced by the vicious circle of ritual violence, creative and protective in nature.

At the height of the sacrificial crisis man's desires are focused on one thing only: violence. And in one way or another violence is always mingled with desire. The statement that violence is "instinctive" adds nothing to our understanding of this strange and startling relationship; on the contrary, it only clouds the issue. Today we know that animals possess individual braking mechanisms to insure that combats between them seldom result in the actual death of the vanquished. Because such mechanisms tend to assure the perpetuation of the species, it would perhaps be not inappropriate to term them *instinctive*. To use the same term in connection with man's lack of such a braking device, however, would be absurd.

The notion of an instinct (or if one prefers, an impulse) that propels men toward violence or death—Freud's famous "death wish"—is no more than a last surrender to mythological thinking, a final manifestation of that ancient belief that human violence can be attributed to some outside influence—to gods, to Fate, to some force men can hardly be expected to control. Once again, it is a mode of thought that refuses to confront human conflicts squarely. It is an act of evasion, an attempt to "pass the buck" and find an alternate sacrificial solution in a situation which makes such a solution increasingly difficult.

In the midst of the sacrificial crisis there is no point in attaching desire to any one object, no matter how attractive, for desire is wholly directed toward violence itself. This does not mean, however, that we must endow man with an instinctive drive toward death or violence. There is still another approach open to us.

In all the varieties of desire examined by us, we have encountered not only a subject and an object but a third presence as well: the rival. It is the rival who should be accorded the dominant role. We must take care, however, to identify him correctly; not to say, with Freud, that he is the father; or, in the case of the tragedies, that he is the brother. Our first task is to define the rival's position within the system to which he belongs, in relation to both subject and object. The rival desires the same object as the subject, and to assert the primacy of the rival can lead to only one conclusion. Rivalry does not arise because of the fortuitous convergence of two desires on a single object; rather, *the subject desires the object because the rival desires it*. In desiring an object the rival alerts the subject to the desirability of the object. The rival, then, serves as a model for the subject, not only in regard to such secondary matters as style and opinions but also, and more essentially, in regard to desires.

When modern theorists envisage man as a being who knows what he wants, or who at least possesses an "unconscious" that knows for him, they may simply have failed to perceive the domain in which human uncertainty is most extreme. Once his basic needs are satisfied (indeed, sometimes even before), man is subject to intense desires, though he may not know precisely for what. The reason is that he desires *being,* something he himself lacks and which some other person seems to possess. The subject thus looks to that other person to inform him of what he should desire in order to acquire that being. If the model, who is apparently already endowed with superior being, desires some object, that object must surely be capable of conferring an even greater plenitude of being. It is not through words, therefore, but by the example of his own desire that the model conveys to the subject the supreme desirability of the object.

We find ourselves reverting to an ancient notion—mimesis—one whose conflictual implications have always been misunderstood. We must understand that desire itself is essentially mimetic, directed toward an object desired by the model.

The mimetic quality of childhood desire is universally recognized. Adult desire is virtually identical, except that (most strikingly in our own culture) the adult is generally ashamed to imitate others for fear of revealing his lack of being. The adult likes to assert his independence and to offer himself as a model to others; he invariably falls back on the formula, "Imitate me!" in order to conceal his own lack of originality.

Two desires converging on the same object are bound to clash. Thus, mimesis coupled with desire leads automatically to conflict. However, men always seem half blind to this conjunction, unable to perceive it as a cause of rivalry. In human relationships words like *sameness* and *similarity* evoke an image of harmony. If we have the same tastes and like the same things, surely we are bound to get along. But what will happen when we share the same desires? Only the major dramatists and novelists have partly understood and explored this form of rivalry.[1] Even Freud treated it in an indirect and distorted fashion. . . .

By a strange but explicable consequence of their relationship, neither the model nor the disciple is disposed to acknowledge the inevitable rivalry. The model, even when he has openly encouraged imitation, is surprised to find himself engaged in competition. He concludes that the disciple has betrayed his confidence by following in his footsteps. As for the disciple, he feels both rejected and humiliated, judged unworthy by his model of participating in the superior existence the model himself enjoys.

The reason for these misunderstandings is not hard to grasp. The model considers himself too far above the disciple, the disciple considers himself too far below the model, for either of them even fleetingly to entertain the notion that their desires are identical—in short, that they might indeed be rivals. To make the reciprocity complete, we need only add that the disciple can also serve as a model, even to his own model. As for the model, no matter how self-sufficient he may appear, he invariably assumes the role of disciple, either in this context or another. From all indications, only the role of disciple is truly essential—it is this role that must be invoked to define the basic human condition.

The mimetic aspects of desire must correspond to a primary impulse of most living creatures, exacerbated in man to the point where only cultural constraints can channel it in constructive directions. Man cannot respond to that universal human injunction, "Imitate me!" without almost immediately encountering an inexplicable counterorder: "Don't imitate me!" (which really

means, "Do not appropriate *my* object"). This second command fills man with despair and turns him into the slave of an involuntary tyrant. Man and his desires thus perpetually transmit contradictory signals to one another. Neither model nor disciple really understands why one constantly thwarts the other because neither perceives that his desire has become the reflection of the other's. Far from being restricted to a limited number of pathological cases, as American theoreticians suggest, the *double bind*—a contradictory double imperative, or rather a whole network of contradictory imperatives—is an extremely common phenomenon. In fact, it is so common that it might be said to form the basis of all human relationships.[2]

Bateson is undoubtedly correct in believing that the effects of the double bind on the child are particularly devastating. All the grown-up voices around him, beginning with those of the father and mother (voices which, in our society at least, speak for the culture with the force of established authority) exclaim in a variety of accents, "Imitate us!" "Imitate me!" "I bear the secret of life, of true being!" The more attentive the child is to these seductive words, and the more earnestly he responds to the suggestions emanating from all sides, the more devastating will be the eventual conflicts. The child possesses no perspective that will allow him to see things as they are. He has no basis for reasoned judgments, no means of foreseeing the metamorphosis of his model into a rival. This model's opposition reverberates in his mind like a terrible condemnation; he can only regard it as an act of excommunication. The future orientation of his desires—that is, the choice of his future models—will be significantly affected by the dichotomies of his childhood. In fact, these models will determine the shape of his personality.

If desire is allowed to follow its own bent, its mimetic nature will almost always lead it into a double bind. The unchanneled mimetic impulse hurls itself blindly against the obstacles of a conflicting desire. It invites its own rebuffs, and these rebuffs will in turn strengthen the mimetic inclination. We have, then, a self-perpetuating process, constantly increasing in simplicity and fervor. Whenever the disciple borrows from his model what he believes to be the "true" object, he tries to possess that truth by desiring precisely what this model desires. Whenever he sees himself closest to the supreme goal, he comes into violent conflict with a rival. By a mental shortcut that is both eminently logical and self-defeating, he convinces himself that the violence itself is the most distinctive attribute of this supreme goal! Ever afterward, violence and desire will be linked in his mind, and the presence of violence will invariably awaken desire. Perhaps this is why the possessions that serve to symbolize being in *Oedipus the King*—the throne and the queen—are behind the stranger's angry gesture at the crossroads. *Violence is the father and king of everything!* Jocasta affirms this truth in declaring that *Oedipus belongs to whomever speaks to him of*

*"phobou"*—*of unhappiness, terror, disasters, nefarious violence of any sort.* The oracular pronouncements of Laius, Creon, and Tiresias and the ill tidings of the messengers emanate from that *logos phobou* to which all the characters in the myth belong. The *logos phobou* is ultimately the wordless language by which mimetic desire and violence communicate with one another.

Violent opposition, then, is the signifier of ultimate desire, of divine self-sufficiency, of that "beautiful totality" whose beauty depends on its being inaccessible and impenetrable. The victim of this violence both adores and detests it. He strives to master it by means of a mimetic counterviolence and measures his own stature in proportion to his failure. If by chance, however, he actually succeeds in asserting his mastery over the model, the latter's prestige vanishes. He must then turn to an even greater violence and seek out an obstacle that promises to be truly insurmountable.

*Mimetic desire* is simply a term more comprehensive than *violence* for religious pollution. As the catalyst for the sacrificial crisis, it would eventually destroy the entire community if the surrogate victim were not at hand to halt the process and the ritualized mimesis were not at hand to keep the conflictual mimesis from beginning afresh. As I have already indicated (a little later on I will formally examine the evidence), there are all sorts of rules and regulations that prevent desire from floating free and attaching itself to the first model that comes along. By channeling its energies into ritual forms and activities sanctioned by ritual, the cultural order prevents multiple desires from converging on the same object. Notably, it protects children from the disastrous effects of the double bind.

. . . I have tried to demonstrate that the characters in tragedy are ultimately indistinguishable. The words used to describe any one of them in psychological, sociological, moral, or even religious terms—for example, "hot-tempered," "tyrannical," "hubristic"—are all equally applicable and equally inadequate. If the commentators have failed to remark that these traits are the common property of all the characters in the play, it is because they are not all affected by them at the same time. Anger, for example, is always transitory. It comes in fits, emerging from a background of tranquillity—which is why it is always referred to as sudden and unexpected. Tyranny, too, is essentially unstable. A newcomer can ascend unexpectedly to the very summit of power, only to plummet, while one of his opponents assumes his lost position. In short, there is always a tyrant and always an oppressed, but the roles alternate. There is always one character who is angry; but while one of the enemy brothers rants and rages, the other may temporarily regain his composure.

In tragedy everything alternates. But we must also reckon with the irresistible tendency of the human spirit to suspend this oscillation, to fix attention on

one extreme or the other. This tendency is, strictly speaking, mythological in nature. It is responsible for the pseudo-determination of the protagonists, which in turn transforms revolving oppositions into stable differences.

The concept of alternation appears in tragedy, but it figures there deprived of its reciprocity. Paradoxically, it becomes a pseudo-specification; it is presented as the characteristic attitude of a single individual in the play. Oedipus, for instance, proclaims himself the child of Fortune and of Chance. (We moderns would be inclined to use the word *destiny*, which lends an air of solemnity and "individuality" to the situation, and avoids any hint of reciprocity.)

The hold of Fortune (*tukhe*) on Oedipus is manifested in a series of "highs" and "lows." "Fortune was my mother, and the years that tracked my life saw me in turn both great and small." In the final lines of the play the chorus defines the hero's existence in terms of his *peripeteiai,* his reversals of fortune; that is, in terms, once again, of alternation. (It matters little whether these lines were or were not written by Sophocles.)

The definition is correct, but it is no more correct for Oedipus than for any other tragic hero. That is apparent if we turn our attention from a single play to the whole corpus of tragedy. If the tragic heroes are all compared, their distinctive traits vanish, for they all successively assume the same roles. Oedipus is an oppressor in *Oedipus the King* but the oppressed in *Oedipus at Colonus;* Creon is oppressed in *Oedipus the King* but becomes the oppressor in *Antigone.* Nobody, in short, incarnates the true oppressor or the true oppressed; and the modern ideological interpretations seriously misconstrue the tragic spirit. They relegate the plays to the company of romantic melodrama or American Westerns. A static Manichaean confrontation of "good guys" and "bad guys," an unyielding rancor that holds fast to its victims, has replaced the revolving oppositions of real tragedy and completely overshadowed the concept of the tragic peripeteia.

Tragedy is interested in reversal as such; it cares little for the domains these reversals happen to affect. Oedipus's alternating states of anger and serenity, for example, contribute no less to his portrait as a child of Fortune than do his alternating periods of exile and kingship. The different rhythm of these alternations and the disparity between the realms to which they belong are such that we would scarcely think of connecting the two; indeed, as far as I know traditional criticism has never attempted to do so. Yet once our attention has been drawn to the subject we may suspect that every motif in tragedy is governed by an alternating movement, and our suspicion is confirmed by close examination.

It is clear that alternation constitutes a *relationship*. In fact, alternation is a fundamental fact of the tragic relationship—which is why it can scarcely be considered characteristic of any single individual. At first glance the alternation

of tragedy may well seem dependent on the object under dispute by the enemy brothers. The object itself seems of such importance that its loss of possession entails a radical reversal of status, a passage from being to nothingness or from nothingness to being. Such is the case for Eteocles and Polyneices, who decide to take turns wielding the power they are incapable of dividing between them. When Eteocles is king, Polyneices is one of his subjects, and vice versa.

However, this alternation of objects has little direct connection with tragic action. The rhythm of the action is faster and more abrupt; it is reflected in the tragic dialogue or *stichomythia,* that is, in the exchange of insults and accusations that corresponds to the exchange of blows between warriors locked in single combat. As we have noticed, the description of the duel between Eteocles and Polyneices in *The Phoenician Women* takes the place of a tragic dialogue and plays an identical role.

Whether the violence is physical or verbal, an interval of time passes between each blow. And each blow is delivered in the hope that it will bring the duel or dialogue to an end, constitute the *coup de grâce* or final word. The recipient of the blow is thrown momentarily off balance and needs time to pull himself together, to prepare a suitable reply. During this interval his adversary may well believe that the decisive blow has indeed been struck. Victory—or rather, the act of violence that permits no response—thus oscillates between the combatants, without either managing to lay final claim to it. Only an act of collective expulsion can bring this oscillation to a halt and cast violence outside the community.

Desire, as we have seen, is attracted to violence triumphant and strives desperately to incarnate this "irresistible" force. Desire clings to violence and stalks it like a shadow because violence is the signifier of the cherished being, the signifier of divinity.

If unanimous violence alone (that is, violence that spends itself) can properly be regarded as generative, all the implications it makes manifest and all the differences it succeeds in establishing are intimately associated with the back-and-forth antagonism that precedes, with the oscillation of victory from one combatant to another throughout the sacrificial crisis. The fits of vertigo that attend the process stem from this terrible oscillation, and they ultimately engulf all perceived reality. Everything oscillates with a violence that seems to favor first one, then another individual or faction. Whatever an initial act of violence seems to settle is invariably subverted by a second act, which reorders everything anew. As long as violence remains present among men, and as long as men pursue it as an absolute, as a kind of divinity, it will continue its devastating oscillations.

Euripides' *Bacchae* offers the clue. The idea of a contest in which divinity

is the prize, passing from one contestant to the other with uniformly disastrous results, is essential to an understanding of all tragic motifs, for the structuring of these motifs is really patterned on the action. The reader may protest that we are dealing with an abstraction, that the idea of a divine stake or prize identical to violence is foreign to *The Bacchae*. This idea may indeed be only suggested here but no one can deny that it is explicit elsewhere and that it is quintessentially Greek. Certainly it is quite explicit in Homer—that is, in a literary text predating the tragedies.

There are several terms in Homer that dramatically illuminate the relationship of violence, desire, and divinity. The most useful, perhaps, in the context of our discussion is the substantive *kudos*. *Kudos* is best defined in terms of semidivine prestige, of mystical election attained by military victory. It was the reward sought by both Greek and Trojan, particularly in single combat.

In his *Dictionary of Indo-European Institutions* Benveniste translates *kudos* as "talisman of supremacy." It is the fascination of superior violence. Violence strikes men as at once seductive and terrifying; never as a simple means to an end, but as an epiphany. Violence tends to generate unanimity, either in its favor or against it. And violence promotes imbalance, tipping the scales of Destiny in one direction or another.

At the least success violence begins to snowball, becoming finally an irresistible avalanche. Those who possess kudos see their strength multiplied a hundredfold; those deprived of it discover that they are hopelessly handicapped. Kudos passes to the man who strikes the hardest—the victor of the moment. It belongs to the man who manages to convince others, and who believes himself, that his violence is completely irresistible. The opposition must then exert itself to break the spell cast by this conviction and to wrest the kudos from the enemy's grasp.

When the rivalry becomes so intense that it destroys or disperses all its objects, it turns upon itself; kudos alone becomes the ultimate object. The word is sometimes translated "glory," but, as Benveniste has remarked, such a translation ignores the magico-religious aspects that are fundamental to the term. Although the modern world lacks a word for this phenomenon, the phenomenon itself is familiar. The spiritual effects of triumphant violence are readily apparent in sexual activity, in games of skill or chance, in athletic matches, and in contests and competitions of all kinds. For the Greeks, the issue of violence carried to its extreme was divinity itself. The epithet *kudros* signifies an attitude of triumphant majesty, a demeanor characteristic of the gods. Man can enjoy this condition only fleetingly, and *always at the expense of other men*. To be a god is to possess kudos forever, to remain forever a master, unchallenged and unchallengeable. That is beyond the reach of mortal man.

It is the gods who confer kudos on men and the gods who take it away. The intermingling of human and divine in human conflicts is so obvious that even Benveniste acknowledges it here; in other cases where this mixture is present he tries to separate the human and the divine, even though their combination might offer a clue to the process of sacralization.

As long as the concept of kudos exists—that is, as long as there exists a prize, eminently desirable and thoroughly abstract, that men strive constantly to wrest from one another—there can be no transcendent force capable of restoring peace. What we are witnessing in this struggle for kudos is the decomposition of the divine, brought about by violent reciprocity. When the tide of battle turns against them, Homer's warriors sometimes justify their retreat with remarks like "Today Zeus has chosen to bestow kudos on our enemies; perhaps tomorrow he will give it to us." This alternation of kudos is identical to the alternations of tragedy. We may even wonder whether the division of the gods into two camps in the *Iliad* is not a late development. The original version may have involved a single god, the personification of kudos, who oscillated from one camp to another depending on the course of battle.

In some Euripidean tragedies the alternation between "high" and "low" is sharply delineated. It is linked to a form of violence that is no longer physical but spiritual, that inverts the relationship between dominating and dominated. In *Andromache,* for instance, Hermione treats the heroine with complete disdain, insisting on the vast gulf that must separate Neoptolemus's lawful wife and queen from his mistress, a captive slave at the mercy of her captors. Presently, however, the tragic peripeteia takes place. Hermione meets her downfall, and becomes in effect the slave of Andromache:

> What god would I invoke? At what shrine offer prayers? Must I slavishly embrace the knees of a slave?

Euripides is less interested in the changes of circumstances brought about by the plot than in Hermione's overreaction to these changes. The nurse remarks:

> My child, I did not hide my disapproval when you gave way to such violent hatred for the Trojan woman; nor do I now approve your giving way to panic.

Overreaction is characteristic of these tragic reversals of fortune. Yet the overreactions that actually serve to alter the power structure in the play are drawn from other sources. Although no decisive action has taken place while Neoptolemus was away in Delphi, a tragic debate has taken place between Hermione's father Menelaus, who is determined to kill Andromache, and the

aged Peleus, who stands forth as her champion. Peleus gains the upper hand and emerges with kudos.

The transferal of kudos is not simply a subjective matter, though it is not objective either. It involves a relationship in which the roles of dominating and dominated are constantly reversed. Neither psychological nor sociological interpretations can help us here. There is no point in invoking a master-slave dialectic because the situation affords no stability of any sort, no synthetic resolution.

In the end the kudos means nothing. It is the prize of a temporary victory, an advantage no sooner won than challenged. It might be compared to those sporting trophies that are passed from winner to winner and that are really nothing but a title, an abstraction. To take the metaphor too seriously, however, would only lead to another mythical and ritualistic distortion. Far from subordinating religion to sport or play (as does Huizinga in *Homo Ludens*), we must subordinate play to religion, and in particular to the sacrificial crisis. Play has a religious origin, to be sure, insofar as it reproduces certain aspects of the sacrificial crisis. The arbitrary nature of the prize makes it clear that the contest has no other objective than itself, but this contest is regulated in such a manner that, in principle at least, it can never degenerate into a brutal fight to the finish.

There is no term in any language that is not accompanied by mythological inflections. In the case of *kudos* the reciprocity of the violence is not relinquished, but is muted so as to suggest some joust or tourney. Because we see that the prize is worthless we tend to assume that the contest itself, no matter how perilous, is only a pastime, an event of limited interest to the protagonists, mere "sport."

To correct this impression it suffices to consider some other psychological terms whose mythological inflections are somewhat different. *Thymos,* for instance, means soul, spirit, or anger like "the anger of Oedipus." At first glance *thymos* has nothing in common with kudos—except for one trait, which we would normally consider altogether trivial: its alternating character. When a man possesses *thymos* he possesses an irresistible dynamism. When *thymos* is withdrawn he is plunged into anguish and despair. *Thymos* is derived form the verb *thuein,* which means to make smoke, to offer sacrifices; to act violently, to run wild.

The *thymos* comes and goes at the bidding of the *thuein*. In fact, kudos and *thymos* represent two different and partial aspects of the same problem. It is not some vulgar trophy or second-rate divinity the adversaries are trying to wrest from each other's grasp, but their very souls, their vital force, their being. Each finds this being reflected in the other's violence, because their mimetic desires have converged on one and the same object.

*Cyclothymia* is the term psychiatrists use to designate the alternating presence and absence of *thymos*. Every case of cyclothymia is characterized by mimetic desire and a strong competitive drive. Psychiatrists make the mistake of regarding cyclothymia as an essentially individual phenomenon; this is a genuinely mythical misconception, identical to the delusion whereby men see all sudden reversals of Destiny, all manifestations of divine anger, as stemming from the action of a single hero (cf. *Oedipus the King*). An individual perspective on cyclothymia yields only half the truth. In all such cases, when one person is high in the favor of fortune, another is low, and vice versa.

Modern psychiatry often fails to perceive the basic antagonism underlying the pathological manifestations of cyclothymia, because all traces of conflict have vanished. The physical violence, even the harsh language of the tragic confrontation no longer manifests itself; the adversary himself has disappeared, or appears in a static form that conceals the reality of the agonistic process. The conflict seems to take place in a domain far removed from the hurly-burly of competition and strife. In our own day literary or artistic creation would qualify as such a domain, for the romantic and modern artist generally claims to draw his creations from the purest inner sources, from a region uncontaminated by imitation. In an age where the tyranny of fashion has never been more absolute, the artist proclaims his independence from all outside influence.

The tragic cyclothymia would engulf an increasing number of individuals if nothing intervened to stop it and would end by plunging the whole community into madness and dissolution. Thus we can easily understand the terrified response of the chorus, its frantic efforts to remain uninvolved and avoid the contamination of mimetic rivalry. The virtues of moderation and "common sense," so dear to ordinary mortals, are openly challenged by the constant shiftings of the tragic situation. This timidity of the chorus offends the Romantic sensibilities of modern-day intellectuals, who are scornful of any reluctance to embrace what is forbidden by custom and law.

Some will attribute the cautiousness of the Greek chorus to a pusillanimous temperament, already at this early date imbued with bourgeois attitudes, or else to an arbitrary and merciless superego. We must be careful to note, however, that it is not the "sinful" act in itself that horrifies the chorus so much as the consequences of this act, which the chorus understands only too well. The vertiginous oscillations of tragedy can shake the firmest foundations and bring the strongest houses crashing to the ground.

Fortunately, even among modern readers there are some who do not hold tragic "conformism" in scorn; certain exceptional individuals who have succeeded, through genius and a good deal of pain, in arriving at a full appreciation of the tragic concept of peripeteia.

At the very portals of madness, Hölderlin paused to question *Antigone* and *Oedipus the King*. Swept up by the same vertiginous movement that seized the heroes of Sophocles, he tried desperately to attain that state of moderate equilibrium celebrated by the chorus. The relationship between tragedy and Hölderlin's madness becomes clear if we accept as literal facts the accounts of his existence set forth in the poet's own poems, novels, essays, and letters. The premises of madness are sometimes neither more nor less than an exceptional encounter with feelings appropriate to Greek tragedy: an increasingly stressful alternation between moments of superhuman exaltation and hours when only the emptiness and desolation of life holds any illusion of reality. The *god* bestows his presence on the poet only, it seems, to withdraw it. A thin thread of remembrance links these alternating visitations and absences, a thread just strong enough to assure the individual's sense of continuity and to sustain those visions of the past that heighten the intoxication of possession but render even more painful the anguish of loss. A being who thought himself eternally damned finds himself ecstatically involved in his own resurrection; a being who thought himself a god is struck with horror at the revelation of his self-delusion. The god is *other*, and the poet, though still alive, is little better than a corpse, for he has lost all reason for living. He is like a sacrificial lamb, dumbly submitting to the executioner's knife.

Hölderlin's *god* often bears a proper name—sometimes the name of the poet himself, sometimes that of another. Usually that other is at the outset a woman, who later assumes the features of a man—the poet Schiller. Contrary to what Jean Laplanche asserts, there is no essential difference between masculine and feminine attributions.[3] The idolized antagonist undergoes first a feminine incarnation, then a masculine incarnation. As the poet's correspondence makes clear, this substitution is unrelated to any sexual difficulties. On the contrary, amatory success deprives the sexual domain of its value as a *test* between the I and the other.

The constant shifting back and forth from divinity to nothingness in Hölderlin's relationships with others is expressed in poetic, mythic, quasi-religious terms as well as in a perfectly rational form, which is at once the most deceptive and most revealing of all. His letters to Schiller lucidly describe the plight of the disciple who sees his model transformed into an obstacle and rival.

In his "Thalia Fragment," a first draft for the *Hyperion*, Hölderlin writes:

> I imagined that the poverty of our nature would change to abundance when two such wretched creatures [men] could share one heart, a single and indivisible life, as if all the ills of our existence were brought about by the dissolution of some primitive unity.
> With melancholy rapture (I can still sense it), thinking of naught but how to

find someone to accept the gift of my loving smile, of how to give myself to the first passerby. . . . Ah! How often I then believed I had encountered and possessed the Ineffable simply by having dared to delve to the very depths of my love! How often I believed I had been granted direct access to the divine! I called out, called again, and the poor creature put in an appearance; embarrassed, ill at ease, often even slightly aggressive—he wanted only a little pleasure, certainly nothing very demanding!

What a blind imbecile I was! I was seeking pearls from beggars even poorer than myself; so very poor, so sunken in poverty, that they were incapable of judging the extent of their misery and delighted in the rags and tatters which covered their naked bodies. . . .

In fact, when it seemed to me that the last remnants of my lost life were at stake, and when my pride began to revive, I found that I had become a mass of unleashed activity and I discovered in myself the omnipotence of despair. Whenever my wan and languishing spirit happened to imbibe an unexpected draught of happiness I flung myself precipitously into the midst of the crowd, spoke out in inspired tones, and sometimes even felt welling up in my eyes the tears of felicity. Or whenever the thought of image of a hero flashed across the dark firmament of my soul, I rejoiced in my surprise, as if a god had seen fit to visit my forlorn domain. And it seemed to me then that a whole world was about to take shape within me. But the more suddenly these dormant powers were stirred into awakening, the more precipitous was their subsequent decline, and unsatiated nature experienced a redoubling of afflictions.

In a letter to Schiller Hölderlin writes:

I have sufficient courage and judgment to free myself from other masters and critics and to pursue my own path with the tranquil spirit necessary for such an endeavor, but in regard to *you,* my dependence is insurmountable; and because I know the profound effect a single word from you can have on me, I sometimes strive to put you out of my mind so as not to be overcome by anxiety at my work. For I am convinced that such anxiety, such worry is the death or art, and I understand perfectly well why it is more difficult to give proper expression to nature when the artist finds himself surrounded by masterpieces than when he is virtually alone amidst the living world. He finds himself too closely involved with nature, too intimately linked with it, to consider the need for rebelling against its authority or for submitting to it. But this terrible alternation is almost inevitable when the young artist is exposed to the mature genius of a master, which is more forceful and comprehensible than nature, and thus more capable of enslaving him. It is not a case of one child playing with another child—the primitive equilibrium attained between the first artist and his world no longer holds. The child is now dealing with men with whom he will never in all probability be familiar enough to forget their superiority. And if he feels this superiority he must become either rebellious or servile. Or must he?

When differences begin to shift back and forth the cultural order loses its stability; all its elements constantly exchange places. So it is that in tragedy the differences between the antagonists never vanish entirely, but are constantly inverted. In such a system enemy "brothers" can never occupy the same position at the same time. Earlier I defined this system in terms of abolished distinctions, of symmetry and reciprocity. Now I am saying that differences never really disappear. The contradiction between the two definitions is, I trust, a contradiction in appearance only.

In a tragedy the reciprocal relationship between the characters is real, but it is the sum of nonreciprocal moments. The antagonists never occupy the same positions at the same time, to be sure; but they occupy these positions in succession. There is never anything on one side of the system that cannot be found on the other side, provided we wait long enough. The quicker the rhythm of reprisals, the shorter the wait. The faster the blows rain down, the clearer it becomes that there is no difference between those who strike the blows and those who receive them. On both sides everything is equal; not only the desire, the violence, the strategy, but also the alternation of victory and defeat, of exaltation and despair. Everywhere we encounter the same cyclothymia.

My original definition therefore holds, and I trust that the concept of shifting differences serves to refine it. After all, it is not the elimination of differences that lends itself to direct observation, but the successive inversion of differences. In the temporal plan of the system there is not a moment when those involved in the action do not see themselves separated from their rivals by formidable differences. When one of the "brothers" assumes the role of father and king, the other cannot but feel himself to be the disinherited son. That explains why the antagonists only rarely perceive the reciprocal nature of their involvement. Each is too intensely engaged in living out his non-reciprocal moment to grasp the whole picture, to take in several of these moments in a single glance and compare them in such a way as to penetrate the illusory quality of singularity that each moment, observed in isolation, seems to possess—in a universe that otherwise appears commonplace, banal, without interest. The *same* characters who are blind to the phenomenon of reciprocity while they are caught up in it perceive it all too well when they are not involved. That is why, during the sacrificial crisis, all men are endowed with the spirit of prophecy—a vainglorious wisdom that deserts them when they themselves are put to the test.

Because they are essentially outsiders and therefore misread the differences shifting back and forth between the antagonists, Oedipus, Creon, and Tiresias in turn imagine themselves capable of "banishing the plague"—that is, of serving as arbitrator in the conflicts convulsing Thebes. Each thinks that

he can make it clear to the antagonists that no difference actually stands between them. And each in turn is drawn into the conflict whose contagiousness he failed to comprehend.

From within the system, only differences are perceived; from without, the antagonists all seem alike. From inside, sameness is not visible; from outside, differences cannot be seen.

Only the outside perspective, which takes into consideration reciprocity and unity and denies the difference, can discern the workings of the violent resolution, the cryptic process by which unanimity is reformed against and around the surrogate victim. When all differences have been eliminated and the similarity between two figures has been achieved, we say that the antagonists are *doubles*. It is their interchangeability that makes possible the act of sacrificial substitution.

My reading of *Oedipus the King* is based on this "outside" perspective, on an objectivity that takes in at a glance the identity of all the antagonists. However, the generative unanimity does not come from outside. It is produced by the antagonists themselves, to whom the objective outlook is utterly alien. The preceding description, then cannot be sufficient. In order for violent unanimity to become a possibility—in order, that is, for the sacrificial substitution to function—their own identity and reciprocity must somehow impose themselves on the antagonists themselves, and triumph within the confines of the system. Both the outside and inside viewpoints must communicate, yet remain distinct; the misapprehension must remain within the system, for otherwise the polarization of violence onto the surrogate victim could not be effected, and the arbitrary choice of that victim would be too readily evident.

We must be prepared, therefore, to start our analysis afresh, and try to examine from within the mechanism responsible for sacrificial substitution in the crisis-ridden community.

As I have said, the differences that seem to separate the antagonists shift ever faster and more abruptly as the crisis grows in intensity. Beyond a certain point the nonreciprocal moments succeed each other with such speed that their actual passage becomes blurred. They seem to overlap, forming a composite image in which all the previous "highs" and "lows," the extremes that had previously stood out in bold relief, now seems to intersect and mingle. Where formerly he had seen his antagonist and himself as incarnations of unique and separate moments in the temporal scheme of things, the subject now perceives two simultaneous projections of the entire time span—an effect that is almost cinematographic.

Up to this point I have described the system in terms of single, unique difference, the difference between the "god" and the "non-god." This is clearly an oversimplification. The "Dionysiac" state of mind can and, as we

have seen, often does erase all manner of differences: familial, cultural, biological, and natural. The entire everyday world is caught up in the whirl, producing a hallucinatory state that is not a synthesis of elements, but a formless and grotesque mixture of things that are normally separate.

It is this monstrosity, this extraordinary strangeness of the world that captures the attention not only of the characters involved but also of latter-day scholars who till the fields of folklore and psychiatry. An attempt is made to classify the monsters; but despite their initial disparities they end by resembling one another; no stable difference really serves to separate them. And there is really nothing very interesting to say about the hallucinatory aspects of an experience that for all practical purposes exists solely to divert attention from the essential fact, which is that the antagonists are truly doubles.

A fundamental principle, often overlooked, is that the double and the monster are one and the same being. The myth, of course, emphasizes only one aspect (usually the monstrous aspect) in order to minimize the other. There is no monster who does not tend to duplicate himself or to "marry" another monster, no double who does not yield a monstrous aspect upon close scrutiny.[4] The duality claims precedence—without, however, eliminating the monstrous; and in the duality of the monster the true structure of the experience is put in relief. The nature of the relationship between monster and double, stubbornly denied by the antagonists, is ultimately imposed on them in the course of the shifting of differences—but it is imposed *in the form of a hallucination*. The unity and reciprocity that the enemy brothers have rejected in the benign form of brotherly love finally impose themselves, both from without and within, in the form of monstrous duality—the most disquieting and grotesque form imaginable.

We can expect little help from literature and even less from medicine in our investigation of the double. Doctors not infrequently share their patients' fascination with burgeoning monstrosities. In so doing they neglect the crucial aspects of the experience: its reciprocal character, its affinity with violence. Psychoanalysts and folklorists declare that these hallucinatory phenomena are purely imaginary. They refuse to acknowledge the reality of the symmetry that underlies the fantasy. This transformation of the real into the unreal is part of the process by which man conceals from himself the human origin of his own violence, by attributing it to the gods. To say that the monstrous double is a god or that he is purely imaginary is to say the same thing in different terms. Our abstract skepticism vis-à-vis religion serves admirably to fill the function formerly performed by religion itself.

To my knowledge only Dostoevsky, both in his early novel *The Double* and in the masterpieces of his maturity, has set forth in concrete terms the elements of reciprocity at work in the proliferation of monsters.

In the collective experience of the *monstrous double* the differences are not eliminated, but muddied and confused. All the doubles are interchangeable, although their basic similarity is never formally acknowledged. They thus occupy the equivocal middle ground between difference and unity that is indispensable to the process of sacrificial substitution—to the polarization of violence onto a single victim who substitutes for all the others. The monstrous double gives the antagonists, incapable of perceiving that nothing actually stands between them (or their reconciliation), precisely what they need to arrive at the compromise that involves unanimity *minus* the victim of the generative expulsion. The monstrous double, all monstrous doubles in the person of one—the "thousand-headed dragon" of *The Bacchae*—becomes the object of unanimous violence:

> Appear, great bull!
> Come, dragon with a thousand heads!
> O come to us, fire-breathing lion!
> Quick, quick, you smiling Bacchant, and cast your fatal net about this man
> who dares to hunt you Maenads!

We can now appreciate the atmosphere of terror and hallucination that accompanies the primordial religious experience. When violent hysteria reaches a peak the monstrous double looms up everywhere at once. The decisive act of violence is directed against this awesome vision of evil and at the same time sponsored by it. The turmoil then gives way to calm; hallucinations vanish, and the détente that follows only heightens the mystery of the whole process. In an instant all extremes have met, all differences fused; superhuman exemplars of violence and peace have in that instant coincided. Modern pathological experiences offer no such catharsis; but although religious and pathological experiences cannot be equated, they share certain similarities.

Many literary texts, both ancient and modern, make reference to the double, to duality, to double vision—references that have long been disregarded. In *The Bacchae,* the monstrous double is everywhere. As we have seen, from the opening of the play animal, human, and divine are caught up in a frenetic interchange; beasts are mistaken for men or gods, gods and men mistaken for beasts. Perhaps the most intriguing instance of this confusion occurs during the encounter between Dionysus and Pentheus, shortly before Pentheus is murdered—that is, at the very moment when the enemy brother is due to disappear behind the form of the monstrous double.

And that is exactly what happens. Pentheus has already fallen prey to Dionysiac vertigo; he *sees double:*

PENTHEUS: I seem to see two suns, two Thebes, with two times seven gates. And you, you are a bull walking before me, with two horns sprouting from your head.

DIONYSUS: You see what you ought to see.

In this extraordinary exchange the theme of the double appears initially in a form completely exterior to the subject, as a double vision of inanimate objects, an attack of dizziness. Here we are dealing solely with hallucinatory elements; they are undeniably a part of the experience, but only a part, and not the essential one. As the passage unfolds, so too does its meaning. Pentheus associates the double vision with the vision of the monster. Dionysus is at once man, god, and bull. The reference to the bull's horns links the two themes: doubles are always monstrous, and duality is always an attribute of monsters.

Dionysus's words are arresting: *"You see what you ought to see."* By seeing double, by seeing Dionysus himself as a monster bearing the double seal of duality and bestiality, Pentheus conforms to the immutable rules of the game. Master of the game, the god makes sure that events take their course according to his plan. The plan is identical to the process we have just described, with the monstrous double making his appearance at the height of the crisis, just before the unanimous resolution.

These lines become even more intriguing when read in conjunction with the passage that follows. Now we have to reckon not with hallucination or vertigo but with real flesh-and-blood doubles. The identical nature of the antagonists is explicitly formulated:

PENTHEUS: Tell me, who do I look like? Like Ino, or like my mother Agauë?

DIONYSUS: You seem the very image of them both.

Similarities are at the heart of the encounter, but the question is treated ambiguously, in terms of family resemblance—a formulation brought to mind by Pentheus's transvestite masquerade. Yet something more is clearly at stake here. Surely it is the similarity of doubles that is being suggested; that of the surrogate victim and the community that expels it, of the sacrificed and the sacrificer. All differences are abolished. *"You seem the very image of them both"*: once again it is the god himself who confirms the basic principles of a process initiated by him and which, in fact, comes to seem a sign of his presence.

The writings of another ancient author are equally vital, I believe, to a discussion of the monstrous double. Empedocles' description of the birth of

monsters has never been adequately interpreted. However, if the cycles described by the philosopher correspond to a cultural system founded on an act of generative violence, maintained by ritual, and destroyed by a new sacrificial crisis, then we can scarcely doubt that the birth of monsters as described by him is meant to suggest terrible apparition of the monstrous double. The author attributes the cyclical movements to the alternation of two fundamental impulses, Love and Hate. *The birth of monsters comes about through the attraction of like for like, under the aegis, not of Love, but of Hate, before the birth of a new world:*

> 57. Then there began to sprout in profusion heads without necks, and arms without bodies or shoulders swarmed everywhere, and naked eyes floated as planets [in the world of Hate].
> 58. The dismembered limbs, subservient to the will of Hate, wander about separately, yearning to unite.
> 59. But as soon as a god draws closer in harmony to another god, the limbs begin to link up at random, and they all rush together;
> 60. We find creatures with revolving legs and countless hands.
> 61. Others are born with two faces, two torsos; there are cows with human heads and men with the heads of cows; and hermaphrodites, whose sex is shrouded in mystery.

The interpretation I propose happens to coincide with the recent tendency to reject "physical" interpretations of pre-Socratic thought; interpretations that are, to be sure, always dependent on the belief that the primary purpose of myths is to explain natural phenomena. Although the more recent interpretations are superior to the early ones they still, I believe, underestimate the religious element in the thinking of Empedocles, and indeed in all the pre-Socratics.

My attempt to link the passage from Empedocles with the phenomenon of the monstrous double may seem less far-fetched if we consider this passage in conjunction with another work of Empedocles, *Purifications*. I alluded to this work earlier on, but it seems to take on new significance in this context. "The father takes hold of his son *who has changed form*, and in a fit of madness, sacrifices him; the son cries out, but his pleas fall on deaf ears; the demented father cuts the son's throat, and prepares an abominable feast in his palace. Similarly, the son seizes the father and the children of their own mother, kills them all and devours their flesh."

Whether or not we choose to take this passage literally, it underscores the atmosphere of acute sacrificial crisis that was the background for Empedocles' work. The father kills his son *who has changed form*, just as Agauë kills her son *who has changed form*, mistaking him for a lion, and just as Pentheus mistakes Dionysus for a bull. As in *The Bacchae*, we are witnessing the degeneration of

a rite into a form of reciprocal violence that is so irrational it conjures up the monstrous double. That is, it harkens back to the very origins of the rite and thus closes the circle of religious compositions and decompositions that preoccupied the pre-Socratics.

The apparition of the monstrous double cannot be verified empirically; nor for that matter can the body of phenomena that forms the basis for any primitive religion. Despite the texts cited above the monstrous double remains a hypothetical creation, as do the other phenomena associated with the mechanism that determines the choice of surrogate victim. The validity of the hypothesis is confirmed, however, by the vast number of mythological, ritualistic, philosophical, and literary motifs that it is able to explain, as well as by the quality of the explanations, by the coherence it imposes on phenomena that until now appeared isolated and obscure.

My hypothesis permits me to essay an explanation of two sets of phenomena that are among the most puzzling in all human culture: possession and the ritual use of masks.

Under the heading *monstrous double* we shall group all the hallucinatory phenomena provoked at the height of the crisis by unrecognized reciprocity. The monstrous double is also to be found wherever we encounter an "I" and an "Other" caught up in a constant interchange of differences. The same set of images is projected almost simultaneously in two symmetrical locations. In *The Bacchae* we discover two types of phenomena that are capable of rapid interchange. The subject of the action, Pentheus, at first sees the two series of images as exterior to himself; this is the phenomenon of "double vision." A moment later one of the two series is perceived as "not me," and the other as "me." It is this second experience we are referring to when we use the term *double*. It is a direct extension of the previous stages, and it retains the concept of an antagonist exterior to the subject—a concept crucial to an understanding of possession.

The subject watches the monstrosity that takes shape within him and outside him simultaneously. In his efforts to explain what is happening to him, he attributes the origin of the apparition to some exterior cause. Surely, he thinks, this vision is too bizarre to emanate from the familiar country within, too foreign in fact to derive from the world of men. The whole interpretation of the experience is dominated by the sense that the monster is alien to himself.

The subject feels that the most intimate regions of his being have been invaded by a supernatural creature who also besieges him without. Horrified, he finds himself the victim of a double assault to which he cannot respond. Indeed, how can one defend oneself against an enemy who blithely ignores all

barriers between inside and outside? This extraordinary freedom of move-ment permits the god—or spirit or demon—to seize souls at will. The condi-tion called "possession" is in fact but one particular interpretation of the monstrous double.

It is hardly surprising that possession should often take the form of a hysterical mimesis. The subject seems to be responding to some outside influence; he has the jerky movements of a marionette. Some presence seems to be acting *through* him—a god, a monster, or whatever creature is in the process of investing his body. He is caught in the double bind of the model-obstacle that condemns both partners to a continual heightening of violence. The monstrous double now takes the place of those objects that held the attention of the antagonists at a less advanced stage of the crisis, replacing those things that each had sought to assimilate and destroy, to incarnate and expel. Possession, then, is an extreme form of alienation in which the subject totally absorbs the desires of another.

The possessed subject bellows like Dionysus the bull; like a lion he is ready to devour anyone who ventures within sight. He can even impersonate inanimate objects. He is at the same time one and many beings as he reenacts the hysterical trance and the crazy mixture of differences that immediately precedes the collective expulsion. There exist entire sects devoted to posses-sion, with their own group sessions. It is interesting to note that in colonial countries or oppressed societies it is often the representatives of the dominant power—the governor-general or the sentry at the barracks gate—who serve as models.

Possession, like everything pertaining to primordial religious experi-ence, tends to acquire a ritual character. The existence of a ritual form of possession implies that something in the nature of an intense case of collec-tive possession took place *initially;* for it is of course that spontaneous occurrence that the ritual is striving to reproduce. Ritual possession seems inseparable at first from the sacrificial rites that serve as its culmination. In principle, the religious practices follow the order of the cycle of violence they are attempting to imitate. Such is the case with the Dinka, in those occasional instances in which possession precedes the immolation of the victim. As soon as the excitement aroused by the chants, dances, and mock combats has reached a certain pitch of intensity, the ritual imprecations pass over into signs of possession. As Lienhardt recounts it,[5] first young men, then adult men and women are overcome. They stagger about among their companions, then fall to the ground in convulsions, moaning or emitting piercing cries.

In some sects possession is regarded as beneficial, in others as harmful.

And there are still others that consider possession beneficial or harmful, depending on the circumstances. Behind these diverse attitudes lies a problem of interpretation similar to the one we have discussed in connection with ritual incest and with festivals. In dealing with liberating violence religion can choose either faithfully to reenact the all too characteristic phenomena of the crisis or systematically to ignore them. The phenomenon of possession, therefore, can appear as sickness, cure, or both at once.

As the rites disintegrate some of the elements that formed them tend to disappear. Others assume new identities, divorced from their past context. Possessions, like many other aspects of primordial experience, can become the chief object of religious preoccupation. In such cases "possession cults" arise. The group sessions of the cult find their climax in an act of sacrificial slaughter.[6] At a later stage of the cult the sacrifice disappears from the rites. The shamans then try to utilize possession for magico-medical purposes. They become "specialists" in the practice of possession.

Still another ritual practice acquires fresh significance in the light of investigations into the monstrous double: the ritual use of masks.

Masks are among the necessary tools of many primitive sects, but we cannot answer with certainty the questions raised by their presence. What do they represent? What is their purpose? How did they originate? Surely there must be some unifying factor, some criterion for masks, among the great variety of forms and styles, something we can recognize if not define. After all, whenever we encounter a mask we do not hesitate to identify it as such. The unity of the mask cannot be extrinsic; it exists in societies remote from each other in space and culture, and it cannot be traced to a single geographical locus. The almost universal use of masks is often said to answer some deep-seated "aesthetic need." Primitive people, we are told, are obsessed with "disguises"; they also have a compulsion to "create forms."

This kind of art criticism offers no real answer to the problem of masks. Primitive art, after all, is fundamentally religious. And masks will undoubtedly, therefore, serve a religious function. They are certainly not "pure inventions"; their models vary greatly from culture to culture, but certain traits remain constant. Although it would not be correct to say that masks invariably represent the human face, they are almost always associated with it: designed to cover the face, to replace it, or in some way to substitute for it.

The problem of the unity and diversity of masks is the same as that of the unity and diversity of myths and rituals. It undoubtedly originates in some real experience, common to a large portion of humanity but now lost to us.

Like the festival in which it often plays an important role, the mask

displays combinations of forms and colors incompatible with a differentiated order that is not primarily that of nature but of the culture itself. The mask mixes man and beast, god and inanimate object. Victor Turner makes reference to a *ndembu* mask that represents at once a human face and a meadow.[7] Masks juxtapose beings and objects separated by differences. They are beyond differences; they do not merely defy differences or efface them, but they incorporate and rearrange them in original fashion. In short, they are another aspect of the monstrous double.

The ritual ceremonies that require the use of masks are reenactments of the original experience. In many cases the celebrants (at least, those who play the most important role in the ceremony) don masks at the climax of the rite, just before the sacrifice. These rites permit the participants to play out all the roles performed by their ancestors during the original crisis. They are enemies first, engaging in mock combats and symmetrical dances; then they put on their masks and change into monstrous doubles. The mask is no apparition drawn from the thin air; it is a transformation of the antagonists' normal features. The different modes of its ritual use, the structure within which the masks operate, are in most cases more revealing than any terms their wearers may use to describe them. If the mask is intended to conceal human faces at a fixed point in the ritual, that is because this is what happened to human faces *the first time*. Masks, then, serve as an interpretation and concrete representation of phenomena that we described previously in purely theoretical terms.

There is no point in trying to determine whether masks represent human or supernatural beings. An inquiry of that kind is relevant only to later developments of the ritual, brought about by a further accentuation of differences, a deepening misapprehension of the phenomena that the ritualistic use of masks allows the wearers to reenact. Masks stand at that equivocal frontier between the human and the "divine," between a differentiated order in the process of disintegration and its final undifferentiated state—the point where all differences, all monstrosities are concentrated, and from which a new order will emerge. There is no point in trying to determine the "nature" of masks, because it is in their nature not to have a nature but to encompass all natures.

Greek tragedy, like the festival and indeed all other rites, is primarily a representation of the sacrificial crisis and the generative violence. The use of masks in the Greek theater requires, therefore, no special explanation; the masks serve the same role as they do elsewhere. Masks disappear when the monsters once again assume human form, when tragedy completely forgets its ritual origins. That is not to say, of course, that tragedy ceases to play a sacrificial role in the broad sense. On the contrary; it has taken over the role of ritual.

## NOTES

Translated by Patrick Gregory.

1. For a discussion of these works, see my *Deceit, Desire, and the Novel* (Baltimore: Johns Hopkins University Press, 1965).

2. See Gregory Bateson et al., "Toward a Theory of Schizophrenia," in *Steps to an Ecology of the Mind* (New York: Ballantine Books, 1972), 201–27.

3. Jean Laplanche, *Hölderlin et la question du père* (Paris: Presses Universitaires de France, 1961).

4. The hysterical experience of the four lovers in *A Midsummer Night's Dream* is a powerful description of this process that generates the monsters of the night, notably the "marriage" of Titania, queen of the fairies, with an ass-headed Bottom. See René Girard, "More Than Fancy's Images: A Reading of *A Midsummer Night's Dream*," in *Textual Strategies: Perspectives in Post-Structural Criticism,* ed. Josué V. Harari (Ithaca, N.Y.: Cornell University Press, 1979).

5. Godfrey Lienhardt, *Divinity and Experience: The Religion of the Dinka* (Oxford: Clarendon Press, 1961).

6. Cf. Henri Jeanmaire's description of the *Zar* and *Bori* (in *Dionysos; Histoire du culte de Bacchus* [Paris: Payot, 1951] 119–31).

7. Victor Turner, *The Forest of Symbols: Aspects of Ndembu Ritual* (Ithaca, N.Y.: Cornell University Press, 1970), 105.

# Part 2

# *Tragedy and Masochism*
## Scene as Other

# Louis Marin
## The Utopic Stage

*Utopia* is a discourse. Better yet, it is a book or volume of signs disposed in a certain order. These signs owe their meaning to a system of which the book is one among an infinite number of possible realizations. In this volume are found sentences, words, and letters that realize, through their differential values, meaning. This definition is true for any book, process, or text. The differential nature of utopia is of a stylistic nature. It is based on a typology of genres that another syntax orders. With Thomas More's *Utopia* as an example, I have noticed that utopia, through its multiple and varied literary *spatial play* (historical narrative, travel narrative, description, illustrating narratives, etc.), is the textual place of production of a representative figure, of a picture within the text whose function consists in dissimulating, within its metaphor, historical contradiction—historical narrative—by projecting it onto a screen. It stages it as a representation by articulating it in the form of a structure of harmonious and immobile equilibrium. By its pure representability it totalizes the differences that the narrative of history develops dynamically. This representation is the project of a utopic practice that keeps inside of itself traces whose critical force remains in a neutralized area of historical contradiction, making possible the constitution of the figure. . . .

There is thus a fiction in utopia, which is its necessary, but not sufficient, characteristic. We must question this, as well as the "spatial play" it implies, by laying out varied literary spaces that produce it. This is done through a sort of double confrontation between myth as ritual and theater as the scene of representation.

## Mythic Ceremonies

I was saying earlier that myth is first and foremost a narrative. It is speech whose repetitive movement creates the antagonism in which society finds its foundation and also the conciliation in which it discovers its history, even if this history is immobile and does not coincide with a progressive accumulation of events. Ritual is the telling of history before history, through which mythic narrative is uttered in complete gesticulation. It is a telling that is simultaneously commemoration and reaccomplishment. It refers to a time that precedes time but that is also the return of this "original" time, its inaugural

repetition. Myth cannot be evacuated of its ritualistic aspect in order to see it as a structure and "logical tool" of mediation in the original contradiction within society because, very simply, as ritual it accomplished the logical operation that structural analysis brings to the fore. The ritual is the "performance" of this operation; it comes to grips with social existence in order to regulate and order it. The mediation and reconciliation are not previously *in* the narrative's structure, the equation establishing the equivalence of contradictory poles. Mediation and reconciliation are instead a temporal process, one of speech and gesture that bring about this equivalence and exchange.

If it is not possible to reduce myth to an object of knowledge constituted only by structural operations that would express its general formula, we must assume a "performing utterance" of myth in two ways: not only does it perform the passage into reality of an adjacent intelligible structure, but it also constitutes this structure. It is the operation by which it is brought about and is repeated. There is a mythic practice irreducible to a theoretical practice, but which awaits its theory.

Ritualistic ceremony reaccomplished mythic narrative: it repeats it, but through this repetition it lays down within social time the order of another texture (and following a different rhythm) that narrative had laid down in its own time and mode. Something occurs during the present moment of the ceremony. This moment is not simply a pure "now" that is chronologically determined. It is the moment when this now and the temporal event of the origin are fused together. The present is the moment of a founding operation where the origin is not a beginning or a first past instant. It is a represence where "chronology" is simultaneously canceled and affirmed. It is constituted at every moment it is played out by a sort of "continuous mythic creation." In ritual the *practice* of mythic narrative is seen to be the ordering of social reality in its double temporal and spatial nature. At this same moment, then, this reality is realized outside of time by a return to the origin from which it is born, and in time by the repetition of original acts where it is unfolded and ordered, where it is made into social reality. It is an immobile time that is repetitive and mimes the origin; it is also the origin's represence in "history" in order to constitute it.[1]

The ritual stages mythic history, but with neither stage nor audience. History is accomplished and is told there but is not represented. If discourse is an element of the ritual, it is an integral part of it, like a hymn, a chant, or praise: narrative, if you like, but a special kind of narrative—a sort of incantation of the original events of which it speaks. In other words, the recitation is contemporaneous with the narrative it tells: an act of speech that is not discernible from other ritualistic behavior. It is an element of the whole ritual, inseparable from it.

## Our Reading

In this respect we must compare ritualistic recitation to reading, which itself obeys the ritualistic to a certain degree. Indeed, reading a novel or short story or even a folktale or myth is the reactivation, evocation, and provocation of a specific form of existence that, before this act of reading, was a simple inactive trace. Avoiding a purely descriptive psychology, we could say that the act of reading projects upon an interior screen characters and events in a film with animated spectral doubles in order to reconstitute, as the reading progresses, the story insofar as it is read. This present reconstitution is not the written story, inscribed and enclosed within the traces on a page or in a volume. No one really knows what this is, in what place or space it is found, under what horizon of the pure existence of ideas without symbols, of signifieds without signs.

But such is the disturbing paradox of reading—in particular of silent, individual reading. It is always distant from its object and determined by its existence, be it in a space and ideal time, so much so that the distance in reading can never be determined by a term of reference by means of which its validity, its objective truth, can be measured. More precisely, the act of reading is determined with reference to an absent term whose existence is absence, but whose position as lack is absolutely necessary in order for the reading to take *place* and for it to have meaning. This absent story, these characters and events, places and things whose referential relation allows the story to be read, exists nowhere else than within the inscribed traces, which, however, do not contain it or enclose it because it must be read. We must retrace these traces through a sort of deciphering in order for the story to exist. From that moment forward it is a story read in that indeterminate distance by which it becomes a fantastic double, a pretext for every dream and possibility.

The imaginary aspect of reading and its product can only exist with reference to another object which it neither describes nor translates. It does not "verify" this always-absent object. In its place the imaginary content is offered as its double, a substitution that is indiscernible from it. This indiscernibility nonetheless assumes the essential condition of this absence to which it owes its absence. It is in this way that reading ushers us into the order of signs—in particular of alphabetical signs, where the same complementary nature, lacking any residue, joins the signifier and the meaning to the written trace. It subordinates it to the sign and integrates it into the system of differential values, where it encounters, as it vanishes, its truth. Reading, even silent reading, substitutes for the play of absence and repetition the indeterminate relation of an absent reference and an imaginary realm that repeats this relation in a representation. This latter is then the equivalence between *sound*

and *meaning*, signifier and signified joined together without supplement or lack. The narrative presented to us in the book to be read is given as the reality it relates, all the while placing the reader at a bridgeless distance from the world it orders through the surprise of events it exposes. The book then makes us enter into the order of the sign as representation, and with this imaginary aspect substituting for reality and forgetting that reading is the reactivation of the trace, the signifier inscribes forgetfulness, which necessarily flows from remembrance because it was never anything but the image of an absence.

## Utopia Is a Book

As far as our own subject is concerned, it must never be forgotten that, first and foremost, utopia is a book. Its productive practice makes us realize what reading books, since the Renaissance, has impelled us to forget: it is a text whose reality is nowhere. It is a signifier whose signified is not a spatial and temporal ideality or a rational intelligibility. It is the product of its own play within the plural space it constructs. Utopia is tied to the book and to the world of discourse as the articulation of the world and of history. It is tied to printing and to signs that the Renaissance visually substituted for the world of speech and listening.[2] It is a world of the written (or a writing of the world) as the ideal representation of history, a world of being that has been substituted for history or being. In the same moment, however, utopia is the book in which the book has been deconstructed by showing the processes that constituted it. It is, in a manner of speaking, the book of the book where the act of reading encounters its accomplishment and end. It is also the place where, through the very content of what is read, dissimulated substitutions that this act accomplishes between sign and symbol, between the imaginary and reality, are represented. This would also be one of the meanings of the figure that is produced by utopic practice beneath the text in the book.

## Representation of Tragedy

With the theatrical representation of tragedy mythic narrative becomes performance, theater. A distancing gesture is thereby accomplished that is not exactly the same as for reading, distance with reference to an absence, but all the same the immediate contact with the ritual has been broken. With tragedy also appear knowledge and purification, contemplation and liberation by the very contemplation of what is known. "To understand, one must suffer,"

exclaims one of the characters in Aeschylus. Suffering is the condition for knowledge; theatrical representation is the contemplation of this suffering. It is its knowledge as well as its freedom (as a gas is freed from a solid after it is analyzed). The opposition contained within one aspect of the tragic, the relationship between the principal character and the chorus, has often been studied. A book aimed at studying the relationship between myth and tragedy claims that the elements of this relationship are "opposing elements, but at the same time solidly interdependent."[3] The opposition is one between mask and disguise, the individual and the collectivity, the mythic hero of the founding legends and the civic community, this latter expressing the feelings, hopes, and judgments of citizens as spectators.

## Return of the Hero into the Performance

The representation of tragedy—tragedy in performance—brings about a double reversal precisely because it is representation. This reversal of complementary elements puts them at odds with each other without breaking them apart or denying their mutual linkage; the one is constantly worked on by the other. The first reversal concerns the mythic narrative on the level of its heroic protagonists. These characters are *played,* not lived or relived, in their original actions that set the origin in the light of its founding presence. They are taken up within discourse uttered by a man whose profession is precisely to narrate. It is certainly true that the mask he wears casts him within a certain religious and social category. He is thus recognized by the spectators as Agamemnon or Oedipus, who will later appear in full presence before the community to repeat the contradiction out of which it springs. The tragic character is an *other* in every possible sense of the word: he is not only the "figure of a hero from another age, always more or less a stranger when it comes to the citizen's ordinary condition."[4] The reactivation of this figure before the eyes of the city is not the reapparition of the hero at its center. He is an other who, because of the mask, becomes other and presents as an object of contemplation the things whose constant presence the ritualistic ceremony had formerly affirmed through repetition.

It is at the very moment that mythic narrative and its characters and events comes into visibility as representations or animated images that their identity is lost. They lose their immediate closeness by which the mythic story was the story and history of society, by which it was constitutive of the reality of the group, and whose telling—words and gestures necessarily unified in the same totality—cemented the community through the periodic representation of its origin. Mythic narrative placed on the tragic stage through its

performance thus becomes vivid theater. It is surrounded by the full light of visibility. Both familiar and recognized, it is in the place of the other: a visible object and representation, not real presence repeatedly accomplished in corporeal and verbal gestures of the group that finds its identity by identifying with it and having this presence identify with it. It is a stunning privilege of sight and light, through which objectivity is placed at a distance and appropriated at this distance, shadowless and honest, but as other. Henceforth language as dialogue can lessen the distance between the protagonists and spectators by using a metric close to prose: a bridgeless distance has been set up in which speech itself has been caught, not only because it must cross that distance, but because it is heard from its far side.

## The Representation of a Theatrical Performance

But this first reversal of mythic narrative carries with it another one, which concerns the community's participation in the story visibly presented on stage through words and images. This second reversal, in a way, influences the first and, in another way, completes it. The other element of the tragic stage is the chorus—"collective and anonymous, it is incarnate by a group of citizens," disguised, not masked.[5] If the tragic heroes and their struggles are the mythic narrative made visible and represented in that other milieu, the chorus presents an element that does not belong to the narrative and places it right in the visibility of the stage. This element is foreign to the space of the first, all the while being connected to it. The chorus is the materialization of the representation inside that which is being represented; it is the relation of visibility constitutive of the tragic representation of myth on the stage. It is the other side of mythic narrative through which this narrative is constituted as representation, is brought to the watchful eye of the spectator in performance. It is the visibility of its reflection, the presence of the image's intransitiveness brought under the spectator's gaze, the neutral element of the verbs: "to represent," "to stage." Through the chorus representation comes to be conscious of itself.

The presence of the chorus on the stage totally closes in representation around itself because it is included in itself in the form of one of its elements, the very act of representing. Nothing escapes the performance, this representation, and it henceforth contains within itself its audience. With the interjection of the chorus, however, theatrical representation is split in two because it does not represent only mythic narrative as visible play within the distance of visibility; this very representation is represented through the presence on stage of the chorus members, who witness the hero's struggles and comment

on them. The stage is thus split in two, on stage: that of the visible, which is only seen, and that of the visible, which is simultaneously seen and seeing. This distance within the distance of representation would be only that if the chorus merely watched on stage. But these chorus members are actors—of another order, true—as they debate through their lines with the hero. They speak with ambiguity, actually, for they both chant and engage in dialogue. They perform a lyrical exultation and an active interrogation; their speech is on two levels as their double position is manipulated on stage. They are actors and spectators at the same time. These spectators are caught in the drama, although they are impotent to act on what takes place. The chorus members are actors in the drama, but on another level and at a distance from the action. They have the power of commentary, however; they hold the tool of discourse upon the action. They know, or rather feel, what is happening, while the protagonists of the mythic narrative are ignorant of, blind to, what is happening.

## The Representation of the City

It is this disquieting shift resulting from the presence of the chorus and the representation of its discourse in the tragic spectacle that opens up the self-contained completeness of tragic performance into the outside. The members of the chorus, by their presence and their discourse, not only represent the representation, not only bring to visibility the visibility of the mythic narrative, but also represent the civic community on stage. They portray the citizens who have come to watch the performance and to take part in the tragic ceremony. The chorus members are the people's representatives and thus can comment on and explain the drama. They clarify it by anticipating the action, by predicting the consequences of a certain action, or by referring to ethical, judicial, or religious principles, which are, in short, interpretative rules of action.[6] But these representatives are there also to express the public's judgment, feelings, and thoughts through questioning. The choral members utter the citizens' discourse. By their presence and voices they represent the citizens' participation in the performance and in the tragic ceremony. The chorus makes this visible for them, and it gives them a voice in it. They are the discourse and visibility of public consciousness within representation. (This is a new dimension for the object of knowledge, which is not only constituted as an object in the light of otherness so that the beginnings of truth are established, but which also englobes the subject of this objectification as if it were one of its own dimensions, becoming an object for itself in the process by which knowledge finds its beginning.) *True* knowledge exists only in the

consciousness of what is known. The luminous otherness in which mythic narrative is revealed echoes the knowing collective subject become aware of itself as subject in the knowledge it acquires of the narrative beyond the recognition of the archaic legend where the community discovered its original antagonisms and found its origins.

Tragic representation thus creates spatial play through the double reversal of narrative and of its representation. There, the primal contradictions, fundamental alienation, and archaic mysteries are objectified and told, told precisely because they are objectified, objectified because they are told. They are caught in the complex interchange of spectators' gazes and in the network of speech. Not simply represented but, indeed, represented within their representation, they are reflected and played out inside their spatial play. Play within play, this shifting of spaces on the same stage is what allows representation to become complete in its wholeness and to shift around inside. Henceforth the marvelous fascination escaping from repetition moves into knowledge and into the contemplative appropriation of contradiction as problems and as objects. This scenic spatial and discursive play, the levels where they come about and the articulations that bind them together, frees the participants from suffering through comprehension of suffering within the discourse of this other on stage. This other is myself, ourselves. This other is myself as this *other* that I come to know. It is society as *our* society, but within differences that allows for true judgment.

## The Utopic Text: Space of Play

Utopia is fiction: a fable skillfully woven by More with "true history," that of his embassy in Flanders and of his stay in Antwerp, Raphael Hythlodaeus comes back from another world situated somewhere beyond, in space and time, or else on this side of the New World. What is the function of this fable? In a way its function is very close to that of the staging of mythic narrative in a performance of tragedy: the fable furnishes a kind of space representation in which contradiction can be figured and played out as a simulacrum so that it can be contemplated as an object of knowledge. But as we already have seen, utopia belongs to the world of the book and the sign in which, through a forgotten substitution, reality is created, brought forth in the discourse that utters it and in its inscription within the voice that silently reactivates it and constantly displaces it toward an absence. Is this comparison between utopia and theatrical performance—representation—justified, or is it nothing more than an ill-inspired metaphor? We saw earlier that description constituted a figure, a picture in the narrative text. We also saw that this figure dissimulated

a latent narrative substituted in turn for an as yet silent history in the form of anecdotal inscriptions. Confronted with the myth as ritual practice and with tragic performance, we must ask ourselves if the utopic text constitutes a space of representational play and if some mythic equivalent is constituted as an object of true knowledge of its figure.

## Tragic Text

We can begin to answer the first question by recalling this fact concerning tragic performance: it is first and foremost the text of an author—Aeschylus, Sophocles, or Euripedes—*before* becoming performance. Do not misunderstand this "before" and "after": they do not necessarily represent a chronology, only the presence of a specific operation *between* the mythic narrative and the theatrical staging. It is an operation that escapes simultaneously the ceremonial and ritual participation that defines the practical and functional involvement of the myth, and the contemplation, no less ceremonial, of this narrative as an object of knowledge conscious of itself and of the problems raised for the collectivity by this very narrative. It is an operation that allows for the transformation from one into the other and, with it, expresses and contributes to the production of a very real transformation of political society. It seems dangerous to consider the textual operation of literary creation, constitutive of tragedy, as a simple variant of mythic narrative. "Good" structural research on a specific myth would predict its tragic rewriting as a variant, a text granted the same rights as the other transcribed versions of the myth. The goal is to construct the general formula that regulates the circular transformations of the versions of the same myth: the myth discovers its identity in the regulatory law of its different versions.

My concern is different: the analysis of the transformations from the mythic "language" of ritual to the tragic ceremony must account for the intervention of a text in the transformation. Whether this text creates it or is an effect, a cause, or a result of it, is not a pertinent question. It suffices to note that the representation of tragedy is the staging of a text, a text closely linked to the social thought of the City, "especially judicial thought in its very elaboration."[7] It is as if historical change and the text were inherently connected, as if history—transformation in the event and the structure—could come about only through the possibility of being written, of being reactivated or revitalized in their traces.

But this text that finds its framework and structure in mythic narrative, the content that the City lives in its present "history," brings this experience to the consciousness of the community by exposing the mythic narrative on

stage. The old contradiction, without ceasing to be one, is known as the current problem, all the while maintaining its relationship to the origin and its intense connection to the founding gestures. This reference receives from the text and from its representation another level of speech and, also, another function. It may very well be that this projection into the visibility of the stage, in the light of its representation, accomplishes the transformation of the profound solidarity with a mythic tradition into a problematic knowledge conscious of its ties to the origin and of its potential force of rupture. It may also very well be that this figurability refers to this intermediary discourse, to this text that performed the most radical transformation on myth by inscribing it as a signifying chain before staging it. It then becomes recognized and yet new, found again and yet discovered, because by it the misunderstanding that is part of all immediate experience turned up in the exposition and in the symbolic play of this very experience.

## Textual Space

But utopia lacks this staging, the representation of its text. It is missing its performance one step beyond reading. It would be better to say that its representation is a figure that the text, in turn, unfolds as a space of language. The descriptive picture that constitutes it (Raphael's discourse in Book Two of *Utopia*) is sketched in a space of storytelling carefully outlined by More in Book One. We witness "a lively account, so animated with action and theater," that once the picture is made through the means discussed here, "we would actually think we were seeing it; we would believe ourselves present," in that Antwerp garden on the same bench as More, Peter Giles, and Raphael, hearing them give orders to "the servants that we should not be interrupted."[8] More attempts to liberate this space—and through reading, actually—because the preface he writes for the book *Utopia* (to be read *before* the book) contains every construction procedure for this space of play, in particular the author's request to seek out Raphael in order to verify, to check up on, or to correct a certain number of traits related to the "figure" and "details" of the picture.

> Therefore I beg you, my dear Peter, either by word of mouth if you can or by letter if he has gone, to reach Hythlodaeus and to make sure that my work includes nothing false and omits nothing true. I am inclined to think that it would be better to show him the book itself. No one else is so well able to correct any mistake, nor can he do this favor at all unless he reads through what I have written.[9]

This is a literary "effect of reality" obtained by the book's real author writing to one of his real friends so that this latter will contact one of the fictional characters of the book; this character purports to be the real author, the former claiming to be simply his transcriber.

## Ironic Parentheses

But More inscribes this effect of reality within an ironic event that indirectly puts it into play—causes it to vibrate, so to speak:

> Nevertheless, to tell the truth, I myself have not yet made up my mind whether I shall publish it at all. So varied are the tastes of mortals, so peevish the characters of some, so ungrateful their dispositions, so wrong-headed their judgments, that *those persons who pleasantly and blithely indulge their inclinations seem to be very much better off than those who torment themselves with anxiety in order to publish something that may bring profit or pleasure to others,* who nevertheless receive it with disdain or ingratitude. Very many men are ignorant of learning; many despise it . . . very many admire only their own work. *This fellow is so grim that he will not hear of a joke; that fellow is so insipid that he cannot endure wit, some are so dull-minded that they fear all satire as much as a man bitten by a mad dog fears water.*[10]

It is not that description is really a trick, that the picture should serve an illusory function so as to be taken for an image or a geographic space in the other world; it really is a series of words, a language chain. With the book we have forever entered into words and signs, never to emerge again. But for this language picture, for this poetic and rhetorical, hypotypotic figure a substitute of a scene is given where the figure could be "represented" outside of space and within words, the substitute for spatial play that is text and only text. Here it is a question of a scene that forms the absent space of a map or the world by multiple voices. From theatrical performance it keeps the complementary play of words that are acts, polar forces of mythic contradiction that have become language in representation, played out in the luminous visibility of the stage. In short, the scenic space that visibly shows mythic antagonism within the discourse of tragedy is utopically figured by the various poles of speech and by their spacing. A space opens up in the words (dialogue), and the textual tissue is stretched in its very contiguousness so that the larger descriptive picture of Book Two can emerge: Utopia. But utopia is being constructed from the very beginning, as early as the preface, when More writes to Peter Giles to send him his book asking that Raphael, one of its characters, check and verify it.

The text is being constructed there as a space of discourse without place, a multivoiced text, a stage for figure.

## Dialogic Structure: Raphael's Two Voices

The importance of dialogue can never be stressed enough in either evident or disguised utopias. Its function is essential because it creates a text where space has been inscribed, where the utopic picture has been offered up to representation: More, Peter Giles, Hythlodaeus; Mentor, Telemachus, Idomenea; Cyrano, the Spanish philosopher; Elia, Socrates' demon . . . a detailed examination of the voices in More's utopia would verify this.[11] *Utopia* is forged out of the intervention and intertwining of two voices. Each occupies two positions, or levels, in the text. "I" is Raphael reciting the descriptive discourse of Book Two. This voice is double, invisible and all-seeing, omnipresent to the whole and to each detail, a cartographic eye, a viewpoint outside any point of view whose discourse can seem to be an image. But "I" is also Raphael, character presented in the discourse and actor seen and memorized by the storyteller. It is a viewpoint *within* the picture, a major element of the deconstruction of its figure in the narrative and in history. Indeed, notice that Raphael's second discursive position produces in *Utopia* the anecdotes and narrative illustrations that as previously shown, constituted the latent reversed history within real history. Raphael is thus the teller of the fragmentary narrative, the intervention of which in the picture is simultaneously the seeming commentary and profound critique. This critique reveals the formal process of production and the system of its content.

The double internal text of the picture that produces it as such (by producing its production in the text) is thus the resulting space of the interference, not of two discourses, but of two positions of speech. A sort of *discursive inclusion* results, and these two viewpoints seem to come from reverse positions in the discourse. The voice of Raphael, who utters the discourse of the describable figure, sees all but remains invisible. It is a discourse without a viewpoint; it finds its origin in the white textual space separating Book One from Book Two: "As for him, when he saw us intent and eager to listen, after sitting in silent thought for a time, he began his tale as follows: The island of the Utopians extends in the center."[12] The space that separates the narrative from the representation, the frame of the painting, is impossible to locate. But the other voice through which the representation is reflected in the adjacent fragments of narrative is the voice of Raphael; it is produced on another level of speech. In order to create these narratives there must be empty surfaces

within the picture. These abscences or hidden elements must be discovered and successively be "invented" by the actor as the narrative continues. The narrative is imbedded in the picture because the actor does not see the unity immediately. At the same time, however, it is precisely because the actor does not see everything that he becomes invisible, that he appears in the descriptive phrase as its producer and locus of enunciation. Thus the figure, as a product and process of production, comes into play, to vibrate, in the separation between Raphael's two voices and within the interference of their spheres of influence.

## More's Two Voices

The other voice is Raphael's protagonist, More. "I" then becomes, in *Utopia,* the voice of a character of the dialogue, though it is also the voice of the writer-author of the text. More reveals his name as a signature at the end of the work: "The end of the afternoon discourse of Raphael Hythlodaeus on the laws and customs of the island of Utopia, hitherto known but to few, as reported by the most distinguished and most learned man, Mr. Thomas More, Citizen and Sheriff of London."[13] In its turn More's discourse englobes Raphael's double discourse in a dialogue slightly shifted with relation to itself. It relates this double discourse to another discursive system, that of historical narrative, and also, by means of the beginning of Book One, to an objective transcendent chronology: historical time, which is also the temporality of our act of reading. If, as we have seen, utopia is linked to real history by means of this articulation, and thereby acquires a density and presence that representation alone would not have had, then, conversely, real history as it would be tied to utopic fiction begins to take on imaginary aspects: the reader begins his trip to the blessed island.

In a certain way More's two voices occupy positions of speech homologous to Raphael's two voices. Thus, in Book Two we meet Raphael the builder of figure, who, seeing all, remains invisible and omnipresent to appear at the very end of the description addressing a universal audience through his present audience in the garden at Antwerp: "I have described to you, as exactly as I could, the structure of that commonwealth which I judge not merely the best but the only one which can rightly claim the name of a commonwealth."[14] In a similar position the author of the treatise on the *Best State of a Commonwealth, or Utopia* is an anonymous voice that never appears in the "body of the text," except in the letter-preface to Peter Giles and in the last sentence as a simple signature.

## The Book's Exit

We thus meet Raphael, a figure in the picture and the actor in a certain number of stories. He is the one discovering a moral trait here, an accident of history there, while he sojourns for five years on the island. He is visible and curious, moving from surprise to surprise. We also meet Thomas More, ambassador to the Flanders of Henry, the eighth of that name, the most invincible King of England, interlocutor, in Antwerp, of Peter Giles and Raphael Hythlodaeus. At the beginning of Book One More occupies an essential place for interpreting *Utopia;* he also reappears at the end of Book Two to initiate an ambiguous transition toward the author of the book, *to exit the book.*

> When Raphael had finished his story, many things came to *my* mind which seemed very absurdly established in the customs and laws of the people described—not only in their method of waging war, their ceremonies and religion . . . but most of all in that feature which is *the principal foundation of their whole structure. I mean their common life and subsistence—without any exchange of money.* This latter alone utterly overthrows all the nobility, magnificence, splendor, and majesty which are in the estimation of the common people, the true glories and ornaments of the commonwealth.[15]

Thus begins a movement to exit the book, as is best, with the well-known phrase: "I readily admit that there are many features in the Utopian commonwealth which *it is easier for me to wish for in our countries than to have any hope of seeing realized.*"[16] This has been a movement interrupted in the preceding paragraph by coming easily and naturally back to More, the character and interlocutor of the dialogue.

> I knew, however, that he was wearied with this tale, and I was not quite certain that he could brook any opposition to his views, particularly when I recalled his censure of others on account of their fear that they might not appear to be wise enough, unless they found some fault to criticize in other men's discoveries. I therefore praised their way of life and his speech and, taking him by the hand, led him into supper.[17]

In other words, More's voice, interlocutor of the dialogue and *historical figure* (the special envoy to Flanders of Henry VIII), is enveloped not by a voice but by the discourse written by an author absent from the text he composed: a voice in the present, coming to its presence not in that space, but outside of space, in the book. This is the final fiction which is the only materially remaining form, the volume we open up and read today.

## The Utopic Stage

This is how the spaces are constructed and locked each within the other. Their play against each other constitutes the utopic stage; it permits time and space to be interlocked in utopia and in history, in the figure and in the book. The island Utopia (as an image) and the work *Utopia* constitute these two non-spaces as limits where the exchange between the narrative of real history and its reverse image, utopic history, takes place. The spaces of the book and figure open up the space of a stage where a double scene is portrayed. There the readers discover how history reveals a narrative mirror image that lets them decode and become aware of it. By labeling our voices, we can diagram the constitution of the utopic text as the last utopia. Raphael I is the narrator of the representation of Utopia; Raphael II is the living figure of this image. More I is the author of the book *Utopia,* More II is the historic figure and Raphael's interlocutor (see fig. 1).

|  | Time | Space |  |
| --- | --- | --- | --- |
| Raphael II | Utopia | image | Raphael I |
| More II | History | book | More I |

Fig. 1. Structure of voices in *Utopia*

There is a surprising consequence: the book *Utopia,* considered as a utopia in its general form, confirms not only the split within the authorial voice but also his disappearance. Of course an author split in two is also a disappearing author. By pointing at himself as a character in his book and, even better, as a *historically* existing figure, as a real representation, More erased himself as the text's author. He witnessed his own appearance and development. This is a procedure (both artificial and profoundly necessary) we will encounter often in the utopias to follow. It is as if utopia came to the author from the outside, as if it had no author or if, amounting to the same thing, the author were an "other." This formal device, "as if," the form that transforms into otherness, is the dialogue constitutive of the book's textuality, the various speech positions that open up the stage on which the utopic figure can be mounted and played.

## The Myth of Staged History

Recall our second inquiry concerning utopic discourse: in this play of utopic representation is a myth or its equivalent constituted as true knowledge? Now

we can answer this question; our previous analyses, in particular the discovery of the homologous positions of More and Raphael as characters, will come to our aid. It is remarkable, in fact, to note that each, separately—one in the dialogue, the other in the figure—plays the role of history. In the one case it is real history, where action and events have truly taken place. These are *past* events, of course, but they actually have taken place, and the text is a trace of their disappeared passage and place. It is a question here of an absent reality, but nonetheless a reality. In the other case we are involved in fictitious history: there are actions and events that our fictitious character Raphael has witnessed while he traveled through the fiction. These are missing actions or events, but the text of *Utopia* is the present inscription and constitutes its true reality. If the positions of the narrator of the figure and the writer of the book define the two poles of the utopic stage, it is legitimate to wonder if the visible result is not the representation of history—that is, the mythic narrative of history as a possible object of knowledge, as the possible place for *just understanding and action.*

The myth of history? What does this mean? That history is a fiction, but also that fiction can be historical. The reversibility of the proposition is demonstrated through the various stretches sketched out by More's and Raphael's voices presenting the figure of Utopia and the book that presents and exposes it. Within the weaves of this network the chief problem that utopia will hold up to Western scruples concerns ideology and practice. *History is fiction:* such could be a definition of ideology according to the road on the "left." *Fiction is historical:* such would be the practice of creating and transforming reality on the "right." Every utopia would attempt to go from one to the other, and such would be the object of representation, representation presented on the stage of the book, within the props of the figure. And such would be the myth of history coming to recognition, to the possibility of knowledge and awareness.

## Satire and Utopia

One way of approaching this difficult problem can be glimpsed through the relation established between satire and utopia. A typology of literary genres and a differential description of their characteristics has been made.[18] Such a direction for research highlights the mythic ritual as the founding relationship between subversive violence—the ritual overthrow of family, social, political, and religious laws—and the periodic return of the norm and of institutions. Saturnalia, Fools' Days, and carnivals are the expressions of the same transgression in different cultural contexts. This transgression ensures the law even

more solidly, whether it be the law of Zeus or of the Church. The essential literary forms of the carnival and satire have also been studied.[19] The celebration of violent repetition and its containment through laws and institutions are evident in the dialogic structure, in the mythic ritual, and in its discursive forms—poetry, theater, and literature. Here is performed the celebration of the founding of social institutions, of their norms and rules. Ritual—in this case myth translated into ceremony or the narrative thereby produced—in providing itself with speech is not a simple "safety valve" to release pressure periodically in order to ensure "social repression" by breaking the severe laws for a limited period of time. Without these laws social cohesion would normally not be guaranteed. The ritual does not constitute a therapeutics of legal authority and social discipline. It is the beginning and foundation of the law through repetition of the former disorder and chaos. But transgression is simultaneously liberating and constitutive. Every institution is repressive; the mythic ceremony performs its overthrow, but the social community exists only through it. The ritual of overthrow is also the ritual of foundation of the overthrown, of the reenactment of the law and of justice, of the norm, and of ritual order of subversion—subversion that existed before order and is again present in the ceremony. But the ritual is also submission of desire into the framework of the institution, in both its symbolic and periodic accomplishment. Thus subversion is also rite, and overthrow is also the institution of overthrow—affirmation of the law by challenging it.

The relation between the ritual of overthrow and satire, between satire and utopia, leads us to the ambiguity contained in every social critique. It simultaneously defines a norm and unfolds the discourse that would deny it. It cannot articulate a discourse without accepting as a presupposition the law that it questions. Adjacent to the critique of the institution is the institution as an idea; alongside real society is one that is ideal. Saturnalian anarchy is the negative, ritualistic critique of the institution in mythic narrative; the norm is this negation, its ideality, and also the positivity where it is accomplished, as the regulation of current constraints makes up the bliss of the Golden Age.

## The Law of Transgression

It is clear that utopic dialogue has a critical function. The representation of the ideal city, of its mores, institutions, and laws—precisely because it is picture and representation—conjures up, as a negative referent, real society; it thus encourages a critical consciousness of this society. As one critic among a number of others writes, the entire work implies an a fortiori reasoning: "if peoples who have not had the privilege of the Revelation can acquire such

virtues, Christ's teachings can inspire even higher ones."[20] If the non-Christian Utopians constitute the "sole republic which merits to be called one," what can be said of the Christian states of the Old World? What can be said of Western governments? Here utopia performs the role of a positively charged norm; with it as a reference the critique of real society will take place. There is a fundamental difference, however, between utopia and the simple critical or satirical discourse. Utopia established transgressions as norm. Subversion becomes figurative representation of the law. In other words, in utopia transgression is not related to the law; it has become the law.

Thomas More is very clear here. Recall the passage where we recognize the exit from Utopia, the beginning of the end of the book.

> Many things came to my mind which seemed very absurdly established in the customs and laws of the people described . . . most of all that feature which is the principal foundation of their whole structure. I mean their common life and subsistence—without any exchange of money. This latter alone utterly overthrows all the nobility, magnificence, splendor, and majesty which are, in the estimation of the common people, the true glories and ornaments of the commonwealth.[21]

The fundamental defining law in Utopia is the transgression of private property. This law has been established by Raphael's interlocutor, the ambiguous author of the book *Utopia:* the dialogic structure of the text forces us to accept the position of transgression of the law as transgression, but in textual form only. Reread similarly the transgression of the father-son relationship in the Utopia of Cyrano de Bergerac. The transgression has become a moral and social law in the Lunar Estates.[22] From this vantage point utopia is not a critique, or at least it can very easily not be one. It is at this precise moment when utopic discourse ceases, when the figurative picture is completed and a critical practice ensues, *outside the book, at the end of discourse.* Utopic discourse is thus constructed in such a way that its end marks the beginning of its meaning, its closure the true inauguration of its signification. It is a discourse that, through its very structure, indicates that critical practice is neither practice nor critical unless it is differentiated from all discursivity. It notes this negatively, in the margins, by an unsaid textual indication. More's political practice and very existence would attest to this fact.

## The Political Ceremony and Irony

The revolutionary political ceremony as enactment and accomplishment outside of representation would constitute the passage to nondiscursivity. Non-founding transgression (to be distinguished from saturnalia and rituals of the

overthrow of social institutions) is excess, the gratuitous spending with total loss, completely excessive consumption that destroys limits, equilibrium, and compensatory exchanges (the first of these being substitution of discourse for the "language of real life"). It is in this way that the Münzerian utopia will emerge into history, some ten years following the composition of *Utopia*.[23] Actually, More's utopic discourse contains the equivalent or substitute of this completely gratuitous loss: irony, the *serio ludere*. Irony can be seen as the completely gratuitous loss of meaning; it annihilates meaning, every meaning, for its opposite. Utopic dialogue is the serious play by which discourse's signification is put into circulation to be immediately removed from it: its stable meaning is erased. The text offers to the reader the consumption of signifieds of completely freed signs. The signifiers, which up to that point seemed to have coherent meaning, are emptied of it. An example to which I shall return concerns the operation where the proper names in Utopia lose their meaning because of indetermination of the signified referent carried along by their signifier. This is so when the island's river is called Anydrus, "No-water," or when our storyteller's name is Hythlodaeus, "Non-sense." Similarly, Cyrano institutes a number of Lunar Estates' laws by creating a metaphoric expression out of ordinary language: song-cents or aroma-food, etc.[24] Irony, the *spoudo-geloion,* or comic seriousness, constitutes several of the utopic ceremony's discursive manipulations. It is transgression of the law of meaning, one that becomes the possibility of a revolutionary practice of language. This is so because language is also a practice among others and not only a regulated order of signs, the legal system of discourse.

With utopia we discover absolute transgression. It is a transgression that has become law and therefore overthrows itself to become its opposite, to crush its own power. At least it *would* have done so if it had not been produced within a figure, a representation, a fiction. Compared to an institution in real society utopia is not another law inherent to an unknown people discovered by some traveling ethnographer possessing objective potential for establishing a blessed island, the *Perfect City* of *simple difference* next to the historical island of England or the real city of London. Utopic law is not another law; it is the "other" to the law. It is constitutionally the very reverse, the very negative, of the law. For the Western traveler America's Topinambu or Patagon are the living transgressions of European Spain or Portugal, because they follow certain laws and customs that are different from, and contrary to, theirs. For these idolatrous and ungodly savages, these immodest creatures of hell, one solitary gesture suffices for reducing all difference, for bringing them into the order and stability of the Christian, European, adult, reasonable norm. The transgression is thus recognized, named, and reduced into a difference with respect to the law.

Utopic transgression is not the same. It is absolute; it is the law as is its other. It is the negativity of reality realized, or rather figured and represented, in fiction, the sole means of representing it in discourse. Utopia is the figure in discourse, created from discourse. It also represents its end, the real practice of transforming reality, of contesting the institution, of transgressing the law; it is the figure of historical negativity. Utopia is indeed a fiction and obeys the unobserved commands of the historically situated ideology from which it emerges. It could not be otherwise. But in this way it informs us that history is a fiction, that it, too, belongs to the discourses that men utter about history in order to give it meaning. It is not irrelevant, from this point of view, to note that More, the historical character from *Utopia,* is an essential element in a commercial venture to improve the economic positions of these English merchants and fabric workshops against whom a part of *Utopia* was written. Here we find a fiction of history through which is expressed an ideology. But Utopia is also the picture of a transgression that is historically determined; it is a transgression that has become the law of figure within figure. It is the figure of the negative of real society and of its laws; it represents transforming practice, historical negativity itself. Its inclusion in discourse can only mean its disappearance in a scientific theory of history. In this way, the fiction is historical; it is the becoming negative of history in representation, and only this, because the fiction is but text and discourse. Its termination will mark the closure of the text, the end of the discourse, and the beginning of revolutionary practice. Its abandonment is signaled by the return to real society and to the general ideology it produces.

## NOTES

Translated by Robert A. Vollrath.

1. See André Green, *The Tragic Effect: The Oedipus Complex in Tragedy,* trans. Alan Sheridan (Cambridge: Cambridge University Press, 1979).

2. With reference to this, see the works of W. J. Ong, especially his *Ramus: Method and the Decay of Dialogue* (Cambridge, Mass.: Harvard University Press, 1958).

3. J.-P. Vernant and P. Vidal-Naquet, *Tragedy and Myth in Ancient Greece,* trans. Janet Lloyd (Brighton, Sussex: Harvester Press, 1981).

4. Ibid., 2.

5. Ibid., 2, 10.

6. Ibid., 7–8. See also J.-H. Finley, *Pandarus and Aeschylus* (Cambridge, Mass.: Harvard University Press, 1955).

7. Vernant and Vidal-Naquet, *Tragedy and Myth,* 3.

8. Thomas More, *Utopia,* ed. Edward Surtz (New Haven, Conn.: Yale University Press, 1964), 57.

9. Ibid., 6.

10. Ibid., 7 (my emphasis).

11. David M. Bevington deals with this subject in "Dialogue in Utopia: Two Sides of the Question," *Studies in Philology* 58, no. 3 (July 1961), 496–509.

12. More, *Utopia*, 57–59.

13. Ibid., 152.

14. Ibid., 146.

15. Ibid., 151 (my emphasis).

16. Ibid., 152 (my emphasis).

17. Ibid., 151–52.

18. Robert E. Elliott's work is essential: *The Shape of Utopia* (Chicago: Chicago University Press, 1970). See also his previous book, *The Power of Satire: Magic, Ritual, Art* (Princeton: Princeton University Press, 1960).

19. Mikhail Bakhtine, *Problems of Dostoevsky's Poetics* (Ann Arbor: Ardis, 1973).

20. R. W. Chambers, *Thomas More* (New York: Harcourt, Brace, 1935). See also Marie Delcourt's introduction to her French translation of *Utopia* (Brussels, 1952).

21. More, *Utopia*, 151.

22. Cyrano de Bergerac, *L'Autre Monde ou les etats et empires de la lune,* introduction by M. Langaa (Paris: Garnier-Flammarion, 1970), 94–95.

23. See Ernst Bloch, *Thomas Münzer als Theologie der Revolution* (Suhrkamp Verlag, 1964), Gesamtansgabe, vol. 3.

24. Cyrano de Bergerac, *L'Autre Monde,* 62–64.

# André Green

## The Psycho-analytic Reading of Tragedy

> *Play is in fact neither a matter of inner psychic reality*
> *nor a matter of external reality....* The place where
> cultural experience is located is in the *potential space*
> between the individual and the environment
> (originally the object).... I am assuming that
> cultural experiences are in direct continuity with play,
> the play of those who have not yet heard of games.
> —D. W. Winnicott

### A Text in Representation:
### Ways from Ignorance to Knowledge

There is a mysterious bond between psychoanalysis and the theater. When Freud cites *King Oedipus, Hamlet,* and *The Brothers Karamazov* as the most awe-inspiring works of literature, he notes that all three are about parricide; less importance has been attached to the fact that two of the three are plays. One naturally wonders whether, for all the interest he showed in the other arts, the theater did not have a special significance for Freud—a significance that outweighed his interest in the plastic arts (despite Michelangelo's "Moses" or Leonardo's "St Anne"), in poetry (despite Goethe, Schiller, or Heine), in the tale (despite Hoffman), in the novel (despite Dostoyevsky and Jensen). Sophocles and Shakespeare are in a class of their own, especially Shakespeare; Freud recognized in him a master whose texts he analyses as if they were the discoveries of some illustrious precursor. But he seems to have had a special affection for the theater in general.

### Scene and other scene

Why is this? Is it not that the theater is the best embodiment of that "other scene," the unconscious?[1] It is that other scene; it is also a stage whose "edge" materially presents the break, the line of separation, the frontier at which conjunction and disjunction can carry out their tasks between auditorium and stage in the service of representation[2]—in the same way as the cessation of

motility is a precondition for the deployment of the dream. The texture of dramatic representation is not the same as that of the dream, but it is very tempting to compare it with phantasy. Phantasy owes a great deal to the reworking by the secondary process of elements that belong rather to the primary processes, these primary processes being then subjected to an elaboration comparable to that of ceremonial, in the ordering of dramatic actions and movements, in the coherence of theatrical plot.[3] But there are many differences between the structure of phantasy and the structure of the theater. Phantasy is closer to a form of theater in which a narrator describes an action occurring in a certain place, but in which, though he is not unconcerned, he does not himself take part. Phantasy is much more reminiscent of the tale, or even the novel. Its links with the "family romance"[4] reinforce this comparison. In the dream, on the other hand, we find the same equality, de jure, if not de facto, that reigns between the various protagonists sharing the space of the stage. So much so that, in the dream, when the dreamer's representation becomes overloaded, the dreamer splits it into two and sets up another character to represent, separately, one or more of his characteristics or affects. Broadly speaking, it would be more correct to say that the theater may be situated *between* dream and phantasy.

Perhaps we should turn to the simplest, most obvious fact. Does not the theater owe its peculiar power to the fact that it is an exchange of language, a succession of bare statements without benefit of commentary? Between the exchanges, between the monologues, nothing is vouchsafed about the character's state of mind (unless he says it himself); nothing is added to these statements that refers to the physical setting, the historical situation, the social context, or the inner thoughts of the characters. There is nothing but the unglossed text of the statements.

In much the same way, the child is the witness of the daily domestic drama. For the *infans* that he remains long after his acquisition of language, there is nothing but the gestures, actions and statements of his parents. If there is anything else, it is up to him to find it and interpret it. The father and mother say this or that, and act in this or that way. What they really think, what the truth really is, he must discover on his own. Every theatrical work, like every work of art, is an enigma, but an enigma expressed in speech: articulated, spoken and heard, without any alien medium filling in its gaps. That is why the art of the theater is the art of the *malentendu,* the misheard and the misunderstood.

*The space of the stage: the spectator in the spectacle*
But this structure creates a space, is conceivable only in a space, that of the stage. The theater defines its own space, and acting in the theater is possible

only in so far as one may occupy positions in that space. The spectacle presents not so much a single, overall view to be understood, more a series of positions that it invites the spectator to take up in order that he may fully participate in what is offered him on the stage. We have to consider, as Jacques Derrida does, the question of the "enclosure" of representation.[5] Just as the dream depends on the enclosure of the dreamer, the enclosure of sleep—beyond which there is no dream, but either waking or somnambulism—the limits of the theater are those of the stage.

The theatrical space is bounded by the enclosure formed as a result of the double reversal created by the exchanges that unfold between the spectator and the spectacle, on either side of the edge of the stage. We may try to eliminate this edge; it is only reconstituted elsewhere. This is the invisible frontier where the spectator's gaze meets a barrier that stops it and sends it back—the first reversal—to the onlooker, that is, to himself as source of the gaze. But, since the spectacle is not meant to enclose its participants in a solipsistic solitude, nor to restrict its own effects by keeping its elements separate from each other, we must account for this in a different way. This return to the source has established a relation between source and object: the spectacle encountered by the gaze as it passes beyond the stage barrier. Nonetheless, the edge of the stage preserves its function of separating source and object. The spectator will naturally compare this with his experience of a similar encounter, where the same relation of conjunction and disjunction is set up, linking the object of the spectator with the objects of the gaze that a different barrier, namely repression, places beyond his reach. It is as if those objects ought not to have been in full view, yet, by some incomprehensible paradox, will not allow the perceiver ever to escape them. They force him to be for ever subjected to their return, experienced in a form at once inescapable, unpredictable, and fleeting. The permanence of the object seen in the spectacle is like the lure that tempts us to think that the solicitation might this time lead to the capture always denied hitherto. By arousing a hope that the secret behind the moment of disappearance of the repressed objects will be revealed, it allows the spectacle to unfold so as the better to surprise that secret.

This reversal on to oneself is always accompanied by a second reversal—the reversal into its opposite—whose meaning is more difficult to grasp. The first reversal enables us to measure, as it were, the fundamental otherness of the spectacle for the spectator. If the spectator allowed this otherness, he would either leave or go to sleep, and that would be the end of a spectacle that had never begun. But this otherness solicits him. Though unable to reject this otherness as totally alien, the gaze detaches itself to some extent from its object, otherwise the total participation of the spectator with the forces of the

spectacle would merge them beneath the eye of a God bringing about from on high the coalescence of auditorium and stage. The gaze explores the stage from the point at which the spectator is himself observed by his object. The boundary between auditorium and stage is duplicated by the boundary between the stage as visible space and the invisible space offstage. Together, these two spaces are opposed in turn to the space of the world, whose steady pressure maintains the space of the theater between its walls.

The contradiction felt by the spectator is such that whereas the project of going to the spectacle initially created a break between the theater and the world, the fact of being at the spectacle replaces the confrontation between the space of the theater and that of the world (which has become invisible and so excluded from the spectator's consciousness) by the confrontation between the visible theatrical space and the invisible theatrical space. The world is the limit of the theater and, to some extent, its raison d'être. But the relation of otherness between the subject and the world is replaced by the otherness of the spectator in respect of the objects of the gaze—an otherness no longer based simply on a boundary (the walls of the theater, or the barrier formed by the edge of the stage), but on another space, one hidden from the gaze. As a result, there occurs a projection of the relationship between theatrical space and the space of the world on to the theatrical space, itself split into a visible theatrical space (the space of the stage) and an invisible theatrical space (the space offstage). This latter space calls for exploration, for it is not only the space by which illusion is created; it is also that in which the false is fabricated. The space of the stage is the space of the plot, the enigma, the secret; the space offstage is that of manipulation, suspicion, plotting. However, this space is circumscribable, since it is confined within the walls of the great chamber that is the theater. (Its unlimited character in the cinema—here the chamber is the camera, but the entire world may be swallowed up in it— makes it impossible to explore these means as a lure for the cinema-spectator.) Thus the limit formed by the edge of the stage is extended to the limits of the space of the stage, this space offering itself as one to be transgressed, passed beyond, through its link with the invisible space offstage.

This transgression is invited, therefore, by that which constitutes its second limit, a radically uncrossable limit, which denies the gaze of the spectator access to the invisible space offstage. Since we have to renounce this second transgression as impossible, all that remains possible is the broadest incorporation of the stage space connoted by the term "illusory," according to which what is incorporated is the opposite of the truth. That is the sense of the second reversal. By a shift of perspective, one might say, from veracity to veridicity, this reversal will affect the unsaid, the unspoken element, of the stage space: its unconscious, invisible problematic which, *qua* non-veridical,

will be caught in the movement of return into its opposite, joining itself to the first reversal, which consists of a turning round upon oneself.[6]

So, whereas the spectacle takes place outside oneself, is alien to oneself, there is constituted the "negative hallucination" of the unsaid of the stage on which all the said is inscribed. The hallucinatory value of representation, which the edge of the stage has materialized by the relation of otherness, both conjoint and disjoint, is inscribed on the opacity of the space offstage in which the false is fabricated. Here the spectator finds himself in a place as metaphorical as that suggested by the appearance of those objects whose repression allows no more than fleeting residues to filter through. They too can be assembled into a constructed scenario. But this construction blocks, so to speak, the view of their original source, where the subject would have to recognize his own silhouette. This is like the negative hallucination in which the subject looks at himself in the mirror and sees all the elements of the setting around him, but not his own image. The impression that one sees without seeing, hears without hearing, speaks without making oneself understood, is also to be found, in a more fragmentary way, in dream space. This is not the result of some deficiency that weakens the living tissue of the dream, making it like a bloodless body—as is shown by the contrast to be found in some dreams between the effect of hyper-reality and the unintelligibility of their messages. The space off-stage frames this "blank" of the stage on which the action is inscribed.

The conjunction of this double reversal makes possible that which is sent back to the spectator as his gaze, refused entry to the space beyond the stage. Out of this refusal is constituted the theatrical space in which outside and inside are no longer meaningful within the enclosure of the two reversals. Yet their two-sidedness—as in the figure constituted by the joining of the double reversal—which was once the expression of the opposition between the theater and the world, has become the opposition in which the spectator is the theater, and also the opposition between the said and the unsaid.

### Text and Representation

Such is the movement of this reading process performed by the spectator—a reading that is never made explicit, but solicited from some other point situated in the potential space between text and representation.

This space defines its objects: words and characters. The characters, heroes and heralds, exist only through what they say. What they say cannot be said in their absence; no one but they can say it. Once again, we are referred back to the text. Even the destruction of the text still leaves a text. Even its abolition in a theater given over to action will refer us back to the notional text implied by the action. What is this text about? It is telling us about a

reason that is the motive-force of the characters and which, by implication, must be ours. And yet, if we are interested in what is being said, it is because at this point an effect is created, not of reason, but of truth. From what point does this truth speak? It speaks from a point in which another reason, an "other reason," is spoken.

This truth is heard with the sense of shock that one feels when made to face something previously dismissed out of hand, regarded as merely improbable, discredited as pure artifice or even trumpery. Phrases like "It's pure theater!" or "How theatrical!" betray the contempt we are supposed to feel for the extravagant pretenses of the counter-truth. The reasons why a spectacle does or does not succeed in achieving its effect, is liked or hated, are obscure. But when it happens, the truth is found not at the center of the stage, but in the flies, where the lighting is placed. For the stagehand who watches the actors from above and from behind the curtain, even the most tragic spectacle is just another show to be put on—*he* has seen it all before. When the truth is present—when the text speaks and when the hero speaks it with veracity— then even the stagehand listens. But if he had to account for this, he would be as much at a loss as the spectator in the front row of the stalls. The comments of the initiate and the connoisseur are no more convincing. Writing about the theater is, generally speaking, mere word-spinning or paraphrase. It throws no light on the spectator's reasons for participating in the spectacle.

We might even suppose that the theater has its effect only in so far as its ways are misunderstood by the spectators. And they cannot but be misunderstood both because of the structure of the subject and because of the unfolding of the spectacle. The moment of truth is so dazzling and so short-lived that it has already passed while one is still waiting for it; or it tricks one's expectations so well that one thinks it has already passed when it is still to come. A reciprocal connection links the terms of a process occurring at two levels. One is that of the spectator's participation in what is taking place before him, which seems to drive the action constantly outside itself, by the very fact of that participation. The other is the internal articulation of the constituent parts that generate, by a logic peculiar to themselves, the ongoing movement of the drama. The paradox of this double process is that the empty place of the spectator is never more clearly seen than when the theater is full—that is to say, when no other spectator can be admitted. This means that the representation can reveal an encounter with a pure testimony through the emergence of something addressed to no one specific person, but to the space occupied by the audience (a locus in constant displacement through its own multifariousness from stalls to gods). This encounter generates the sequence of actions in such a way that they follow on from one another of their own accord, as a result of the tensions that govern their conjunctions and disjunctions. No

reading can be either that of the representation or that of the text, but only that of a text in performance, *in representation*.

## Aristotle and Artaud

Reflection on the theater extends from Aristotle to Antonin Artaud. Aristotle laid down canons that were accepted until fairly recently. The signifier/signified problematic is already to be found in the six elements that Aristotle distinguishes in tragedy. In this respect, the *Poetics* constitutes a composite whole that moves from thematic analysis, an analysis of the fable, to a linguistic analysis whose links with the preceding analysis are never made quite clear.

In his analysis of the fable, Aristotle notes the part played by phantasy and gives it precedence over reality: "It is not the poet's business to tell what has happened or the kind of things that would happen—what is possible according to probability or necessity."[7] The aim is simply to arouse fear and pity; and Aristotle declares, without further explanation that this result is never better attained than when illustrated by relations of kinship: "When sufferings are engendered among the affections—for example, if murder is done or planned, or some similar outrage is committed, by brother on brother, or son on father, or mother on son, or son on mother—that is the thing to aim at" (Aristotle, 35).

The family, then, is the tragic space par excellence, no doubt because in the family the knots of love—and therefore of hate—are not only the earliest, but also the most important ones. But the fable must culminate in a recognition—a passage from ignorance to knowledge. Recognition by representation. The tragic space is the space of the unveiling, the revelation, of some original kinship relation, which never works more effectively than through a sudden reversal of fortune, a peripeteia.

It might be objected that this is taking things too literally. The theater is the art of mimesis. What follows from this? If the theater is the art of imitation—the art of the false, say its detractors—it is because Aristotle sees in imitation a specifically human characteristic: "The impulse to imitate is inherent in man from his childhood; he is distinguished among the animals by being the most imitative of them, and he takes the first steps of his education by imitating. Everyone's enjoyment of imitation is also inborn" (Aristotle, 20). The psychoanalyst is delighted: Aristotle presents him with two of his favourite parameters, childhood and pleasure.

This remark will have a wider implication if one compares it with Aristotle's recommendation to take the bonds formed by kinship as material for the fable. For the climax toward which the fable is tending is recognition, which has its fullest effect only when it is wholly bound up with the sudden reversal of the action in the peripeteia. If we acquire our earliest knowledge through imitation, and if the passage from ignorance to knowledge (recogni-

tion) is effected by a sudden reversal, may we not think, from a more modern standpoint, that it is a question not so much of imitation as of identification? This sudden reversal would appear to center on the relation of identification and desire, on the one hand, and, on the other, on the bipartite function of identification, since it is an identification that contradicts the two terms of the parental couple. (And this more especially because catharsis presupposes identification, since its true meaning is not a purification of the passions, which is a Christian interpretation of tragedy, but the treatment of emotion by emotion, with the aim of discharging it. However, this discharge must not be conceived as some kind of antiphlogistic effect, since its action is more in the nature of an "assuagement accompanied by pleasure," which implies a participation in which the Other[8] is involved.)

The series of examples given by Aristotle of kinship relations depicted in tragedy says nothing about any action between the parents, or about the effect of the father on his children (only the reverse case is cited). This is a strange omission in a text that refers so often to Orestes and Iphigenia, yet ignores the nature of the relations between their parents.

At the level of the signified, the kinship-relations model seems most effective in the matter of mimesis. At the level of the signifier, Aristotle observes that by far the most important thing is to excel in metaphors (Aristotle, 50). My remarks below are freely based on Lacan's notion of the paternal metaphor. It is a happy chance that links the kinship relation to metaphor. It is as if the kinship relation were metaphorical of all the others—and, within it, in the shadow in which Aristotle keeps it, the relation that unites the parents or the relation that expresses the effect of the father on his children to an even greater degree than the others; as if metaphor, at the level of the signifier in poetic creation, rediscovered at the level of language the creation about which the parental metaphor implicitly speaks.

A fable centered around kinship relations indicates not what has been but what might have been, as if it had occurred as the myths recount it. Dramatic art embodies these myths in speech. All theater is embodied speech. The tragedy of Oedipus is impossible; how can the life of a single man pile up such a set of coincidences? It is not for the psychoanalyst to answer; but rather for the countless spectators of *King Oedipus,* who might say, with Aristotle, "a convincing improbability is preferable to what is unconvincing even though it is possible" (Aristotle, 58).

In a prophetic text that is now more than thirty years old, Artaud calls for "an end to masterpieces." As a true man of the theater, his concern is with the recipient of the work, the public. In the name of the public, Artaud demands the right to be involved, to be strongly affected. He does not hesitate to condemn and even to sacrifice on the altar of the theater works of

genius that no longer work today. "And if, for example, the masses today no longer understand *King Oedipus,* I would venture to say *King Oedipus* is at fault as a play and not the masses."⁹ Artaud is looking for a way by which we might recover the tragic *phobos.* If the appearance of the blinded Oedipus does not make us flinch, if it is powerless to arouse in us an emotion as violent as that which it aroused in the Greeks, if we are no longer capable of going into trance before such a vision, then we can only conclude that the representation of tragedy has become inoperative and that it must be dropped from the repertoire. We must rediscover the ways in which a relationship of enchantment and possession was created between a spectacle and its spectator. We must demand that theater, to use his image, should affect us as music affects snakes, by a shudder that strikes us first in the belly and runs through our whole body. At the risk of our having to burn Shakespeare, Artaud calls for the advent of a theater of flesh and blood.

How can we not approve of Artaud's intentions if it is a matter of giving back life and participation to the audience at a theatrical festival, so that new blood can flow once more in its veins? But what Artaud demands is more radical. He wishes to face the modern spectator with something in which the intelligibility of the spectacle is no longer, as in the past, related to its emotional resonance. He aims to provoke in the theatrical event, at any price, a *frisson* that shakes the spectator out of his passivity, out of the softening seduction that anesthetizes him by way of the pleasant, the picturesque and the decorative. The theater of diversion must give way to a corrosive theater that will gnaw away at the shell that is constricting it and give us back a forgotten aspect of the spectacle. This is the theater of cruelty.

Artaud often had to explain what he meant by "cruelty." It was far from any notion of sadism or bloody spectacle. One has only to read the "Letters on Cruelty" and the two "Manifestos" on the theater of cruelty to understand that it involves something quite different. Artaud's revolt was no mere gesture: it aims at getting a particular result. This result is the restoration of a world always present in man, but covered up, buried—whose resurrection the spectator must live through. Artaud's virtue is that he gave back to the poetic world its face of carnal violence. It is a theater that challenges verbal language, that appeals to a physicality of signs, to their cumulative effect, to their intensive mobilization around gestures and around the voice, which passes beyond the ordinary expressive range of speech. What the spectator sees must be totally absorbing, what he hears profoundly disturbing—an effect produced by the strangeness of the masks, the disproportion of their forms and the suddenness of their appearance. He alludes to dreams on several occasions, but always in a sense far removed from the sentimental affectation that usually accompanies writing on art and much closer to Freud's:

If theater is as bloody and inhuman as dreams, it is . . . to demonstrate and to confirm in us beyond all forgetting the idea of a perpetual conflict, and of a spasm where life is cut through at every moment; where the whole of creation rises up against our state as finished beings. It is to give permanent, concrete and everyday form to the metaphysical sense of certain fables whose very atrociousness and vigour suffice to show that their source and meaning derive from essential principles. (Artaud, 140–41)

It is not a matter of rejecting language; we must seek "a directly communicative *language*." Artaud rejects the form of speech that wants to subordinate all forms of communication to the "intellectual dignity" of grammatical articulation, as a necessary condition of the circulation and exchange of meanings.

Can we even base a theory of writing on Artaud? The letter to Paulhan of 28 May 1933, which I quote, is evidence rather that Artaud attributes "the ossification of speech" to the fact that the theater, which reflects this degeneration, reduces speech to the level of writing, attributes the same value to the written and spoken word.

Western theater only acknowledges as language, only allows the properties and qualities of language, only permits the name language to be applied (with the sort of intellectual dignity generally attributed to the word) to articulated language, grammatically articulated: that is to say, to spoken or written language, speech which whether spoken or not has no value greater than that of the merely written language.[10]

This reintroduction of the dimension of the body, this vibration of the organic, does not abolish language, but reestablishes language at its sources. For Artaud, these sources are quite unambiguously physical. To "make grammatical" is to control this movement between bodily sources and objects of representation, at their points of intersection, where they form a network in which they can give rise to one another, come together to form unstable, but nevertheless pregnant matrices of meaning, subject to a certain order. This order cannot fail to make its presence felt: it cannot entirely dominate the material on which it works. It suggests what such an order in the modes of syntactic connection might be, but leaves out of account their relations of subordination. For Artaud, as for Freud, language is the completion of that other "pre-language," to which many modifications must be made before it can be truly given the name.

. . . To reread the "Letters on Cruelty" is to see that there is a kinship between Freud and Artaud that goes well beyond the limited question of the dream, and which extends to the much more general plan of the antagonism

between the life and death drives in the relations that he adumbrates between good and evil.

What Artaud calls evil is what corresponds in Freud to that silent activity of the death drive, which one never actually grasps, but encounters only in the processes in which it is linked with Eros. Cruelty is the process of this fusion. Eros shows us that the process of connection, in so far as it has already appropriated the destructive force of death with no return, remains marked by this exclusion of the silence of death and has erected over its ruins ever larger built-up areas. Eros does not save death, does not simply stand as an adversary confronting it; it incorporates its destructive force as a force of possession aimed at whatever opposes its expansion:

> I use the word cruelty in the sense of hungering after life, cosmic vigour, relentless necessity, in the Gnostic sense of a whirlwind of life eating up the shadows, in the sense of that pain, apart from whose inescapable necessity life could not continue. (Artaud, 155)

Artaud speaks in terms that Freud would not reject, of that kernel "ever more and more reduced, more and more eroded," of everlasting evil. The silence of the death drive, the absence that denies us any direct grasp of its manifestation, its access being only retrospective and deductive, is clearly indicated in the following lines:

> The desire for Eros is cruel since it consumes contingencies. Death is cruelty, resurrection is cruelty, since in all directions within a circular enclosed world there is no room for the true death, since ascension is a rending, finite space feeds on lives, and every stronger form of life passes through the others, and so eats them in a massacre that is a transfiguration and a good. . . . Cruelty causes things to coagulate, causes the plans of the created to form. (Artaud, 157)

Artaud's tragic quality derives from the fact that the monster of his visionary endeavor devoured its author. Abandoned or misunderstood by his best friends, who faded away at his approach, he himself seems to have been unable to bear the determination that he demanded and desired. The further he advances in his project, the more identification with the process of creation gives way to identification with the creator as the agent, rather than the actor, of his creation. The further away one seems to move from the principle of submission to the higher determinism that governs the individual who practices the act of cruelty, the more imperious becomes the wish for a proclamation in which Artaud claims to be not only each of his progenitors, but the product of the generation or the single progenitor engendering himself.

> There is in the cruelty that we practise a kind of higher determinism to which the executioner-torturer is himself subjected and which he must be *determined* to endure if the time comes. . . . The hidden god, when he creates, obeys the cruel necessity of creation that he has imposed on himself. (Artaud, 154–55)

At this point Artaud tries to get round the difference between the sexes that he inevitably meets on this road. To remain in the neuter is a temptation impossible to satisfy; the body has become the theater of the struggle between the masculine and feminine. The lure of a direct access to what is hidden by repression through an approach that would no longer be deductive, but provocative, was to lead in Artaud to a possession of his body as a space of exploration and transformation, a locus of attentiveness and receptivity where only shadows move, and in which he was to find the true, absent death.

> First the belly. Silence must start in the belly, left, right, at the spot where hernial swellings occur, where surgeons operate. . . . To know in advance what points of the body to touch is to throw the spectator into magic trances. (Artaud, 223 and 206)

This localizing knowledge, with its inductive power, will now coincide with the incorporation of the space of the dream by the dreamer:

> I cry out in dreams
> But I know I am dreaming;
> My will-power prevails
> On *both sides of the dream*.
> (Artaud, 223)

Derrida has rightly pointed out that the force of Artaud's assault is "against the abusive wielder of the logos, against the father, against the God of a stage subjugated to the power of speech and text" (Derrida, 47, above—ED.). The first manifesto of the theater of cruelty already indicated the direction of a movement that substitutes, for the duality of author and director, "a kind of sole creator on whom falls the double responsibility both for the play and for the action" (Artaud, 142). From now on the father was challenged only to have his place usurped in the celebration of a unique, non-repetitive, ephemeral spectacle.

The localization of "both sides of the dream" appears to express the imperceptible transition that turns the mere intention to follow the principle determining all creation into an ever more autonomous, demiurgic creativity, as Artaud became increasingly aware of the experience of the body, which provides the key for the forging of the magic chain by which every effect is

produced: "To be familiar with the points of localization in the body is to reforge the magic links" (Artaud, 206). It is to center the site of the unique creator in the empty zone from which all space extends outward. The vacuum of the body has now taken over a place homologous with the one Artaud once assigned to evil. But it is as if, as soon as this void was named or its limits fixed, it was bound to concentrate its own strength around it and hold on to it—having become an "asphyxiated void." The phallus forbids access to it.

> Yet, this is the secret, as *in the theater*. The power will not flow outward. The active masculine will be forced in upon itself. And it will retain breathing's forceful will-power. It will retain it for the body as a whole, while outwardly there will be a picture of the disappearance of strength which the *senses will believe they are witnessing*. (Artaud, 221)

The effect of theatrical illusion is no longer that liberating expansion, that communicative flame that fires the audience; it is the process of evaporation of those things we were looking at, which are suddenly not there in the space of the stage. That is why Artaud calls on the spectator to forge that magic chain in which we now have to find the sequence of the images of an unconscious problematic.

### The Post-Freud Theater

The failure of the theater of cruelty is perhaps less important than the effect it had on the theater that survived. Even if contemporary drama cannot legitimately be said to be part of Artaud's prophetic vision, is it not the main thing that we have the new mobilization of the emotions that its creator demanded? An art of entertainment, of the picturesque or of decoration is giving way to productions that have a less seductive effect on the spectator.

Artaud's views counterbalance Aristotle's condemnation of the improbable, the uselessly wicked, the contradictory, the opposite of the requirements of art. All that Aristotle condemns, contemporary theater has made its guiding principles: theater of cruelty, theater of disjointed language, theater of the cry, theater of unease and theater of disturbance. This is our theater: the theater in our image. But, in the final analysis, is not all theater, simply by virtue of the fact that it is a field vectorized by desire, a theater with the characteristics listed by Aristotle? It is a question to be asked. It would be too simplistic to link it to the anxiety of the modern world, for the world has lived through other periods at least as anxiety-ridden as our own. It would be more correct to say that it is the post-Freud theater. A theater of desire, a theater of the primary process, which tends towards discharge (hence the role of spontaneity, of the cry, of crisis), which is ignorant of time and space (theater of

ubiquity and nontemporality), which abandons the requirements of logic (theater of contradiction) and, lastly, a theater of condensation and displacement (theater of symbolization).

This non-Aristotelian theater could not fail, therefore, to be connected with a Freudian theater. "Freudian" does not mean a theater that presents the discoveries of psychoanalysis, but a theater that depicts the processes whose formal characteristics Freud has stated.

But it should be noted that although the distance to the affect is here reduced to a minimum, eliminating anything that could be an obstacle to personal reception, the reasons why we feel involved in the spectacle are still as opaque as the reasons why we feel moved by Sophocles or Shakespeare. What, then, becomes of Aristotle's recognition? Is it possible to say that a concern with recognition has been banished from our stage? This would be to deny that contemporary drama centers on the same fundamental obsessions that constitute the object of psychoanalytic investigation. This preoccupation supports my belief that a limited number of fables or myths serve as models and have the power to produce the variation that demonstrates the link with the underlying theme, constantly giving proof of their richness "in essential principles," as Artaud says.

However, the more direct the approach, the more clouded the horizon against which it stands out, the more the reward of pleasure offered to the spectator has to be paid for by an equal measure of anxiety, as if to keep at bay any clear view of the underlying theme.

It is as if the mutation produced by the Aristotlian notion of "recognition" has, by reducing the relation between ignorance and knowledge to a simple echo-relation lacking in true revelatory power, completely permeated the new formal peculiarities of contemporary drama. The modern theater has found forms capable of expressing a type of signification quite different from that of the classical tradition, and closer to the unconscious. But behind this apparent progress, the meaning that emerges in this context seems like a miraculous effect, without explanatory force, referring only to itself, finding in itself the motives and effects of its action. The modern theater has dealt with themes even more subject to taboo than those of ancient tragedy, and more evocative of the unconscious; but the emotional shock felt by the spectator is accompanied by no explanation as to why the representation produces this shock. This taste for strange and powerful emotions seems to testify to a desire for immunization, rather than for greater understanding. So it is left to science, through the exposition, even the diffusion, of psychoanalytic and other texts, to explain at the theoretical level the syntax of this discourse, provided that a respectful distance is kept from the work of art.

. . . What we can say, however, is that there is a pre-Freudian and post-Freudian way of listening to the unconscious. The entry of psychoanalysis into the world of culture produced a change in the relation between the implicit and the explicit. Yet this new situation has in no way altered the link between the work and its effect so far as the passage from ignorance to knowledge of the unconscious is concerned. Far from shifting our attention away from the works of the past, these changes seem to bring us back to them. The sense of this return would seem to be one whereby a work not only speaks directly, but also, in the absence of any other source, provides knowledge. "In *King Oedipus*, there is the incest theme and the idea that nature does not give a rap for morality. And there are wayward powers at large we would do well to be aware of, call them *fate* or what you will" (Artaud, 114). It is the privilege of masterpieces to be embodiments both of the power of the signifier and of the power of the forces that work upon it, to be the product of the work of the contradictions that they set in opposition. In the period we are discussing, there was no gap, such as exists today, between the discourse of works of art and the knowledge that science is articulating elsewhere, on another plane, so we are at least spared intellectual double vision. The import of the work is inexhaustible; it is not to be discovered through some vain attempt to get at an underlying reality by brutally tearing away its aesthetic veils.

The aim of a psychoanalytic reading is the search for the emotional springs that make the spectacle an effective matrix in which the spectator sees himself involved and feels himself not only solicited but welcomed, as if the spectacle were intended for him. Once this matrix is identified, it is necessary to analyse the elements that combine to make the recognition intelligible. The recognition is presented in a shifting mode, moving from ignorance to knowledge—whether on the part of the hero or the spectator—and remains opaque until we have unravelled the complexities of the means by which the opposed or collaborative forces have pierced the wall of repression. This penetration undermines the apperception of the spectacle, which then passes from the plane of overt monstration to that of a covert demonstration, whose different stages must be reconstituted.

## Toward a Psychoanalytic Reading of Tragedy

What right has the psychoanalyst to meddle in the business of tragedy? Freud proceeded with extreme caution in his search among the common stock of culture for examples of the expression of the unconscious. Today, when psychoanalysis is less concerned to seek validations outside its own field of practice, is it still proper to seek material for interpretation in works of art?

Many people, including some psychoanalysts, believe that the period must now end in which psychoanalytic investigation turned to cultural productions, myths of works of art, to provide evidence for a possible mapping of the unconscious outside the domain of neurosis. Psychoanalysis has provided enough proof of its scientific character, and ought to confine its efforts to the strict framework, defined by its own rigorous parameters, of psychoanalytic treatment. The view is well founded; the field of psychoanalysis will always remain the locus in which the exchanges between analyst and analysand unfold. When the analyst ventures outside the analytic situation, in which he is in direct contact with the unconscious, as it were, he must proceed with caution. The work of art is handed over to the analyst; it can say nothing more than is incorporated in it and cannot, like the analysand, offer an insight into the work of the unconscious *in statu nascendi*. It cannot reveal the state of its functioning through the operation that consists in analysing by free association—that is to say, by providing material that reveals its nature in the very act by which it makes itself known. It does not possess any of the resources that make analysis bearable: that of going back on what one has said, rejecting the intolerable connection at the moment when it presents itself, putting off the moment of an emerging awareness, even denying, by one of the many ways available to the analysand, the correctness of an interpretation or the obviousness of some truth brought by repetition to the front of the stage and needing to be deciphered. The work remains obstinately mute, closed in upon itself, without defences against the treatment that the analyst may be tempted to subject it to.

It would be illusory to believe that one can use a work to provide proof of psychoanalytic theories. Psychoanalysts know that this enterprise is vain, since no degree of consciousness can overcome unconscious resistance. In certain cases, it happens that a fragment of psychical reality manages to overcome repression and seems to emerge with exceptional ease. One then has regretfully to admit, powerless to do anything about it, that the effect is usually followed by a reactivation of the psychical conflict of which this fragment is an integral part. Persuasion, whatever those unacquainted with psychoanalytic experience may think, has never been one of the analyst's instruments; however much he is tempted to use it to get himself out of some impasse in a difficult case, its use will always prove disappointing. The same can be said when the analyst presents the results of his analytic work on some cultural object. If he does not stay close enough to the lines of force that govern the architecture of his object, the truth that even a partly correct analysis contains runs a strong risk of not being recognized, for all its rightness, because the factors opposed to crossing the barriers of the censor find solid support in objections which, though superficial, are reinforced by

rationalization. It is therefore particularly necessary to be vigilant in the account of any such investigation. In psychoanalytic treatment, the repetition compulsion again and again offers to disclose the meaning of a conflictual organization, which one can then approach in a fragmentary way. In the analysis of a work of art, everything is said in a single utterance by whoever assumes the task of interpretation, and no inkling is given of the long process of elaboration that has made it possible to arrive at the conclusions now advanced in connected form.

These few remarks are not intended to reassure those who fear the intrusion of psychoanalysis into a domain in which it could have a restricting effect. No interpretation can avoid constraining the work, in the sense that it necessarily forces it into the frame provided by a certain conceptual approach. The work may then be seen from a different perspective, with a new meaning that enlarges it by inserting it in a wider frame of reference. To speak is above all to choose this restricted economy within the enclosure of discourse, in order to give oneself ways towards a development that is impossible if one says nothing.

. . . In the last resort, what people fear most of all about the psychoanalyst is the threat that he will apply some pathological label to the creator or his creations. The keywords in the psychoanalytic vocabulary—though they have value only when placed in the structural ensemble from which they derive their coherence—continue to intimidate; no one feels secure from the unpleasant feeling he would have if, unexpectedly, this vocabulary were applied to him. In our time, this fear has taken on a curiously paradoxical form. We all talk about the pervert and proclaim our potential brotherhood with him; but the mere mention of the word "normality" is ruthlessly pounced on and denounced. Yet the psychoanalytic texts never postulate a norm—analysts have been attacked enough by physicians and psychiatrists for doing just that—except as a relative term that must be posited somewhere if we are to understand differences of degree or gradations between one structure and another. Resistance to psychoanalytic terminology makes itself felt as soon as it emerges from an unthreatening world of generalization, a world in which its resort to metaphorical terms allows us to harbor the secret hope that we are dealing with the language of some new mythology. It is easy to forget that psychoanalysis has been persecuted precisely for abolishing the frontiers between health and illness and showing the presence in the so-called normal man of all the potentialities whose pathological forms reflect back a magnified, caricatural image. It was Roland Barthes who wrote this condemnation of traditional criticism: "It wishes to preserve in the work an absolute value, untouched by any of those unworthy 'other elements' represented by history and the lower depths of the *psyche:* what it wants is not a constituted work,

but a *pure* work, in which any compromise with the world, any misalliance with desire, is avoided."[11] These remarks can be applied to a good deal of the new criticism, or to those upholders of a theory of writing who defend a sort of literary absolutism.

When a psychoanalyst enters the universe of tragedy, it is not to "pathologize" this world; it is because he recognizes in all the products of mankind the traces of the conflicts of the unconscious. And although it is true that he must not, as Freud rightly remarked, expect to find there a perfect correspondence with what his experience has led him to observe, he is right in thinking that works of art may help him to grasp the articulation of actual but hidden relations, in the cases that he studies, through the increased distortions that accompany the return of the repressed. Freud never thought that he had anything to teach gifted creators of authentic genius, and he never hid his envy of the exceptional gifts that allowed them, if not direct access, at least considerably easier access to the relations that govern the unconscious.

The exploitation of these gifts is directed towards obtaining the "bonus of pleasure" that is made possible through the displacements of sublimation; this would tend to establish a relation of disjunction between the product of artistic creation and the symptom. For the first has the effect of negating the action of repression; but the second, because it is the expression of the return of the repressed, erupts into the consciousness only after paying the entrance fee of displeasure at the prohibition of satisfaction. Satisfaction, then, is indissolubly linked to the need for punishment associated with the guilt engendered by desire, whose symptom thus becomes its herald. The satisfaction of desire cannot be separated from submission to the sanction of the prohibition that weighs upon it.

This difference between symptom and creation now makes it possible to indicate their resemblance, if not their similarity. In both symptom and creation, the processes of symbolic activity are at work, as they are also in the dream or the phantasy. So artistic creation, "pathological" creation, and dream creation are linked by symbolic activity, their difference being situated in the accommodation that each offers to the tension between the satisfaction bound up with the realization of desire and the satisfaction bound up with the observance of its prohibition. Neurosis, Freud would say, is the individual, asocial solution of the problems posed to the human condition. At the social level, morality and religion propose other solutions. Between the two, at the meeting point of the individual and society, between the personal resonance of the work's content and its social function, art occupies a transitional position, which qualifies the domain of illusion, which permits an inhibited and displaced *jouissance*[12] obtained by means of objects that both are and are not what they represent.

Breaking the action of repression does not mean exposing the unconscious in all its starkness, but revealing the effective relation between the inevitable disguising and the indirect unveiling that the work allows to take place. The unconscious sets up a communication between a sentient, corporeal space and the textual space of the work. Between the two stand prohibition and its censor; the symbolic activity is the disguise and the exclusion of the unacceptable, and the substitution of the excluded term by another less unacceptable one, more capable of slipping incognito into the area that is closed to it. Indeed, if every text is a text only because it does not yield itself up in its entirety at a first reading, how can we account for this essential dissimulation other than by some prohibition that hangs over it? We can infer the presence of this prohibition by what it allows to filter through of a conflict of which it is the outcome, marked by the lure it offers, calling on us to traverse it from end to end. We shall often feel a renewed disappointment, faced by its refusal to take us anywhere except to the point of origin from which it took its own departure.

## The Trans-narcissistic Object

The products of artistic creation are evidence of work. Every examination of them travels, however briefly, the route of their birth. These products set up in the field of illusion a new category of objects related to psychical reality. Their relation with the objects of phantasy enables us to understand their function more clearly. The objects of phantasy, which, on their admission to consciousness, had to undergo distortion and adjustments to make them compatible with conscious logic, remain, as I said above, occult; the reticence of their message testifies to the precariousness of this cover. But the veil that hides them also corresponds to another requirement. They are an integral part of an equilibrium in which the realizations of desire that are carried out through them are inseparable from a condition of appropriation by the subject, which is necessary to feed his narcissistic idealization. The unity of the phantasy is inseparable from the narcissistic unity that it helps to form. The types of objects to which artistic creations correspond are on the other hand characteristically objects of ejection, expulsion: objects put into circulation through disappropriation by their creator, who expects their appropriation by others to authenticate their paternity. The upsurge of desire that gave them birth is repeated at each new reception. This enables us to map out in such productions the narcissistic double of their creator, which is neither his own image, nor his own personality, but a projected construction, a configuration formed in place of the narcissistic idealization of the recipient of the work.

Thus the structures of phantasy face in two directions. First, towards the object, they sustain desire and help to form whatever serves in fulfilling it:

dream, symptom, or sexual activity—the means placed at the disposal of the discharge and the channels open to it. Second, they serve the search for an idealizing subjective unit involving the renunciation of the satisfaction of a complete discharge (aesthetic *jouissance* being subjected to the inhibition of the aim of the drive), but in which the narcissistic construction of the other is accepted. So the objects of artistic creation may properly be called *trans-narcissistic:* that is to say, they bring the narcissisms of producer and consumer into communication in the work. The communication of the two fields of this double orientation will give us a clue to whatever may arouse, as an after-effect, the desire phantasy, through the mediation of this narcissistic idealization.

The psychoanalytic approach to the work of art need not involve a study of the personality of the artist, but there is no need to exclude the possibility. It is enough to be aware of this narcissistic construction that is the artist's double, and to seek to map out the points of impact at which the desire phantasy is set in motion, even if this phantasy inevitably fails to satisfy its recipient. But, through the disjunctions so revealed, we may posit hypotheses concerning the mode of articulation that holds its parts together. . . .

Our aim, therefore, is to rediscover, in a work whose specific nature is the labor of representation unfolding according to its own procedures, an analogue of what Freud described in his first intuitions about the functioning of the psychical apparatus. This process is the play of a pluri-functional system, which never progresses continuously and in a single direction; it goes back over inscriptions that have already been traced and slides away from obstacles; it reproduces its message with a distortion that forces us back to it; receives some new impulsion that overcomes a resistance; or breaks into fragments. It recomposes these dissociated fragments into a new message incorporating other elements from another fragmented totality, preserving at the essential level that nucleus of intelligibility without which no new crossing of the boundary can be made. It preserves itself from annihilation and consequent oblivion by a protective distortion which prevents it being recognized. The work of representation, which unceasingly maintains an effect of tension in the spectator, is the reconstitution of the process of formation of the phantasy, just as the analysis of the dream, through the resistance to the work of association and to the regroupings that this work operates, replicates the construction of the dream process.

This brings us, then, to our object: the psychoanalytic reading of a tragedy, a reading situated in the potential space between text and representation. Here a question inevitably arises: how are we to understand the *jouissance* felt by the spectator of a tragedy, when the spectacle arouses pity and terror? This question brings us back to Aristotle's problem, for which Freud tried to provide a new answer. The work of art, says Freud, offers an

"incentive bonus" to whoever experiences it. "We give the name of an *incentive bonus,* or a *fore-pleasure,* to a yield of pleasure such as this, which is offered to us so as to make possible the release of still greater pleasure arising from deeper psychical sources."[13] There is a discharge, then, but it is a partial discharge, desexualized by aim-inhibition and displacement of sexual pleasure. But we still have to account for the effect of tragedy.

How may we extend or replace the hypothesis of catharsis as a purging of the passions? Tragedy certainly gives pleasure, but pleasure tinged with pain: a mixture of terror and pity. But there is no tragedy without a tragic hero, that is, without an idealized projection of an ego that finds here the satisfaction of its megalomaniac designs. The hero is the locus of an encounter between the power of the bard, who brings the phantasy to life, and the desire of the spectator, who sees his phantasy embodied and represented. The spectator is the ordinary person to whom nothing of importance happens. The hero is the man who lives through exceptional adventures in which he performs his exploits, and who, in the last resort, must pay the gods dearly for the power he acquires in this way. Becoming a demigod, he enters into competition with the gods, and so must be crushed by them, thus assuring the triumph of the father.

The spectator's pleasure will be compounded of his movement of identification with the hero (pity, compassion) and his masochistic movement (terror). Every hero, and therefore every spectator, is in the position of the son in the Oedipal situation: the son must become (move toward being) like the father. He must be brave and strong, but he must not do everything the father does. He must show proper respect for the father's prerogatives (his *having*), namely those of paternal power, sexual possession of the mother, and physical power, the right of life and death over his children. In this respect, the father, even when dead, indeed especially when dead, sees this power still further increased in the beyond: totem and taboo.

Tragedy, then, is the representation of the phantasy myth of the Oedipus complex, which Freud identified as the constitutive complex of the subject. Thus the frontiers between the "normal" individual, the neurotic, and the hero became blurred in the subjective structure that is the subject's relation to his progenitors. The encounter between myth and tragedy is obviously not fortuitous. First, because every history, whether it is individual or collective, is based on a myth. In the case of the individual, this myth is known as phantasy. Second, because Freud himself includes myth in the psychoanalytic field: "It seems quite possible to apply the psycho-analytic views derived from dreams to products of ethnic imagination such as myths and fairy-tales" (*SE,* 13:185). (In his study of the structure of myths, Lévi-Strauss refers to the myth, without further explanation, as an "absolute object.") Freud rejects the traditional

interpretation of myths as mere attempts to explain natural phenomena, or as cult practices that have become unintelligible. It is highly likely that he would have much to say about the structuralist interpretation. For the essential function of these collective productions was, in Freud's view, the assuaging of unsatisfied or unsatisfiable desires. This is my interpretation too; it finds support in the foundations of the Oedipus complex, which forbids parricide and incest and so condemns the subject to seek other solutions if he is to satisfy these desires. Tragedy is, at a collective level, one of these substitute solutions. The psychoanalytic reading of tragedy, therefore, will have as its aim the mapping of the traces of the Oedipal structure concealed in its formal organization, through an analysis of the symbolic activity, which is masked from the spectator's perception and acts on him unknown to himself. . . .

## Writing and Representation

We often hear it said that the work cannot be reduced to its significations. The constitution of the signified by the action of the signifier is undoubtedly its essential nature. That which seems to elude psychoanalytic investigation forces us here to recognize its limits. But it is often a study of the latent signified, the relation of the manifest to the latent, that is most likely to throw light on the form of the signifier at any given point. In the long succession of signifiers in linked sequence which constitutes the work, the unconscious signified rises between two signifiers from the gulf or absence in which it resides and determines the difference between the "natural" form of discourse and its literary form—not in order to express what has to be said, but in order to indicate, by veiling it, what needs to be hidden.

My constant concern will be to show the double articulation of the theatrical phantasy: that of the scene, which takes place on the stage, and is given an ostensible significance for the spectator; and that of the other scene that takes place—although everything is said aloud and intelligibly and takes place in full view—unknown to the spectator, by means of this chainlike mode and its unconscious logic.

But where does the operation of writing enter into this? This, it might be objected, is where the specificity of the work is to be found.

What about Aeschylus, Shakespeare, and Racine as writers? This brings us to some of the crucial questions of contemporary criticism. In literature, should we allow privilege to the signifier or the signified? Why, for whom does one write? Put like that, the question cannot be answered. Signifier and signified are *relata* that necessarily refer back to one another, since the segmentation of the one cannot but affect the other by the same division. What is at issue, then, is not so much which has precedence over the other as the nature of the relation between them.

The resistance to the signified that is becoming so strongly marked in the present state of criticism is a sign of rejection and mistrust. Because it has for too long been linked with "psychology," the signified has, so to speak, run out of breath. It is obvious that the work is not merely the signified that it overlays: it is the work of formalization without which there can be no work of art, but merely an expression of intention. If the work were merely what it signifies, what difference would there be between writing as literature and the writing of a treatise on psychology, a political manifesto, or an advertising brochure? But this reference back to the specificity of the literary conceals a suspicion about the signified—especially, as I have said, if this signified is that of psychoanalysis.

It has recently been objected that psychoanalysis has turned away from "the becoming literary of the literal."[14] The originality of the literary signifier appears to have been misunderstood by psychoanalytic criticism, which, for the most part, remains an "analysis of literary, or rather, non-literary signi-fieds." Although it is true that literature sets out to be an exploration through the practice of the possibilities of language, it stumbles sooner or later upon the unspoken aspect of the work, on what we now call its "unreadability," as the navel-cord from which it draws all its strength. Nothing appears to be external to this writing, whose links with representation have been undone. But what if writing *is* representation, as in the theater? Do we not find here a defeat for that ambition, always present in non-theatrical literary forms, the ambition to be free of all direct reference to representation? It is facile to say that a literary statement can only refer to the whole body of other statements. This evident fact is meaningful only because every text demonstrates in this way the distance between itself and its object, in the process of once more traversing that distance. The object at which it is directed can never be embodied in any text; yet what emerges from this confrontation is not an endless dizzy round of texts, but the absence that inhabits them all. This is the absence of the work summing up all other texts, and canceling them out by occupying the space of the written text, which has no difference, which is unique, which recovers the unity of the past and renders all further effort vain. This body of the letter is distilled from the text only to return to it in the representation of the nature and elements of writing. (And if there is a whole literature exploiting the artifices of representation, punctuation, layout, and the addition of non-written signs, is it not precisely in order to displace one kind of unsaid and replace it by another? If one wishes to serve the text, one must first ask oneself in what service the text is supposed to be acting. To whom does the text speak? Who speaks through the text?) This is proof, if proof were needed, that the process of literature is not to become the stigmata of the relation between writing and representation, but to establish the rela-

tion between two systems of representation, writing's system of representation being unable to take any other way than that of the representation of the nonrepresented in representation.

There is much to be said about this operation of the non-represented: this book is an attempt to say something about it. But it should be clear that it is in the *absence of representation* that this operation is carried out and not in a deliverance from representation. The way in which certain literary "integrists" make use of Freud's writings does not always reveal a clear understanding of them. If one wishes to refer to a "trace," rather than to a signifier/signified opposition, how can the trace obstruct every relation with representation—even in the diastem, the spacing and the difference that call it into being? The confusion between the unrepresentable and the non-represented seems to be the source of errors of interpretation. Not that the two are unrelated. The non-represented refers us back to the sense of lack that obtrudes in the "too full" of any representation; in its plenitude, this representation tries to block the outlet, because it is itself the result of the pressure of this lack, which can still be traced in it. The fact that this lack is at the origin of the unrepresentability of the process of writing refers back all the more inevitably to the non-representable, because it is blocked, of the non-represented. The trace maintains itself between the threat of being worn away—so causing the collapse of the whole signifying system—and its own persistence, which is revelatory of its nature, if only through reference back to all the other traces of the thing that it reveals or rather distorts as it unveils. This revelation is not continuous with its own nature, but is caught up in another web, in another texture. "In its implications the distortion of a text resembles a murder: the difficulty is not perpetrating the deed, but getting rid of its traces" (*SE* 23:43). The great virtue of the concept of "trace" is that it provides an opposition to the notion of language as a presence in itself: for it points to an absence in language. It is this absence inhabiting language that is revealing; without being confused with a materialization of the lack, absence conveys the lack in its effect and makes it possible to sustain a discourse on this absence not to cement the identity of absence and non-existence.[15]

Yet, despite the many attempts to eliminate it from discourse, one still finds representation elsewhere, for instance in ideology, short-circuiting the individual signified. The desire to prevent creative subjectivity from being a fetish and to merge writing into the impersonality of the revolutionary movement is praiseworthy enough in its modesty. It shows us above all that "readability" is easier when, overleaping several mediations, it is dissolved in the social body. If psychoanalysis, in centering its attention on the signified, has overleapt the mediations of the literary, we have now to say that literary "integrism," forced by its own process to challenge a literally repressed signified, conceives

no mediation between literature and ideology. Despite its overt professions, this "integrism" reduces the value of the passion of writing, of reading and of the power of repetition to engender both the process and the challenge to it. It falls into the same willed search for "lucidity" that it condemns elsewhere. It thus cancels itself out, in the sense that it is its own debtor. What I deprecate in this approach is not, therefore, that it neglects the signified, but that it adopts too readily the thesis of an elusive signified. The unsaid is the absence of the signified, not its ungraspability. The effect of this absence is the condition of the investment produced by what the counter-investment keeps separate. In this respect, literary exchange is, like all exchange, an exchange of desire, with a view to a deferred, postponed *jouissance*.

The originality of the literary signified can only reside, therefore, at our level of exploration, in the literalness of the unsaid of the signified. This unsaid, whose effects are displaced on the occasion of the conjoint reading-writing of the literary product (since all writing is a reading and vice versa), will be established by a study of the relation between the manifest signified and the difference between the literary signifier and the ordinary signifier. This difference has the function of introducing the effect of deception by which the web of the latent signified is attracted, caught and held in its network. But this attempt never manages to make the two planes coincide, and, at each writing-writing, the project fails and the difference is unveiled in the substitution in which something else is revealed. It is the constantly renewed and never successful attempt which replicates the difference between the ordinary signifier and the literary signifer (a difference that is supposed to imprison what refuses to be named in the manifest) through the genre, construction, and organization of the work. Repetition hollows out the bed in which this disparity must be filled and, by rendering it more perceptible, apprehends it. Theatrical representation multiplies this difference between the ordinary signifier and the literary signifier by stressing all the non-literary signifiers, the physical means at the disposal of the actor: prosody, phrasing, use of the body, which are here not only seen but exploited—one can see how it is, in fact, almost as much a duplication of difference as an increase of it. It is this time lag in the oppositions between the signifiers of language (ordinary and literary) and the non-linguistic signifiers that serve, as it were, as a transmission belt for another duplication, that of the opposition between the spoken words of the play and its staging in scenes, acts, and so on.

## The Other Side of the Oedipus Complex

My approach, then, has led me to place the Oedipus complex in the forefront of my psychoanalytic reading of tragedy, in the signifier/signified relation or the analysis of the trace, since in the last resort every text springs from a

murder (of the father), carried out with the intention of obtaining pleasure, sexual possession (of the mother). This is the radical, some would say imperialist, conclusion to which I am led.

The Oedipus complex is generally known in the form of the positive Oedipus complex of the boy: rivalry with the father leading to parricidal wishes and to a desire for the mother to the point of its incestuous fulfillment—extreme forms whose expression is represented only in the unconscious. But, from 1923 onward, Freud showed the existence in each individual of a double Oedipus complex, both positive and negative (the second being the reverse of the first). These two terms each occupy one end of the chain, of which only traces, which have survived repression, remain. The girl is subjected to the same structure as the boy. As a result, the human being of either sex carries within, by the very fact of human bisexuality, a double identification, masculine and feminine: the seal of Oedipus. It follows, therefore, that the Oedipus complex is at least quadruple—positive and negative, masculine and feminine—for each individual.

## NOTES

Translated by Alan Sheridan.

1. The French *scène* translates both "stage" and "scene." Here, however, I felt obliged to use the English "stage" where this was unequivocally meant. The "other scene" is the reference to Freud's notion of the drama as "another scene" *(ein anderer Schauplatz)*.—TRANS.

2. In French, *représentation* covers much the same ground as the English "representation." Both words are used to translate the German *Vorstellung,* a word with a long history in German philosophy and one that Freud took up and developed in his own way. (See entry under "Idea" in Jean Laplanche and J.-B. Pontalis, *The Language of Psycho-Analysis,* trans. Donald Nicholson-Smith [New York Norton, 1973], 200–201.) However the French word also translates "performance," in the theatrical sense. It is natural, therefore, for Green to play on both senses of the word—the psychological and the theatrical. For this reason I have avoided the word *performance* in this translation.—TRANS.

3. For an account of the primary and secondary processes, the reader is referred to Laplanche and Pontalis, *The Language of Psycho-Analysis,* 339–41. Broadly speaking, they correspond to unconscious mental activity, governed by the pleasure principle, and conscious mental activity, governed by the reality principle.—TRANS.

4. The term *Familienroman,* or "family romance," was coined by Freud as a name for fantasies in which the subject imagines that his relationship to his parents is other than it really is (as when he imagines, for example, that he is really a foundling). Such fantasies are grounded in the Oedipus complex. (See Laplanche and Pontalis, *The Language of Psycho-Analysis,* 160.)—TRANS.

5. The author is referring in part to Derrida's essay, "The Theatre of Cruelty and the Closure of Representation," reprinted in this volume.—ED.

6. In psychoanalysis, the "turning round upon the subject's own self" is a process whereby the drive replaces an independent object by the subject's own self. It is a form of "reversal into the opposite." (See Laplanche and Pontalis, *The Language of Psycho-Analysis*, 399.)—TRANS.

7. Aristotle, *Poetics*, trans. L. J. Potts as *Aristotle on the Art of Fiction* (Cambridge: Cambridge University Press, 1953), 29. Subsequent references are given in the text.

8. Like many of Lacan's terms, *Autre* or *grand Autre* is extremely difficult to define. Lacan himself resists such definitions, regarding them as a dead hand on the vital potentiality of language. The best way to understand Lacan's concepts is operationally; that is, seeing them at work in a number of contexts. One of Lacan's best-known formulas is "The unconscious is the discourse of the Other." The Other, says Lacan, is "the locus of the deployment of speech (the other scene, *ein anderer Schauplatz*, of which Freud speaks in *The Interpretation of Dreams*)" (Jacques Lacan, *Ecrits: A Selection*, trans. Alan Sheridan [New York: Norton, 1977], 264.) "The Other as previous site of the pure subject of the signifier holds the master position, even before coming into existence, to use Hegel's term against him, as Absolute Master" (Lacan, 305)—TRANS.

9. Antonin Artaud, *Le Theatre et son double* (Paris: Gallimard, 1972), 114. Subsequent references are given in the text.

10. Antonin Artaud, *Oeuvres complètes* (Paris: Gallimard, 1956), 4:141.

11. Roland Barthes, *Critique et verité* (Paris: Seuil, 1966), 37.

12. There is no adequate translation in English for the French *jouissance*. "Enjoyment" conveys the sense, contained in *jouissance*, of "enjoyment" of rights, of property, etc. Unfortunately, the word has lost much of its Shakespearean power in modern English. In French, *jouissance* also has the sexual connotation of "ejaculation." (*Jouir* is the slang equivalent of "to come.") Green is using the term here in the Lacanian sense, in contradistinction with "pleasure." For Lacan, pleasure obeys the law of homeostasis Freud evokes in *Beyond the Pleasure Principle*, whereby, through discharge, the psyche seeks the lowest possible level of tension. *Jouissance* transgresses this law and, in that respect, it is beyond the pleasure principle.—TRANS.

13. Sigmund Freud, *The Standard Edition of the Complete Psychological Works*, ed. and trans. James Strachey 23 vols. (London: Hogarth Press and the Institute of Psychoanalysis, 1953–74), 9:153. Subsequent references appear in the text, abbreviated *SE*.

14. Jacques Derrida, *Writing and Difference*, trans. Alan Bass (Chicago: University of Chicago Press, 1978), 230.

15. An elucidation of these points is to be found in my article "L'objet (a) de J. Lacan," *Cahiers pour l'analyse*, no. 3.

# Jean-François Lyotard
## The Unconscious as Mise-en-Scène

First of all, I should make clear what I mean by the word *mise-en-scène*. *Mettre en scène* (to stage) is to transmit signifiers from a "primary" space to another space, which is the auditorium of a theater, cinema, or any related art. I offer a classic example: one evening, at the Paris Opera, we are listening to *Der Rosenkavalier*, by Richard Strauss. This is a "performance"; of what is it made? Singer-actors on stage, musicians in the orchestra pit, stagehands and light crew in the wings, all are following a large number of prescriptions. Some of these are inscribed in certain documents: the libretto by Hoffmanstahl, the score by Richard Strauss. Others can be solely oral, from the director Rudolf Steinbock—as in stage directions for the actors or directions for the lighting and scenery. This simplified example enables us to distinguish three different phases of the staged work.

The final phase is the performance we are attending. It consists of a group of stimuli—colors, movements, light, sounds. This ensemble which besieges our sensory body "tells" it a story—in this example, the story of *Der Rosenkavalier*. The performance steers us along a course composed of a series of audible intensities, timbres, and pitches; of sentences and words arranged according to expert rhetoric; and of colors, intensities of light, etc.

The initial phase of the work (but is it a work at this point?) is characterized by the heterogeneity of the arts which will be used to put the performance together: a written drama, a musical score, the design of the stage and auditorium, the machinery at the disposal of the theater, etc. We have here groups of signifiers forming so many messages, or constraints in any case, belonging to different systems: the rules of the German (or better, Austrian) language, the rules of the prevalent rhetoric, and those prevailing in Hoffmanstahl's writing on the one hand; and on the other hand, the constraints of musical composition and Strauss's own relation to those constraints, etc.; nevertheless, even in this initial phase, there is something which limits the disorder that could result from such a heterogeneity—this is the single reference imposed on all the messages which make up the work: the story of *Der Rosenkavalier* itself.

But what is this story itself, this reference, if not an effect of reality produced by a certain combination of various signifiers contributed by the different arts? It is the very function of this kind of mise-en-scène to create this effect of reality, the story, to make it the apparent motive of the work. The

mise-en-scène cannot succeed unless a great number of new decisions are made, decisions not prescribed by the writer, the musician, or the designer; the mise-en-scène must specify the execution of such and such a narrative sequence in the finest detail, and that implies the detailed coordination of the orchestra's actions and those of the singer-actors, together with the lighting effects controlled by the light crew.

The intervention of the director is thus no less creative than that of the poet or the musician; but it is not on the same level as theirs. The director's intervention is a subsequent elaboration of their product. In this sense, the mise-en-scène is subordinate to the noble arts of drama, music, etc. But inversely, the mise-en-scène takes hold of the text, the score, and the architectural space, and it "gives life," as they say, to these signifiers. "Give life" means two things (1) the mise-en-scène turns written signifiers into speech, song, and movements executed by bodies capable of moving, singing, and speaking; and this transcription is intended for other living bodies—the spectators—capable of being moved by these songs, movements, and words. It is this transcribing on and for bodies, considered as multisensory potentialities, which is the work characteristic of the mise-en-scène. Its elementary unity is polyesthetic like the human body: capacity to see, to hear, to touch, to move. . . . The idea of performance (in French: *la représentation de ce soir,* this evening's performance), even if it remains vague, seems linked to the idea of inscription on the body.

I might add that I would find the same essential characteristics were I to analyze the function of mise-en-scène in films, at least in the great Hollywood productions of the thirties. If I have taken my example from the operas of Richard Strauss, it is only to remain in the cultural context which was Freud's. The important thing in this context is that mise-en-scène consists of a complex group of operations, each of which transcribes a message written in a given sign system (literary writing, musical notation) and turns it into a message capable of being inscribed on human bodies and transmitted by those to other bodies: a kind of somatography. Even more important, and less dependent on the classic context, is the simple fact of transcription—that is, the fact of a change in the space of inscription—call it a diagraphy, which henceforth will be the main characteristic of mise-en-scène.

Psychoanalysis is first of all an interpretative method. In any interpretative method there is the presupposition that the data to be interpreted simultaneously display and conceal a primary message which the interpreter should be able to read clearly. The interpreter unravels what the director has put together. In several studies, *The Interpretation of Dreams (Die Traumdeutung)* in particular, "A Contribution to the Study of the Origins of Sexual Perversions," and at the end of the analysis of Schreber's paranoia, Freud ventures to put forward the single or various possible readings of the messages hidden in

symptoms such as paranoid delusion, fantasies, and dreams. We know that for Freud desire is what gives utterance to these primary messages, whereas the unconscious is their director and gives them a disguise in order to exhibit them on the stage. The accent is on deception. In colloquial French one says to a hypocrite: "Arrête ton cinéma" [Cut the act].

This presupposition raises a difficulty, both theoretical and technical, which comes straight from the preceding notion of mise-en-scène. If it is true that symptoms, obscure as they are, result from the mise-en-scène of transparent libidinal messages, their interpretation then requires operations closer to deciphering than translation. For translation consists, at least in principle, in transcribing linguistic signifiers into other linguistic signifiers, while referring to a signified supposedly independent of the two languages. But when we trace the symptomatic "performance" back to the elements which, in principle, constitute its primary phase, we must shift from one register of inscription (the register of somatic symptoms in the case of conversion hysteria, for example) to an entirely different register (in the example, the register in which the desire of the patient is supposed to "speak"), that is, a linguistic register which is clearly intelligible. This transcription encounters at least two difficulties: (1) when we say that desire "speaks," are we using metaphor to say that desire is not nonsense? If so, it does not follow that the meaning of its expressions (the symptoms) is of a linguistic nature. If not, that is, if desire really speaks a language, then we must elaborate its grammar and vocabulary, which brings us to the second difficulty: (2) the operations that permit one to deduce the primary message from its performance do not seem to be rule-governed, as Freud himself acknowledges. The transcription of a libidinal message into symptoms seems to be achieved through irregular, unexpected devices. We may say, and Freud himself says, that the unconscious uses all means, including the most crudely fashioned puns, to stage desire. That seems likely to cut short interpretation, properly speaking.

Let us consider the case of dreams. Freud clearly distinguishes the three phases of representation we described for mise-en-scène. Dream thoughts *(Traumgedanke)* constitute the primary data (the libretto, the score) which are supposed to be perfectly legible. Freud calls the "performance" dreamcontent *(Trauminhalt)*, that is, the narrative told by the patient on the stage of the analyst's couch. The dreamwork (die *Traumarbeit*), which turns dream-thoughts into dreamcontent, is the equivalent of mise-en-scène. According to Freud, this mise-en-scène works by means of a set of four operators: condensation, displacement, the taking into consideration of suitability for plastic representation, and secondary revision. It may be that these are universal operators for mise-en-scène. But it is certain that contrary to the hypotheses of Jakobson and Lacan they are not linguistic operators (especially those a

translator would use). Even if for certain ones (condensation and displacement) we can find equivalents in language, we would not find them on the supposedly primary level of enunciation but on the very complex level of rhetorical or stylistic formulation, as Benveniste has shown. Yet that level already implies a certain mise-en-scène in the writer's or speaker's practice. Actually, these "levels" exist only in the fiction of structuralists: the most simple utterance carries with it a primitive rhetoric. Its being uttered, its arrangement have already made it a diminutive stage.

Still another observation on the way in which Freud, from the outset, formulates interpretation. The two basic ideas of mise-en-scène and interpretation are like the recto and verso of the same principle, which is a principle of distrust. In the presence of a dream or a symptom, in the presence of data in general, one decides to be wary: This datum, one thinks, does not say what it says; it is deceptive. This is the principle that Nietzsche identified perfectly as at the origin of the desire of knowledge. One must not be deceived just as in ethics one must not deceive. According to this principle, mise-en-scène is only the implementation of deception which in return given rise to the counter-effect of truth on the part of the interpreter, the search for causes and errors, the correction of the data. Yet we can ask, along with Nietzsche, why is it better not to be deceived than to be deceived? And above all: aren't we surely deceived by our heeding only distrust?

*Die Traumdeutung* was completed in 1899. Twenty years later in 1919, Freud published the analysis of a fantasy called "A Child Is Being Beaten." We are interested in this text for two reasons. At that time, Freud had completely revised his first typography of the psychic apparatus and was revising his libido theory (theory of instincts). It was in 1920 in *Beyond the Pleasure Principle* that he worked out the theory of death-instincts and the theory of general repetition.

We are dealing with a much more sophisticated hypothesis about the messages of desire than the one developed in *The Interpretation of Dreams*. Moreover, the analysis of "A Child Is Being Beaten" is conducted in such a systematic way as to provide a veritably microscopic dissection of the unconscious as stage director.

It is a fantasy very common with women. Its appearance coincides with masturbation; and acknowledgment of the fantasy is made difficult by a strong feeling of shame. The fantasy consists in a kind of scene or tableau vivant where the patient, placed in the position of spectator, sees an adult authority figure (a school-master, a teacher) flogging some young boys. With the help of his patients' recollections, Freud "discovers" that this scene hides another one, which he sums up with the sentence: "The father is beating the

child (that I hate)." This first phase constitutes the primary message, whereas the scene: "A child is being beaten" is similar to the final performance. In between there is the mise-en-scène.

But it is not as simple as this. Between the first and the last phase, Freud says, it is necessary to postulate an intermediate phase which he calls: "my father is beating me." Phase no. 2 is not related to any recollections mentioned by the patients. It results from a construction *(Konstruktion)* built by the analyst. In brief, the whole process is *not* achieved in two steps but three steps to be enumerated in the following "chronological" order: (1) the father is beating the child that I hate; (2) my father is beating me; (3) a child is being beaten.

It is impossible here to examine in detail all the transformations that succeed one another from the first phase of the fantasy to the last one. I will limit myself to two observations.

First, Freud disassociates the different components of the scene for each phase, just as we disassociated the components of the mise-en-scène that were music, libretto, lighting, etc. I mean that from one phase to the other, each component is dealt with in a specific way. He writes: "Beating-phantasies have an historical development which is by no means simple, and in the course of which they are changed in most respects more than once—as regards their relation to the author of the phantasy, and as regards their object, their content, and their significance." *(Collected Papers,* 2:178) When Freud speaks of the *relation* of the fantasy to the patient, he refers to her position in relation to the stage: Is she on the stage or in the audience? She is a spectator in the first phase, and she seems to be so in the third; but she is an actress in the second: it is then *she* who is the child that is beaten. With the word *content* Freud refers to the clinical manifestation in which the fantasy is one symptom among others (as Jean Nassif says): phase no. 3 seems to be sadistic, like phase no. 1, and phase no. 2 masochistic. The *object* is the sex of the victim: either a boy or a girl in phase no. 1 ; always boys in the last phase, but in the intermediate phase, it is the patient herself as a little girl. And with *significance* Freud refers to the value in terms of affect of the act of beating: Is a person flogged through love or hatred? If my father beats the child that I— his daughter—hate, then he loves me. But if, as in phase no. 2, my father beats me, it is to punish me because he hates the incestuous love I feel for him. In the third phase the masochistic component is maintained, but enveloped in sadism: The value of the final scene in terms of affect is ambivalence.

We see that we need a great number of operations, each of them working on a particular component in phases 1 and 2, in order to arrive at the result of the final performance. And in this sense, Freud's analysis is an important contribution to the understanding of mise-en-scène, at least in

the still traditional form we defined in the example of Richard Strauss. We also realize that these operations are entirely misleading. For instance, from "the father is beating the child that I hate" to "my father is beating me," it is necessary that the patient, who was a spectator, become an actress, that the love of the father be turned into hatred, that the hatred for the other child be changed into the hatred the little girl feels for herself, that the initial jealousy, which perhaps is not even sexualized, be replaced by a drive with a strongly anal component, that the sex of the victim be changed (from male to female), along with the position of the patient in relation to the stage. Likewise, to get from sentence no. 1 to sentence no. 3 requires linguistic transformations: the active voice in "The father is beating the child" becomes the passive voice in "A child is being beaten," the determinant *the* in *the child* is turned into *a,* and the part of the father is finally deleted.

After *The Interpretation of Dreams,* Freud elaborated a great number of these operations, particularly in the various studies which make up the *Metapsychology* published in 1914.

It is these operations which we find explicitly or not in the transformations undergone by the tableau of the fantasy "A Child Is Being Beaten." Since these operations are, according to Freud, characteristic of the unconscious, it is indeed the unconscious that stages the discourse of the young girl's desire and this mise-en-scène, far from being a translation, would be the transcription of a pictorial text of virtual bodies, with effect on the real body of the spectator (masturbation). Somatography requires both the exhibition and the concealment of the initial message.

The time has come to make a second observation on the nature of mise-en-scène in this text of Freud's compared to what it was in *The Interpretation of Dreams.* Are we able to speak here of fantasythoughts as Freud, in 1900, spoke of dreamthoughts? Can we identify a primary message of equally primary signification underneath the fantasmatic performance—something akin to the wish: that my father love me? Certainly not. What stands in the way is the considerably greater importance which Freud attached to the dynamics and the economy of drives. In 1900, dreamthoughts could be rather simply formulated because the conception of the desire which gave them utterance was itself rather simple: this desire was more a wish, *ein Wunsch,* than a force. The distinction could be made rather clearly between what desire "said," even secretly, and what the unconscious mise-en-scène made it say in the dream's manifest content. But in our text of 1919, it's an entirely different matter: not only are these operations of mise-en-scène much more complex than the four operations described in *The Interpretation of Dreams,* but desire is no longer conceived of as a wish, but as a bloc of forces, in the sense of a dynamics.

These forces are called instincts, or better, drives. They are characterized by their impetus or by their aim (to love or hate, for example), by their object, that is, by whatever elements these forces lay siege to or invest. But drives are never observable in themselves; they are always represented and by three kinds of representatives: words, images, and affects.

I will not develop here the question of representing drives on the symptom-stage. The important point is that drives themselves can undergo genuine metamorphoses. Freud lists four of them in "Drives and Their Vicissitudes" (1915): (1) reversal into its opposite (love is transformed into hate, for example); (2) the turning round upon the subject's own self (for example, the love for a person who has passed away is transformed into love for oneself through griefwork; or sadism is transformed into masochism); (3) repression, and finally (4) sublimation; these last two further affecting the outcome of metamorphoses of drive-representatives.

In the case of the beaten child fantasy, we have seen that what separates phase one and phase two, for example, is not only stagework involving representatives, it is also and above all a working which affects the objects and aims of the drives themselves: the change from sadism to masochism implies the reversal of active pleasure into its opposite, passive pleasure, and the turning round of the initial object of the drives (the other child) upon the subject of the patient. Therefore it is not the director's interpretation of the libretto and the score which is modified, it is the libretto and score themselves which have changed between the two phases to the point of expressing the opposite of what they were "saying." A second, entirely different mode of desire has annexed itself to the primary mode.

Will we be able to say that this second phase of the fantasy represents the first phase? That the girl's masochism is a mise-en-scène on her initial sadism? We would have to suppose that the messages of desire are not elementary but that they are already performances and that they have been worked at by a kind of pre-mise-en-scène. But this pre-mise-en-scène would then deal with nothing but the "drive-text," if we can still go on speaking thusly, and it would be much more archaic than the mise-en-scène we have spoken of up until now, which was concerned only with drive-representatives. Finally, it would be necessary to explain why, in order to be represented, the initial sadism must be transformed into masochism.

Sometimes Freud lets himself be carried away by this vertigo of representation and causality which keeps endlessly multiplying mise-en-scène, changing representeds into representatives of other representeds. However, the properties which Freud acknowledges in the drive processes prohibit our following him along this line. They indicate the opposite direction. In numerous texts, Freud insists on the fact that the logical, spatial, and temporal

properties of the "primary processes," which are the metamorphoses of drives, do not fit into the categories of rational thought. From our perspective, this means that primary messages, subsequently staged by a set of transcriptions, do not "speak" at all. I will give only one example of these texts: it concerns the temporality of drives and it can be applied perfectly to the case of the beaten child fantasy. It is a passage from the 1915 article "Drives and Their Vicissitudes":

> We may split up the life of each drive into a series of "thrusts" distinct from one another in the time of their occurrence but each homogenous within its own period, whose relation to one another is comparable to that of successive eruptions of lava. We can then perhaps picture to ourselves that the earliest and most primitive drive-eruption persists in an unchanged form and undergoes no development at all. The next "thrust" would then from the outset have undergone a change of form, being turned, for instance, from active to passive, and it would then, with this new characteristic, be superimposed upon the earlier layer, and so on. So that, if we take a survey of the tendency of drives from its beginning up to any given stopping-point, the succession of "thrusts" which we have described would present the picture of a definite development of the drive.
>
> The fact that, at that later period of development, the drive in its primary form may be observed side by side with its (passive) opposite deserves to be distinguished by the highly appropriate name introduced by Bleuler: *ambivalence*.

This text, as well as those works of Freud that echo it, is of great importance for our problem. A drive-siege never lets up; the opposite or inverse investment which accompanies it does not suppress the first, does not even conceal it, but sets itself up next to it. All investments are, in this way, contemporaneous with each other: one loves and hates the same object at the same time and in the same respect, which is contrary to the rules of intelligibility and chronology.

If such are the space, time, and logic of drives, then the desire of the woman who fantasizes the beaten child is not a clear message; it is composed of three drive-investments that (1) are logically incompossible, (2) are simultaneous, and (3) concern the same regions of the body. Therefore we must not say that the unconscious stages the message of desire. We must at least say that desire is not a legible text, and that it need not be given a disguise by a mise-en-scène in order to be represented, since it eludes interpretation on its own, due to its dischronisms, its polytopisms, and its paralogisms.

If we follow this direction which Freud indicates here and there starting in 1920, it is thus the distinction between the discourse of desire and its being disguised by the mise-en-scène of the unconscious which tends to become inoperative. For that reason, the idea of mise-en-scène tends both to

expand itself inordinately and to overextend itself to the point of vanishing. And it is in this way that it becomes congruent with the theatrical, critical, artistic, and perhaps political inquiries which make up what Ihab Hassan calls "post-modernism" and which Freud's explicit and implicit esthetics resolutely ignores.

In conclusion, to illustrate this orientation, I shall use the example of an already classic work from the visual arts Underground which permits a good approach to the problem of mise-en-scène in a contemporary context. My goal in choosing this work is to make clear *a contrario* just how much the Freudian conception of the unconscious and even desire depends on a particular aesthetic, that of official late-nineteenth-century Viennese theater and opera. If we are attentive to what is going on now, notably in the most audacious inquiries in the most recent arts, and if we bring their lessons back to Freud's discourse, not only will it seem necessary to diminish the import of his discourse but we will also better understand what are the stakes of "post-modernism" as a whole. What is at stake is not to exhibit truth within the closure of representation but to set up *perspectives* within the return of the *will*.

*La Région Centrale* is a "film" by Michael Snow, shot in Canada in 1970–71. A special device designed by the filmmaker allows the axis of the camera to be positioned in all possible directions around the point where the camera is connected to the device. This device is itself attached to a mobile shaft which can also turn in every direction around a swivel joint attached to the body of the apparatus. Finally, this apparatus is fixed to the ground. The lense can thus scan every plane passing through all the points of the sphere of the shaft's movements. Because camera and shaft rotate independently of each other, the final speed resulting from their velocities can vary. The setting of the focal distance is synchronized with the motion of the lense so that the images are always legible. The apparent velocity of transition from one image to another varies with the distance of the objects. The apparatus is placed on an elevated platform which overlooks a forest skyline and a landscape with lakes on one side, but on the other side the view is limited by a rocky ridge. The zenith and the nearest patch of ground, including the base of the apparatus, appear in the shot for the same reason as do all the horizontal planes.

The film is presented as a series of continuous sequences. Each one is accorded a unit of velocity and a unit of greater complexity due to the distinctness of the respective movements of camera and shaft. The scanning thus proposed by Michael Snow lasts about three hours in all. The spectator's gaze is carried along supple and irregular trajectories explored by the lense and carried away on a both infinite and bounded voyage that opens up every perspective on sky and ground to the gaze. Not only do the angles and

distances change continually but also the light and color. No sounds assist in interpreting the images, with the exception of a weak signal which indicates changes in the program of the apparatus' movements.

It would take too long to examine the work Michael Snow has done on each of the parameters of traditional cinematographic representation. May three remarks be sufficient:

1. The stage, in its usual sense, supposes a stage-frame, a picture frame, an image-frame, that demarcates three regions with its edge: the unreal space, Freud would say fantasmatic or oneiric, where the action takes place; the real space where the spectators are; and the hidden space where the theater machinery is concealed. Because of this framing, this kind of mise-en-scène implies a complementary unframing. Michael Snow's apparatus eliminates framing: he lets us see what traditional framing excludes from the shot, including the machinery itself. And owing to the fact that he dispenses with the wings, the orchestra pit, and the idea of a meaning hidden underneath appearances, he abandons the principle of distrust.

The device which produces *La Région Centrale* belongs to a paradoxical logic related to that of the sophists and Nietzsche: there is nothing but perspectives; one can invent new ones. The statement that there are only perspectives includes itself among them, just as Snow's camera aims itself at its own base. With such a logic, the function of language is no longer to signify a given object, and the function of the image is no longer to deceive by means of false recognition. Language is not made for telling the truth and film is not made to disguise truth on a fantasmatic stage. Both are inexhaustible means for experimenting with new effects, never seen, never heard before. They create their own reference, therefore their object is not identifiable; they create their own addressee, a disconcerted body, invited to stretch its sensory capacities beyond measure.

2. The closure of the movements of Snow's camera results in all the images' referring to a same space, but the infinite variety of scannings results in their all being different. There we have the visual equivalent of the Freudian metaphor of drive-eruptions: many different figures, a closeup of a pebble, a lake on the horizon, a cloud, are all packed into the same region by the camera.

This region is central because all the figures smash themselves on Snow's film due to the coagulent, contripetal, materialist force of the lense's journey. But the bloc of figures thus stockpiled remains without stable identity, and that is due to the fact that the images are not actually taken from a fixed center but by a lense whose very complex movement results from the composition of two movements, those of the camera and shaft. The accumulation of figures on the film succeeds in not constituting any identifiable geometric space, such

as a stage should be so that a story may be enacted there. The center of the region is a labyrinth.

3. The time of *La Région Centrale* breaks with that of narration: the film doesn't tell any story. Not only is there no action rolling along, but any unrolling of images is at the same time their being rolled around each other because of the closure of the lense's movements. Or else, but it is still the same thing, the film tells all the tales born of all the images it shows. At every moment, the spectator has the possibility of isolating a single view and of using it to start telling a story about skylines or forests, or the stuff of the earth, or the clouds in the sky, etc.; all of these budding stories form an immense chatter in which we find all times mixed together (for example, astronomical, geological, and technological time). Here again, whether the accent is placed on the atemporality of the film or on the multitemporality of these stories, we encounter an equivalent of the dischronisms of Freud's primary processes, and we understand why Michael Snow preferred the weak and, properly speaking, drivelike sound which gives a rhythm to the movements of the apparatus, to any utterance, no matter how bizarre.

Can we say that mise-en-scène has disappeared from such a spectacle? The mise-en-scène by a Rudolf Steinbock or a libretto by Hoffmanstahl and a score by Richard Strauss—yes (if at least we ignore the frame of the movie screen). But not mise-en-scène as somatography, and not as diagraphy either. For nothing prevents us from saying that here the camera is the interpreter of a text, namely, the program which Snow fed into his machine and whose written signifiers the machine transforms into movements and into emotions on the spectators' bodies.

Are Snow's instructions analogous to the discourse of desire and are the machine's operations analogous to the mise-en-scène of desire by the unconscious? This could be stretching the analogy a bit. Snow's filming machine cannot be compared to Freud's machine of the unconscious unless we underline the strange character of the operations they perform, one on drive material, the other on visual material. And if we can say that Snow's program of movements is a result of desire, it would be on the condition of understanding desire not as a set of instructions promoted by some love- or hate-wish but as the will to create realities. This double restriction is sufficient to displace the problematic of the unconscious and mise-en-scène from Freud to Nietzsche and beyond.

When the force used to stage something has no goal other than to make manifest its potentiality, when it is the same force that produces and implements the most sophisticated programs and machines, the distinction between desire and the unconscious disappears entirely. By the same token, works must not be taken as symptoms symbolically expressing a concealed

discourse, but as attempts to state perspectives of reality. Interpretation must in turn give way to descriptions of devices. As for these descriptions, they are no less prescriptive in nature than works; they continue and eventually reroute the perspective-creating potentialities these works contain. Inversely, the time has come to consider the would-be symptoms as artistic creations.

Instead of our interpreting the mise-en-scène of the unconscious, we should use these works to set up perspectives of realities with an eye on enjoying heretofore unexperienced intensities. The machines which are drawn into play are, essentially, no longer the machines of illusion and memory, but apparati for experimentation which permit us to quarter sensibility and draw it out beyond this old body.

Translated by Joseph Maier.

# Philippe Lacoue-Labarthe
## Theatrum Analyticum

*The pleasure produced by tragic myth has the same
heritage as the impression of pleasure that dissonance
provokes in music.*
—Nietzsche, *The Birth of Tragedy*

*Eros:* You ask too much, Thanatos.
—Pavese, *Dialogues with Leuco*

The following remarks concern a text of Freud published by Max Graf in 1942, "Psychopathic Characters on the Stage." There are at least two principal reasons that make this an interesting text. First of all, among all the posthumous texts this one stands alone as an enigma, not only because Freud did not publish it (nor want it published, or write it for publication), but because he seems to have "forgotten" its very existence, or in any event to have *lost touch* with it.[1] If this occurrence is not unique, it is still sufficiently uncommon to make the text intriguing, to provoke our attention and to demand an investigation that would consider both the history of Freud's thought and the position that this semiclandestine text was able to assume (and maintain) within it. The second reason, less limited in scope, pertains to the subject matter of this text, the theater. If this essay is now generally admitted to be one of the most important written by Freud on this subject, it is because it poses directly and in terms probably not found elsewhere a decisive question that has since come to be the focus of an entire critique of Freud: the question of the relation of psychoanalysis to theatricality or, more generally, to *representation*.

At a certain point, it seems likely that these two apparently unrelated reasons are in fact one and the same, and this is what we shall endeavor to indicate here, albeit in summary fashion.

To do so we must begin by referring to the situation (or the "scene") in France, and in particular to the philosophical and political debate concerning Freud that has been going on for several years, above all since the publication of *Anti-Oedipus* and, less superficially of Girard's work.[2] Here several developments must be considered. First, there was the growing recognition that theatricality functions as a *model* or even a *matrix* in the constitution of psychoanalysis; established theoretically by Lacan, of course, it was then

confirmed by diverse commentators, such as Starobinski and Green.³ This resulted not merely in justice being meted out to would-be "applied psycho-analysis," but also in the rigorous delineation of one of the most pervasive metaphorical networks in Freud, as well as in the construction of the "analyti-cal scene" itself. At the same time, but elsewhere, the consequences of the Heideggerian questioning of representation had begun to make themselves felt and, accentuated and displaced, to *work* effectively.

The reaction—with or without quotation marks—was not long in com-ing. Yet, however problematic the newly discovered psychoanalytical "sceno-morphics" may have appeared, and despite the strict precautions invoked and practiced by those who reintroduced the "closure of representation" (begin-ning with the very concept of "closure" itself), a critical tendency emerged which, in its haste, was only too happy to free itself of one of the more cumbersome of those "cultural cadavers," whose time—it was rumored—had come. Such criticism should not necessarily be deemed to be beneficial simply because it shakes up academic habits a bit, or because it opposes to Capital precisely what the latter tends to encourage. At any rate, the great discovery of this critical movement was that Freud had remained a pure and simple prisoner of the Western system and of the mechanics of representation—of Graeco-Italian scenography, of classical dramaturgy, etc.—and that he had even added to its coercive power by presenting it as a structural necessity of the human subject in general.⁴ This was then held to explain both the timo-rous, relatively sterile and conservative aspect of his aesthetics, and more importantly, the repressive character (institutionally, but also theoretically) of psychoanalysis itself. This description is obviously schematic and in need of further "discrimination" (that would include explanations of our grievances with regard to the obscure premises of anti-Freudism as well as our reticences concerning all movements that are simply "anti-"). It does give, however, a general idea of what has been happening in France, and probably elsewhere, during the past few years.

A recent page of Jean-François Lyotard bears witness to the situation just described (and will also permit us to continue a discussion initiated under other circumstances). Commenting on the text of Freud with which we propose to deal, Lyotard summarizes the essence of this critical motif:

> The privileged status of the theater in Freudian thought and practices, with respect to the other arts, has already been noted. Freud not only acknowledges this, but on at least one occasion makes an apparent effort to justify it. In a short text of 1905–6 entitled "Psychopathic Characters on the Stage," he sug-gests a genesis of psychoanalysis that would be oriented by the questions of guilt, indebtedness and repayment. Sacrifice, destined to appease a divinity

angered by man's revolt, would constitute the matrix. Greek tragedy, itself arising from the sacrifice of the goat—as Freud believes—would engender the socio-political drama, then its individual (psychological) form, of which psycho-pathology and—we would add—psychoanalysis would in turn be the off-shoots. This genealogy not only permits us to discern that the analytical relationship is organized along the lines of a ritual sacrifice; it also suggests the identity of the spaces in which the operation of acquittal takes place. The temple, theater, political chamber and office are all *de-realized* spaces, as La-planche and Pontalis put it, spaces circumscribed by and exempt from the laws of so-called reality, in which desire can play itself out in all of its ambivalence, a region where the "things themselves" of desire are replaced by tolerated *simulacra* that are assumed not to be fictions, but authentic libidinal produc-tions, simply exempted from realist censorship.[5]

None of this, of course, is false, On the contrary, it should be stressed that this reading is entirely necessary, for it in fact uncovers something in Freud that should not be ignored, even though Ehrenzweig was one of the few commentators to have called attention to it. Nor do we intend, as is often done in such cases, to object on "philological" grounds, by reproaching Lyotard, for instance, for forcing the text to produce a genealogy of psycho-analysis that is not really there (Freud himself does not go beyond compari-son),[6] or for "mixing up" the text, without further ado, with the celebrated seventh section of the fourth chapter of *Totem and Taboo* (where Freud places considerable emphasis on questions involving the origin of the theater, issues which in this text are present only in embryonic form. In the later text Freud does in fact speak of the "tragic fault," guilt, payment of debt, etc.). Such reproaches, however, would only be of secondary importance.

Let us say, then, that by and large, Lyotard is right.

But he is right only on one condition—or rather on two, which are merely two sides of the same coin. The first condition involves posing, or imagining, that there is a *reality* "outside representation"; that this reality, far from being what Bataille called and Lacan calls the impossible, is that which can present itself actually and as such; and that consequently there is, in general, the possibility of presentation, of presence, and of plenitude as something whole, virginal, unadulterated, and uncorruptible. A primeval state where we could and would be *ourselves,* subjects (in whatever form that might be), unalienated and integral, prior to all fault and to every prohibi-tion, to wars and rivalry—prior also, it is clear, to all institutions. The condition thus amounts to nothing less than relegating, once and for all, the reality principle to the obsolescent arsenal of the metaphysical police-force. But there is still the other condition: that the *necessity* of the representational

scheme *[dispositif]* for psychoanalysis (affirmed by Freud and determining the practice of analysis) be derived solely from *desire* (and from a pleasure without hiatus, full, whole, etc.), or more precisely, from "drive produc-tions" *["productions pulsionnelles"]* that in turn derive solely from the *libido.* If what analysis deals with are merely drives insofar as they are libidinal; if, in general, there is nothing but libido—and a libido that is invulnerable, never frayed, marred, or riddled (that is, shot through and blackened, or furrowed and doomed to die), then it is certain that the function of de-realization in what Luce Irigaray has described as the "possible practices of analysis" *[le practicable analytique]* can, and indeed must be called into question. The whole problem consists in knowing whether analysis is concerned only with the libidinal, or whether there is an aspect of the drives (not, however, one that simply *manifests itself*) that is irreducible to the libido, above all in the sense of a univocally "positive" striving.

If we raise this question, it is obviously not out of respect for "Freudian orthodoxy." Orthodoxy as such is of little interest to us and we are only too well aware of the role played by orthopedics—that is, of a rectification that is ontological, virile, committed to domination, and properly political—in all forms of orthodoxy, as in all submission to a discourse that is tutorial and paternalistic. It is also clear that we have not broached this question in order to "save" Freud from a *univocal* reading (he needs no help in this regard), since no one can be interested in reintroducing ambiguity for its own sake. Our concern is to extricate Freud, or rather "his" text, from a critique commit-ted precisely to the opposing values "univocal" versus "equivocal." The ques-tion thus becomes one of the usage of texts and of criticism, which is also a "political" question. With Freud, however, things are always much more complicated. Regardless of his own desire and of the unquestionable (but *reversible . . .* ) critical power of analysis, there is ultimately nothing in Freud that permits a *decision,* i.e. the determination of a decisive meaning (be it primary, final, hidden, etc.), that in turn would be sufficiently certain to enable us either to appropriate or to exclude it. Or, for that matter, to allow for appropriation or exclusion in general. Our intention, therefore, is not to preserve a benevolent "neutrality," but rather to call a certain kind of doctrinal *identification* into question, in the name of a notion that is less simple, less self-assured, less triumphant—and hence, less apt to be "confiscated" by any type of critique. And, given the importance of what is at stake here, a little subtlety is perhaps not too much to ask.

The charge that Lyotard addresses to Freud is, in fact, twofold. On the one hand, it is directed at the representational scheme as being one of dereali-zation, i.e., as the closure (the *temple*) of the tragic site—the stage, insofar as

it is a substitute for the place of the actual ritual sacrifice, commemorating the murder of the *Urvater* (that this is the version of *Totem and Taboo* is of little matter here). If one can read between the lines, this accusation already includes that pretheatrical phenomenon, ritual, or the religious as such, whether or not the latter is understood to imply real violence, sacrifice, exclusion, etc. In this respect, Lyotard's position converges with the critique developed by Girard, for whom Christianity stands alone as the sole explicit acceptance of violence ever manifested, by contrast to the totality of vicarious formations (whether religious, political, aesthetic) intended to channel such violence but which, by masking it and causing it to be forgotten, actually exacerbate it. On the other hand, however, Lyotard's accusation bears on the "psychic" *instrumentality* or *support* of this derealization, which transforms the evocation of sacrifice, murder, and of suffering into something not merely tolerable but even desirable (to the point of producing therapeutic effects). This is to say that Lyotard calls into question the libidinal formalism of Freudian aesthetics—the hypnotic, anesthetizing power of form, as he puts it,[7] including the intricate network of *Lustgewinn, Nebengewinn, Vorlust, Verlockungsprämie,* etc. This formalism is held responsible for Freud's inability to consider or even to perceive what Ehrenzweig has termed the *disruptive* function of art, and in particular of modern art, as opposed to its merely vicarious aspect.[8] The notion of art as disruption, of course, implies that its function must be other than merely "secondary," that it have the power to put us in the presence of the Real itself (of *présence*), that in one way or another it can become an *event:* in short, that it *affects,* one might say, *effectively.*

It is hardly difficult to see that the genuine target of this twofold accusation is not so much Freud himself as a (if not *the*) entire philosophical tradition, and in particular Aristotle, whose authority Freud invokes explicitly at the beginning of "Psychopathic Characters on the Stage," although implicitly he probably never ceased to appeal to it, be it out of prudence, "academism," or for other less anecdotal reasons that will appear in due course. In thus taking refuge in an appeal to the philosophical, Aristotelian tradition, Freud proffers, so to speak, the tool of his own undoing. All that is left unsettled, it would seem, is the question of how this apparently unreserved submission actually functions. But this is precisely where the difficulties begin.

How in fact does "Psychopathic Characters on the Stage" "function"? How does this text present itself? Modestly, as is almost always the case with Freud; namely, as a simple development of Aristotle's poetics of drama, intended merely to render the latter more "precise": "If, as has been assumed since the time of Aristotle, the purpose of the play *(Schauspiel)* is to arouse 'terror and pity,' to bring about a 'purification of affects,' it is possible to describe that goal in rather more detail by saying that it concerns opening up

sources of pleasure or enjoyment in our emotional life."⁹ But this gesture obviously serves to cover up—and this is *also* always the case—Freud's scarcely concealed desire of producing the *truth* of those poetics, of taking its measure and of revealing its ultima ratio. In other words, "Psychopathic Characters on the Stage" presents itself as nothing more nor less than a psychoanalytic reading—as an interpretation and hence as a *translation* of the *Poetics* (albeit an active and, as we shall see, a transformational one). This reading, it is true, reduplicates the analogous or homologous translation given by "German Romanticism" to a question first posed in Germany during the time of Lessing, concerning the difference between the Ancients and the Moderns (between the Greek and the Occidental, the Oriental and the Hesperian, etc.). This question, that dominated the entire field of historical aesthetics from Hölderlin, Hegel, and the Schlegels to Nietzsche, finally produced a general theory of culture or of civilization.

Hence, in order to evaluate the meaning and import of Freud's gesture with some precision, it may be sufficient to compare it with an operation that is similar, even though its initial purpose may have been entirely different: that of Nietzsche in *The Birth of Tragedy*. That this comparison is not entirely arbitrary should be clear, for whatever Freud's "denials" concerning this relationship may have been, it is now generally recognized that psychoanalysis is closely bound up with certain major intuitions of Nietzsche. Indeed, the question raised by Nietzsche, one concerning not only tragedy but art in general (since tragedy, in entirely classical, even Hegelian fashion, is its paragon), is exactly the same question that Freud, through Aristotle, poses in the very first two paragraphs of "Psychopathic Characters on the Stage." Even the terminology employed (particularly in chapter 22 of *The Birth of Tragedy*) is identical. It can be formulated as follows: How can the spectacle of suffering, annihilation, and death by enjoyable, and indeed more so than any other spectacle? It is true that Nietzsche (who, of course, was not unaware of the Aristotelian origins of the question) rejects any response that does not ultimately refer to "aesthetical principles," including therefore and above all Aristotle himself. In other words, Nietzsche dismisses the *cathartic* interpretation of tragedy, and moreover not without vehemence. But in the name of what? Here is the bill of indictment:

> Never since Aristotle has an explanation of the tragic effect been offered from which aesthetic states of an aesthetic activity of the listener could be inferred. Now the serious events are supposed to prompt pity and fear to discharge *[Entladung]* themselves in a way that relieves us; now we are supposed to feel elevated and inspired by the triumph of good and noble principles, at the sacrifice of the hero in the interest of a moral vision of the universe. I am sure that for

countless men precisely this, and only this, is the effect of tragedy, but it plainly follows that all these men, together with their interpreting aestheticians, have had no experience of tragedy as a supreme *art*.

The pathological discharge, the *catharsis* of Aristotle, of which philologists are not sure whether it should be included among medical or moral phenomena, recalls a remarkable notion of Goethe's. "Without a lively pathological interest," he says, "I, too, have never yet succeeded in elaborating a tragic situation of any kind, and hence I have rather avoided than sought it. Can it perhaps have been yet another merit of the ancients that the high-point of pathos was with them merely aesthetic play, while with us the truth of nature must cooperate in order to produce such a work?"

We can now answer this profound final question in the affirmative after our glorious experiences, having found to our astonishment that the deepest pathos can indeed be merely aesthetic play in the case of musical tragedy. Therefore we are justified in believing that now for the first time the primal phenomenon of the tragic can be described with some degree of success. Anyone who still persists in talking only of those vicarious effects proceeding from extra-aesthetic spheres, and who does not feel that he is above the pathological-moral process, should despair of his aesthetic nature.[10]

We have chosen to quote this text at length in order to show just how far removed we seem to be from the discourse of Freud. Ultimately no one would appear more open to such an indictment than Freud himself, even at the risk of attributing a strange gift of prophecy to Nietzsche. In reality, however, things are quite different. Once one takes into account the specifically Nietzschean oppositions (the Dionysian and the Apollonian, music and the plastic arts, the "immediate reproduction" of the original Unity versus its mediate, reduplicated reproduction) the answer becomes perfectly clear: tragedy, however it is approached, including its "properly" musical or Dionysiac aspect, never *presents* as such the suffering that it (re)presents *(darstellt);* on the contrary, it presupposes an already circumscribed space, of derealization if one insists, and by virtue of which the "high-point of pathos" is always an *aesthetic play.* Even music, it should be stressed, including its worst varieties (that of *Tristan,* for example)—even *dissonance* still (or already) produces enjoyment. And it is clear why: at some point, ontologically, but also aesthetically, if the world is to be understood as an "aesthetic phenomenon," or if art, in the narrow sense is to be understood as the "imitation" of the production of things that are—at some point, then, *suffering itself is enjoyment,* even if it is only as the *discharge (Entladung),* i.e., as the *catharsis* of the contradiction that constitutes it.

If one makes allowances for the ontological "speculation," all this is not very different from the type of response that Freud puts forth, prudently, in

"Psychopathic Characters on the Stage." His apparent submission to the Aristotelian model should not be misconstrued. Certainly, at no time does Freud go beyond the limits attributed by Nietzsche to the "pathological-moral" interpretation of tragedy. On the face of things, at least. And it seems no less certain that he is satisfied simply to translate Aristotle. The first lines are in fact an almost literal translation of the *Poetics:* for if Freud, at the outset, seems to commit or to repeat the well-known misinterpretation of the catharsis of emotions in general,[11] it becomes clear in the course of the text, when the discussion focuses on the drama, i.e. on tragedy, that he understands catharsis in the limited sense of a "purgation" of suffering alone (that is, of terror and compassion). And there is no doubt that it could be demonstrated, based on the texts concerned, that "libidinal derealization," in the sense of an economical law (of economizing), both governs aesthetic enjoyment and also transcribes faithfully the χαρὰν ἀβλαβῆ, "the joy without harm or loss" that Aristotle, in the Politics (VIII, 1342a), attributes to catharsis, precisely in its medical, homeophathic, "pharmaceutical" function (catharsis utilized φαρμακείας χάριν).[12] The fact nevertheless remains that on one fundamental point, this "faithful" translation in reality upsets Aristotelian theory. This takes place when, intentionally or not, Freud moves from medicine back to what was probably the origin of catharsis, to religion, and raises the question of mimesis (i.e., "mimicry," or, in his language, *identification*) as that which renders the "cathartic machine" itself possible. It is true that Freud, in conformity with Aristotle, will continue to maintain the analogy of art with the play of the child until, but not including *Beyond the Pleasure Principle*,[13] and that like Nietzsche in the final chapters of *The Birth of Tragedy*, he transfers the Aristotelian *recognition* (ἀναγνώρισις) onto the relation between scene and audience, thus involving the spectator.[14] Yet despite all this, Freud still introduces an element that is foreign to the Aristotelian "program," but that explains the link between catharsis and mimesis, something that had remained unthought throughout the entire tradition (with the exception of Nietzsche).[15] This is simply the notion that tragic pleasure is *masochistic* in essence and hence—although this is not made explicit in 1906, for reasons that will appear shortly—that it is closely bound up with *narcissism* itself:

> Being present as an interested spectator at a spectacle or play [written here "*Schau-spiel*": "*Schau*," "spectacle," and "*Spiel*," "play" or "game"] does for adults what play does for children, whose hesitant hopes of being able to do what grown-up people do are in that way gratified. The spectator is a person who experiences too little, who feels that he is a "poor wretch to whom nothing of importance can happen," who has long been obliged to damp down, or rather displace, his ambition to stand in his own person at the hub of world affairs; he

longs to feel and to act and to arrange things according to his desires—in short, to be a hero. And the playwright and actor enable him *to identify himself* with a hero. They spare him something, too. For the spectator knows quite well that actual heroic conduct such as this would be impossible for him without pains and sufferings and acute fears, which would almost cancel out the enjoyment. He knows, moreover, that he has only *one* life, and that he might perhaps perish even in a *single* such struggle against adversity. Accordingly, his enjoyment is based on an illusion; that is to say, his suffering is mitigated by the certainty that, firstly, it is someone other than himself who is acting and suffering on the stage, and, secondly, that after all it is only a game, which can threaten no damage to his personal security. . . .

Several other forms of creative writing *[Dichtung]*, however, are equally subject to these same preconditions for enjoyment. . . . But drama *[Drama]* seeks to explore emotional possibilities more deeply and to give an enjoyable shape even to forebodings of misfortune; for this reason it depicts the hero in his struggles, or rather (with masochistic satisfaction) in defeat. This relation to suffering and misfortune might be taken as characteristic of drama, whether, as happens in serious plays, it is only *concern* that is aroused, and afterwards allayed, or whether, as happens in tragedies, the suffering is actually realized.[16]

The reference to masochism in no way undermines the *economic* character of tragic pleasure (as is proved later in the essay by the exclusion of physical illness from the space of the scene; this is a result of the law according to which suffering must be compensated, a law that governs theatrical identification and hence provides the norm for the dramatic form itself).[17] But the economic system here put in place is not a simple one. Already a paradox begins to emerge that will be of great consequence once the question of masochism (and of narcissism) has begun to transform, metapsychologically, the theory of drives. This is the question of the role played by the "supplementary gain," the *Nebengewinn,* in the "economy" of "enjoyment." Freud explains that the "purification of affects [of emotions]" signifies the total release, in our emotional life, of the "sources of pleasure *[Lust]* and of enjoyment *[Genuss];*" and he adds immediately (it is the era of the book on Jokes) "just as in the comical, the *Witz,* etc., the same effects are produced by the workings of our intelligence, which (otherwise) has rendered many of these sources inaccessible."[18] The dissymetrical character of the comparison (in which the "workings of the intelligence" appear as an agent of repression) should not surprise us: the appeal to the *Witz* ushers in what the final paragraph of "Psychopathic Characters on the Stage" will identify as the "preliminary pleasure" *(Vorlust)* discussed in the *Three Essays* and the *Witz.*[19] This "supplementary gain" in the position of an "incitement bonus" *(Verlockungsprämie),*[20] far from implying, as Lyotard suggests, some kind of "anesthetizing power of form," supposes on the contrary a

specific pleasure involving an "elevated tension" *(Höherspannung)* or, if one prefers, an "intensification" (involving the augmentation of pain) for its own sake:

> In this connection the prime factor is unquestionably the process of getting rid of one's own emotions by "blowing off steam" *[das Austoben];* and the subsequent enjoyment corresponds on the one hand to the relief produced by a thorough discharge *[Abfeuern]* and on the other, no doubt to an accompanying sexual excitation; for the latter, as we may suppose, appears as a supplementary gain *[Nebengewinn]* whenever an affect is aroused, and gives people the sense, which they so much desire, of an intensification *[Höherspannung]* of their psychical state.[21]

Theatrical enjoyment, in other words, is totally masochistic. Suffering causes pleasure only when *formally* prepared by this supplement of pleasure which itself, however, implies pain. As in Nietzsche, or in Goethe, the "high-point of pathos" is consequently nothing more than "aesthetic play" (would this be a possible definition of masochism?). And as in Nietzsche, this is moreover just what explains the superiority of Greek tragedy to the drama of the Moderns:

> Suffering of every kind is thus the subject-matter of drama, and from this suffering it promises to give the audience pleasure. Thus we arrive at a first precondition of this form of art: that it should not cause suffering to the audience, that it should know how to compensate, by means of the possible satisfactions involved, for the sympathetic suffering which is aroused. (Modern writers have particularly often failed to obey this rule.)[22]

This is why the second psychoanalytical "translation" proposed by Freud here should be that of the relation between Greek and modern (Shakespearean) dramaturgy, in conformity to the constant association opposing *Hamlet* to *Oedipus* which this text, all appearances notwithstanding, does not deny.[23] Genealogically, the modern "break" occurs when the unconscious—that is, the difference between the repressed and the nonrepressed—is introduced into the tragic conflict. Up to and including the psychological drama—which, according to Freud's typology, comprises not simply the theater of "characters" or social theater, but also the "tragedy of love" and the opera—the theater is still situated within the horizon of the Greek system of representation. But once what is described in *The Interpretation of Dreams* as the "secular advance of repression"[24] has taken place; once, that is, the general space of neurosis has been established, the modern epoch of drama has begun:

But the series of possibilities grows wider; and psychological drama turns into psychopathological drama when the source of the suffering in which we take part and from which we are meant to derive pleasure is no longer a conflict between two almost equally conscious impulses [which was the case for Oedipus], but between a conscious impulse and a repressed one. Here the precondition of enjoyment is that the spectator should himself be a neurotic, for it is only such people who can derive pleasure instead of simple aversion from the revelation and the more or less conscious recognition of a repressed impulse. In anyone who is *not* neurotic this recognition will meet only with aversion and will call up a readiness to repeat the act of repression which has earlier been successfully brought to bear on the impulse: for in such people a single expenditure of repression has been enough to hold the repressed impulse completely in check. But in neurotics the repression is on the brink of failing; it is unstable and needs a constant renewal of expenditure, and this expenditure is spared if recognition of the impulse is brought about.[25]

This explains why, in order to maintain the thesis of catharsis apparently intact, it was necessary to modify the Aristotelian scheme of "recognition" by introducing identification. For only the principle of identification authorizes the recognition of the repressed. In no way, however, does this prevent modern catharsis from being as "economical" as that of the Greeks (if one makes allowances for certain rules, more subtle and sophisticated than in the past, such as that of *averted attention,* formulated by Freud in regard to *Hamlet,* and that aims at the weakening of resistances inherent to neurosis).[26] Otherwise, as was the case before, the establishment of the system implies an exclusion—in this case not only that of suffering and physical illness but of mental illness, of a successfully constituted neurosis, which is "alien" (and hence that resists recognition); an exclusion, one could doubtless say, of *alienation* or of *madness.*

The entire operation is thus devoid of mystery, if not of difficulties. The "economically oriented" aesthetics is already present, in a condensed form, even though as late as *Beyond the Pleasure Principle* Freud will (still) feel compelled to formulate it as a project.[27] But when he mentions it again, it will only be to deny its importance with regard to the far more serious and difficult question concerning what is prior to the "pleasure principle," or beyond it, or in any event "independent" of it "and, perhaps, more primitive than it." All this is well known, as is the fact that this question is introduced in the space opened by the break with the Aristotelian analogy, maintained until then, between the play (of the child) and the play on the stage [the *Schauspiel*]. The allusion to Aristotle is even made perfectly explicit: "Whatever the case may be," writes Freud [*that is, whatever the insurmountable difficulties presented by the* indecidable *character of play may be*], "it emerges from this

discussion that to explain play by means of an imitative instinct is to formulate a useless hypothesis."[28] But this is not all. For it is clear that if play is thus to be separated from "artistic play and artistic imitation," it is essentially for two reasons: First, because play does not imply the mechanism of representation or, to be more exact (since there is always the crib of the *Fort/Da* player as counterexample), the mechanism of the spectacle. If there is mimicry involved, it is one that is effective, direct, and *active,* comparable to that of the actor (and not of the spectator). The process of identification thus implied is more immediate, but also more compromising than the actor's, since the difference that constitutes the scene has vanished (or exists only in a embryonic state). Hence, the derealizing closure of the theatrical site has not yet been really established (or at least only in part, if we accept the necessity of a *primitive* interiorization of the representational cleavage). The second reason for the separation is that play—which is ultimately and necessarily part of a *libidinal economy* (but is an economy conceivable that would not be libidinal or "erotic"?)—by virtue both of its very nature, reproducing and repeating the "disagreeable," and of its function (i.e., abreacting and striving for mastery), presupposes an indirect way to pleasure, by contrast with the participation of the spectacle. Thus, in implying a renunciation (albeit a provisional one) of pleasure, or a reiteration (be it ephemeral and simulated) of suffering, play involves a break (however brief, furtive, or tentative) with the economic system. At one moment or another (and at a point impossible to localize), there is thus an element of *loss* in play. And hence a risk. One must get lost in play (and take risks) to win (back oneself). There, in an inverted form, is the entire difficulty of the *generalized economy* in the sense of Bataille. The economy of play is not just another simple economy, like the theatrical-spectacular economy, at least in its Aristotelian version. It is an economy of difference and deferral *(une économie différée)*. What it lacks, in short, is precisely the anesthetizing form (if something of the sort indeed exists), even if play is the birth of form. And we can hardly ignore what is revealed and also concealed by this differance—in the Derridean sense—deferring gain, pleasure, security, and even sur-vival; namely, (the) death (drive) "itself."

And yet, by virtue of a kind of chiasmus, marking both the disorientation of psychoanalysis and the manifestation of an inextricable question, all this is not very far from emerging, apropos not of play but of dramatic mimesis, when Freud, in "Psychopathic Characters on the Stage," introduces the notion of masochism in order to account for tragic pleasure. If this use of the notion is especially problematic at the time, it is because it is situated at the very frontier between stage and auditorium, actor and spectator, and because "masochistic satisfaction" is opposed from the very beginning to "direct enjoyment" (a contradiction that explains the necessary scenic, and hence epic

"elevation" of the victim). In this connection Freud writes, "Heroes are first and foremost rebels against God or against something divine: and pleasure must be derived from the feeling of anguish experienced by the weaker being confronted by divine might. This pleasure is due to masochistic satisfaction, but also to direct enjoyment of an individual whose greatness is nevertheless accentuated."[29] But this is also what Freud betrays by submitting to the constraint of a system, and by the double exclusion of illness and madness. In each case it is the ambivalence of *identification* that is at stake; and once the dualism of the drives has been established, it is identification that will provide the center around which both the description of the Oedipus complex and the construction of that "scientific myth"—here still in a stage of germination—of the "primal horde" will be reorganized (albeit not without difficulty).[30]

It is obvious that it is impossible, in a sketch of this kind, to follow, in all of its complexity, the textual network in which the Freudian notion of death is precariously elaborated, and in which, as Freud always indicated in his numerous historical recapitulations of the *Trieblehre,* the questions of masochism, narcissism, identification etc. intersect. However, in terms of our immediate interest here, that is, the question of theatricality itself, we can at least point out something that never becomes explicit in the text of 1906 (which, however, it therefore renders aporetic),[31] but which will be directly stated in a text of 1916: namely, that the split of representation does not take place *within* the libido but rather *between* the libido (desire) and death, and that it is therefore, to use another terminology, the limit of the economic scheme in general: "Our own death is indeed unrepresentable [*unvorstellbar*], and whenever we make the attempt to represent it we can perceive that we really do so only as spectators. Hence, the psychoanalytic school could venture on the assertion that at bottom no one believes in his own death, or to put the same thing in another way, in the unconscious every one of us is convinced of his own immortality."[32]

Like the female, or maternal genitals, death cannot present itself as such, or as Lyotard would say, "in person." Just as the female abyss has an apotropaic structure (as obscenity),[33] death is submitted to the ineluctable necessity of re-presentation (in the sense of a mise-en-scène, of a *Darstellung*), and hence of identification and of mimicry as well:

> in the world of fiction, in literature or in theater we seek a substitute [*Ersatz*] for loss of life. There we still find people who know how to die. . . . there alone we can enjoy the condition which makes it possible for us to reconcile ourselves with death, namely, that behind all the vicissitudes of life there remains for us another life intact. . . . In the realm of fiction we discover that plurality of lives for which we crave. We die by identifying with a given hero, yet we survive him, and are ready to die again with the next hero just as safely.[34]

If it is permissible to play on a "popular" etymology, we might say that death is *ob-scene*. At the very least, Freud is convinced that death "cannot be looked in the face" and that art (like religion) has the privilege of being the beginning of economic representation—that is, of libidinal representation. Death never appears as such, it is in the strict sense unrepresentable, or the unrepresentable itself, if this expression has any meaning: *the death drive works in silence; all the noise of life emanates from Eros.* "It" (the Id) works, "it" unsettles all manifestation, but it never manifests "itself" and if it ever does become "manifest," it has long since been "eroticized"—as in art, including modern art, and no matter what havoc has been wrought with the form or the work it has dared to assume. All we ever apprehend of death is its *ebb*.[35] This is the origin of the "economic problem of masochism." This is why representation and its machinery *(dispositif)* does not comprise an enclave within the libidinal but rather the libidinal itself. Or the *economy of death* (in the double sense of the genitive, of course). And to introduce the opposition of primary and secondary process here, as do Ehrenzweig and Lyotard, does not change matters. On the contrary. It is precisely the unconscious that does not know death (negation), or, if one prefers, that does not want to hear about it (denial, *Verneinung*).

All this defines Freud's thought as being essentially "tragic." Certainly, this is nothing new; unless, perhaps, one begins to investigate the precise relation of the tragic, in the modern sense (including that of Nietzsche), to philosophy, from which—by contrast with ancient tragedy—it proceeds or, if you like, succeeds. What in fact tragic thought reveals is that the *necessity of representation* exceeds the limits of mere art or religion, and that "thought" itself is condemned to representation. And this in turn explains why, for Freud as for Nietzsche (albeit for diverse reasons) both philosophy and science are themselves to be comprehended as "works of art," or even as myths or rational fictions. "Thought" is condemned to representation because death, in the final analysis, is precisely what "the life of the Spirit" is terrified of, for it compels the Spirit, whether it wants to or not, to avow its incapacity to "maintain itself." The unconscious, as Hyppolite and Lacan have shown with the famous example of the *Verneinung*,[36] obeys a logic comparable to that of Hegel: it "supercedes" *(aufhebt)* death, it denies it and is only willing to speak or to "know" anything about it on the condition of imagining itself to be exempt from it, i.e. of refusing to "believe in it." Inversely (and even if this reversibility is not absolute), the logic at work in philosophy ignores death in its own fashion, and all the more so when it claims to have internalized it. But death is precisely what cannot be internalized and it is this, perhaps, that constitutes the Tragic (including what Bataille called *dramatization*): the "consciousness" or rather—which is the same—the *avowal* that all

one can do with death is to theatricalize it. In any event, what is certain is that to protest in the name of the alleged mission of art to look death in the face[37] has never amounted to anything more than making Freud into a pre-Hegelian rather than a Hegelian, which is hardly a step forward. And what is worse is that this attitude tends to miss entirely the place in Freud where the function of theatricality as matrix comes to impose itself in a decisive manner: namely, beyond the constitution of the *"analytical scene"* (and hence a fortiori beyond the beginnings of the "cathartic method"), in the metapsychology itself: in the irreducible dualism of the drives.

The fact remains that the fundamental theatricality of analysis is confusingly similar to that of philosophy itself. Which, in turn, is an almost certain indication of the fact that analysis *also* is a part of philosophy, depending upon it and subordinate to it. Its "tragic thought" in no way transgresses the closure of philosophy. And up to a point, it is true, it cannot be denied that analysis as a whole is constructed along the lines of philosophical representation, which is to say, within the space delimited by the (political) scenography of Plato. This holds even if it is equally true that analysis *subsequently* makes possible the recognition and deconstruction of this system by distinctly revealing the hopes of royalty and of mastery, the "basilic" desire at work in the philosophical *deflection* of tragedy. But all this is perhaps not what is essential. For even without taking into account the minute and "systematic" disruption to which Freud practically, empirically submitted the machinery of representation,[38] his texts reveal consistently the troubled concern that, in spite of everything (and with Freud, this "everything" is impressive), haunts the philosophical (and medical) desire for mastery. Here, we will cite only one example, because it closely involves one of the major motifs of "Psychopathic Characters on the Stage." We have seen that modern dramaturgy supposes the cultural or social establishment of neurosis. A quarter-century later (i.e. really very late), while he is once again reworking the same hypothesis, Freud will ask himself to what extent, exactly, and above all how one can speak of a society's or a civilization's being neurotic. It is an apparently harmless question, but one that in fact brutally undermines the power of medicine itself (in the Nietzschean, philosophical sense of a "medicine of civilization"), both in the diagnosis and in the therapy. This occurs in *Civilization and Its Discontents*, and it does not require an excess of imagination to recall what such a text might have represented in 1930:

> there is one question which I can hardly evade. If the development of civilization has such a far-reaching similarity to the development of the individual and if it employs the same methods, may we not be justified in reaching the diagnosis that, under the influence of cultural urges, some civilizations, or some epochs of

civilization—possibly the whole of mankind—have becomes "neurotic"? And analytic dissection of such neuroses might lead to therapeutic recommendations which could lay claim to great practical interest. . . . But we should have to be very cautious and not forget that, after all, we are only dealing with analogies and that it is dangerous, not only with men but also with concepts, to tear them from the sphere in which they have originated and been evolved. Moreover, the diagnosis of communal neuroses is faced with a special difficulty. In an individual neurosis we take as our starting point the contrast that distinguishes the patient from his environment, which is assumed to be "normal." For a group all of whose members are affected by one and the same disorder no such background could exist; it would have to be found elsewhere. And as regards the therapeutic application of our knowledge, what would be the use of the most correct analysis of social neuroses, since no one possesses authority to impose such a therapy upon the group?[39]

It goes without saying that these few remarks are too brief to want to be "decisive." Such could hardly be their purpose, since the intention that has dictated them was rather to mark the "constitutive" *undecidability* of Freud's treatment of representation. The critical disruption of the medical-philosophical discourse does not exclude the possibility of itself being translated into "conservative" terms, as often happens. But one should not simply abandon its interrogative, subversive power to be picked up and super-ceded—*aufgehoben*—by whoever happens along. In this (Hegelian) sense, Freud himself never "picked up" anything. His "academism," his economic and libidinal formalism, however questionable they may be, are not without reason, and it is one that is far more audacious than the prudence and circumspection that seem to be the cause. Which is not, however, to say—and here, at least, we are in agreement with Lyotard—that they are not without problems.

This is why, far from *reinforcing* Freudianism, we will finish here with a *question*. In the text from which we began, Lyotard speaks of the "credence accorded by Freud to the Sophoclean and Shakespearean libretti."[40] This is the same criticism that Nietzsche, at the time of *The Birth of Tragedy*, directed at the entire Western tradition of commentary on Greek tragedy and "operatic culture." Lyotard goes no further. There is, however, a symptom involved that should not be neglected. It is no accident that Freud repeatedly avows himself to be devoid of all sensibility for music and to be incapable of being interested in it. In such declarations he is perhaps only being consistent with the Aristotelian (and also Platonic) elimination of *musical* catharsis—that is, as Rohde demonstrated, of Dionysian (and feminine) Carybantianism. On this point, Nietzsche himself "hesitated," as one

says. He was highly suspicious, for instance—and not just because of prudery or of "protestant" severity—of all experience that claimed to be free and wild, "barbarian" or Dionysian. Rather, it was because he *also* knew that the Dionysian *itself* was inaccessible, or, which amounts to the same, that music *itself* has always been plastic, figural—Apollonian. And, had he not refused to read him, Freud might have *recognized* something in a text of this genre:

> We need not conjecture regarding the immense gap which separated the *Dionysian Greek* from the Dionysian Barbarian. From all quarters of the ancient world—to say nothing of the modern—from Rome to Babylon, we can point to the existence of Dionysian festivals, types which bear, at best, the same relation to the Greek festivals which the bearded satyr, who borrowed his name and attributes from the goat, bears to Dionysus himself. In nearly every case these festivals centered in extravagant sexual licentiousness, whose waves overwhelmed all family life and its venerable traditions; the most savage natural instincts were unleashed, including even that horrible mixture of sensuality and cruelty which has always seemed to me to be the real "witches' brew." For some time, however, the Greeks were apparently perfectly insulated and guarded against the feverish excitements of these festivals, though knowledge of them must have come to Greece on all the routes of land and sea; for the figure of Apollo, rising full of pride, held out the Medusa's head to this grotesquely uncouth Dionysian power.[41]

This "resurrection" or "consolidation" (which is that of Doric art) confronted with the Dionysiac—this apotropaic gesture is precisely the moment that, in the history of Greek culture, precedes the "reconciliation" of the Apollonian and the Dionysian, which only the "noble art" of Greece (the tragedy) revealed itself capable of assuring. One can think whatever one cares to about such a reconciliation. For us there is no doubt that it must be deconstructed, if only in its (surviving) dialectical aspect, which is to say in all that still masks the recognition of the ineluctable representation that it implies. There is no need, it is true, to mobilize Apollo for that, and Nietzsche himself, moreover, will end up doing without him. For it is within the Dionysian itself that the *interdiction* of presence takes place, or, to put it in another language (one that Freud uses in an enigmatic text to justify the desire of art),[42] death incessantly undermines and deports all "presence" irrevocably, dooming us to repetition. A thought that should not be cast aside as an embarrassment, or indicted as a symptom of nihilism, as a "pious and depressed thought." Rather, it is what Nietzsche called "heroism"; and heroism—that is, the impossible ethical (and not pathetical) trial of the abyss—has never been known to signify nihilism.

NOTES

Translated by Robert Vollrath and Samuel Weber.

1. This manuscript was given by Freud, at an undetermined time, to the historian and music theorist Max Graf, a longtime member of Freud's circle of friends and disciples. Graf published it for the first time in 1942, in an English translation by H. A. Bunker. The text, which was entitled "Psychopathic Characters on the Stage," appeared in the *Psychoanalytical Quarterly* 11, no. 4. This is the version included in volume 7 of the *Standard Edition*. The original was first published in 1962 (*Neue Rundschau*, 73) before appearing in volume 10 (*Bildende Künste und Literatur*, 1970) of the *Studienausgabe* published by Fischer in Frankfurt. It is not included in Freud's *Gesammelte Werke*. Despite Graf's belief that the text was written in 1904, it is now generally considered to have been composed in 1905, or at the latest, early in 1906. Thus it is roughly contemporary with the *Three Essays on the Theory of Sexuality, Jokes and Their Relation to the Unconscious,* and perhaps even *Delusions and Dreams in Jensen's "Gradiva."* It is not clear, however, why Freud decided to give the text to Graf, without indicating the slightest intention of having it published (or even of correcting it).

The present text appeared originally in an earlier version entitled "A Note on Freud and Representation" *[Note sur Freud et la représentation]* and was designed to accompany the first French translation of Freud's text, done in collaboration with Jean-Luc Nancy, which appeared in the review *Digraphe* 3 (autumn 1974).

[English citations of "Psychopathic Characters on the Stage" are from the *Standard Edition of the Complete Psychological Works of Sigmund Freud,* ed. James Strachey et al., 23 vols. (London: Hogarth Press, 1953–74), 7:305–10 (henceforth: *SE*). In order to maintain continuity with Lacoue-Labarthe's and Nancy's French translation of this text, we have retranslated where necessary.—TRANS.]

2. See in particular, René Girard, *Violence and the Sacred,* trans. Patrick Gregory (Baltimore: Johns Hopkins University Press, 1977); and Gilles Deleuze and Félix Guattari, *Anti-Oedipus,* trans. Robert Hurley, Mark Seem, and Helen R. Lane (Minneapolis: University of Minnesota Press, 1983).

3. Jean Starobinski, "Hamlet et Freud," preface to the French translation of E. Jones, *Hamlet et Oedipe* (Paris: Gallimard, 1976); André Green, *The Tragic Effect: The Oedipus Complex in Tragedy,* trans. Alan Sheridan (Cambridge: Cambridge University Press, 1979), and "Shakespeare, Freud et le parricide," *Le Nef* 32 (July–October 1967). Concerning the reading of "Psychopathic Characters on the Stage," see also O. Mannonni, *Clefs pour l'imaginaire ou l'Autre scène* (Paris: Seuil, 1969); and Sarah Kofman, *The Childhood of Art: An Interpretation of Freud's Aesthetics* (New York: Columbia University Press, 1988).

4. See, in particular, Jacques Derrida, "The Theatre of Cruelty and the Closure of Representation" [reprinted in this collection—ED.], and "Freud and the Scene of Writing," in *Writing and Difference,* trans. Alan Bass (Chicago: University of Chicago Press, 1978).

5. Jean-François Lyotard, "Beyond Representation," trans. Jonathan Culler, in *The Lyotard Reader,* ed. Andrew Benjamin (Oxford: Basil Blackwell, 1989), 155–68. Although we only cite what closely concerns "Psychopathic Characters on the Stage," the entirety of Lyotard's critical treatment of Freudian aesthetics should be taken into account, including texts such as "Jewish Oedipus," and "Current Major Trends in the Psychoanalytic Study of Artistic and Literary Expressions," in *Dérive à partir de Marx*

*et de Freud* (Paris: U.G.E., 1973), or "Freud According to Cezanne" in *Des Dispositifs pulsionnels* (Paris: U.G.E., 1973).

6. Freud probably *never* goes beyond comparison. The model here is the famous phrase, "the tragedy of Oedipus unfolds like an analysis." But if Lyotard is thus able to "literalize" this figure, it is because he has previously interpreted the text as deducing the psychopathics (the neurosis) of Greek tragedy, and then psychopathology itself from psychoanalysis. Freud, however, simply says that, at a given moment and for determinate reasons, the tragic scene becomes the site of a neurotic type of conflict. Which is not quite the same thing, since it implies that the theater enters the space of neurosis, but it does not produce it. Just as tragedy does not produce the Oedipus complex, even if the form of that complex is *necessarily* dramatic, and even if the structure of the scene, in general, is *necessarily* Oedipal.

7. Lyotard, "Beyond Representation," 12: "The seductive enticement *[prime de séduction]*," says Lyotard in particular, "operates no differently in Freud's thesis than does sleep in his theory of dreams, which functions to lower the defenses and with which all of secondary revision conspires." [Lyotard's essay was written to serve as the preface to the French edition (1974) of Anton Ehrenzweig's *The Hidden Order of Art* (London: Weidenfeld and Nicholson, 1967) to which Lacoue-Labarthe refers below.—Ed.]

8. See Ehrenzweig, *Hidden Order of Art,* especially chap. 5, 64–77.—Ed.

9. Freud, "Psychopathic Characters," 7:305.

10. Friedrich Nietzsche, *The Birth of Tragedy,* trans. Walter Kaufmann (New York: Vintage, 1967), 132–33.

11. This is the classical misinterpretation par excellence, to which the entire French seventeenth century, almost without exception, succumbed.

12. In still other words, Freud follows the Aristotelian thesis in all respects: namely, that catharsis is doubled (and constituted) by an "accompaniment of pleasure"; i.e., the thesis of relief or alleviation through pleasure (see *Politics,* VIII, 1342a).

13. The analogy can be found, for instance, in "Creative Writers and Day-Dreaming" (1908), *SE* 9:141–53, or in sec. 6 of "Formulations on the Two Principles of Mental Functioning" (1911), *SE* 12:218–26.

14. See Starobinski, "Hamlet et Freud," ix. This is obviously what renders possible the analytical "verification" of the paradigmatic character assumed by *Oedipus Rex* in Aristotle's *Poetics,* and thus of the matricial function of theatricality with regard to analysis, including the elevation of "Oedipus" in general to the rank of an absolute paradigm. In *Beyond the Pleasure Principle,* identification will retain its Oedipal character, even as primary identification (and not withstanding the practically insurmountable difficulties it provokes, discussed in postscript B of *Group Psychology and the Analysis of the Ego, SE* 18:135–37).

15. See in particular his analysis of the tragic effect developed from the viewpoint of the "artist as spectator" in chapters 21–24 of *The Birth of Tragedy.* This analysis concerns essentially the exemplary function of tragic myth. The Nietzschean theory of identification can be found here in embryonic form, whose place in his general "typology" is well known.

16. Freud, "Psychopathic Characters," 7:305–6.

17. "But the suffering represented is soon restricted to *mental* suffering; for no one wants physical suffering who knows how quickly all mental enjoyment is brought to an end by the changes in somatic feeling that physical suffering brings about. If we

are sick we have one wish only: to be well again and to be quit of our present state. We call for the doctor and medicine, and for the removal of the inhibition on the play of fantasy which has pampered us into deriving enjoyment even from our own sufferings. If a spectator puts himself in the place of someone who is physically ill he finds himself without any capacity for enjoyment or psychical activity. Consequently, a person who is physically ill can only figure on the stage as a piece of stage property and not as a hero, unless, indeed, some peculiar physical aspects of his illness makes psychical activity possible—such, for instance, as the sick man's forlorn state in the *Philoctetes* or the hopelessness of the sufferers in the class of plays that center around consumptives." Freud, "Psychopathic Characters," 7:305–6.

18. Freud, "Psychopathic Characters," 305.

19. "In general, it may perhaps be said that the neurotic instability of the public and dramatist's skill in avoiding resistances and offering fore-pleasures *[Vorlust]* can alone determine the limits set upon enjoyment of abnormal characters on the stage." Freud, "Psychopathic Characters," 310. Cf. *Three Essays on the Theory of Sexuality,* 3:1, *SE* 7:208–11, and *Jokes,* B: 4 and 5, *SE* 8:117–58. The difficulty in this text lies in the fact that fore-pleasure, which normally should permit the *avoidance* of intolerable tensions, here appears to overlap with another species of pleasure, to which Freud, moreover, attributes an independent mechanism: this is the sexual pleasure bound up with the deferral of discharge, which thus becomes a "super-tension" that is desired for its own sake. Here, in condensed form, lies the whole (future) problem of masochism. The reading we are attempting here tends not to resolve the problem, but to intensify it.

20. See "Creative Writers and Day-Dreaming" (1907).

21. Freud, "Psychopathic Characters," 7:305.

22. Ibid., 307.

23. The heroical-mythical figure invoked here as the emblem of tragedy in a way reminiscent of *Totem and Taboo* (4:7), is that of Prometheus: "The fact that drama originated out of sacrificial rites (the goat and the scapegoat) in the cult of the gods cannot be unrelated to this meaning of drama. It appeases, as it were, a rising rebellion against the divine regulation of the universe, which is responsible for the existence of suffering. Heroes are first and foremost rebels against God or against something divine . . . Here we have a mood like that of Prometheus. . . ." But just as the sacrificial origins of drama, in *Totem and Taboo,* are inscribed in the Oedipal matrix (revised, so to speak, by Nietzsche: Dionysus' laceration as a reminder of the original murder), here it is Oedipus who governs the entire genealogy of the drama and who accounts for the psychopathological drama (in conformity with the Oedipal version of *Hamlet* proposed in *The Interpretation of Dreams*).

24. Freud, *The Interpretation of Dreams* 5:4, *SE* 4, 241–42. If we were retracing the overall movement of Freud's interpretation of *Hamlet,* "Psychopathic Characters on the Stage" would be situated—following the argument advanced by Starobinski (who was apparently unaware of this text) midway between *The Interpretation of Dreams* and the *Introductory Lectures on Psycho-Analysis* (the *Vorlesungen* of 1916). Concerning the interpretation of a *hidden conflict* in *Hamlet* (". . . the conflict in *Hamlet* is so hidden that at first I had to guess that it was there"), cf. also Lyotard, "Jewish Oedipus," and in particular everything there concerning the "non-fulfillment of the paternal utterance as the difference between the Modern and the Greeks."

25. Freud, "Psychopathic Characters," 7:308–9.

26. "The first of these modern dramas is *Hamlet.* It has as its subject a man of

normal behavior who becomes neurotic, owing to the peculiar nature of the task by which he is faced. A man, that is, in whom an impulse that has hitherto been successfully suppressed endeavors to make its way into action. *Hamlet* is distinguished by three characteristics which seem important in connection with our present discussion. (1) The hero is not psychopathic, but only *becomes* psychopathic in the course of the action of the play. (2) The repressed impulse is one of those which are similarly repressed in all of us, and the repression of which is part and parcel of the foundation of our personal evolution. . . . As a result of these two characteristics it is easy for us to recognize ourselves in the hero. . . . (3) It appears as a necessary precondition of this form of art that the impulse that is struggling into consciousness, however clearly it is recognizable, is never given a definite name; so that in the spectator too the process is carried through with his attention averted, and he is in the grip of his emotions instead of taking stock of what is happening. A certain amount of resistance is no doubt saved in this way, just as, in an analytical treatment, we find derivatives of the repressed material reaching consciousness, owing to a lower resistance, while the repressed material itself is unable to do so." Freud, "Psychopathic Character," 7:309–10.

27. Freud, *Beyond the Pleasure Principle,* chapter 2, in fine.

28. Cf. *Poetics,* 1448b: "Imitation is natural to man from childhood, etc." Concerning the "undecidable" nature of play, Freud makes a note of it twice during the course of this development. At the very least this renders problematic Lyotard's claim that the *fort/da* analysis attests to "the recurrent power of the theatrical process in Freud's epistemological unconscious," "Beyond Representation," 13.

29. Freud, "Psychopathic Characters," 7:306.

30. Cf. Freud, *Group Psychology and the Analysis of the Ego,* postscript B.

31. Would this account for his "forgetting" the text?

32. Freud, "Thoughts for the Times on War and Death," (chap. 2, "Our Attitude towards Death"), *SE* 14:289–300.

33. Cf. "The Head of Medusa." Suffice it to say that in pursuing a certain number of Rohde's indications in Psychè, particularly concerning the catharsis of impurity or the union of the apotropaion with catharsis, the relation between catharsis and femininity invites examination in the light of the relation of death (and suffering) to catharsis.

34. Freud, "Thoughts for the Times on War and Death," *SE* 14:291.

35. This renders the Jungian deviation denounced by Freud, for instance in chapter 6 of *Civilization and its Discontents,* a constant possibility. That is, the reduction of the drives to a single libido is always possible, as the most recent discourse of Lyotard confirms—see in particular *Libidinal Economy,* trans. Iain Hamilton Grant (Bloomington, IN.: Indiana University Press, 1993).

36. Lacan, *Ecrits* (Paris: Seuil, 1966).

37. See Lyotard, "Current Major Trends," where in "fulfillment" of the interpretation proposed by Blanchot of the Orpheus allegory, Lyotard writes in the following: "But the story of the legendary adventure continues. Orpheus turns around. His desire to *see* the figure exceeds his desire to lead it back to the light. Orpheus wants to see in the night, to see the night. In attempting to see Eurydice, he loses all possibility of letting her be seen: the figure is that which has no face, killing whomever disfigures *[dévisage]* her because she fills him with her own night. . . . But Orpheus has gone to search for Eurydice precisely because of this disfigurement, and not in order to produce a work; the artist has not descended into the night in order to render himself

capable of producing a harmonious song, or the reconciliation of night and day, or to earn laurels for his art. He has gone to search for the figural instance, that other of his own work, to see the invisible, to see death. The artist is someone in whom the desire to see death even at the price of dying triumphs over the desire to produce." But all of this is only conceivable on the condition that one considers death to be a "figure," and correlatively, the artist's descent into the inferno—frequent enough in modern art—to be itself, "biographically," a "work of art." The equivocation of Lyotard with which we take issue stems ultimately from *Discours, Figure* (Paris: Klincksieck, 1971), the terminology of which reemerges here. Theoretically, Lyotard's point of departure is his determination of the figure, or the figural, against our every expectation, as something pertaining not to the real of manifestation (and correlatively, his determination of writing as designating the order of constituted discourse). This is without a doubt the origin of our disagreement.

38. Refer to Luce Irigaray, "La philosophie par derriére," a paper given to the "Groupe de recherche sur les théories du signe et du texte" at the University of Strasbourg II.

39. Freud, *Civilization and its Discontents,* chap. 8.

40. Lyotard, "Beyond Representation," 10.

41. Nietzsche, *The Birth of Tragedy,* chap. 2.

42. Freud, "On Transience," *SE* 14:305–7.

Part 3

# *Staging Power*
## Transgressive Alterity

# Louis Althusser

## The "Piccolo Teatro": Bertolazzi and Brecht—Notes on a Materialist Theater

I should like to make amends to the Piccolo Teatro of Milan and their extraordinary production at the Théatre des Nations in July 1962. Amends for the condemnation and disappointment that Bertolazzi's *El Nost Milan* drew so copiously from Parisian criticism,[1] depriving it of the audiences it deserved. Amends, because, far from diverting our attention from the problems of modern dramaturgy with tired, anachronistic entertainment, Strehler's choice and his production take us to the heart of these problems.

Readers will forgive me if I give a brief summary of the plot of Bertolazzi's play, so that what follows can be understood.[2]

The first of its three acts is set in the Milan Tivoli in the 1890s: a cheap, poverty-stricken fun-fair in the thick fog of an autumn evening. With this fog we already find ourselves in an Italy unlike the Italy of our myths. And the people strolling at day's end from booth to booth, between the fortunetellers, the circus, and all the attractions of the fairground: unemployed, artisans, semibeggars, girls on the lookout, old men and women on the watch for the odd halfpenny, soldiers on a spree, pickpockets chased by the cops . . . neither are these people the people of our myths, they are a subproletariat passing the time as best they can before supper (not for all of them) and rest. A good thirty characters who come and go in this empty space, waiting for who knows what, for something to happen, the show perhaps?—no, for they stop at the doorway, waiting for something of some sort to happen in their lives, in which nothing happens. They wait. However, at the end of the act, in a flash a "story" is sketched out, the image of a destiny. A girl, Nina, stands transfixed by the lights of the circus, staring with all her heart through a rent in the canvas at the clown performing his perilous act. Night has fallen. For one moment, time is in suspense. But she is already being watched by the Togasso, the good-for-nothing who hopes to seduce her. A quick defiance, retreat, departure. Now an old man appears, the "fire-eater," her father, and he has seen everything. Something has taken shape, which might turn into a tragedy.

A tragedy? It is completely forgotten in the second act. It is broad day in

the spacious premises of a cheap eating-house. Here again we find a whole crowd of poor people, the same people but different characters: the same poverty and unemployment, the flotsam of the past, the tragedies and comedies of the present: small craftsmen, beggars, a cabman, a Garibaldian veteran, some women, etc. Also a few workers who are building a factory, in sharp contrast with their lumpen-proletarian surroundings: they are already discussing industry, politics, and, almost, the future, but only just and with difficulty. This is Milan from below, twenty years after the conquest of Rome and the deeds of the Risorgimento: King and Pope are on their thrones, the masses are in poverty. Yes, the day of the second act is indeed the truth of the night of the first: these people have no more history in their lives than they had in their dreams. They survive, that is all: they eat (only the workers depart, called by the factory hooter), they eat and wait. A life in which nothing happens. Then, just at the end of the act, Nina reappears on the stage, for no apparent reason, and with her the tragedy. We learn that the clown is dead. The men and women leave the stage little by little. The Togasso appears, he forces the girl to kiss him and give him what little money she has. Hardly more than a few gestures. Her father arrives. (Nina is weeping at the end of the long table.) He does not eat: he drinks. After a terrible struggle he succeeds in killing the Togasso with a knife and then flees, haggard, overwhelmed by what he has done. Once again a lightning flash after a long grind.

In the third act it is dawn in the women's night shelter. Old women, blending into the walls, sitting down, talk or stay silent. One stout peasant woman, bursting with health, will certainly return to the country. Some women pass; as always, we do not know them. The lady warden leads her whole company to Mass when the bells ring. When the stage has emptied, the tragedy begins again. Nina was sleeping in the shelter. Her father comes to see her for the last time before prison: she must realize at least that he killed for her sake, for her honor . . . but suddenly everything is reversed: Nina turns on her father, on the illusions and lies he has fed her, on the myths which will kill him. But not her; for she is going to rescue herself, all alone, for that is the only way. She will leave this world of night and poverty and enter the other one, where pleasure and money reign. The Togasso was right. She will pay the price, she will sell herself, but she will be on the other side, on the side of freedom and truth. The hooters sound. Her father has embraced her and departed, a broken man. The hooters still sound. Erect, Nina goes out into the daylight.

There are the themes of this play and the order in which they appear, pressed into a few words. Altogether not much. Enough, however, to foster misunderstandings, but also enough to clear them up, and discover beneath them an astonishing depth.

The first of these misunderstandings is, of course, the accusation that the play is a "*mélodrame misérabiliste*." But anyone who has "lived" the performance or studied its economy can demolish this charge. For if it does contain melodramatic elements, as a whole, the drama is simple a criticism of them. Nina's father does indeed live his daughter's story in the melodramatic mode, and not just his daughter's adventure, but above all his own life in his relations with his daughter. He has invented for her the fiction of an imaginary condition, and encouraged her in her romantic illusions; he tries desperately to give flesh and blood to the illusions he has fostered in his daughter: as he wishes to keep her free from all contact with the world he has hidden from her, and as, desperate that she will not listen to him, he kills the source of Evil, the Togasso. So he lives intensively and really the myths he has constructed to spare his daughter from the law of this world. So the father is the very image of melodrama, of the "law of the heart" deluding itself as the "law of the world." It is precisely this deliberate unconsciousness that Nina rejects. She makes her own real trial of the world. With the clown's death her adolescent dreams have died too. The Togasso has opened her eyes and dispatched her childhood myths along with her father's. His violence itself has freed her from words and duties. She has at last seen this naked, cruel world where morality is nothing but a lie; she has realized that her safety lies in her own hands and that she can only reach the other world by selling the only goods at her disposal: her young body. The great confrontation at the end of the third act is more than a confrontation between Nina and her father, it is the confrontation of a world without illusions with the wretched illusions of the "heart," it is the confrontation of the real world with the melodramatic world, the dramatic access to consciousness that destroys the myths of melodrama, the very myths that Bertolazzi and Strehler are charged with. Those who make this charge could quite easily have found in the play the criticism they tried to address to it from the stalls.

But there is another, deeper reason that should clear up this misunderstanding. I was trying to hint at it in my summary of the play's "sequence," when I pointed out its strange "temporal" rhythm.

For this is, indeed, a play remarkable for its internal dissociation. The reader will have noted that its three acts have the same structure, and almost the same content: the coexistence of a long, slowly passing, empty time and a lightning-short, full time; the coexistence of a space populated by a crowd of characters whose mutual relations are accidental or episodic—and a short space, gripped in mortal combat, inhabited by three characters: the father, the daughter, and the Togasso. In other words, this is a play in which about forty characters appear, but the tragedy concerns only three of them. Moreover, there is no *explicit* relationship between these two times or between these two

spaces. The characters of the time seem strangers to the characters of the lightning: they regularly give place to them (as if the thunder of the storm had chased them from the stage), only to return in the next act, in other guises, once the instant foreign to their rhythm has passed. If we deepen the latent meaning of this dissociation it will lead us to the heart of the play. For the spectator actually lives this deepening as he moves from disconcerted reserve to astonishment and then passionate involvement between the first and the third acts. My aim here is merely to reflect this lived deepening, to make explicit this latent meaning which affects the spectator despite himself. But the decisive question is this: why is it that this dissociation is so expressive, and what does it express? What is this absence of relations to suggest a latent relation as its basis and justification? How can there coexist two forms of temporality, apparently foreign to one another and yet united by a lived relationship?

The answer lies in a paradox: the true relationship is constituted precisely by the absence of relations. The play's success in illustrating this absence of relations and bringing it to life gives it its originality. In short, I do not think we are dealing with a melodramatic veneer on a chronicle of Milanese popular life in 1890. We are dealing with a melodramatic consciousness criticized by an existence: the existence of the Milanese subproletariat in 1890. Without this existence it would be impossible to tell what the melodramatic consciousness was; without this critique of the melodramatic consciousness it would be impossible to grasp the tragedy latent in the existence of the Milanese subproletariat: its powerlessness. What is the significance of the chronicle of wretched existence that makes up the essential part of the three acts? Why is this chronicle's time a march-past of purely typed, anonymous and interchangeable beings? Why is this time of vague meetings, brief exchanges, and broached disputes precisely an empty time? In its progress from the first act through the second to the third, why does this time tend towards silence and immobility? (In the first act there is still a semblance of life and movement on the stage; in the second, everyone is sitting down and some are already lapsing into silence; in the third, the old women blend into the walls.) Why— if not to suggest the actual content of this wretched time: it is a time in which nothing happens, a time without hope or future, a time in which even the past is fixed in repetition (the Garibaldian veteran) and the future is hardly groped for in the political stammerings of the laborers building the factory, a time in which gestures have no continuation or effect, in which everything is summed up in a few exchanges close to life, to "everyday life," in discussions and disputes which are either abortive or reduced to nothingness by a consciousness of their futility.[3] In a word, a stationary time in which nothing resembling History can yet happen, an empty time, accepted as empty: the time of their situation itself.

I know of nothing so masterly in this respect as the setting for the second act, because it gives us precisely *a direct perception of this time*. In the first act it was still possible to wonder whether the waste land of the Tivoli only harmonized with the nonchalance of the unemployed and idlers who saunter between the few illusions and few fascinating lights at the end of the day. In the second act it is overwhelmingly obvious that the empty, closed cube of this cheap restaurant is an image of time in these men's situation. At the bottom of the worn surface of an immense wall, and almost at the limit of an inaccessible ceiling covered with notices of regulations half effaced by the years but still legible, we see two enormously long tables, parallel to the footlights, one downstage, the other midstage; behind them, up against the wall, a horizontal iron bar dividing off the entrance to the restaurant. This is the way the men and women will come in. Far right, a high partition perpendicular to the line of the tables separates the hall from the kitchens. Two hatches, one for alcohol, the other for food. Behind the screen, the kitchens, steaming pots, and the imperturbable cook. The bareness of this immense field created by the parallel tables against the interminable background of the wall, constitutes an unbearably austere and yawning location. A few men are seated at the tables. Here and there. Facing the audience, or with their backs to them. They will talk face on or backward, just as they are sitting. In a space which is too large for them, a space they will never be able to fill. Here they will make their derisory exchanges, but however often they leave their places in an attempt to join some chance neighbour, who has tossed them a proposal across tables and benches, they will never abolish tables or benches, which will always cut them off from each other, under the inalterable, silent regulation that dominates them. This space is really the time they live in. One man here, another there. Strehler has scattered them around. They will stay where they are. Eating, pausing in their meal, eating again. At these times, the gestures themselves reveal all their meaning. The character seen face-on at the beginning of the scene, his head hardly higher than the plate he would prefer to carry between his two hands. The time it takes him to fill his spoon, to lift it up to his mouth and over it, in an interminable movement designed to ensure that not one scrap is lost, and when at last he has filled his mouth, he lingers over his portion weighing it up before swallowing it. Then we see that the others with their backs to us are making the same movements: their raised elbows compensating for their unstable backs—we see them eating, absently, like all the other absent people, making the same holy movements in Milan and in all the world's great cities, because that is the whole of their lives, and there is nothing which would make it possible for them to live out their time otherwise. (The only ones with an air of haste are the laborers, their life and work punctuated by the hooters.) I can think of no comparable

representation in spatial structure, in the distribution of men and places, of the deep relations between men and the time they live.

Now for the essential point: this temporal structure—that of the "chronicle"—is opposed to another temporal structure: that of the "tragedy." For the tragedy's time (Nina) is full: a few lightning flashes, an articulated time, a "dramatic" time. A time in which some history must take place. A time moved from within by an irresistible force, producing its own content. It is a dialectical time par excellence. A time that abolishes the other time and the structure of its spatial representation. When the men have left the restaurant, and only Nina, her father, and the Togasso are left, something has suddenly disappeared: as if the diners had taken the whole décor with them (Strehler's stroke of genius: to have made two acts one, and played two different acts *in the same décor*), the very space of walls and tables, the logic and meaning of these locations; as if conflict alone substituted for this visible and empty space another dense, invisible, irreversible space, with one dimension, the dimension that propels it towards tragedy, ultimately, the dimension that had to propel it into tragedy if there was really to be any tragedy.

It is precisely this opposition that gives Bertolazzi's play its depth. On the one hand, a non-dialectical time in which nothing happens, a time with no internal necessity forcing it into action; on the other, a dialectical time (that of conflict) induced by its internal contradiction to produce its development and result. The paradox of *El Nost Milan* is that the dialectic in it is acted marginally, so to speak, in the wings, somewhere in one corner of the stage and at the ends of the acts: this dialectic (although it does seem to be indispensable to any theatrical work) is a long time coming: the characters could not care less about it. It takes its time, and never arrives until the end, initially at night, when the air is heavy with the renowned night-owls, then as midday strikes, with the sun already on its descent, finally as dawn rises. This dialectic always appears after everyone has departed.

How is the "delay" of this dialectic to be understood? Is it delayed in the way consciousness is for Marx and Hegel? But can a dialectic be delayed? Only on condition that it is another name for consciousness.

If the dialectic of *El Nost Milan* is acted in the wings, in one corner of the stage, it is because it is nothing but the dialectic of a consciousness: the dialectic of Nina's father and his consciousness. And that is why its destruction is the precondition for any real dialectic. Here we should recall Marx's analyses in *The Holy Family* of Eugène Sue's personages.[4] The motor of their dramatic conduct is their identification with the myths of bourgeois morality: these unfortunates live their misery within the arguments of a religious and moral conscience; in borrowed finery. In it they disguise their problems and even their condition. In this sense, melodrama is a foreign consciousness as a

veneer on a real condition. The dialectic of the melodramatic consciousness is only possible at this price: this consciousness must be borrowed from outside (from the world of alibis, sublimations, and lies of bourgeois morality), and it must still be lived as *the* consciousness of a condition (that of the poor) even though this condition is radically foreign to the consciousness. It follows that between the melodramatic consciousness on the one hand, and the existence of the characters of the melodrama on the other, there can exist no *contradiction* strictly speaking. The melodramatic consciousness is not contradictory to these conditions: it is a quite different consciousness, imposed from without on a determinate condition but without any dialectical relation to it. That is why the melodramatic consciousness can only be dialectical if it ignores its real conditions and barricades itself inside its myth. Sheltered from the world, it unleashes all the fantastic form of a breathless conflict which can only ever find peace in the catastrophe of someone else's fall: it takes this hullabaloo for destiny and its breathlessness for the dialectic. In it, the dialectic turns in a void, since it is only the dialectic of the void, cut off from the real world for ever. This foreign consciousness, without contradicting its conditions, cannot emerge from itself by itself, by its own "dialectic." It has to make a rupture— and recognize this nothingness, discover the non-dialecticity of this dialectic.

This never happens with Sue: but it does in *El Nost Milan*. In the end the last scene does give an answer to the paradox of the play and of its structure. When Nina turns on her father, when she sends him back into the night with his dreams, she is breaking both with her father's melodramatic consciousness and with his "dialectic." She has finished with these myths and the conflicts they unleash. Father, consciousness, dialectic, she throws them all overboard and crosses the threshold of the other world, as if to show that it is in this poor world that things are happening, that everything has already begun, not only its poverty, but also the derisory illusions of its consciousness. This dialectic which only comes into its own at the extremities of the stage, in the aisles of a story it never succeeds in invading or dominating, is a very exact image for the quasi-null relation of a false consciousness to a real situation. The sanction of the necessary rupture imposed by real experience, foreign to the content of consciousness, is to chase this dialectic from the stage. When Nina goes through the door separating her from the daylight she does not yet know what her life will be; she might even lost it. At least *we* know that she goes out into the real world, which is undoubtedly the world of money, but also the world that produces poverty and imposes on poverty even its consciousness of "tragedy." And this is what Marx said when he rejected the false dialectic of consciousness, even of popular consciousness, in favor of experience and study of the other world, the world of Capital.

At this point someone will want to stop me, arguing that what I am

drawing from the play goes beyond the intentions of the author—and that I am, in fact, attributing to Bertolazzi what really belongs to Strehler. But I regard this statement as meaningless, for at issue here is the play's latent structure and nothing else. Bertolazzi's explicit intentions are unimportant: what counts, beyond the words, the characters and the action of the play, is the internal relation of the basic elements of its structure. I would go further. It does not matter whether Bertolazzi consciously wished for this structure, or unconsciously produced it: it constitutes the essence of his work; it alone makes both Strehler's interpretation and the audience's reaction comprehensible.

Strehler was acutely aware of the implications of this remarkable structure,⁵ and his production and direction of the actors were determined by it; that is why the audience was bowled over by it. The spectators' emotion cannot be explained merely by the "presence" of this teeming popular life— nor by the poverty of these people, who still manage to keep up a hand-to-mouth existence, accepting their fate, taking their revenge, on occasion with a laugh, at moments by solidarity, most often by silence—nor by the lightning tragedy of Nina, her father and the Togasso; but basically by their unconscious perception of this structure and its profound meaning. The structure is nowhere exposed, nowhere does it constitute the object of a speech or a dialogue. Nowhere can it be perceived directly in the play as can the visible characters or the course of the action. But it is there, in the tacit relation between the people's time and the time of the tragedy, in their mutual imbalance, in their incessant "interference" and finally in their true and delusive criticism. It is this revealing latent relation, this apparently insignificant and yet decisive tension that Strehler's production enables the audience to perceive without their being able to translate this presence directly into clearly conscious terms. Yes, the audience applauded in the play something that was beyond them, which may even have been beyond its author, but which Strehler provided him: a meaning buried deeper than words and gestures, deeper than the immediate fate of the characters who live this fate without ever being able to reflect on it. Even Nina, who is for us the rupture and the beginning, and the promise of another world and another consciousness, does not know what she is doing. Here we can truly say that consciousness is delayed—for even if it is still blind, it is a consciousness aiming at last at a real world.

If this reflection on an "experience" is acceptable, we might use it to illuminate other experiences by an investigation into their meaning. I am thinking of the problems posed by Brecht's great plays, problems which recourse to such concepts as the alienation-effect or the epic theater has perhaps not in principle perfectly solved. I am very struck by the fact that a latent asymmetrical-critical

structure, the dialectic-in-the-wings structure found in Bertolazzi's play, is in essentials also the structure of plays such as *Mother Courage* and (above all) *Galileo*. Here again we also find forms of temporality that do not achieve any mutual integration, which have no relation to one another, which coexist and interconnect, but never meet each other, so to speak; with lived elements which interlace in a dialectic which is localized, separate, and apparently ungrounded; works marked by an internal dissociation, an unresolved alterity.

The dynamic of this specific latent structure, and in particular, the coexistence without any explicit relation of a dialectical temporality and a non-dialectical temporality, is the basis for a true critique of the illusions of consciousness (which always believes itself to be dialectical and treats itself as dialectical), the basis for a true critique of the false dialectic (conflict, tragedy, etc.) by the disconcerting reality which is its basis and which is waiting for recognition. Thus, the war in *Mother Courage*, as opposed to the personal tragedies of her blindness, to the false urgency of her greed; thus, in *Galileo* the history that is slower than consciousness impatient for truth, the history which is also disconcerting for a consciousness which is never able to "take" durably on to it within the period of its short life. This silent confrontation of a consciousness (living its own situation in the dialectical-tragic mode, and believing the whole world to be moved by its impulse) with a reality which is indifferent and strange to this so-called dialectic—an apparently undialectical reality, makes possible an immanent critique of the illusions of consciousness. It hardly matters whether these things are said or not (they are in Brecht, in the form of fables or songs): in the last resort it is not the words that produce this critique, but the internal balances and imbalances of forces between the elements of the play's structure. For there is no true critique which is not immanent and already real and material before it is conscious. I wonder whether this asymmetrical, decentered structure should not be regarded as essential to any theatrical effort of a materialist character. If we carry our analysis of this condition a little further we can easily find in it Marx's fundamental principle that it is impossible for any form of ideological consciousness to contain in itself, through its own internal dialectic, an escape from itself, that, *strictly speaking, there is no dialectic of consciousness:* no dialectic of consciousness which could reach reality itself by virtue of its own contradictions; in short, there can be no "phenomenology" in the Hegelian sense: for consciousness does not accede to the real through its own internal development, but by the radical discovery of what is *other than itself.*

It was in precisely this sense that Brecht overthrew the problematic of the classical theater—when he renounced the thematization of the meaning and implications of a play in the form of a consciousness of self. By this I mean that, to produce a new, true, and active consciousness in his spectators,

Brecht's world must necessarily exclude any pretensions to exhaustive self-recovery and self-representation in the form of a consciousness of self. The classical theater (though Shakespeare and Molière must be excepted, and this exception explained) gave us tragedy, its conditions and its "dialectic," completely reflected in the speculative consciousness of a central character—in short, reflected it total meaning in a consciousness, in a talking, acting, thinking, developing human being: what tragedy is for us. And it is probably no accident that this formal condition of "classical" aesthetics (the central unity of a dramatic consciousness, controlling the other, more famous "unities") is closely related to its material content. I mean that the material, or the themes, of the classical theater (politics, morality, religion, honor, "glory," "passion," etc.) are precisely ideological themes, and they remain so, without their ideological nature ever being questioned, that is, criticized ("passion" itself, opposed to "duty" or "glory" is no more than an ideological counterpoint—never the effective dissolution of the ideology). But what, concretely, is this uncriticized ideology if not simply the "familiar," "well-known," transparent myths in which a society or an age can recognize itself (but not know itself), the mirror it looks into for self-recognition, precisely the mirror it must break if it is to know itself? What is the ideology of a society or a period if it is not that society's or period's consciousness of itself, that is, an immediate material which spontaneously implies, looks for and naturally finds its forms in the image of a consciousness of self living the totality of its world in the transparency of its own myths? I am not asking why these myths (the ideology as such) were not *generally* questioned in the classical period. I am content to be able to infer that a time without real self-criticism (with neither the means nor the need for a real theory of politics, morality and religion) should be inclined to represent itself and recognize itself in an uncritical theater, that is, the theater whose (ideological) material presupposed the formal conditions for an aesthetic of the consciousness of self. Now Brecht can only break with these formal conditions because he has already broken with their material conditions. His principal aim is to produce a critique of the spontaneous ideology in which men live. That is why he is inevitably forced to exclude from his plays this formal condition of the ideology's aesthetics, the consciousness of self (and its classical derivations: the rules of unity). For him (I am still discussing the "great plays"), no character consciously contains in himself the totality of the tragedy's conditions. For him, the total, transparent consciousness of self, the mirror of the whole drama is never anything but an image of the ideological consciousness, which does include the whole world in its own tragedy, save only that this world is merely the world of morals, politics, and religion, in short, of myths and drugs. In this sense these plays are decentered precisely because they can have no center, because, although the illusion-

wrapped, naive consciousness is his starting point, Brecht refuses to make it that center of the world it would like to be. That is why in these plays the center is always to one side, if I may put it that way, and in so far as we are considering a demystification of the consciousness of self, the center is always deferred, always in the beyond, in the movement going beyond illusion toward the real. For this basic reason the critical relation, which is a real production, cannot be thematized for itself: that is why no character is in himself "the morality of history"—except when one of them comes down to the footlights, takes off his mask and, the play over, "draws the lessons" (but then he is only a spectator reflecting on it from the outside, or rather prolonging its movement: "we have done our best, now it is up to you").

It should now be clear why we have to speak of the dynamic of the play's latent structure. It is the structure that we must discuss in so far as the play cannot be reduced to its actors, nor to their explicit relations—only to the dynamic relation existing between consciousness of self alienated in spontaneous ideology (Mother Courage, her sons, the cook, the priest, etc.) and the real conditions of their existence (war, society). This relation, abstract in itself (abstract with respect to the consciousness of self—for this abstract is the true concrete) can only be acted and represented as characters, their gestures and their acts, and their "history" only as a relation which goes beyond them while implying them; that is, as a relation setting to work abstract structural elements (e.g. the different forms of temporality in *El Nost Milan*—the exteriority of dramatic crowds, etc.), their imbalance and hence their dynamic. This relation is necessarily latent in so far as it cannot be exhaustively thematized by any "character" without ruining the whole critical project: that is why, even if it is implied by the action as a whole, by the existence and movements of all the characters, it is their deep meaning, beyond their consciousness—and thus hidden from them; visible to the spectator in so far as it is invisible to the actors—and therefore visible to the spectator in the mode of a perception which is not given, but has to be discerned, conquered and drawn from the shadow which initially envelops it, and yet produced it.

Perhaps these remarks give us a more precise idea of the problem posed by the Brechtian theory of the alienation-effect. By means of this effect Brecht hoped to create a new relation between the audience and the play performed: a critical and active relation. He wanted to break with the classical forms of identification, where the audience hangs on the destiny of the "hero" and all its emotional energy is concentrated on theatrical catharsis. He wanted to set the spectator at a distance from the performance, but in such a situation that he would be incapable of flight or simple enjoyment. In short, he wanted to make the spectator into an actor who would complete the unfinished play, but in real life. This profound thesis of Brecht's has perhaps been too often

interpreted solely as a function of the technical elements of alienation: the abolition of all "impressiveness" in the acting, of all lyricism and all "pathos": al fresco acting; the austerity of the set, as if to eliminate any eye-catching relief (cf. the dark ochre and ash colors in *Mother Courage*); the "flat" lighting; the commentary placards to direct the readers' attention to the external context of the conjuncture (reality), etc. The thesis has also given rise to psychological interpretations centered around the phenomenon of identification and its classical prop: the hero. The disappearance of the hero (whether positive or negative), the object of identification, has been seen as the very precondition of the alienation-effect (no more hero, no more identification—the suppression of the hero being also linked to Brecht's "materialist" conception—it is the masses who make history, not "heroes"). Now, I feel that these interpretations are limited to notions which may well be important, but which are not determinant, and that it is essential to go beyond the technical and psychological conditions to an understanding that this very special critique must be constituted in the spectator's consciousness. In other words, if a distance can be established between the spectator and the play, it is essential that in some way this distance should be produced within the play itself, and not only in its (technical) treatment, or in the psychological modality of the characters (are they really heroes or nonheroes? Take the dumb daughter on the roof in *Mother Courage,* shot because she beat her infernal drum to warn the unknowing city that an enemy was about to fall on it, is she not, in fact, a "positive hero"? Surely we do temporarily "identify" with this secondary character?). It is within the play itself, in the dynamic of its internal structure, that this distance is produced and represented, at once criticizing the illusions of consciousness and unraveling its real conditions.

This—that the dynamic of the latent structure produces this distance within the play itself—must be the starting point from which to pose the problem of the relation between the spectator and the performance. Here again Brecht reverses the established order. In the classical theater it was apparently quite simple: the hero's temporality was the sole temporality, all the rest was subordinate to it, even his opponents were made to his measure, they had to be if they were to be *his* opponents; they lived *his* time, *his* rhythm, they were dependent on him, they were merely his dependants. The opponent was really *his* opponent: in the struggle the hero belonged to the opponent as much as the opponent did to the hero, the opponent was the hero's double, his reflection, his opposite, his night, his temptation, his own unconscious turned against him. Hegel was right, his destiny was consciousness of himself as of an enemy. Thereby the content of the struggle was identified with the hero's consciousness of himself. And quite naturally, the spectator seemed to "live" the play by "identifying" himself with the hero,

that is, with his time, with his consciousness, the only time and the only consciousness offered him. In Bertolazzi's play and in Brecht's great plays this confusion becomes impossible, precisely because of their dissociated structure. I should say, not that the heroes have disappeared because Brecht has banished them from his plays, but that even as the heroes they are, and in the play itself, the play makes them impossible, abolishes them, their consciousness and its false dialectic. This reduction is not the effect of the action alone, nor of the demonstration which certain popular figures are fated to make of it (on the theme: neither God nor Caesar); it is not even merely the result of the play appreciated as an unresolved story; it is not produced at the level of detail or of continuity, but at the deeper level of the play's structural dynamic.

At this point close attention is essential: up till now only the play has been discussed—now we must deal with the spectator's consciousness. I should like to show in a few words that this is not, as might have been thought, a new problem, but really the same one. However, if this is to be accepted, two classical models of the spectatorial consciousness which cloud our reflection must first of all be relinquished. The first of these misleading models is once again a consciousness of self, this time the spectator's. It accepts that the spectator should not identify with the "hero"; he is to be kept at a distance. But is he not then outside the play judging, adding up the score and drawing the conclusions? Mother Courage is presented to you. It is for her to act. It is for you to judge. On the stage the image of blindness—in the stalls the image of lucidity, led to consciousness by two hours of unconsciousness. But this division of roles amounts to conceding to the house what has been rigorously excluded from the stage. Really, the spectator has no claim to this absolute consciousness of self which the play cannot tolerate. The play can no more contain the "Last Judgement" on its own "story" than can the spectator be the supreme Judge of the play. He also sees and lives the play in the mode of a questioned false consciousness. For what else is he if not the brother of the characters, caught in the spontaneous myths of ideology, in its illusions and privileged forms, as much as they are? If he is kept at a distance from the play by the play itself, it is not to spare him or to set him up as a Judge—on the contrary, it is to take him and enlist him in this apparent distance, in this "estrangement"—to make him into this distance itself, the distance which is simply an active and living critique.

But then, no doubt, we must also reject the second model of the spectatorial consciousness—a model that will haunt us until it has been rejected: the identification model. I am unable to answer this question fully here, but I shall try to pose it clearly: surely the invocation of a conception of identification (with the hero) to deal with the status of the spectatorial consciousness is to hazard a dubious correlation? Rigorously speaking, the

concept of identification is a psychological, or, more precisely, a psychoana-
lytic concept. Far be it from me to contest the effectivity of psychological
processes in the spectator seated in front of the stage. But it must be said that
the phenomena of projection, sublimation, etc., that can be observed,
described, and defined in controlled psychological situations cannot by them-
selves account for complex behaviour as specific as that of the spectator-
attending-a-performance. This behavior is primarily social and cultural-
aesthetic, and as such it is also ideological. Certainly, it is an important task to
elucidate the insertion of concrete psychological processes (such as identifica-
tion, sublimation, repression, etc., in their strict psychological senses) in
behavior which goes beyond them. But this first task cannot abolish the
second—the definition of the specificity of the spectatorial consciousness
itself—without lapsing into psychologism. If the consciousness cannot be
reduced to a purely psychological consciousness, if it is a social, cultural, and
ideological consciousness, we cannot think its relation to the performance
solely in the form of a psychological identification. Indeed, before (psycho-
logically) identifying itself with the hero, the spectatorial consciousness recog-
nizes itself in the ideological content of the play, and in the forms characteris-
tic of this content. Before becoming the occasion for an identification (an
identification with self in the species of another), the performance is, funda-
mentally, the occasion for a cultural and ideological recognition.[6] This self-
recognition presupposes as its principle an essential identity (which makes the
processes of psychological identification themselves possible, in so far as they
are psychological): the identity uniting the spectators and actors assembled in
the same place on the same evening. Yes, we are first united by an
institution—the performance, but more deeply, by the same myths, the same
themes, that govern us without our consent, by the same spontaneously lived
ideology. Yes, even if it is the ideology of the poor par excellence, as in *El Nost
Milan,* we still eat of the same bread, we have the same rages, the same
rebellions, the same madness (at least in the memory where stalks this ever-
imminent possibility), if not the same prostration before a time unmoved by
any History. Yes, like Mother Courage, we have the same war at our gates,
and a handsbreadth from us, if not in us, the same horrible blindness, the
same dust in our eyes, the same earth in our mouths. We have the same dawn
and night, we skirt the same abysses: our unconsciousness. We even share the
same history—and that is how it all started. That is why we were already
ourselves in the play itself, from the beginning—and then what does it matter
whether we know the result, since it will never happen to anyone but our-
selves, that is, still in our world. That is why the false problem of identifica-
tion was solved from the beginning, even before it was posed, by the reality of
recognition. The only question, then, is what is the fate of this tacit identity,

this immediate self-recognition, what has the author already done with it? What will the actors set to work by the Dramaturg, be Brecht or Strehler, do with it? What will become of this ideological self-recognition? Will it exhaust itself in the dialectic of the consciousness of self, deepening its myths without ever escaping from them? Will it put this infinite mirror at the center of the action? Or will it rather displace it, put it to one side, find it and lose it, leave it, return to it, expose it from afar to forces which are external—and so drawn out—that like those wineglasses broken at a distance by a physical resonance, it comes to a sudden end as a heap of splinters on the floor.

To return finally to my attempt at definition, with the simple aim of posing the question anew and in a better form, we can see that the play itself *is* the spectator's consciousness—for the essential reason that the spectator has no other consciousness than the content which unites him to the play in advance, and the development of this content in the play itself: the new result which the play *produces* from the self-recognition whose image and presence it is. Brecht was right: if the theater's sole object were to be even a "dialectical" commentary on this eternal self-recognition and non-recognition—then the spectator would already know the tune, it is his own. If, on the contrary, the theater's object is to destroy this intangible image, to set in motion the immobile, the eternal sphere of the illusory consciousness's mythical world, then the play is really the development, the production of a new consciousness in the spectator—incomplete, like any other consciousness, but moved by this incompletion itself, this distance achieved, this inexhaustible work of criticism in action; the play is really the production of a new spectator, an actor who starts where the performance ends, who only starts so as to complete it, but in life.

I look back, and I am suddenly and irresistibly assailed by *the* question: are not these few pages, in their maladroit and groping way, simply that unfamiliar play *El Nost Milan*, performed on a June evening, pursuing in me its incomplete meaning, searching in me, despite myself, now that all the actors and sets have been cleared away, for the *advent* of its silent discourse?

## NOTES

Translated by Ben Brewster.

1. "Epic melodrama" . . . "Poor popular theatre" . . . "Noxious Central European Miserabilism" . . . "Tear jerker" . . . "destestable sentimentalism" . . . "Worn out old shoe" . . . "A Piaf croon" . . . "Miserabilist melodrama, realist excess" (comments drawn from *Parisien-libéré, Combat, Figaro, Libération, Paris-Presse, Le Monde*).

2. Bertolazzi was a late-nineteenth-century Milanese playwright who achieved no more than moderate success—no doubt because of his obstinate persistence in *verismo* of a style odd enough to displease the public which then set "theatrical taste": the bourgeois public.

3. There is a whole tacit conspiracy among these poor folk to separate quarrelers, to circumvent unbearable pains, such as those of the unemployed young couple, to reduce all the troubles and disturbances of this life to its truth: to silence, immobility and nothingness.

4. Marx's book (*The Holy Family*, English translation, Moscow, 1956) contains no explicit definition of melodrama. But it does tell us its genesis, with Sue as its eloquent witness.

(*a*) The *Mystères de Paris* present morality and religion as a *veneer* on "natural" beings ("natural" despite their poverty or disgrace). What efforts have gone into this veneer! It needed Rodolphe's cynicism, the priest's moral blackmail, the paraphernalia of police, prison, internment, etc. Finally "nature" gives in: a foreign consciousness will henceforth govern it (and catastrophes multiply to guarantee its salvation).

(*b*) The origin of this "veneer" is obvious: it is Rodolphe who imposes this borrowed consciousness on these "innocents." Rodolphe neither comes from the "people," nor is he "innocent." But (naturally) he wants to "save" the people, to teach them that they have souls, that God exists, etc.—in other words, whether they will or no he gives them bourgeois morality to parrot so as to keep them quiet.

(*c*) It can be inferred (cf. *The Holy Family*, 242: "Eugène Sue's personages . . . must express as the result of their *own* thoughts the conscious motive of their acts, the reason why the writer makes them behave in a certain way and no other") that Sue's novel is the admission of his own project: to give the "people" a literary myth which will be both the propadeutic for the consciousness they must have, and the consciousness they must have to be the people (i.e., "saved," i.e., subordinate, paralyzed and drugged, in a word moral and religious). It could not be more bluntly put that it was the bourgeoisie itself that invented for the people the popular myth of the melodrama, that proposed or imposed it (serials in the popular press, cheap "novels") just as it was the bourgeoisie that "gave" them night shelters, soup kitchens, etc.: in short, a fairly deliberate system of preventive charities.

(*d*) All the same, it is entertaining to witness the majority of established critics pretending to be disgusted by melodrama! As if in them the bourgeoisie had *forgotten* that melodrama was its own invention! But, in all honesty, we must admit that the invention dated quickly: the myths and charities handed out to the "people" are otherwise organized today, and more ingeniously. We must also accept that at heart it was an invention for others, and it is certainly very disconcerting to see your own works sitting squarely at your right hand for all to see—or parading unashamedly on your own stages! Is it conceivable, for example, that the romantic press (the popular "myth" of recent times) should be invited to the spiritual concert of ruling ideas? We must not mix ranks.

(*e*) It is also true that one can allow oneself what one would forbid others (it used to be what marked out the "great" in their own consciousness): an exchange of roles. A Person of Quality can use the back stairs for fun (borrow from the people what he has given it, or left over for it). Everything depends on the double-meaning of this surreptitious exchange, on the short terms of the loan, and on its conditions: in other words, on the irony of the game in which one proves to oneself (so this proof is

necessary?) that one is not to be fooled by anything, not even by the means that one is using to fool others. In other words one is quite prepared to borrow from the "people" the myths, the trash that one has fabricated and handed out (or sold) to them, on condition that they are suitably accommodated and "treated." Good or mediocre "treaters" (such as Bruant and Piaf, and the Frères Jacques, respectively) may arise from their ranks. One makes oneself "one of the people" through a delight in being above one's own methods; that is why it is essential to play at being (not being) the people that one forces the people to be, the people of popular "myth," people with a flavor of melodrama. This melodrama is not worthy of the stage (the real, theatrical stage). It is savored in small sips in the cabaret.

(*f*) My conclusion is that neither amnesia, nor disgust, nor irony produce even the shadow of a critique.

5. "The principal feature of the work is precisely the sudden appearances in it of a truth as yet hardly defined. . . . *El Nost Milan* is a drama sotto voce, a drama continually referred back, reconsidered, a drama which is focused from time to time only to be deferred once again, a drama which is made up of a long grey line broken by the cracks of a whip. This is no doubt the reason why Nina and her Father's few decisive cries stand out in particularly tragic relief. . . . We have decided to make some rearrangements in the construction of the play so as to stress this secret structure. Bertolazzi's four acts have been reduced to three by the fusion of the second and third acts" (Program Notes).

6. We should not imagine that this self-recognition escapes the exigencies which, in the last instance, command the destiny of the ideology. Indeed, art is as much the desire for self-recognition as self-recognition itself. So, from the beginning, the unity I have assumed to be (in essentials) achieved so as to restrict the analysis, the stock of common myths, themes, and aspirations which makes representation possible as a cultural and ideological phenomenon—this unity is as much a desired or rejected unity as an achieved unity. In other words, in the theatrical world, as in the aesthetic world more generally, ideology is always in essence the site of a competition and a struggle in which the sound and fury of humanity's political and social struggles is faintly or sharply echoed. I must say that it is very odd to put forward purely psychological processes (such as identification) as explanations of spectatorial behavior, when we know that the effects of these processes are sometimes radically absent—when we know that there are professional and other spectators who do not want to understand anything, even before the curtain rises, or who, once the curtain has been raised, refuse to recognize themselves in the work presented to them, or in its interpretation. We need not look far for a wealth of examples. Was not Bertolazzi rejected by the late-nineteenth-century Italian bourgeoisie and forced into failure and poverty? And here in Paris, June 1962, was he not condemned—along with Strehler—without a hearing, a real hearing, by the leaders of "Parisian" public consciousness? Whereas a large popular audience now accepts and recognizes him in Italy?

# Michel Foucault
## Theatrum Philosophicum

I must discuss two books of exceptional merit and importance: *Différence et répétition* and *Logique du sens*. Indeed, these books are so outstanding that they are difficult to discuss; this may explain, as well, why so few have undertaken this task. I believe that these works will continue to revolve about us in enigmatic resonance with those of Klossowski, another major and excessive sign,[1] and perhaps one day, this century will be known as Deleuzian.

One after another, I should like to explore the many paths which lead to the heart of these challenging texts. As Deleuze would say, however, this metaphor is misleading: there is no heart, but only a problem—that is, a distribution of notable points; there is no center, but always decenterings, series that register the halting passage from presence to absence, from excess to deficiency.[2] The circle must be abandoned as a faulty principle of return; we must abandon our tendency to organize everything into a sphere. All things return on the straight and narrow, by way of a straight and labyrinthine line. Thus, fibrils and bifurcation (Leiris's marvelous series would be well suited to a Deleuzian analysis).

What philosophy has not tried to overturn Platonism? If we defined philosophy at the limit as any attempt, regardless of its source, to reverse Platonism, then philosophy begins with Aristotle; or better yet, it begins with Plato himself, with the conclusion of the *Sophist* where it is impossible to distinguish Socrates from the crafty imitators; or it begins with the Sophists who were extremely vocal about the rise of Platonism and who ridiculed its future greatness with their perpetual play on words.

Are all philosophies individual species of the genus "anti-Platonic?" Does each begin with a declaration of this fundamental rejection? Can they be grouped around this desired and detestable center? Rather, the philosophical nature of a discourse is its Platonic differential, an element absent in Platonism but present in other philosophies. A better formulation would be: it is an element in which the effect of absence is induced in the Platonic series through a new and divergent series (consequently, its function in the Platonic series is that of a signifier that is both excessive and absent); and it is also an element in which the Platonic series produces a free, floating, and excessive circulation in that other discourse. Plato, then, is the excessive circulation in that other discourse. Plato, then, is the excessive and deficient father. It is useless to define a philosophy by its anti-Platonic character (as a plant is

distinguished by its reproductive organs); but a philosophy can be distinguished somewhat in the manner in which a phantasm is defined, by the effect of a lack when it is distributed into its two constituent series—the "archaic" and the "real";[3] and you will dream of a general history of philosophy, a Platonic phantasmatology, and not an architecture of systems.

In any event, Deleuze's "reversed Platonism"[4] consists of displacing himself within the Platonic series in order to disclose an unexpected facet: division. Plato did not establish a weak separation between the genus "hunter," "cook," or "politician," as the Aristotelians said; neither was he concerned with the particular characteristics of the species "fisherman" or "one who hunts with snares";[5] he wished to discover the identity of the true hunter. *Who is?* and not *What is?* He searched for the authentic, the pure gold. Instead of subdividing, selecting, and pursuing a productive seam, he chose among the pretenders and ignored their fixed cadastral properties; he tested them with the strung bow which eliminates all but one (the nameless one, the nomad). But how does one distinguish the false (the simulators, the "so-called") from the authentic (the unadulterated and pure)? Certainly not by discovering a law of the true and false (truth is not opposed to error but to false appearances), but by looking, beyond these manifestations to a model, a model so pure that the actual purity of the "pure" resembles it, approximates it, and measures itself against it; a model that exists so forcefully that in its presence the sham vanity of the false copy is immediately reduced to nonexistence. With the abrupt appearance of Ulysses, the eternal husband, the false suitors disappear. *Exeunt* simulacra.

Plato is said to have opposed essence to appearance, a higher world to this terrestrial world, the sun of truth to the shadows of the cave (and it becomes our duty to bring essences back into the world, to glorify the world, and to place the sun of truth within man). But Deleuze locates Plato's singularity in the delicate sorting operation which precedes the discovery of essence, because it necessitates the world of essences in its separation of false simulacra from the multitude of appearances. Thus, it is useless to attempt the reversal of Platonism by reinstating the rights of appearances, ascribing to them solidity and meaning, and bringing them closer to essential forms by lending them a conceptual backbone: these timid creatures should not be encouraged to stand upright. Neither should we attempt to rediscover the supreme and solemn gesture which established, in a single stroke, the inaccessible Idea. Rather, we should welcome the cunning assembly that simulates and clamors at the door. And what will enter, submerging appearance and breaking its engagement to essence, will be the event; the incorporeal will dissipate the density of matter; a timeless insistence will destroy the circle that imitates eternity; an impenetrable singularity will divest itself of its contamination by purity; the actual semblance

of the simulacrum will support the falseness of false appearances. The sophist springs up, and challenges Socrates to prove that he is not the illegitimate usurper.

To reverse Platonism with Deleuze is to displace oneself insidiously within it, to descend a notch, to descend to its smallest gestures—discrete, but *moral*—which serve to exclude the simulacrum; it is also to deviate slightly from it, to encourage from either side the small talk it excluded; it is to initiate another disconnected and divergent series; it is to construct, by way of this small lateral leap, a dethroned para-Platonism. To convert Platonism (a serious task) is to increase its compassion for reality, for the world, and for time. To subvert Platonism is to begin at the top (the vertical distance of irony) and to grasp its origin. To pervert Platonism is to search out the smallest details, to descend (with the natural gravitation of humor) as far as its crop of hair or the dirt under its fingernails—those things that were never hallowed by an idea; it is to discover its initial decentering in order to recenter itself around the Model, the Identical, and the Same; it is the decentering of oneself with respect to Platonism so as to give rise to the play (as with every perversion) of surfaces at its border. Irony rises and subverts; humor falls and perverts.[6] To pervert Plato is to side with the Sophists' spitefulness, the rudeness of the Cynics, the arguments of the Stoics, and the fluttering visions of Epicurus. It is time to read Diogenes Laertius.

We should be alert to the surface effects in which the Epicurians take such pleasure:[7] emissions proceeding from deep within bodies and rising like the wisps of a fog—interior phantoms that are quickly reabsorbed into other depths by the sense of smell, by the mouth, by the appetites; extremely thin membranes, which detach themselves from the surfaces of objects and proceed to impose colors and contours deep within our eyes (floating epiderm, visual idols); phantasms created by fear or desire (cloud gods, the adorable face of the beloved, "miserable hope transported by the wind"). It is this expanding domain of intangible objects that must be integrated into our thought: we must articulate a philosophy of the phantasm that cannot be reduced to a primordial fact through the intermediary of perception or an image, but that arises between surfaces, where it assumes meaning, and in the reversal that causes every interior to pass to the outside and every exterior to the inside, in the temporal oscillation that always makes it precede and follow itself—in short, in what Deleuze would perhaps not allow us to call its "incorporeal materiality."

It is useless to seek a more substantial truth behind the phantasm, a truth to which it points as a rather confused sign (thus, the futility of "symptomatologizing"); it is also useless to contain it within stable figures and to

construct solid cores of convergence where we might include, on the basis of their identical properties, all its angles, flashes, membranes, and vapors (no possibility of "phenomenalization"). Phantasms must be allowed to function at the limit of bodies; against bodies, because they stick to bodies and protrude from them, but also because they touch them, cut them, break them into sections, regionalize them, and multiply their surfaces; and equally, outside of bodies, because they function between bodies according to laws of proximity, torsion, and variable distance—laws of which they remain ignorant. Phantasms do not extend organisms into an imaginary domain; they topologize the materiality of the body. They should consequently be freed from the restrictions we impose upon them, freed from the dilemmas of truth and falsehood and of being and nonbeing (the essential difference between simulacrum and copy carried to its logical conclusion); they must be allowed to conduct their dance, to act out their mime, as "extra-beings."

*Logique du sens* can be read as the most alien book imaginable from *The Phenomenology of Perception*.[8] In this latter text, the body-organism is linked to the world through a network of primal significations, which arise from the perception of things, while, according to Deleuze, phantasms form the impenetrable and incorporeal surface of bodies; and from this process, simultaneously topological and cruel, something is shaped that falsely presents itself as a centered organism and that distributes at its periphery the increasing remoteness of things. More essentially, however, *Logique du sens* should be read as the boldest and most insolent of metaphysical treatises—on the basic condition that instead of denouncing metaphysics as the neglect of being, we force it to speak of extra-being. Physics: discourse dealing with the ideal structure of bodies, mixtures, reactions, internal and external mechanisms; metaphysics: discourse dealing with the materiality of incorporeal things—phantasms, idols, and simulacra.

Illusion is certainly the source of every difficulty in metaphysics, but not because metaphysics, by its very nature, is doomed to illusion, but because for the longest time it has been haunted by illusion and because, in its fear of the simulacrum, it was forced to hunt down the illusory. Metaphysics is not illusory—it is not merely another species of this particular genus—but illusion is a metaphysics. It is the product of a particular metaphysics that designated the separation between the simulacrum on one side and the original and perfect copy on the other. There was a critique whose task was to unearth metaphysical illusion and to establish its necessity; Deleuze's metaphysics, however, initiates the necessary critique for the disillusioning of phantasms. With this grounding, the way is cleared for the advance of the Epicurean and materialist series, for the pursuit of their singular zig-zag. And it does not lead, in spite of itself, to a shameful metaphysics; it leads joyously to

metaphysics—a metaphysics freed from its original profundity as well as from a supreme being, but also one that can conceive of the phantasm in its play of surfaces without the aid of models, a metaphysics where it is no longer a question of the One Good, but of the absence of God and the epidermic play of perversity. A dead God and sodomy are the thresholds of the new metaphysical ellipse. Where natural theology contained metaphysical illusion in itself and where this illusion was always more or less related to natural theology, the metaphysics of the phantasm revolves around atheism and transgression. Sade and Bataille and somewhat later, the palm upturned in a gesture of defense and invitation, Roberte.[9]

Moreover, this series of liberated simulacrum is activated, or mimes itself, on two privileged stages: that of psychoanalysis, which should eventually be understood as a metaphysical practice since it concerns itself with phantasms; and that of the theater, which is multiplied, polyscenic, simultaneous, broken into separate scenes that refer to each other, and where we encounter, without any trace of representation (copying or imitating), the dance of masks, the cries of bodies, and the gesturing of hands and fingers. And throughout each of these two recent and divergent series (the attempt to "reconcile" these series, to reduce them to either perspective, to produce a ridiculous "psychodrama" has been extremely naive), Freud and Artaud exclude each other and give rise to a mutual resonance. The philosophy of representation—of the original, the first time, resemblance, imitation, faithfulness—is dissolving; and the arrow of the simulacrum released by the Epicureans is headed in our direction. It gives birth—rebirth—to a "phantasmaphysics."

Occupying the other side of Platonism are the Stoics. Observing Deleuze in his discussion of Epicurus and Zeno, of Lucretius and Chrysippus, I was forced to conclude that his procedure was rigorously Freudian. He does not proceed—with a drum roll—toward the great Repression of Western philosophy; he registers, as if in passing, its oversights. He points out its interruptions, its gaps, those small things of little value that were neglected by philosophical discourse. He carefully reintroduces the barely perceptible omissions, knowing full well that they imply a fundamental negligence. Through the insistence of our pedagogical tradition, we are accustomed to reject the Epicurean simulacra as useless and somewhat puerile; and the famous battle of Stoicism, which took place yesterday and will reoccur tomorrow, has become cause for amusement in the schools. Deleuze did well to combine these tenuous threads and to play, in his own fashion, with this network of discourses, arguments, replies, and paradoxes, those elements that circulated for many centuries in Mediterranean cultures. We should not scorn Hellenistic confusion or Roman platitudes, but listen to those things said on the great surface of the empire; we should be

attentive to those things that happened in a thousand instances, dispersed on every side: fulgurating battles, assassinated generals, burning triremes, queens poisoning themselves, victories that invariably led to further upheavals, the endlessly exemplary Actium, the eternal event.

To consider a pure event, it must first be given a metaphysical basis.[10] But we must be agreed that it cannot be the metaphysics of substances, which can serve as a foundation for accidents; nor can it be a metaphysical coherence, which situates these accidents in the entangled nexus of causes and effects. The event—a wound, a victory-defeat, death—is always an effect produced entirely by bodies colliding, mingling, or separating, but this effect is never of a corporeal nature; it is the intangible, inaccessible battle that turns and repeats itself a thousand times around Fabricius, above the wounded Prince Andrew.[11] The weapons that tear into bodies form an endless incorporeal battle. Physics concerns causes, but events, which arise as its effects, no longer belong to it. Let us imagine a stitched causality: as bodies collide, mingle, and suffer, they create events on their surfaces, events that are without thickness, mixture, or passion; for this reason, they can no longer be causes. They form, among themselves, another kind of succession whose links derive from a quasi-physics of incorporeals—in short, from metaphysics.

Events also require a more complex logic.[12] An event is not a state of things, something that could serve as a referent for a proposition (the fact of death is a state of things in relation to which an assertion can be true or false; dying is a pure event that can never verify anything). For a ternary logic, traditionally centered on the referent, we must substitute an interrelationship based on four terms. "Marc Antony is dead" *designates* a state of things; *expresses* my opinion or belief; *signifies* an affirmation; and, in addition, has a *meaning:* "dying." An intangible meaning with one side turned toward things because "dying" is something that occurs, as an event, to Antony, and the other toward the proposition because "dying" is what is said about Antony in a statement. To die: a dimension of the proposition; an incorporeal effect produced by a sword; a meaning and an event; a point without thickness or substance of which someone speaks and which roams the surface of things. We should not restrict meaning to the cognitive core that lies at the heart of a knowable object; rather, we should allow it to reestablish its flux at the limit of words and things, as what is said of a thing (not its attribute or the thing in itself) and as something that happens (not its process or its state). Death supplies the best example, being both the event of events and meaning in its purest state. Its domain is the anonymous flow of speech; it is that of which we speak as always past or about to happen and yet it occurs at the extreme point of singularity. A meaning-event is as neutral as death: "not the end, but

the unending; not a particular death, but any death; not true death, but as Kafka said, the snicker of its devastating error."[13]

Finally, this meaning-event requires a grammar with a different form of organization,[14] since it cannot be situated in a proposition as an attribute (to be *dead*, to be *alive*, to be *red*) but is fastened to the verb (to die, to live, to redden). The verb, conceived in this fashion, has two principle forms around which the others are distributed: the present tense, which posits an event, and the infinitive, which introduces meaning into language and allows it to circulate as the neutral element to which we refer in discourse. We should not seek the grammar of events in temporal inflections; nor should we seek the grammar of meaning in the fictitious analyses of the type: to live = to be alive. The grammar of the meaning-event revolves around two asymmetrical and insecure poles: the infinitive mode and the present tense. The meaning-event is always both the displacement of the present and the eternal repetition of the infinitive. "To die" is never localized in the density of a given moment, but from its flux it infinitely divides the shortest moment. To die is even smaller than the moment it takes to think it, and yet dying is indefinitely repeated on either side of this width-less crack. The eternal present? Only on the condition that we conceive the present as lacking plenitude and the eternal as lacking unity: the (multiple) eternity of the (displaced) present.

To summarize: at the limit of dense bodies, an event is incorporeal (a metaphysical surface); on the surface of words and things, an incorporeal event is the *meaning* of a proposition (its logical dimension); in the thread of discourse, an incorporeal meaning-event is fastened to the verb (the infinitive point of the present).

In the more or less recent past, there have been, I think, three major attempts at conceptualizing the event: neopositivism, phenomenology, and the philosophy of history. Neopositivism failed to grasp the distinctive level of the event; because of its logical error, the confusion of an event with a state of things, it had no choice but to lodge the event within the density of bodies. to treat it as a material process, and to attach itself more or less explicitly to a physicalism ("in a schizoid fashion," it reduced surfaces into depth); as for grammar, it transformed the event into an attribute. Phenomenology, on the other hand, reoriented the event with respect to meaning: either it placed the bare event before or to the side of meaning—the rock of facticity, the mute inertia of occurrences—and then submitted it to the active processes of meaning, to its digging and elaboration; or else it assumed a domain of primal significations, which always existed as a disposition of the world around the self, tracing its paths and privileged locations, indicating in advance where the event might occur and its possible form. Either the cat whose good sense precedes the smile or the common sense of the smile that anticipates the cat.

Either Sartre or Merleau-Ponty. For them, meaning never coincides with an event; and from this evolves a logic of signification, a grammar of the first person, and a metaphysics of consciousness. As for the philosophy of history, it encloses the event in a cyclical pattern of time. Its error is grammatical;[15] it treats the present as framed by the past and future: the present is a former future where its form was prepared and the past, which will occur in the future, preserves the identity of its content. First, this sense of the present requires a logic of essences (which establishes the present in memory) and of concepts (where the present is established as a knowledge of the future), and then a metaphysics of a crowned and coherent cosmos, of a hierarchical world.

Thus, three systems that fail to grasp the event. The first, on the pretext that nothing can be said about those things which lie "outside" the world, rejects the pure surface of the event and attempts to enclose it forcibly—as a referent—in the spherical plenitude of the world. The second, on the pretext that signification only exists for consciousness, places the event outside and beforehand, or inside and after, and always situates it with respect to the circle of the self. The third, on the pretext that events can only exist in time, defines its identity and submits it to a solidly centered order. The world, the self, and God (a sphere, a circle, and a center): three conditions that invariably obscure the event and that obstruct the successful formulation of thought. Deleuze's proposals, I believe, are directed to lifting this triple subjection which, to this day, is imposed on the event: a metaphysics of the incorporeal event (which is consequently irreducible to a physics of the world), a logic of neutral meaning (rather than a phenomenology of signification based on the subject), and a thought of the present infinitive (and not the raising up of the conceptual future in a past essence).

We have arrived at the point where the two series of the event and the phantasm are brought into resonance—the resonance of the incorporeal and the intangible, the resonance of battles, of death that subsists and insists, of the fluttering and desirable idol: it subsists not in the heart of man but above his head, beyond the clash of weapons, in fate and desire. It is not that they converge in a common point, in some phantasmatic event, or in the primary origin of the simulacrum. The event is that which is invariably lacking in the series of the phantasm—its absence indicates its repetition devoid of any grounding in an original, outside of all forms of imitation, and freed from the constraints of similitude. Consequently, it is disguise of repetition, the always singular mask that conceals nothing, simulacra without dissimulation, incongruous finery covering a nonexistent nudity, pure difference.

As for the phantasm, it is "excessive" with respect to the singularity of the event, but this "excess" does not designate an imaginary supplement

adding itself to the bare reality of facts; nor does it form a sort of embryonic generality from which the organization of the concept gradually emerges. To conceive of death or a battle as a phantasm is not to confuse them either with the old image of death suspended over a senseless accident or with the future concept of a battle secretly organizing the present disordered tumult; the battle rages from one blow to the next and the process of death indefinitely repeats the blow, always in its possession, which it inflicts once and for all. This conception of the phantasm as the play of the (missing) event and its repetition must not be given the form of individuality (a form inferior to the concept and therefore informal), nor must it be measured against reality (a reality which imitates an image); it presents itself as universal singularity: to die, to fight, to vanquish, to be vanquished.

*Logique du sens* shows us how to develop a thought capable of comprehending the event *and* the concept, their severed and double affirmation, their affirmation of disjunction. Determining an event on the basis of a concept, by denying any importance to repetition, is perhaps what might be called knowing; and measuring the phantasm against reality, by going in search of its origin, is judging. Philosophy tried to do both, it dreamed of itself as a science, and presented itself as a critique. Thinking, on the other hand, requires the release of a phantasm in the mime that produces it at a single stroke; it makes the event indefinite so that it repeats itself as a singular universal. It is this construction of the event *and* the phantasm that leads to thought in an absolute sense. A further clarification: if the role of thought is to produce the phantasm theatrically and to repeat the universal event in its extreme point of singularity, then what is thought itself if not the event that befalls the phantasm and the phantasmatic repetition of the absent event? The phantasm and the event, affirmed in disjunction, are the object of thought *(le pensé)* and thought itself *(la pensée)*;[16] they situate extra-being at the surface of bodies where it can only be approached by thought and trace the topological event in which thought itself is formed. Thought must consider the process that forms it and form itself from these considerations. The critique-knowledge duality becomes absolutely useless as thought declares its nature.

This formulation, however, is dangerous. It implies equivalence and allows us once more to imagine the identification of an object and a subject. This would be entirely false. That the object of thought *(le pensé)* forms thought *(la pensée)* implies, on the contrary, a double dissociation: that of a central and founding subject to which events occur while it deploys meaning around itself; and of an object that is a threshold and point of convergence for recognizable forms and the attributes we affirm. We must conceive of an indefinite, straight line that (far from bearing events as a string supports its knots) cuts and recuts into each moment so many times that each event arises

as both incorporeal and indefinitely multiple. We must imagine not the synthesizing-synthesized subject, but an uncrossable fissure. Moreover, we must envisage a series lacking the primal appendages of simulacra, idols, and phantasms that always exist on either side of the gap in the temporal duality in which they form themselves and in which they signal to each other and come into existence as signs. The splitting of the self and the series of signifying points do not form a unity that permits thought to be both subject and object, but they are in themselves the event of thought *(la pensée)* and the incorporeality of the object of thought *(le pensé)*, the object of thought *(le pensé)* as a problem (a multiplicity of dispersed points) and thought *(la pensée)* as mime (repetition without a model).

This is why *Logique du sens* could have as a subtitle: *What is thinking?* This question always implies two different contexts throughout Deleuze's book: that of Stoic logic as it relates to the incorporeal and the Freudian analysis of the phantasm. What is thinking? The Stoics explain the operation of a thought concerning the objects of thought, and Freud tells us how thought is itself capable of thought. Perhaps, for the first time, this leads to a theory of thought that is complete freed from both the subject and the object. The thought-event is as singular as a throw of the dice; the thought-phantasm does not search for truth, but repeats thought.

In any case, we understand Deleuze's repeated emphasis of the mouth in *Logique du sens*. It is through this mouth, as Zeno recognized, that cartloads of food pass as well as carts of meaning ("If you say cart, a cart passes through your mouth."). The mouth, the orifice, the canal where the child intones the simulacra, the dismembered parts, and bodies without organs; the mouth in which depths and surfaces are articulated. Also the mouth from which falls the voice of the other giving rise to lofty idols that flutter above the child and form the superego. The mouth where cries are broken into phonemes, morphemes, semantemes: the mouth where the profundity of an oral body separates itself from incorporeal meaning. Through this open mouth, through this alimentary voice, the development of language, the formation of meaning, and the flash of thought extend their divergent series.[17] I would enjoy discussing Deleuze's rigorous phonocentrism were it not for the fact of a constant phonodecentering. Let Deleuze receive homage from the fantastic grammarian, from the dark precursor who nicely situated the remarkable facets of this decentering:

Les dents, la bouche
Les dents la bouchent
L'aidant la bouche
Laides en la bouche
Lait dans la bouche, etc.[18]

*Logique du sens* causes us to reflect on matters that philosophy has neglected for many centuries: the event (assimilated in a concept, from which we vainly attempted to extract it in the form of a *fact*, verifying a proposition, of *actual experience*, a modality of the subject, of *concreteness*, the empirical content of history); and the phantasm (reduced in the name of reality and situated at the extremity, the pathological pole, of a normative sequence: perception—image—memory—illusion). After all, what most urgently needs thought in this century, if not the event and the phantasm.

We should thank Deleuze for his efforts. He did not revive the tiresome slogans: Freud with Marx, Marx with Freud, and both, if you please, with us. He developed a convincing analysis of the essential elements for establishing the thought of the event and the phantasm. His aim was not reconciliation (to expand the furthest reaches of an event with the imaginary density of a phantasm, or to ballast a floating phantasm by adding a grain of actual history); he discovered the philosophy which permits the disjunctive affirmation of both. Prior to *Logique du sens*, Deleuze formulated this philosophy with completely unguarded boldness in *Différence et répétition*, and we must now turn to this earlier work.

Instead of denouncing the fundamental omission that is thought to have inaugurated Western culture, Deleuze, with the patience of a Nietzschean genealogist, points to the variety of small impurities and paltry compromises.[19] He tracks down the miniscule, repetitive acts of cowardliness and all those features of folly, vanity, and complacency that endlessly nourish the philosophical mushroom, what Leiris might call "ridiculous rootlets." We all possess good sense; we all make mistakes, but no one is dumb (certainly, none of us). There is no thought without good will; every real problem has a solution, because our apprenticeship is to a master who has answers for the questions he poses; the world is our classroom. A whole series of insignificant beliefs. But in reality, we encounter the tyranny of goodwill, the obligation to think "in common" with others, the domination of a pedagogical model, and most importantly, the exclusion of stupidity—the disreputable morality of thought whose function in our society is easy to decipher. We must liberate ourselves from these constraints; and in perverting this morality, philosophy itself is disoriented.

Consider the handling of difference. It is generally assumed to be a difference *from* or *within* something; behind difference, beyond it—but as its support, its site, its delimitation, and consequently as the source of its mastery—we pose, through the concept, the unity of a group and its breakdown into species in the operation of difference (the organic domination of the Aristotelian concept). Difference is transformed into that which must be

specified within a concept, without overstepping its bounds. And yet above the species, we encounter the swarming of individualities. What is this boundless diversity, which eludes specification and remains outside the concept, if not the resurgence of repetition? Underneath the ovine species, we are reduced to counting sheep. This stands as the first form of subjection: difference as specification (within the concept) and repetition as the indifference of individuals (outside the concept). But subjection to what? To common sense which, turning away from the mad flux and anarchical difference, invariably recognises the identity of things (and this is at all times a general capacity). Common sense extracts the generality of an object while it simultaneously establishes the universality of the knowing subject through a pact of goodwill. But what if we gave free rein to ill will? What if thought freed itself from common sense and decided to function only in its extreme singularity? What if it adopted the disreputable bias of the paradox, instead of complacently accepting its citizenship in the *doxa*? What if it conceived of difference differentially, instead of searching out the common elements underlying difference? Then difference would disappear as a general feature that leads to the generality of the concept, and it would become—a different thought, the thought of difference—a pure event. As for repetition, it would cease to function as the dreary succession of the identical, and would become displaced difference. Thought is no longer committed to the construction of concepts once it escapes goodwill and the administration of common sense, concerned as it is with division and characterization. Rather, it produces a meaning-event by repeating a phantasm. The morality of goodwill, which assists common sense thought, had the fundamental role of protecting thought from its "genital" singularity.

But let us reconsider the functioning of the concept. For the concept to master difference, perception must apprehend global resemblances (which will then be decomposed into differences and partial identities) at the root of what we call diversity. Each new representation must be accompanied by those representations that display the full range of resemblances; and in this space of representation (sensation—image—memory), likenesses are put to the test of quantitative equalization and graduated quantities, and in this way the immense table of measurable differences is constructed. In the corner of this graph, on its horizontal axis where the smallest quantitative gap meets the smallest qualitative variation, at this zero point, we encounter perfect resemblance and exact repetition. Repetition, which functions within the concept as the impertinent vibration of identities, becomes, within a system of representation, the organizing principles for similarities. But *what* recognises these similarities, the exactly alike and the least similar—the greatest and the smallest, the brightest and the darkest—if not good sense? Good sense is the

world's most effective agent of division in its recognitions, its establishment of equivalences, its sensitivity to gaps, its gauging of distances, as it assimilates and separates. And it is good sense that reigns in the philosophy of representation. Let us pervert good sense and allow thought to play outside the ordered table of resemblances; then it will appear as the vertical dimension of intensities, because intensity, well before its gradation by representation, is in itself pure difference: difference that displaces and repeats itself, that contracts and expands; a singular point that constricts and slackens the indefinite repetitions in an acute event. One must give rise to thought as intensive irregularity—disintegration of the subject.

A last consideration with respect to the table of representation. The meeting point of the axes is the point of perfect resemblance, and from this arises the scale of differences as so many lesser resemblances, marked identities: differences arise when representation can only partially present what was previously present, when the test of recognition is stymied. For a thing to be different, it must first no longer be the same; and it is on this negative basis, above the shadowy part that delimits the same, that contrary predicates are then articulated. In the philosophy of representation, the relationship of two predicates, like red and green, is merely the highest level of a complex structure: the *contradiction* between red and not-red (based on the model of *being* and *non-being*) is active on the lowest level; the non-identity of red and green (on the basis of the *negative* test of *recognition*) is situated above this; and this ultimately leads to the *exclusive* position of red and green (in the table where the *genus* color is *specified*). Thus for a third time, but in an even more radical manner, difference is held fast within an oppositional, negative, and contradictory system. For difference to exist, it was necessary to divide the "same" through contradiction, to limit its infinite identity through non-being, to transform its positivity which operates without specific determinations through the negative. Given the priority of similarity, difference could only arise through these mediations. As for repetition, it is produced precisely at the point where the barely launched mediation falls back on itself; when, instead of saying no, it twice pronounces the same yes, when it constantly returns to the same position, instead of distributing oppositions within a system of finite elements. Repetition betrays the weakness of similarity at the moment when it can no longer negate itself in the other, when it can no longer recapture itself in the other. Repetition, at one time pure exteriority and a pure figure of the origin, has been transformed into an internal weakness, a deficiency of finitude, a sort of stuttering of the negative: the neurosis of dialectics. For it was indeed toward dialectics that the philosophy of representation was headed.

And yet, how is it that we fail to recognize Hegel as the philosopher of the greatest differences and Leibniz as the thinker of the smallest differences?

In actuality, dialectics does not liberate differences; it guarantees, on the contrary, that they can always be recaptured. The dialectical sovereignty of similarity consists in permitting differences to exist, but always under the rule of the negative, as an instance of non-being. They may appear as the successful subversion of the Other, but contradiction secretly assists in the salvation of identities. Is it necessary to recall the unchanging pedagogical origin of dialectics? The ritual in which it is activated, which causes the endless rebirth of the aporia of being and non-being, is the humble classroom interrogation, the student's fictive dialogue: "This is red; that is not red. At this moment, it is light outside. No, now it is dark." In the twilight of an October sky, Minerva's bird flies close to the ground: "Write it down, write it down," it croaks, "tomorrow morning, it will no longer be dark."

The freeing of difference requires thought without contradiction, without dialectics, without negation; thought that accepts divergence; affirmative thought whose instrument is disjunction; thought of the multiple—of the nomadic and dispersed multiplicity that is not limited or confined by the constraints of similarity; thought that does not conform to a pedagogical model (the fakery of prepared answers), but that attacks insoluble problems— that is, a thought that addresses a multiplicity of exceptional points, which are displaced as we distinguish their conditions and which insist and subsist in the play of repetitions. Far from being the still incomplete and blurred image of an Idea that eternally retains our answers in some upper region, the problem lies in the idea itself, or rather, the Idea exists only in the form of a problem: a distinctive plurality whose obscurity is nevertheless insistent and in which the question ceaselessly stirs. What is the answer to the question? The problem. How is the problem resolved? By displacing the question. The problem cannot be approached through the logic of the excluded third, because it is a dispersed multiplicity; it cannot be resolved by the clear distinctions of a Cartesian idea, because as an idea it is obscure-distinct; it does not respond to the seriousness of the Hegelian negative, because it is a multiple affirmation; it is not subjected to the contradiction of being and non-being, since it is being. We must think problematically rather than question and answer dialectically.

The conditions for thinking of difference and repetition, as we have seen, have undergone a progressive expansion. First, it was necessary, along with Aristotle, to abandon the identity of the concept, to reject resemblance within representation, and simultaneously to free ourselves from the philosophy of representation; and finally, it was necessary to free ourselves from Hegel— from the opposition of predicates, from contradiction and negation, from all of dialectics. But there is yet a fourth condition and it is even more formidable than the others. The most tenacious subjection of difference is undoubtedly that maintained by categories. By showing the number of different ways in

which being can express itself, by specifying its forms of attribution, by imposing in a certain way the distribution of existing things, categories create a condition where being maintains its undifferentiated repose at the highest level. Categories organize the play of affirmations and negations, establish the legitimacy of resemblances within representation, and guarantee the objectivity and operation of concepts. They suppress the anarchy of difference, divide differences into zones, delimit their rights, and prescribe their task of specification with respect to individual beings. On one side, they can be understood as the a priori forms of knowledge, but, on the other, they appear as an archaic morality, the ancient decalogue that the identical imposed upon difference. Difference can only be liberated through the invention of an acategorical thought. But perhaps invention is a misleading word, since in the history of philosophy there have been at least two radical formulations of the univocity of being, those given by Duns Scotus and Spinoza. In Duns Scotus's philosophy, however, being is neutral, while for Spinoza it is based on substance; in both contexts, the elimination of categories and the affirmation that being is expressed for all things in the same way had the single objective of maintaining the unity of being. Let us imagine, on the contrary, an ontology where being would be expressed in the same fashion for every difference, but could only express differences. Consequently, things could no longer be completely covered over, as in Duns Scotus, by the great monochrome abstraction of being, and Spinoza's forms would no longer revolve around the unity of substance. Differences would revolve of their own accord, being would be expressed in the same fashion for all these differences, and being would no longer be a unity that guides and distributes them, but their repetition as difference. For Deleuze, the noncategorical univocity of being does not directly attach the multiple to a unity (the universal neutrality of being, or the expressive force of substance); it allows being to function as that which is repetitively expressed as difference. Being is the recurrence of difference, without any difference in the form of its expression. Being does not distribute itself into regions; the real is not subordinated to the possible; and the contingent is not opposed to the necessary. Whether the battle of Actium or the death of Antony were necessary or not, the being of both these pure events—to fight, to die—is expressed in the same manner, in the same way that it is expressed with respect to the phantasmatic castration that occurred and did not occur. The suppression of categories, the affirmation of the univocity of being, and the repetitive revolution of being around difference— these are the final conditions for the thought of the phantasm and the event.

We have not quite reached the conclusion. We must return to this "recurrence," but let us pause a moment.

Can it be said that Bouvard and Pécuchet make mistakes? Do they commit blunders whenever an opportunity presents itself? If they make mistakes, it is because there are rules that underlie their failures and under certain definable conditions they might have succeeded. Nevertheless, their failure is constant, whatever their action, whatever their knowledge, whether or not they follow the rules, whether the books they consulted were good or bad. Everything befalls this undertaking—errors, of course, but also fires, frost, the foolishness and perversity of men, a dog's anger. Their efforts were not wrong; they were totally botched. To be wrong is to mistake a cause for another; it is not to foresee accidents; it may derive from a faulty knowledge of substances or from the confusion of necessities with possibilities. We are mistaken if we apply categories carelessly and inopportunely. But it is altogether different to ruin a project completely: it is to ignore the framework of categories (and not simply their points of application). If Bouvard and Pécuchet are reasonably certain of precisely those things which are largely improbable, it is not that they are mistaken in their discrimination of the possible but that they confuse all aspects of reality with every form of possibility (this is why the most improbable events conform to the most natural of their expectations). They confuse, or rather are confused by, the necessity of their knowledge and the contingency of the seasons, the existence of things and the shadows found in books: an accident, for them, possesses the obstinacy of a substance and those substances seized them by the throat in their experimental accidents. Such is their grand and pathetic stupidity, and it is incomparable to the meager foolishness of those who surround them and make mistakes, the others whom they rightfully disdain. Within categories, one makes mistakes; outside of them, beyond or beneath them, one is stupid. Bouvard and Pécuchet are acategorical beings.

These comments allow us to isolate a use of categories that may not be immediately apparent; by creating a space for the operation of truth and falsity, by situating the free supplement of error, categories silently reject stupidity. In a commanding voice, they instruct us in the ways of knowledge and solemnly alert us to the possibilities of error, while in a whisper they guarantee our intelligence and form the a priori of excluded stupidity. Thus, we court danger in wanting to be freed from categories; no sooner do we abandon their organizing principle than we face the magma of stupidity. At a stroke we risk being surrounded not by a marvelous multiplicity of differences, but by equivalences, ambiguities, the "it all comes down to the same thing," a leveling uniformity, and the thermodynamism of every miscarried effort. To think within the context of categories is to know the truth so that it can be distinguished from the false; to think "acategorically" is to confront a black stupidity and, in a flash, to distinguish oneself from it. Stupidity is

contemplated: sight penetrates its domain and becomes fascinated; it carries one gently along and its action is mimed in the abandonment of oneself; we support ourselves upon its amorphous fluidity; we await the first leap of an imperceptible difference, and blankly, without fever, we watch to see the glimmer of light return. Error demands rejection—we can erase it; we accept stupidity—we see it, we repeat it, and softly, we call for total immersion.

This is the greatness of Warhol with his canned foods, senseless accidents, and his series of advertising smiles: the oral and nutritional equivalence of those half-open lips, teeth, tomato sauce, that hygiene based on detergents; the equivalence of death in the cavity of an eviscerated car, at the top of a telephone pole and at the end of a wire, and between the glistening, steel blue arms of the electric chair. "It's the same either way," stupidity says, while sinking into itself and infinitely extending its nature with the things it says of itself; "Here or there, it's always the same thing; what difference if the colors vary, if they're darker or lighter. It's all so senseless—life, women, death! How ridiculous this stupidity!" But in concentrating on this boundless monotony, we find the sudden illumination of multiplicity itself—with nothing at its center, at its highest point, or beyond it—a flickering of light that travels even faster than the eyes and successively lights up the moving labels and the captive snapshots that refer to each other to eternity, without ever saying anything: suddenly, arising from the background of the old inertia of equivalences, the striped form of the event tears through the darkness, and the eternal phantasm informs that soup can, that singular and depthless face.

Intelligence does not respond to stupidity, since it is stupidity already vanquished, the categorical art of avoiding error. The scholar is intelligent. But it is thought that confronts stupidity, and it is the philosopher who observes it. Their private conversation is a lengthy one, as the philosopher's sight plunges into this candleless skull. It is his death mask, his temptation, perhaps his desire, his catatonic theater. At the limit, thought would be the intense contemplation from close up—to the point of losing oneself in it—of stupidity; and its other side is formed by lassitude, immobility, excessive fatigue, obstinate muteness, and inertia—or rather, they form its accompaniment, the daily and thankless exercise which prepares it and which it suddenly dissipates. The philosopher must be sufficiently perverse to play the game of truth and error badly: this perversity, which operates in paradoxes, allows him to escape the grasp of categories. But aside from this, he must be sufficiently "ill humored" to persist in his confrontation with stupidity, to remain motionless to the point of stupefaction in order to approach it successfully and mime it, to let it slowly grow within himself (this is probably what we politely refer to as being absorbed in one's thoughts), and to await, in the always unpredictable conclusion to this elaborate preparation, the shock of difference. Once

paradoxes have upset the table of representation, catatonia operates within the theater of thought.

We can easily see how LSD inverts the relationships of ill humor, stupidity, and thought: it no sooner eliminates the supremacy of categories than it tears away the ground of its indifference and disintegrates the gloomy dumbshow of stupidity; and it presents this univocal and acategorical mass not only as variegated, mobile, asymmetrical, decentered, spiraloid, and reverberating, but causes it to rise, at each instant, as a swarming of phantasm-events. As it slides upon this surface at once regular and intensely vibratory, as it is freed from its catatonic chrysalis, thought invariably contemplates this indefinite equivalence transformed into an acute event and a sumptuous, appareled repetition. Opium produces other effects: thought gathers unique differences into a point, eliminates the background and deprives immobility of its task of contemplating and soliciting stupidity through its mime. Opium ensures a weightless immobility, the stupor of a butterfly that differs from catatonic rigidity; and far beneath, it establishes a ground that no longer stupidly absorbs all differences, but allows them to arise and sparkle as so many minute, distanced, smiling, and eternal events. Drugs—if we can speak of them generally—have nothing at all to do with truth and falsity; only to fortunetellers do they reveal a world "more truthful than the real." In fact, they displace the relative positions of stupidity and thought by eliminating the old necessity for a theater of immobility. But perhaps, if it is given to thought to confront stupidity, the drugs, which mobilize it, which color, agitate, furrow, and dissipate it, which populate it with differences and substitute for the rare flash a continuous phosphorescence, are the source of a partial thought—perhaps.[20] At any rate, in a state deprived of drugs, thought possesses two horns: one is perversity (to baffle categories) and the other ill humor (to point to stupidity and transfix it). We are far from the sage who invests so much goodwill in his search for the truth that he can contemplate with equanimity the indifferent diversity of changing fortunes and things; far from the irritability of Schopenhauer who became annoyed with things that did not return to their indifference of their own accord. But we are also distant from the "melancholy" which makes itself indifferent to the world and whose immobility—alongside books and a globe—indicates the profundity of thought and the diversity of knowledge. Exercising its ill will and ill humor, thought awaits the outcome of this theater of perverse practices: the sudden shift of the kaleidoscope, signs that light up for an instant, the results of the thrown dice, the outcome of another game. Thinking does not provide consolation or happiness. Like a perversion, it languidly drags itself out; it repeats itself with determination upon a stage; at a stroke, it flings itself outside the dice box. At the moment when chance, the theater, and perversions enter into resonance, when chance dictates a resonance

among the three, then thought becomes a trance; and it becomes worthwhile to think.

The univocity of being, its singleness of expression, is paradoxically the principal condition which permits difference to escape the domination of identity, which frees it from the law of the Same as a simple opposition within conceptual elements. Being can express itself in the same way, because difference is no longer submitted to the prior reduction of categories; because it is not distributed inside a diversity that can always be perceived; because it is not organized in a conceptual hierarchy of species and genus. Being is that which is always said of difference, it is the *Recurrence* of difference.[21]

With this term, we can avoid the use of both *Becoming* and *Return*, because differences are not the elements—not even the fragmentary, intermingled, or monstrously confused elements—of an extended evolution that carries them along in its course and occasionally allows their masked or naked reappearance. The synthesis of Becoming might seem somewhat slack, but it nevertheless maintains a unity—not only and not especially that of an infinite container, but also the unity of fragments, of passing and recurring moments, and of floating consciousness where it achieves recognition. Consequently, we are led to mistrust Dionysus and his Bacchantes even in their state of intoxication. As for the Return, must it be the perfect circle, the well-oiled millstone, which turns on its axis and reintroduces things, forms, and men at their appointed time? Must there be a center and must events occur on its periphery? Even Zarathustra could not tolerate this idea:

> "Everything straight lies," murmured the dwarf disdainfully. "All truth is crooked, time itself is a circle."
> "Spirit of Gravity!" I said angrily, "do not treat this too lightly."[22]

And convalescing, he groans:

> "Alas! Man will return eternally, abject man will return eternally."[23]

Perhaps what Zarathustra is proclaiming is not the circle; or perhaps the intolerable image of the circle is the last sign of a higher form of thought; perhaps, like the young shepherd, we must break this circular ruse—like Zarathustra himself, who bit off the head of a serpent and immediately spat it away.[24]

Chronos is the time of becoming and new beginnings. Piece by piece, Chronos swallows the things to which it gives birth and which it causes to be reborn in its own time. This monstrous and lawless becoming—the endless

devouring of each instant, the swallowing up of the totality of life, the scattering of its limbs—is linked to the exactitude of re-beginning. Becoming leads into this great, interior labyrinth, a labyrinth no different in nature from the monster it contains. But from the depths of this convoluted and inverted architecture, a solid thread allows us to retrace our steps and to rediscover the same light of day. Dionysus with Ariadne: you have become my labyrinth. But Aeon is *recurrence* itself, the straight line of time, a splitting quicker than thought and narrower than any instant. It causes the same present to arise— on both sides of this indefinitely splitting arrow—as always existing, as indefinitely present, and as indefinite future. It is important to understand that this does not imply a succession of present instances that derive from a continuous flux and that, as a result of their plenitude, allow us to perceive the thickness of the past and the outline of a future in which they in turn become the past. Rather, it is the straight line of the future that repeatedly cuts the smallest width of the present, that indefinitely recuts it starting from itself. We can trace this schism to its limits, but we will never find the indivisible atom that ultimately serves as the minutely present unity of time (time is always more supple than thought). On both sides of the wound, we invariably find that the schism has already happened (and that it had already taken place, and that it had already happened that it had already taken place) and that it will happen again (and in the future, it will happen again): it is less a cut than a constant fibrillation. What repeats itself is time; and the present—split by this arrow of the future that carries it forward by always causing its swerving on both sides—endlessly recurs. But it recurs as singular difference; and the analogous, the similar, and the identical never return. Difference recurs; and being, expressing itself in the same manner with respect to difference, is never the universal flux of becoming; nor is it the well-centered circle of identities. Being is a return freed from the curvature of the circle; it is Recurrence. Consequently, the death of three elements: of Becoming, the devouring Father—mother in labor; of the circle, by which the gift of life passes to the flowers each springtime; of recurrence—the repetitive fibrillation of the present, the eternal and dangerous fissure fully given in an instant, universally affirmed in a single stroke.

By virtue of its splintering and repetition, the present is a throw of the dice. This is not because it forms part of a game in which it insinuates small contingencies or elements of uncertainty. It is at once the chance within the game and the game itself as chance; in the same stroke, both the dice and rules are thrown, so that chance is not broken into pieces and parcelled out, but is totally affirmed in a single throw. The present as the recurrence of difference, as repetition giving voice to difference, affirms at once the totality of chance. The univocity of being in Duns Scotus led to the immobility

of an abstraction; and in Spinoza, it led to the necessity and eternity of substance, but here it leads to the single throw of chance in the fissure of the present. If being always declares itself in the same way, it is not because being is one, but because the totality of chance is affirmed in the single dice throw of the present.

Can we say that the univocity of being has been formulated on three different occasions in the history of philosophy, by Duns Scotus and Spinoza and finally by Nietzsche—the first to conceive of univocity as returning and not as an abstraction or a substance? Perhaps we should say that Nietzsche went as far as the thought of the Eternal Return; more precisely, he pointed to it as an intolerable thought. Intolerable, because as soon as its first signs are perceived, it fixes itself in this image of the circle that carries in itself the fatal threat that all things will return—the spider's reiteration. But this intolerable nature must be considered because it exists only as an empty sign, a passageway to be crossed, the formless voice of the abyss whose approach is indissociably both happiness and disgust, disgust. In relation to the Return, Zarathustra is the "Fürsprecher," the one who speaks for . . . , in the place of . . . , marking the spot of his absence. Zarathustra does not function as Nietzsche's image, but as his sign, the sign (and not at all a symptom) of rupture. Nietzsche left this sign, the sign closest to the intolerable thought of the eternal return, and it is our task to consider its consequences. For close to a century, the loftiest enterprise of philosophy has been directed to this task, but who has the arrogance to say that he had seen it through? Should the Return have resembled the nineteenth century's conception of the end of history, an end that circled menacingly about us as an apocalyptic fantasmagoria? Should we have ascribed to this empty sign, imposed by Nietzsche as an *excess,* a series of mythic contents that disarmed and reduced it? Should we have attempted, on the contrary, to refine it so that it could unashamedly assume its place within a particular discourse? Or should this excessive, this always misplaced and displaced sign have been accentuated; and instead of finding an arbitrary meaning to correspond to it, instead of constructing an adequate word, should it have been made to enter into resonance with the supreme meaning which today's thought supports as an uncertain and controlled ballast? Should it have allowed recurrence to resound in unison with difference? We must avoid thinking that the return is the form of a content which is difference; rather, from an always nomadic and anarchical difference to the unavoidably excessive and displaced sign of recurrence, a lightning storm was produced which will, one day, be given the name of Deleuze: new thought is possible; thought is again possible.

This thought does not lie in the future, promised by the most distant of new beginnings. It is present in Deleuze's texts—springing forth, dancing

before us, in our midst; genital thought, intensive thought, affirmative thought, acategorical thought—each of these an unrecognizable face, a mask we have never seen before; differences we had no reason to expect, but which nevertheless lead to the return, as masks of their masks, of Plato, Duns Scotus, Spinoza, Leibniz, Kant, and all other philosophers. This is philosophy not as thought, but as theater: a theater of mime with multiple, fugitive, and instantaneous scenes in which blind gestures signal to each other. This is the theater where the explosive laughter of the Sophists tears through the mask of Socrates; where Spinoza's methods conduct a wild dance in a decentered circle while substance revolves about it like a mad planet; where a limping Fichte announces "the fractured I ≠ the dissolved self"; where Leibniz, having reached the top of the pyramid, can see through the darkness that celestial music is in fact a *Pierrot lunaire*.[25] In the sentry box of the Luxembourg Gardens, Duns Scotus places his head through the circular window; he is sporting an impressive moustache; it belongs to Nietzsche, disguised as Klossowski.

## NOTES

Translated by Donald F. Bouchard and Sherry Simon, edited by Donald F. Bouchard.

1. Foucault's essay on Klossowski, "La Prose d'Actéon," appeared in *Nouvelle Revue Francaise*, no. 135 (1964); for Deleuze's analysis of Klossowski, see *The Logic of Sense*, trans. Mark Lester with Charles Stivale (New York: Columbia University Press, 1990), 280–301.—ED.

2. The concepts of series, sequence, and succession are explored throughout *The Archaeology of Knowledge*, trans. A. M. Sheridan Smith (New York: Harper and Row, 1972); on decenterings, see especially 12–24.—ED.

3. See *Difference and Repetition*, trans. Paul Patton (New York: Columbia University Press, 1994) 124–25.—ED.

4. *Difference and Repetition*, 126–28 and 59–61; *The Logic of Sense*, 253–60.

5. See *The Sophist*, 220–21.—ED.

6. On the rising of irony and the plunging of humor, cf. *Difference and Repetition*, 5, and *The Logic of Sense*, 134–41.

7. *The Logic of Sense*, 266–77.

8. M. Merleau-Ponty, *The Phenomenology of Perception*, trans. Colin Smith (London: Routledge and Kegan Paul, 1962).—ED.

9. In Klossowski's trilogy, *Les Lois de l'hospitalité* (Paris: Gallimard, 1965). For Deleuze's discussion of Roberte, see *The Logic of Sense*, especially 285–87.—ED.

10. Cf. *The Logic of Sense*, 4–11.

11. Fabricius was a Roman general and statesman (d. 250 B.C.); Prince Andrew is a main character in Tolstoy's *War and Peace*.—ED.

12. Cf. *The Logic of Sense,* 12–22.

13. Maurice Blanchot, *The Space of Literature,* trans. Ann Smock (Lincoln: University of Nebraska Press, 1982), cited in *Difference and Repetition,* 149. Cf. also *The Logic of Sense,* 148–53.

14. Cf. *The Logic of Sense,* 181–85.

15. Cf. Nietzsche, *The Geneology of Morals,* I, 13.—ED.

16. The English word "thought" translates the French *le pensé* (meaning the thing being thought: the *object* of thought) and *la pensée* (thought itself). Where the meaning might be unclear, the original French word appears in parentheses.—ED.

17. On this subject, see *The Logic of Sense,* 186–233. My comments are, at best, an allusion to these splendid analyses.

18. Deleuze writes in *The Logic of Sense,* 91: "Artaud says that Being, which is non-sense, has teeth"; on "dark precursors," see *Difference and Repetition,* 119–21: "We call the *disparate* the dark precursor." Cf. "Nietzsche, Geneology, History," in *Language, Counter-Memory, Practice,* ed. Donald F. Bouchard (Ithaca, N.Y.: Cornell University Press, 1977) 143, for a discussion of the "disparate" as the "historical beginning of things."—ED.

19. This entire section considers, in a different order from that of the text, some of the themes which intersect within *Difference and Repetition.* I am, of course, aware that I have shifted accents and, far more important, that I have ignored its inexhaustible riches. I have reconstructed one of several possible models. Therefore, I will not supply specific references.

20. "What will people think of us?" (Note added by Gilles Deleuze.)

21. On these themes, cf. *Difference and Repetition,* 35–42, 294–301; *The Logic of Sense,* 162–68, 177–80.

22. *Thus Spoke Zarathustra,* part 3, "Of the Vision and the Riddle," sec. 2.—ED.

23. Ibid., "The Convalescent," sec. 2.—ED.

24. Ibid.—ED.

25. Schoenberg's song cycle, transcribed from the poems of the Belgian poet Albert Giraud.—ED.

# Gilles Deleuze

## One Less Manifesto

### Theater and its Critique

Carmelo Bene[1] describes his play *Romeo and Juliet* as "a critical essay on Shakespeare." But the fact is that Carmelo Bene does not write on Shakespeare; the critical essay is actually a play. How do we understand the relationship between theater and its critique, between the original and derivative plays? Just what is the critical function of the theater of Carmelo Bene?

It is not a matter of reading Shakespeare "critically," or of theater within theater, or of parody, or of a new version of the play, etc. Bene works differently, in a new fashion. Let us suppose that he amputates an element, that he subtracts something from the original play. To be precise, he does not call his play on Hamlet one more *Hamlet* but "one less *Hamlet*," just like Laforgue.[2] He proceeds not by addition but by subtraction, by amputation. How he chooses the element for amputation is yet another question which we will treat later. But, for now, we can cite the example of how he amputates Romeo, how he neutralizes the Romeo of the original play. Because a part chosen not arbitrarily is now missing, the entire play could thus loose its balance, turn upon itself, and land on a different side. If you amputate Romeo, you will witness an astonishing development, the development of Mercutio, who was only a virtuality in the play by Shakespeare. In Shakespeare, Mercutio dies quickly. But, in Bene, he does not want to die, he cannot die, he does not manage to die since he will become the subject of the new play.

First of all, there is the constitution of a character on the stage itself. Even objects and props await their destiny, that is, the necessity attributed to them by the *whims* of the character. The play initially involves itself with the fabrication of the character, its preparation, its birth, its stammerings, its variations, its development. This critical theater is constitutive theater. Critique is a constitution. The theater maker is no longer an author, an actor, or a director. S/he is an operator. Operation must be understood as the movement of subtraction, of amputation, one already covered by the other movement that gives birth to and multiplies something unexpected, like a prosthesis: the amputation of Romeo and the colossal development of Mercutio, one in the other. It is a theater of surgical precision. Consequently, if Carmelo Bene often needs a primary play, it is not to make it a fashionable parody or to add

239

literature to literature. On the contrary, it is to subtract literature, to subtract the text, for example, a part of the text, and to observe the result. *May words stop making "text"* . . . It is a theater experimentation that bears more love for Shakespeare than all of the commentaries.

Take the case of Bene's *S.A.D.E.* Here, on the backdrop of a stock recitation of the Sadean text, the sadistic image of the Master is what finds itself to be amputated, paralyzed, reduced to a masturbatory twitch. At the same time, the masochistic Servant seeks himself, develops himself, metamorphosizes himself, experiments with himself, creates himself on stage in relation to the deficiencies and impotencies of the Master. The Servant is not at all the reverse image of the Master, nor his replica or contradictory identity: he creates himself piece by piece, bit by bit, from the neutralization of the Master; he acquires his autonomy from the Master's amputation.

The comes *Richard III,* where Bene goes the furthest, perhaps, in his theatrical construction. What is amputated here, what is subtracted, is the entire royal and princely system. Only Richard III and the women are retained. Thus appears in a new light what existed only virtually in the tragedy. *Richard III* may be Shakespeare's only tragedy in which women have their own tales of war. And Richard, for his part, is less interested in power than in reintroducing or reinventing a war machine, even if it means the destruction of the apparent balance or peace of the state (what Shakespeare call Richard's secret, the "secret close intent"). In performing the subtraction of characters of State Power, Bene gives free reign to the creation of the soldier on stage, with his prostheses, his deformities, his tumors, his malpractices, his variations. The soldier has always been considered in mythology as coming from an origin different from that of the statesman or the king: deformed and crooked, he always comes from elsewhere. Bene brings them onto the stage: while the women at war enter and exit anxious for their whining children. Richard III will deform himself to amuse the children and restrain the mothers. He will fashion himself with prostheses as he arbitrarily takes objects from a drawer. He will create himself a little like Mr. Hyde with colors, noises, and things. He will make himself, or rather unmake himself, according to a line of continuous variation.[3] Bene's play begins with very beautiful "note on the feminine" (in Kleist's *Penthesilea,* isn't there already such a relation of the warrior, Achilles, with the feminine, with the transvestite?).

Bene's plays are short, no one knows better than he how to end them. He detests all principles of consistency or eternity, of textual permanency: "The spectacle begins and ends at the same moment it occurs." And the play ends with the creation of the character. It has no other purpose and does not extend further than the process of this creation. It ends with birth when it normally ends with death. One would not conclude that these characters have

an "Ego." On the contrary, they do not have one at all. Richard III, the Servant, and Mercuzio are born only in a continuous series of metamorphoses and variations. The character is part of the totality of the scenic design including colors, lights, gestures, and words. Oddly, it is often said that Carmelo Bene is a great actor—a compliment mixed with disapproval, with an accusation of narcissism. Bene's pride would rather trigger a process over which he is the controller, the mechanic or the operator (he himself says: the protagonist) rather than the actor. To give birth to a monster or a colossus . . .

This is neither a theater of the author *(d'auteur)* nor a critique of the author *(d'auteur)*.[4] But if this theater is inseparably creative and critical, what is the nature of the critique? It is not Bene reading Shakespeare. At most one could say that if an Englishman at the end of the sixteenth century has a certain image of Italy, an Italian of the twentieth century may send back an image of Britain that incorporates Shakespeare: Bene's admirable, giant decor of *Romeo and Juliet,* with its immense goblets and flasks and Juliet who falls asleep in a cake, shows Shakespeare through the eyes of Lewis Carroll, but a Lewis Carroll via Italian comedy (Carroll already proposed an entire system of subtractions of Shakespeare in order to develop unanticipated virtualities).[5] Nor is it a critique of countries or societies. One questions the nature of Bene's initial subtractions. In the three preceding cases, what is subtracted, amputated, or neutralized are the elements of power, the elements that constitute or represent a system of power: Romeo as representative of familial power, the Master as representative of sexual power, kings and princes as representatives of state power. But the elements of power in the theater are what insure both the coherence of the subject in question and the coherence of the representation on stage. It is both the power of what is represented and the power of theater itself. In this sense, the traditional actor enters into an ancient complicity with princes and kings, while the theater is complicitous with power: thus Napoleon and Talma.[6] The actual power of theater is inseparable from a representation of power in theater, even if it is a critical representation.

But Carmelo Bene possesses a different understanding of the critique. When he decides *to amputate* the elements of power, he changes not only the theatrical matter but also the form of theater, which ceases to be a "representation" at the same time as the actor ceases to be an actor. He gives free reign to a different theatrical matter and to a different theatrical form, which would not have been possible without this subtraction. One could say that Bene is not the first to create a theater of nonrepresentation. One could cite at random Artaud, Bob Wilson, Grotowski, the Living Theater . . . Yet I do not believe in the usefulness of filiations. Alliances are more important than filiations. Bene has very different degrees of alliance with those I have just cited. He belongs to a movement that deeply disturbs contemporary theater.

But he belongs to this movement only by what he invents himself and not the opposite. And the originality of his bearing, the totality of his methods, first appears to us as coming from the subtraction of the stable elements of power that will release a new potentiality of theater, an always unbalanced, non-representative force.

## Theater and Its Minorities

Carmelo Bene is very interested in the notions of Major and Minor.[7] He gives them a live body. What is a "minor" character? What is a "minor" author? First Bene says that it is unwise to be interested in the beginning or end of something, in points of origin or termination. What is interesting is never the way in which someone starts or finishes. Of interest is the middle *(le milieu)*, what is happening in the middle. It is not by chance that the greatest speed is in the middle. People often dream of starting or restarting from zero; and they also fear their arrival, their terminal point. They think in terms of future or past; but the past and even the future are *history*. What counts, on the other hand, is the becoming: becoming-revolutionary, and not the future or the past of the revolution. "I will arrive nowhere, I do not want to arrive any-where. There are no arrivals. I am not interested in where someone arrives. One could easily arrive at madness. What does that mean?" It is in the middle that he experiences the becoming, the movement, the speed, the vortex. The middle is not a means but, on the contrary, an excess. Things sprout from the middle. That was Virginia Woolf's idea. But the middle does not at all mean to belong to the times, to be of one's time, to be historical. It means just the opposite. It is the means by which very different times communicate. It is neither the historical nor the eternal but the untimely. A minor author is precisely that—without future or past, s/he has only a becoming, a middle *(un milieu),* by which s/he communicates with other times, with other spaces.[8] Goethe used to give stern lectures to Kleist as he explained that a great author, a major author, owed it to himself to be of his time. But Kleist was incurably minor. "Antihistoricism," says Carmelo Bene: *do you know which men must be seen in their century? Those we call the greatest. Goethe, for example, cannot be seen outside of the Germany of his time, or, if he leaves his time, it is immediately to rejoin the eternal. But truly great authors are the minor ones, the untimely ones. It is the minor author who delivers the true masterpiece. The minor author does not interpret his or her time; no one has a fixed time, time depends on the man:* François Villon, Kleist, or Laforgue. So isn't there a great incentive in subjecting authors considered major to a minor author treatment in order to rediscover their potential becomings? Shakespeare, for example?

There would appear to be two contrary operations. On the one hand, one ascends to "the major": one makes a doctrine from a thought, one makes a culture from a way of life, one makes History from an event. One thus pretends to discover and admire, but in fact one normalizes. In Bene's opinion, it is like the peasants from Puglia: you can give them theater, cinema, and even television.[9] It is not a question of regretting the old times, but of frightening oneself in the face of the operation to which the peasants have been subjected, the graph, the transplant done on their back to normalize them. They have become major. Then, operation for operation, surgery against surgery, one can conceive the opposite: how "to minorate" *(minorer)* (a term employed by mathematicians), how to impose a minor treatment or a treatment of minoration to extract becomings against History, lives against culture, thoughts against doctrine, graces or disgraces against dogma. When you see how the traditional theater treats Shakespeare, his magnification-normalization, one calls for another treatment that would recover the active force of the minority. Theologians are major, but certain Italian saints are minor. "The saints sanctified by grace: Saint Joseph of Copertino, the imbeciles, the idiot saints, Saint Francis of Assisi who danced for the Pope . . . I say that there is already culture from the moment we begin examining an idea, not living that idea. If we are the idea, then we can perform the Saint Vitis dance and we are in a state of grace. We will begin to be wise just when we are disgraced." We save ourselves, we become minor, only by the creation of a disgrace or a deformity. It is the operation of grace itself. Like in the story of Lourdes: make my hand return like the other one . . . but God always chooses the wrong hand. How to understand this operation? Kleist stuttering and grinding his teeth?

Major and minor also refer to languages.[10] Can one distinguish in each era major, global, or national vehicular languages and minor vernacular languages? Would English and American English be major today and Italian minor? One distinguishes a high and low language in societies expressing themselves in two languages or more. But isn't that also true of unilingual societies? We could define major languages even when they have little international importance: these would be languages with a strong homogeneous structure (standardization) and centered on invariables, constants, or universals of a phonological, syntactical, or semantic nature. Bene outlines a linguistics for laughs: thus French seems to be a major language even with the loss of its international expansion because it has a strong homogeneity and strong phonological and syntactical constants. This is not without consequence for theater: "French theaters are museums of the everyday, a disconcerting and boring repetition, because we go in the evening, in the service of spoken and written language, to see and hear what we heard and saw during the day.

Theatrically: there is really no difference between Marivaux and the Director of the Paris train station except that you cannot take the train at the Odeon Theater." English may be founded on other invariables, for example, primarily semantic constants. It is always by means of constants and homogeneity that a language is major: "England is a history of kings . . . The Gielguds and the Oliviers are living copies of the departed Kembles and Keans. The monarchy of *the once upon a time*—that is the English tradition." In brief, major languages are languages of power, as different as they may be. They can be contrasted with minor languages: Italian, for example ("Our country is young, it does not yet have a language . . ."). And, already, one no longer has a choice; one must define minor languages as *languages of continuous variability*—whether the considered dimension may be phonological, syntactical, semantical, or even stylistical. A minor language is comprised of only a minimum of structural constancy and homogeneity. It is not, however, a pulp, a mixture of dialects, since it finds its *rules* in the construction of a continuum. Indeed, the continuous variation will apply to all the sonorous and linguistic components in a sort of generalized chromatics. It will be theater itself or the "spectacle."

But, as a result, it is difficult to contrast languages that would be major by nature with others that would be minor. Protests occur, notably in France, against the imperialism of English and American English. But the counterpart of this imperialism is precisely that British and American English are best worked over by the minorities employing them from within. Note how the Anglo-Irish of Synge strains the English, and imposes on it a vanishing line[11] or a line of continuous variation: "the way . . ." Of course, this is certainly not the same way that minorities work over American English, say, black English and all American idioms of the ghetto. But, in any case, there is no imperial language that is not hallowed out, swept away by these lines of inherent and continuous variation, that is, by these minor usages. Major and minor languages, therefore, qualify less as different languages than as different usages of the same language. Kafka, a Czech Jew writing in German, makes German a minor usage, and thus produces a decisive linguistic masterpiece (more generally, the work of minorities on German in the Austrian empire). At the most, one could say that one language is more or less endowed with these minor usages.

Linguists often have a debatable understanding of the object they study. They say that all language is, of course, a heterogeneous mixture, but that one can study it scientifically only in view of a homogeneous and constant subsystem: a dialect, a patois, a ghetto language would then be subjected to the same rules as a standard language (Noam Chomsky). The variations that affect a language would be considered, then, either as extrinsic and outside of

the system or as attesting to a mixture of two systems that would be homogeneous in themselves. But this rule of constancy and homogeneity may already suppose a certain usage of the language under consideration: a major usage treating language as a state of power, a marker of power. A small number of linguists (notably William Labov) have noted in all language the existence of lines of variation applying to all the components and constituting immanent rules of a new type. You will not come across a homogeneous system that has yet to be shaped by an immanent, continuous, and constant variation: here is what defines all language in its minor usage, an enlarged color field, a black English for each language. Continuous variability is not explained by bilingualism, nor by a mixture of dialects, but by language's most inherent, creative property as apprehended in minor usage. And, to a certain degree, this is the "theater" of language.

## Theater and Its Language

This is not an issue of antitheater, of theater in the theater, or of theater denying the theater, etc.: Carmelo Bene is disgusted by so-called avant-garde formulas. It is a matter of a more precise operation: you begin by subtracting, deducting everything that would constitute an element of power, in language and in gestures, in the representation and in the represented. You cannot even say that it is a negative operation because it already enlists and releases positive processes. You will then deduct or amputate history because History is the temporal marker of Power. You will subtract structure because it is the synchronic marker, the totality of relations among invariants. You will subtract constants, the stable or stabilized elements, because they belong to major usage. You will amputate the text because the text is like the domination of language over speech and still attests to invariance or homogeneity. You deduct dialogue because it transmits elements of power into speech and causes them to spread: it is your turn to speak under such codified conditions (linguists try to determine "the universals of dialogue"). Etc, etc. As Franco Quadri explains, you deduct even diction and action: the playback is first of all a subtraction.[12] But what remains? Everything remains, but under a new light with new sounds and new gestures.

For example, you say: "I swear." But this is not at all the same *énoncé* when uttered before the law, in a love scene, or in childhood. And this variation affects not only the exterior situation, not only the physical intonation, but also the signification, the syntax, and the phonemes from within. You will then transmit an *énoncé* through all the variables that could affect it in the shortest amount of time. The *énoncé* will never be more than the sum of

its own variations that frees it from each apparatus of power capable of fixing it and that gives it the slip from all constancy. You will construct the continuum of *"I Swear."* Suppose that Lady Anne says to Richard III: "You disgust me." It is hardly the same *énoncé* when uttered by a woman at war, a child facing a toad, or a young girl feeling a pity that is already consenting and loving . . . Lady Anne will have to move through all these variables. She will have to stand erect like a woman warrior, regress to a childlike state, and return as a young girl—as quickly as possible on a line of continuous variation. Carmelo Bene never stops tracing lines that overlap positions, regressions, and rebirths. He places language and speech in continuous variation. Hence Bene's very original use of playback, since playback will guarantee the amplitude of these variations and provide them with order. It is odd, since there is no dialogue in this theater; for voices, simultaneous or successive, superimposed or transposed, are caught in this spatiotemporal continuity of variation. It is a sort of *Sprechgesang*. In song, it is a matter of maintaining the pitch, but in the *Sprechgesang,* one always varies the pitch with ascendings and descendings. The text, then, is not what counts as mere material for variation. One would even have to overload the text with nontextual, and yet internal, directions, *which would be not merely scenic,* which would function as operators consistently conveying the scale of variables through which the *énoncé* passes, exactly as in a musical score. Now that is the way Carmelo Bene writes, with a writing (*écriture*) that is neither literary nor dramatic, but truly performative, whose effect on the reader is very strong and very strange. In *Richard III,* you see these operators occupying a lot more space than the text itself. Bene's theater must be seen, but also read, even though the text is, properly speaking, not essential. This is not a contradiction. It is rather like reading a score. Bene's wariness of Brecht is understandable in this context: Brecht performed the greatest "critical operation," but this operation was enacted "on the text and not on the stage." The complete critical operation consists of (1) deducting the stable elements, (2) placing everything in continuous variation, (3) then transposing everything in *minor* (this is the role of the company in responding to the notion of the "smallest" interval).

How might we understand this usage of language in terms of variation? One could explain it in many ways: to be bilingual, *but* in a single language, in a unique language . . . To be a foreigner, *but* in one's own tongue . . . To stammer, *but* as a stammerer of language itself, not only of speech . . . Adds Bene: to talk to oneself, in one's own ear, *but* in the middle of the market, in the public square . . . One must agree to accept each of these formulas as is in order to define Bene's work and to perceive not what anxieties of influence, but what alliances, what contacts he maintains with other older or contemporary attempts. Bilingualism puts us on the track but only on the track. Since

the bilingual leaps from one language to another, one speaker can have a minor usage, the other a major usage. One can even produce a heterogeneous mixture of several languages and several dialects. But, here, it is in one and the same language that one must become bilingual. It is on my own tongue that I must impose the heterogeneity of variation. It is within my own tongue that I must etch a minor usage and deduct the elements of power or majority. One can always start from an exterior situation: for example, Kafka, a Czech Jew writing in German, Beckett, an Irishman writing simultaneously in English and French, Pasolini employing the dialectical variations of Italian. But it is in German itself that Kafka traces a vanishing line or a line of continuous variation. It is French itself that Beckett stammers. And so does Jean-Luc Godard in a different way, as well as Gherasim Luca in yet another. And it is English that Bob Wilson whispers and mumbles (since whispering does not imply a weak intensity but, on the contrary, an intensity with indefinite pitch). But the formula for stammering is just as approximate as that of bilingualism. Stammering, in general, is a speech problem. But to make language stammer is a different matter. It is to impose the work of continuous variation on language, on all interior elements of language, phonological, syntactical, and semantic. I believe Gherasim Luca to be one of the greatest French poets of all times. He certainly does not owe this to his Romanian origin, but he uses this origin to make French stammer in itself, with itself, to import stammering into language itself and not into speech. Read or listen to the poem "Passionately," which was recorded as well as published in the collection *The Song of the Carp*.[13] Such an intensity of language and such an intense usage of language has never been equalled. A public reading of poems by Gherasim Luca is a complete and marvelous theatrical event. To be a stranger, then, in one's own language . . . It is not to speak "as" an Irishman or a Romanian speaking French. This would be the case for neither Beckett nor Luca. It is to impose on language, as it is spoken perfectly and soberly, this line of variation that will make you a foreigner in *your own* language or make a foreign language your own or make your language a bilingualism immanent to your foreignness. Always return to Proust's formula: "masterpieces are written in a kind of foreign language."[14] Or, conversely, the novella, "The Great Swimmer," by Kafka (who never knew how to swim): "I must acknowledge that I am here in my own country and, that despite all my efforts I do not understand a word of the language you speak." These are Carmelo Bene's alliances or encounters, involuntary or not, with those I have just cited. And they count only in relation to how Bene constructs his own methods of stammering, whispering, and varying his own language to intensify it on the level of each of its elements.

All the linguistic and sonorous components, inseparably language *and*

speech, are put in a state of continuous variation. But this is not without effect on other nonlinguistic components like actions, passions, gestures, attitudes, objects, etc. For one cannot treat the elements of language and speech as so many interior variables without placing them in a reciprocal relation with exterior variables, in the same continuity, in the same flux of continuity. It is in the same movement that language will tend to escape the system of power structuring it. And, similarly, action will tend to escape the system of Mastery or domination organizing it. In an excellent article, Corrado Augias shows how Bene brings together a work of "aphasia" on language (whispered, stammered, and deformed diction, barely audible or deafening sounds), and a work of "obstruction" on objects and gestures (costumes limiting movement instead of aiding it, props thwarting change of place, gestures either too stiff or excessively "soft").[15] So it works in *Salomé:* the apple being continually swallowed and spit up; the costumes never ceasing to fall off and needing continually to be put back on; the stage props always useless rather than useful, as with the table that separates instead of supporting things—one must always surmount objects instead of using them. The same goes for *S.A.D.E.* with the perpetually delayed act of copulation, and, especially, with the Servant, who hinders and impedes himself in a continuous series of his own metamorphoses because he must not *master* his role as *servant,* and, at the beginning of *Richard III,* with Richard never ceasing to lose his balance, to totter, to slip from the dresser on which he leans . . .

## The Theater and Its Gestures

Must it be said, however, that this double principle, of aphasia and obstruction, reveals its relations of power in which each body becomes an obstacle to the body of the other, as each will thwart the will of others? There is something else, different from a play of oppositions, that would return us to the system of power and domination. That is, by constant obstruction, gestures and movements are placed in a state of continuous variation in relation to one another and themselves, just like voices and linguistic elements are sustained in this state of variation. The gesture of Richard III always vacates its own level, its own height, by a fall, a rise, or a slip:[16] the gesture in perpetual and positive imbalance. The costume that one takes off and puts back on, that falls off and is put back on, is like the variation of clothing. Likewise the variation of flowers that takes place so frequently in Bene. Indeed, there are very few shocks and oppositions in Bene's theater. One could conceive of ways of producing stammering by making words clash, by producing a contrast of

phonemes, or even a confrontation of varying dialects. But these are not the means employed by Carmelo Bene. On the contrary, the beauty of his *style* is how it induces stammering by the creation of melodious lines that free language from a system of dominant oppositions. The same goes for the *grace* of the gestures on stage. It is odd, then, that angry women, as well as critics, would have reproached Bene for his staging of the feminine body, and would have accused him of sexism and phallocratism. The woman-object in *S.A.D.E,* the nude young woman, undergoes all the metamorphoses imposed on her by the sadistic Master.[17] She is transformed into a successive series of familiar objects: but the point is that she traverses these metamorphoses, she never assumes degrading poses. She takes the cue from her gestures, following their line of variation that allows her to escape the domination of the Master and to flourish outside of his control by prolonging her grace throughout the entire series. Compliments to the actress who played this role in Paris. But the theater of Carmelo Bene never unfolds in relation to force and opposition, regardless of its "toughness" and "cruelty." Put even better, the relations of force and opposition are part of what is shown only to be subtracted, deducted, neutralized. Carmelo Bene is not very interested in conflicts. They serve as a simple prop for Variation. Bene's theater unfolds itself only in relation to the variation that eliminates "masters."

What counts in variation are the relations of speed or sluggishness, the modifications of these relations as they carry the gestures and *énoncés* along a line of transformation, in accordance with variable coefficients. It is in this context that Bene's writing and gestures are musical: because each form is deformed by modifications of speed. The result is that the same gesture or word is never repeated without obtaining different characteristics of time. This is the musical formula of continuity, or of form as transformation. The "operators" of Bene's style and staging are just such indicators of speed that no longer belong to theater even though they are not outside of theater. And, precisely, Bene has found the way to enunciate them clearly in the "text" of his plays, even though they are not part of the text. Physicians of the Middle Ages spoke of deformed movements and qualities that followed the distribution of speed among the different points of a body in motion, or the distribution of intensities among the different points of a subject.[18] It seems to me that two essential aims of the arts should be the subordination of form to speed, to the variation of speed, and the subordination of the subject to intensity or to affect, to the intense variation of affects.[19] Bene participates fully in this movement that produces the critique of form and subject (in the double sense of "theme" and "self"). Only affects and no subject, only speeds and not form. But again what counts are Bene's means of realizing this aim: the continuity of variation. When he identifies grace with the movement of

disgrace (the "saint idiots" he adores), he only wishes to subordinate qualified forms to the deformity of movement or of quality. There is a geometrical dimension to Bene's theater, a geometry in the sense of Nicholas Oresme,[20] a geometry of speeds, intensities, and affects.

The films of Carmelo Bene are not filmed theater. Perhaps this is because the cinema does not use the same speeds of variation as does theater, and above all because the two variations, those of language and gesture, do not have the same relation in the two mediums. In particular, is it possible for cinema to directly construct a sort of visual music, as if it were the eyes that first grasped the sound, while theater has trouble forsaking the primacy of the ear through which actions are first heard?[21] (Already in his theatrical version of *Notre Dame des Turcs,* Bene sought the means for theater to surpass this domination of words and to arrive at a direct perception of the action: "The audience had to follow the action through windows and heard nothing except when the actor deigned to open a small window . . ."). But the important thing, in any case, in theater as in cinema, is that the two variations must not remain parallel. In one way or another, they must be *placed one within the other.* The continuous variation of gestures and things, the continuous variation of language and sounds, can interrupt, cut, and recut one another; they must nevertheless prolong each other, *forming one and the same continuum,* which, depending on the case, will be cinematic, theatrical, musical, etc. A separate study of Bene's films is needed.[22] But, to remain with the theater works, I would like to investigate how Bene proceeds in *Richard III,* this very recent play in which he goes the farthest.

*Richard III* begins entirely on two lines of variation that blend and alternate while not yet coalescing. Richard's gestures always slip, change height, fall in order to rise; and the gestures of the servant dressed as Buckingham are in keeping with his. Similarly, the voice of the duchess always changes tonalities, passing through all the variables of the mother, at the same time as Richard's voice mumbles and is reduced to the "articulations of a troglodyte." If the two variations still remain relatively separate, like two intersecting continuities, it is because Richard has not yet created himself on stage. In the beginning, he is still searching for the elements of his coming creation among ideas and things. He is not yet the object of fear, love, and pity. He has not yet achieved his "political election," not yet mounted his war machine. He has not yet achieved the disgrace of "his" grace, the deformity of his form . . . But in the great scene with Lady Anne, Richard will construct himself before our eyes. The sublime scene of Shakespeare, often accused of excess and lack of verisimilitude, will not be parodied by Bene, but multiplied according to the variable speeds or developments that will come together in a single continuity of creation (not a dramatic unity). (1) Richard, or rather the

actor playing Richard, begins to "understand." He begins to understand his own idea and the means of this idea. First he searches the drawers of the chest where he finds casts and prostheses, all the monstrosities of the human body. He takes them, drops them, takes yet another, tries them on, hides them from Anne, then sports them triumphantly. He accomplished the *miracle* when his good hand becomes just as stiff and twisted as the other. He wins his political election, he creates his deformities, his war machine. (2) Lady Anne, for her part, enters into this complicity with Richard: she insults him and hates him while he still maintains his "form" but becomes distressed with each deformity while already in love and approving. It is as if she were creating a new character for herself as well, one measuring its own variation in relation to the variation of Richard. She begins by aiding him irresolutely in his search for prostheses. Then, better and better, faster and faster, she herself will seek the loving deformity. She will marry a war machine instead of remaining in the shadow and power of a state apparatus.[23] She herself performs a variation close to Richard's by continually undressing and dressing herself in a rhythm of regression-progression echoing Richard's subtractions-constructions. (3) And each one's vocal variations, phonemes and tonalities, form a tighter and tighter line infringing on each one's gestures, and visa versa. The spectator must not only understand but unknowingly hear and see the aim already pursued by the earliest mumblings and falls: the Idea has become visible, perceptible, the politics have become erotic. From this moment, there would not be two intersecting continuities but one and the same continuum in which the words and gestures play the role of variables in transformation . . . (the rest of the play and the admirable conceit of the ending deserves close analysis: where we realize that Richard's purpose was not to conquer a state apparatus but to construct a war machine that is inseparably political *and* erotic).

## Theater and its Politics

Suppose that Bene's admirers agree more or less with these functions of theater as I have tried to define them. That is, to eliminate the constants and invariants not only in language and gesture but also even in theatrical representation and what is represented on the stage. Thus to eliminate every occurrence of power: the power of what theater represents (the King, the Princes, the Masters, the System), but also the power of theater itself (the Text, the Dialogue, the Actor, the Director, the Structure). Consequently, to transmit everything through continuous variation as on a creative vanishing line that constitutes a minor tongue in language, a minor character on the

stage, a set of minor transformation in relation to dominant forms and sub-jects. Suppose we agree on these points. We still must entertain some practi-cal, basic questions: (1) what is the use of such theater for the outside world, since it is still a matter of theater, and nothing but theater? (2) and exactly how does Bene put into question the power of theater or theater as power? How is he less narcissistic than an actor, less authoritarian than a director, less despotic than a text? On the contrary, would he not be even more narcissistic, since he calls himself the text, the actor, and the director (I am a mass, "see how politics becomes mass, the mass of *my* atoms . . .")?

Nothing is accomplished without realizing how someone's genius is fused with extreme modesty, the extent of humility. Carmelo Bene makes all of his arrogant declarations to express something very humble. First of all, that the theater, even that of which he dreams, amounts to almost nothing. That theater apparently does not change the world or cause a revolution. Bene does not believe in the avant-garde. Nor does he believe in a popular theater, in a theater for everyone, in a form of communication between the theater maker and the people. That is because, when one speaks of a popular theater, one always privileges a certain *representation of conflicts,* conflicts of the individual and society, of life and history, contradictions and oppositions of all kinds that cut across a society as well as its individuals. But, whether naturalist or hyperrealist, etc., this representation of conflicts is truly narcissis-tic and everyone's affair. There is a popular theater analogous to the narcis-sism of the worker. Without a doubt, there is Brecht's attempt to make contradictions and oppositions something other than represented; but Brecht himself only wants them to be "understood" and for the spectator to have the elements of possible "solution." This is not to leave the domain of representa-tion but only to pass from one dramatic pole of bourgeois representation to an epic pole of popular representation. Brecht does not push the "critique" far enough. As a substitute for the representation of conflicts, Bene proposes the presence of variation as a more active, more aggressive element. But why do conflicts generally depend on representation? Why does theater remain repre-sentative each time it focuses on conflicts, contradictions, and oppositions? It is because conflicts are already normalized, codified, and institutionalized. They are "products." They are already a representation that can be repre-sented so much the better on stage. A conflict that is not yet normalized depends on something more profound. It is like lightning coming from somewhere else and announcing something else—a sudden emergence of creative, unexpected, and subrepresentative variation. Institutions are the or-gans of the representation of recognizable conflicts. And theater is an institu-tion. Theater is "official," even when avant-garde or popular. By what destiny have Brechtians taken power over an important aspect of theater? The critic

Giuseppe Bertolucci described the situation of theater in Italy (and else-where) at the time Bene undertook his experiments: because the social reality escapes us, "a theater for all has become an ideological lure and an objective factor of immobility."[24] The same applies to Italian cinema with its pseudo-political ambitions. In the words of Marco Montesano, "despite its conflictual appearances, it is an institutional cinema because the conflict it portrays is the conflict foreseen and controlled by the institution." It is a theater, a narcissistic, historicist, and moralizing cinema. Bene describes even the rich and the poor as belonging to the same system of power and domination that divides them into "poor slaves" and "rich slaves" and that casts the artist in the role of intellectual slave, on one side or on the other. But just how do we break free of this situation of conflictual, official, and institutionalized representation? How do we account for the underground workings of a free and present variation that slips through the nets of slavery and eludes the entire situation?

Would there, then, not be other directions: The lived theater in which conflicts are experienced rather than represented, as in a psychodrama? The aesthetic theater in which formalized conflicts become abstract, geometrical, and ornamental? The mystical theater that tends to abandon representation to arrive at communal and ascetic life "beyond spectacle"? None of these directions suits Carmelo Bene, who would still prefer pure and simple representation . . . Like Hamlet, he searches for a simpler, humbler formula.

The entire question turns around *majority rule*. Since theater for all, the popular theater, is a little like democracy, it summons majority rule. Except that this rule is very ambiguous. It presupposes a state of power or domination and not the opposite. It is obvious that there can exist more flies and mosquitoes than men. Man is nonetheless a standard measure in relation to which mankind is necessarily the majority. The majority does not designate a larger quantity but, rather, the measure by which other quantities of any kind are deemed to be smaller. For example, women and children, blacks and Native Americans, etc. are minorities in relation to the measure established by Man—white, Christian, average-male-adult-inhabitant of contemporary American or European cities (Ulysses). But, at this point, everything reverses itself. For if the majority rejects an historical or structural model of power, it must also be said that *the entire world* is minority, potentially minority, as much as it deviates from this model. But might not continuous variation be just such an amplitude that always overflows, by excess or lack, the representative threshold of majority measure? Might not continuous variation be the minority becoming of everybody in contrast to the majority rule of Nobody. Might not theater, thus, discover a sufficiently modest, but nevertheless, effective function? This antirepresentational function would be to trace, to construct in some way, a figure of the minority consciousness as each one's

254 | *Gilles Deleuze*

potential. To render a potentiality present and actual is a completely different matter from representing a conflict.[25] It could no longer be said that art has power, that it is still a matter of power, even when it criticizes Power. For, by shaping the form of a minority consciousness, art speaks to the strengths of becoming that are of another domain than that of Power and measured representation. "Art is not a form of power except when it ceases to be art and begins to become demagoguery." Art is subject to many powers, but it is not a form of power. It is of little consequence that the actor-author-director exerts influence and assumes an authoritarian manner, even a very authoritarian one. This would be the authority of perpetual variation in contrast to the power or despotism of the invariant. This would be the authority, the autonomy of the stammerer who has acquired the right to stammer in contrast to the "well-spoken" majority. Of course there is always a great risk that the minority form will restore a majority, remake a measurement (when art begins again to become demagoguery . . .). Variation must always vary itself. That is, it must travel through new and always unexpected routes.

What are these routes from the point of view of a politics of theater? Who is this man of the minority—with the word *man* (*l'homme*) no longer pertaining since it carries the sign of the majority? Why not *woman* or *transvestite,* except that they also are already too codified? The traces of a politics are clearly evident in the declarations and positions of Carmelo Bene. The border, that is to say, the line of variation, does not divide masters and slaves, rich and poor. This is because an entire regime of relations and oppositions is woven from one and the other that makes the master into a rich slave, and the slave into a poor master, *at the heart of the same majority system.* The border is not inscribed in History, neither inside an established structure, nor even in "the people." Everyone appeals to the people in the name of the majority language. But where are the people? "The people are missing."[26] In truth, the border divides History and antihistoricism, that is to say specifically, "those that History does not take into account." It divides the structure and the vanishing lines that traverse it. It divides the people and the *ethnic.* The ethnic is the minority, the vanishing line in the structure, the antihistorical element in History. Carmelo Bene himself leads a minority life in solidarity with the people of Puglia: his South or third world, in the sense that everyone has a South or third world. But when he speaks of the peoples of Puglia, of whom he is one, he knows that the word *poor* is completely unsuitable. How can you call a people "poor" who would rather starve than work? How you can call a people "slaves" who refuse to play the game of master and slave? How can you speak of a conflict where there was something very different, a fiery variation, an antihistorical variant—the mad riot of Campi Salentina, such as Bene describes it. But we have subjected them to a strange graft, to a strange

operation: we have mapped, represented, normalized, historicized them, integrated them into majority rule. And there, indeed, we have made them poor. We have made them slaves. We have turned them into the people. We have rendered them major in History.

A last danger, before we believe we have understood the words of Carmelo Bene. He has absolutely no interest in becoming the head of a regional troupe. To the contrary, he demands and requires state theaters. He fights for them. He fosters no cult of poverty in his work. It would take a lot of bad political faith to see this as a "contradiction" or sellout. Bene has never pretended to launch a regional theater. A minority already begins to become normalized when one encloses it on itself or when one encircles it in a nostalgic dance (it thereby becomes a subcomponent of the majority). Carmelo Bene is never more Puglian, more a southerner, than when he creates a universal theater with English, French, and American combinations. What he takes from Puglia is a line of variation, air, earth, sun, colors, lights, and sounds that he himself will vary in a completely different manner, along other lines. Consider *Notre Dame des Turcs,* which is more complicitous with the Puglians than if he had staged a play as their representative poet.

To conclude, *minority has two meanings* that are related, no doubt, but very distinct. First of all, minority denotes a state of rule, that is to say, the situation of a group that, whatever its size, is excluded from the majority, or even included, but as a subordinate fraction in relation to the standard of measure that regulates the law and establishes the majority. In this context, we can say that women, children, the South, the third world, etc., are still minorities, as numerous as they are. But, then, let us take this first meaning literally. There follows a second meaning: minority no longer denotes a state of rule, but a becoming in which one enlists. To become-minority. This is a goal, a goal that concerns the entire world since the entire world is included in this goal and in this becoming inasmuch as everyone creates his or her variation of the unity of despotic measure and escapes, from one side or the other, from the system of power that is part of the majority. In the second sense, it is obvious that the minority is much more numerous than the majority. For example, women are a minority in the first sense. But, in the second sense, everyone is a becoming-woman, a becoming-woman who acts as everyone's potentiality. In this context, women are no more becoming-women than men themselves. A universal becoming-minority. Minority here denotes the strength of a becoming while majority designates the power or weakness of a state, of a situation. Here is where theater or art can surge forward with a specific, political function. This is on the condition that minority represents nothing regionalist, nor anything aristocratic, aesthetic, or mystical.

Theater will surge forward as something representing nothing but what presents and creates a minority consciousness as a universal-becoming. It forges alliances here and there according to the circumstances, following the lines of transformation that exceed theater and take on another form, or else that transform themselves back into theater for another leap. It is truly a matter of consciousness-raising, even though it bears no relation to a psychoanalytic consciousness, nor to a Marxist political consciousness, nor even to a Brechtian one. Consciousness, consciousness-raising is a tremendous strength but one made neither for solutions nor for interpretations. When consciousness abandons solutions and interpretations, it thus acquires its light, its gestures and its sounds, its decisive transformation. Henry James wrote: "She ended up knowing more than she could ever interpret; there were no more obscurities clouding her clear vision. There remained only a raw light." The more we attain this form of minority consciousness, the less isolated we feel. Light. We are our own mass, by ourselves, "the mass of my atoms." Under the ambition of formulas, there is the most modest appreciation of what might be a revolutionary theater, a simple loving potentiality, an element for a new becoming of consciousness.

## NOTES

Translated by Eliane dal Molin and Timothy Murray. The notes are the translators'.

1. Deleuze's essay is accompanied by the following bibliographical notice about the work of Carmelo Bene that may be of assistance to readers: "José Guinot and the International Center of Dramaturgy introduced the work of Carmelo Bene in France, and dedicated a publication to it which includes the play *S.A.D.E.*, writings by Carmelo Bene, and a general bibliography: cf. *Carmelo Bene, dramatugie*, 1977. In *XXe siécle*, 50, there is a beautiful analysis of the theater and cinema of Carmelo Bene by Jean-Paul Manganaro. Bene presented his comic operas *Romeo and Juliet* and *S.A.D.E.* in Paris during the Festival d'Automne, 1977. These films have been projected in France: *Notre Dame des Turcs, Capricci, Don Juan, Salomé*.

2. The nineteenth-century poet Jules Laforgue wrote a number of short stories from 1885 to 1886 whose literary subjects included Hamlet, Lohengrin, Salomé, and Perseus, among others. In these prosaic pieces, Laforgue continues his poetic queries of life, love, and anguish.

3. Deleuze's notion of continuous variation puns on the biological term signifying a "variation in which a series of intermediate types connects to the extremes" *(Webster's Third New International Dictionary)*. This concept is central to Deleuze's thinking and receives detailed attention throughout *Difference and Repetition,* trans. Paul Patton (New York: Columbia University Press, 1994) and *A Thousand Plateaus: Capitalism and Schizophrenia,* coauthored with Félix Guattari, trans. Brian Massumi (Minneapolis: University of Minnesota Press, 1987).

4. "The coming into being of the notion of 'auteur' constitutes," according to Michel Foucault, "the privileged moment of *individualization* in the history of ideas, knowledge, literature, philosophy, and the sciences." Michel Foucault, "What Is an Author?" in *Textual Strategies: Perspectives in Post-Structuralist Criticism,* ed. Josué V. Harari (Ithaca, N.Y.: Cornell University Press, 1979), 141.

5. Deleuze here refers to his extensive remarks on Lewis Carroll in *The Logic of Sense,* trans. Mark Lester (New York: Columbia University Press, 1990).

6. Talma was a famous classical actor during the Napoleonic era whose reputation was built on his extraordinary performances in plays by Racine.

7. Here, Deleuze draws on his essay with Félix Gauattari, *Kafka: Toward a Minor Literature,* trans. Dana Polan (Minneapolis: University of Minnesota Press, 1986).

8. While our translation of *milieu* as "middle" is compatible with Deleuze's emphasis on the temporality, the becoming of the minor, we would not wish it to negate the spatial dimension of *milieu,* which Deleuze and Félix Guattari stress in *A Thousand Plateaus:* "To the extent that elements and compounds incorporate or appropriate materials, the corresponding organisms are forced to turn to other 'more foreign and less convenient' materials that they take from still intact masses or organisms. The milieu assumes a third figure here: it is no longer an interior or exterior milieu, even a relative one, nor an intermediate milieu, but instead an *annexed or associated milieu.* . . . The associated milieu is thus defined by the capture of energy sources (respiration in the most general sense), by the discernment of materials, the sensing of their presence or absence (perception) and by the fabrication or nonfabrication of the corresponding compounds (response, reaction)" (51).

9. Puglia is Bene's native region in Southern Italy.

10. This section is developed by Deleuze and Guattari in chapter 4, "November 20, 1923—Postulates of Linguistics," in *A Thousand Plateaus,* 75–110.

11. In contrast with Brian Massumi, who translates "une ligne de fuite" as "a line of flight" (see, for instance, his admirable translation of *A Thousand Plateaus,* 202), we prefer "vanishing line" in order to preserve Deleuze's sensitivity, in this essay, to the tradition of pictorial and theatrical perspective.

12. See Franco Quadri, *L'Avantguardia teatrale in Italia: Materiali, 1960–1976* (Turin: G. Einaudi, 1977).

13. Gherasim Luca, *Le Chant de la carpe* (Paris: Soleil Noir, 1973), recorded by Givaudan.

14. Proust's formula, "Les beaux livres sont écrits dans une sorte de langue étrangére," is from "Notes sur la littérature et la critique," in *Contre Sainte-Beuve* (Paris: Gallimard, 1971), 305.

15. Corrado Augias was a controversial journalist and intellectual of the 1960s and 1970s who is now hosting an Italian television program on books. Deleuze provides no information about the specific article to which he alludes.

16. The English translation dulls Deleuze's theatrical punning here: "par une chute ou par une remontée, par une glissade" should be understood to envelope the gestures of Richard III in the architectonics of the stage: "by a fall [of a curtain, "une chute"], a rise [of a curtain, or a restaging of a play, "une remontée"], or a slip [or a dance step, "une glissade"].

17. Readers may find it helpful to read these comments in the context of Deleuze's essay on Sade and Masoch in *Masochism: "Coldness and Cruelty",* trans. Jean

McNeil, published with *Venus in Furs* by Leopold von Sacher-Masoch (New York: Zone Books, 1989).

18. See Deleuze's discussion of Duns Scotus in *Difference and Repetition,* 35–40.

19. See Deleuze's discussion of affect, action, and movement in *Cinema 1: The Movement-Image,* trans. Hugh Tomlinson and Barbara Habberjam (Minneapolis: University of Minnesota Press, 1986), esp. chap. 6–8.

20. Nicholas Oresme was a fourteenth-century mathematician and geometrician who made notable contributions in analyzing how qualities and velocities vary in intensity, force, and resistance.

21. See Deleuze's comparison of cinema and theater in "The Components of the Image," chapter 9 of *Cinema 2: The Time-Image,* trans. Hugh Tomlinson and Robert Galeta (Minneapolis: University of Minnesota Press, 1989), 225–61.

22. In *Cinema 2,* 247–48, Deleuze develops these brief remarks about Bene's films.

23. Deleuze refers to Louis Althusser's concept of state apparatus, which Althusser develops in "Ideology and Ideological State Apparatuses," in *Lenin and Philosophy and Other Essays,* trans. Ben Brewster (New York: Monthly Review Press, 1971), 127–86. For a detailed discussion of Deleuze's contrast between a state apparatus and a "war machine," see Deleuze and Guattari, "1227: Treatise on Nomadology—The War Machine," chapter 12 of *A Thousand Plateaus,* 350–423.

24. Giuseppe Bertolucci is not be confused with his older brother, Bernardo, with whom he cowrote *Novecento (1900)* and *La Luna.* In addition to becoming Bernardo's producer, Giuseppe made a documentary on the filming of *Novecento* as well as his own films, *Andare e venire (Round Trip)* in 1972; *Berlinguer, ti voglio bene (I Love You, Berlinguer)* in 1976; *An Italian Woman* in 1980.

25. This nature of "actualization" receives extensive anlaysis in Deleuze's chapter, "Ideas and the Synthesis of Difference," in *Difference and Repetition,* 168–221.

26. "Missing persons" in the American sense?

# Frantz Fanon
## Algeria Unveiled

The way people clothe themselves, together with the traditions of dress and finery that custom implies, constitutes the most distinctive form of a society's uniqueness, that is to say the one that is the most immediately perceptible. Within the general pattern of a given costume, there are of course always modifications of detail, innovations which in highly developed societies are the mark of fashion. But the effect as a whole remains homogeneous, and great areas of civilization, immense cultural regions, can be grouped together on the basis of original, specific techniques of men's and women's dress.

It is by their apparel that types of society first become known, whether through written accounts and photographic records or motion pictures. Thus, there are civilizations without neckties, civilizations with loin-cloths, and others without hats. The fact of belonging to a given cultural group is usually revealed by clothing traditions. In the Arab world, for example, the veil worn by women is at once noticed by the tourist. One may remain for a long time unaware of the fact that a Moslem does not eat pork or that he denies himself daily sexual relations during the month of Ramadan, but the veil worn by the women appears with such constancy that it generally suffices to characterize Arab society.

In the Arab Maghreb, the veil belongs to the clothing traditions of the Tunisian, Algerian, Moroccan and Libyan national societies. For the tourist and the foreigner, the veil demarcates both Algerian society and its feminine component.[1] In the case of the Algerian man, on the other hand, regional modifications can be noted: the *fez* in urban centers, turbans and *djellabas*[2] in the countryside. The masculine garb allows a certain margin of choice, a modicum of heterogeneity. The woman seen in her white veil unifies the perception that one has of Algerian feminine society. Obviously what we have here is a uniform which tolerates no modification, no variant.[3]

The *haïk*[4] very clearly demarcates the Algerian colonized society. It is of course possible to remain hesitant before a little girl, but all uncertainty vanishes at the time of puberty. With the veil, things become well-defined and ordered. The Algerian woman, in the eyes of the observer, is unmistakably "she who hides behind a veil."

We shall see that this veil, one of the elements of the traditional Algerian garb, was to become the bone of contention in a grandiose battle, on account of which the occupation forces were to mobilize their most powerful and

most varied resources, and in the course of which the colonized were to display a surprising force of inertia. Taken as a whole, colonial society, with its values, its areas of strength, and its philosophy, reacts to the veil in a rather homogeneous way. The decisive battle was launched before 1954, more precisely during the early 1930s. The officials of the French administration in Algeria, committed to destroying the people's originality, and under instructions to bring about the disintegration, at whatever cost, of forms of existence likely to evoke a national reality directly or indirectly, were to concentrate their efforts on the wearing of the veil, which was looked upon at this juncture as a symbol of the status of the Algerian woman. Such a position is not the consequence of a chance intuition. It is on the basis of the analyses of sociologists and ethnologists that the specialists in so called native affairs and the heads of the Arab Bureaus coordinated their work. At an initial stage, there was a pure and simple adoption of the well-known formula, "Let's win over the women and the rest will follow." This definition of policy merely gave a scientific coloration to the "discoveries" of the sociologists.

Beneath the patrilineal pattern of Algerian society, the specialists described a structure of matrilineal essence. Arab society has often been presented by Westerners as a formal society in which outside appearances are paramount. The Algerian woman, an intermediary between obscure forces and the group, appeared in this perspective to assume a primordial importance. Behind the visible, manifest patriarchy, the more significant existence of a basic matriarchy was affirmed. The role of the Algerian mother, that of the grandmother, the aunt and the "old woman," were inventoried and defined.

This enabled the colonial administration to define a precise political doctrine: "If we want to destroy the structure of Algerian society, its capacity for resistance, we must first of all conquer the women; we must go and find them behind the veil where they hide themselves and in the houses where the men keep them out of sight." It is the situation of woman that was accordingly taken as the theme of action. The dominant administration solemnly undertook to defend this woman, pictured as humiliated, sequestered, cloistered. . . . It described the immense possibilities of woman, unfortunately transformed by the Algerian man into an inert, demonetized, indeed dehumanized object. The behavior of the Algerian was very firmly denounced and described as medieval and barbaric. With infinite science, a blanket indictment against the "sadistic and vampirish" Algerian attitude toward women was prepared and drawn up. Around the family life of the Algerian, the occupier piled up a whole mass of judgments, appraisals, reasons, accumulated anecdotes, and edifying examples, thus attempting to confine the Algerian within a circle of guilt.

Mutual aid societies and societies to promote solidarity with Algerian

women sprang up in great number. Lamentations were organized. "We want to make the Algerian ashamed of the fate that he meets out to women." This was a period of effervescence, of putting into application a whole technique of infiltration, in the course of which droves of social workers and women directing charitable works descended on the Arab quarters.

The indigent and famished women were the first to be besieged. Every kilo of semolina distributed was accompanied by a dose of indignation against the veil and the cloister. The indignation was followed up by practical advice. Algerian women were invited to play "a functional, capital role" in the transformation of their lot. They were pressed to say no to a centuries-old subjection. The immense role they were called upon to play was described to them. The colonial administration invested great sums in this combat. After it had been posited that the woman constituted the pivot of Algerian society, all efforts were made to obtain control over her. The Algerian, it was assured, would not stir, would resist the task of cultural destruction undertaken by the occupier, would oppose assimilation, so long as his woman had not reversed the stream. In the colonialist program, it was the woman who was given the historic mission of shaking up the Algerian man. Converting the woman, winning her over to the foreign values, wrenching her free from her status, was at the same time achieving a real power over the man and attaining a practical, effective means of destructuring Algerian culture.

Still today, in 1959, the dream of a total domestication of Algerian society by means of "unveiled women aiding and sheltering the occupier" continues to haunt the colonial authorities.

The Algerian men, for their part, are a target of criticism for their European comrades, or more officially for their bosses. There is not a European worker who does not sooner or later, in the give and take of relations on the job site, the shop or the office, ask the Algerian the ritual questions: "Does your wife wear the veil? Why don't you take your wife to the movies, to the fights, to the café?"

European bosses do not limit themselves to the disingenuous query or the glancing invitation. They use "Indian cunning" to corner the Algerian and push him to painful decisions. In connection with a holiday—Christmas or New Year, or simply a social occasion with the firm—the boss will invite *the Algerian employee and his wife*. The invitation is not a collective one. Every Algerian is called in to the director's office and invited by name to come with "your little family." "The firm being one big family, it would be unseemly for some to come without their wives, you understand?" Before this formal summons, the Algerian sometimes experiences moments of difficulty. If he comes with his wife, it means admitting defeat, it means "prostituting his wife," exhibiting her, abandoning a mode of resistance. On the other hand,

going alone means refusing to give satisfaction to the boss; it means running the risk of being out of a job. The study of a case chosen at random—a description of the traps set by the European in order to bring the Algerian to expose himself, to declare: "My wife wears a veil, she shall not go out," or else to betray: "Since you want to see her, here she is"—would bring out the sadistic and perverse character of these contacts and relationships and would show in microcosm the tragedy of the colonial situation on the psychological level, the way the two systems directly confront each other, the epic of the colonized society, with its specific ways of existing, in the face of the colonialist hydra. . . .

Before the Algerian intellectual, racialist arguments spring forth with special readiness. For all that he is a doctor, people will say, he still remains an Arab. "You can't get away from nature." Illustrations of this kind of race prejudice can be multiplied indefinitely. Clearly, the intellectual is reproached for limiting the extension of learned Western habits, for not playing his role as an active agent of upheaval of the colonized society, for not giving his wife the benefit of the privileges of a more worthy and meaningful life. . . .

The phenomena of counter-acculturation must be understood as the organic impossibility of a culture to modify any one of its customs without at the same time reevaluating its deepest values, its most stable models. To speak of counter-acculturation in a colonial situation is an absurdity. The phenomena of resistance observed in the colonized must be related to an attitude of counter-assimilation, of maintenance of a cultural, hence national, originality.

The occupying forces, in applying their maximum psychological attention to the veil worn by Algerian women, were obviously bound to achieve some results. Here and there it thus happened that a woman was "saved," and symbolically unveiled.

These test-women, with bare faces and free bodies, henceforth circulated like sound currency in the European society of Algeria. These women were surrounded by an atmosphere of newness. The Europeans, overexcited and wholly given over to their victory, carried away in a kind of trance, would speak of the psychological phenomena of conversion. And in fact, in the European society, the agents of this conversion were held in esteem. They were envied. The benevolent attention of the administration was drawn to them.

After each success, the authorities were strengthened in their conviction that the Algerian woman would support Western penetration into the native society. Every rejected veil disclosed to the eyes of the colonialists horizons until then forbidden, and revealed to them, piece by piece, the flesh of Algeria

laid bare. The occupier's aggressiveness, and hence his hopes, multiplied tenfold each time a new face was uncovered. Every new Algerian woman unveiled announced to the occupier an Algerian society whose systems of defense were in the process of dislocation, open and breached. Every veil that fell, every body that became liberated from the traditional embrace of the *haïk,* every face that offered itself to the bold and impatient glance of the occupier, was a negative expression of the fact that Algeria was beginning to deny herself and was accepting the rape of the colonizer. Algerian society with every abandoned veil seemed to express its willingness to attend the master's school and to decide to change its habits under the occupier's direction and patronage.

We have seen how colonial society, the colonial administration, perceives the veil, and we have sketched the dynamics of the efforts undertaken to fight it as an institution and the resistances developed by the colonized society. At the level of the individual, of the private European, it may be interesting to follow the multiple reactions provoked by the existence of the veil, which reveal the original way in which the Algerian woman manages to be present or absent.

For a European not directly involved in this work of conversion, what reactions are there to be recorded?

The dominant attitude appears to us to be a romantic exoticism, strongly tinged with sensuality.

And, to begin with, the veil hides a beauty.

A revealing reflection—among others—of this state of mind was communicated to us by a European visiting Algeria who, in the exercise of his profession (he was a lawyer), had had the opportunity of seeing a few Algerian women without the veil. These men, he said, speaking of the Algerians, are guilty of concealing so many strange beauties. It was his conclusion that a people with a cache of such prizes, of such perfections of nature, owes it to itself to show them, to exhibit them. If worst came to worst, he added, it ought to be possible to force them to do so.

A strand of hair, a bit of forehead, a segment of an "overwhelmingly beautiful" face glimpsed in a streetcar or on a train, may suffice to keep alive and strengthen the European's persistence in his irrational conviction that the Algerian woman is the queen of all women.

But there is also in the European the crystallization of an aggressiveness, the strain of a kind of violence before the Algerian woman. Unveiling this woman is revealing her beauty; it is baring her secret, breaking her resistance, making her available for adventure. Hiding the face is also disguising a secret; it is also creating a world of mystery, of the hidden. In a confused way, the European experiences his relation with the Algerian

woman at a highly complex level. There is in it the will to bring this woman within his reach, to make her a possible object of possession.

This woman who sees without being seen frustrates the colonizer. There is no reciprocity. She does not yield herself, does not give herself, does not offer herself. The Algerian has an attitude toward the Algerian woman which is on the whole clear. He does not see her. There is even a permanent intention not to perceive the feminine profile, not to pay attention to women. In the case of the Algerian, therefore, there is not, in the street or on a road, that behavior characterizing a sexual encounter that is described in terms of the glance, of the physical bearing, the muscular tension, the signs of disturbance to which the phenomenology of encounters has accustomed us.

The European faced with an Algerian woman wants to see. He reacts in an aggressive way before this limitation of his perception. Frustration and aggressiveness, here too, evolve apace. Aggressiveness comes to light, in the first place, in structurally ambivalent attitudes and in the dream material that can be revealed in the European, whether he is normal or suffers from neuropathological disturbances.[5]

In a medical consultation, for example, at the end of the morning, it is common to hear European doctors express their disappointment. The women who remove their veils before them are commonplace, vulgar; there is really nothing to make such a mystery of. One wonders what they are hiding.

European women settle the conflict in a much less roundabout way. They bluntly affirm that no one hides what is beautiful and discern in this strange custom an "altogether feminine" intention of disguising imperfections. And they proceed to compare the strategy of the European woman, which is intended to correct, to embellish, to bring out (beauty treatments, hairdos, fashion), with that of the Algerian woman, who prefers to veil, to conceal, to cultivate the man's doubt and desire. On another level, it is claimed that the intention is to mislead the customer, and that the wrapping in which the "merchandise" is presented does not really alter its nature, nor its value.

The content of the dreams of Europeans brings out other special themes. Jean-Paul Sartre, in his *Réflections sur la question Juive,* has shown that on the level of the unconscious, the Jewish woman almost always has an aura of rape about her.

The history of the French conquest in Algeria, including the overrunning of villages by the troops, the confiscation of property and the raping of women, the pillaging of a country, has contributed to the birth and the crystallization of the same dynamic image. At the level of the psychological strata of the occupier, the evocation of this freedom given to the sadism of the conqueror, to his eroticism, creates faults, fertile gaps through which both

dreamlike forms of behavior and, on certain occasions, criminal acts can emerge.

Thus the rape of the Algerian woman in the dream of a European is always preceded by a rending of the veil. We here witness a double deflowering. Likewise, the woman's conduct is never one of consent or acceptance, but of abject humility.

Whenever, in dreams having an erotic content, a European meets an Algerian woman, the specific features of his relations with the colonized society manifest themselves. These dreams evolve neither on the same erotic plane, nor at the same tempo, as those that involve a European woman.

With an Algerian woman, there is no progressive conquest, no mutual revelation. Straight off, with the maximum of violence, there is possession, rape, near-murder. The act assumes a para-neurotic brutality and sadism, even in a normal European. This brutality and this sadism are in fact emphasized by the frightened attitude of the Algerian woman. In the dream, the woman-victim screams, struggles like a doe, and as she weakens and faints, is penetrated, martyrized, ripped apart.

Attention must likewise be drawn to a characteristic of this dream content that appears important to us. The European never dreams of an Algerian woman taken in isolation. On the rare occasions when the encounter has become a binding relationship that can be regarded as a couple, it has quickly been transformed by the desperate flight of the woman who, inevitably, leads the male "among women." The European always dreams of a group of women, of a field of women, suggestive of the gynaeceum, the harem—exotic themes deeply rooted in the unconscious.

The European's aggressiveness will express itself likewise in contemplation of the Algerian woman's morality. Her timidity and her reserve are transformed in accordance with the commonplace laws of conflictual psychology into their opposite, and the Algerian woman becomes hypocritical, perverse, and even a veritable nymphomaniac.

We have seen that on the level of individuals the colonial strategy of destructuring Algerian society very quickly came to assign a prominent place to the Algerian woman. The colonialist's relentlessness, his methods of struggle were bound to give rise to reactionary forms of behavior on the part of the colonized. In the face of the violence of the occupier, the colonized found himself defining a principled position with respect to a formerly inert element of the native cultural configuration. It was the colonialist's frenzy to unveil the Algerian woman, it was his gamble on winning the battle of the veil at whatever cost, that were to provoke the native's bristling resistance. The deliberately aggressive intentions of the colonialist with respect to the *haïk* gave a new life to this dead element of the Algerian cultural stock—dead

because stabilized, without any progressive change in form or color. We here recognize one of the laws of the psychology of colonization. In an initial phase, it is the action, the plans of the occupier that determine the centers of resistance around which a people's will to survive becomes organized.

It is the white man who creates the Negro. But it is the Negro who creates negritude. To the colonialist offensive against the veil, the colonized opposes the cult of the veil. What was an undifferentiated element in a homogeneous whole acquires a taboo character, and the attitude of a given Algerian woman with respect to the veil will be constantly related to her overall attitude with respect to the foreign occupation. The colonized, in the face of the emphasis given by the colonialist to this or that aspect of his traditions, reacts very violently. The attention devoted to modifying this aspect, the emotion the conqueror puts into his pedagogical work, his prayers, his threats, weave a whole universe of resistances around this particular element of the culture. Holding out against the occupier on this precise element means inflicting upon him a spectacular setback; it means more particularly maintaining "co-existence" as a form of conflict and latent warfare. It means keeping up the atmosphere of an armed truce.

Upon the outbreak of the struggle for liberation, the attitude of the Algerian woman, or of native society in general, with regard to the veil was to undergo important modifications. These innovations are of particular interest in view of the fact that they were at no time included in the program of the struggle. The doctrine of the Revolution, the strategy of combat, never postulated the necessity for a revision of forms of behavior with respect to the veil. We are able to affirm even now that when Algeria has gained her independence such questions will not be raised, for in the practice of the Revolution the people have understood that problems are resolved in the very movement that raises them.

Until 1955, the combat was waged exclusively by the men. The revolutionary characteristics of this combat, the necessity for absolute secrecy, obliged the militant to keep his woman in absolute ignorance. As the enemy gradually adapted himself to the forms of combat, new difficulties appeared which required original solutions. The decision to involve women as active elements of the Algerian Revolution was not reached lightly. In a sense, it was the very conception of the combat that had to be modified. The violence of the occupier, his ferocity, his delirious attachment to the national territory, induced the leaders no longer to exclude certain forms of combat. Progressively, the urgency of a total war made itself felt. But involving the women was not solely a response to the desire to mobilize the entire nation. The women's entry into the war had to be harmonized with respect for the revolutionary nature of the war. In other words, the women had to show as much spirit of

sacrifice as the men. It was therefore necessary to have the same confidence in them as was required from seasoned militants who had served several prison sentences. A moral elevation and a strength of character that were altogether exceptional would therefore be required of the women. There was no lack of hesitations. The revolutionary wheels had assumed such proportions; the mechanism was running at a given rate. The machine would have to be complicated; in other words its network would have to be extended without affecting its efficiency. The women could not be conceived of as a replacement product, but as an element capable of adequately meeting the new tasks. . . .

It must be constantly borne in mind that the committed Algerian woman learns both her role as "a woman alone in the street" and her revolutionary mission instinctively. The Algerian woman is not a secret agent. It is without apprenticeship, without briefing, without fuss, that she goes out into the street with three grenades in her handbag or the activity report of an area in her bodice. She does not have the sensation of playing a role she has read about ever so many times in novels, or seen in motion pictures. There is not that coefficient of play, of imitation, almost always present in this form of action when we are dealing with a Western woman.

What we have here is not the bringing to light of a character known and frequented a thousand times in imagination or in stories. It is an authentic birth in a pure state, without preliminary instruction. There is no character to imitate. On the contrary, there is an intense dramatization, a continuity be-tween the woman and the revolutionary. The Algerian woman rises directly to the level of tragedy. . . .

Among the tasks entrusted to the Algerian woman is the bearing of messages, of complicated verbal orders learned by heart, sometimes despite complete absence of schooling. But she is also called upon to stand watch, for an hour and often more, before a house where district leaders are conferring.

During those interminable minutes when she must avoid standing still, so as not to attract attention, and avoid venturing too far since she is responsi-ble for the safety of the brothers within, incidents that are at once funny and pathetic are not infrequent. An unveiled Algerian girl who "walks the street" is very often noticed by young men who behave like young men all over the world, but who use a special approach as the result of the idea people habitu-ally have of one who has discarded the veil. She is treated to unpleasant, obscene, humiliating remarks. When such things happen, she must grit her teeth, walk away a few steps, elude the passers-by who draw attention to her, who give other passers-by the desire either to follow their example, or to come to her defense. Or it may be that the Algerian woman is carrying in her

bag or in a small suitcase twenty, thirty, forty million francs, money belonging to the Revolution, money which is to be used to take care of the needs of the families of prisoners, or to buy medicine and supplies for the guerrillas.

This revolutionary activity has been carried on by the Algerian woman with exemplary constancy, self-mastery, and success. Despite the inherent, subjective difficulties and notwithstanding the sometimes violent incomprehension of a part of the family, the Algerian woman assumes all the tasks entrusted to her.

But things were gradually to become more complicated. Thus the unit leaders who go into the town and who avail themselves of the women-scouts, of the girls whose function it is to lead the way, are no longer new to political activity, are no longer unknown to the police. Authentic military chiefs have now begun to pass through the cities. These are known, and are being looked for. There is not a police superintendent who does not have their pictures on his desk.

These soldiers on the move, these fighters, always carry their weapons—automatic pistols, revolvers, grenades, sometimes all three. The political leader must overcome much resistance in order to induce these men, who under no circumstance would allow themselves to be taken prisoner, to entrust their weapons to the girl who is to walk ahead of them, it being up to them, if things go badly, to recover the arms immediately. The group accordingly makes its way into the European city. A hundred meters ahead, a girl may be carrying a suitcase and behind her are two or three ordinary-looking men. This girl who is the group's lighthouse and barometer gives warning in case of danger. The file makes its way by fits and starts; police cars and patrols cruise back and forth.

There are times, as these soldiers have admitted after completing such a mission, when the urge to recover their weapons is almost irresistible because of the fear of being caught short and not having time to defend themselves. With this phase, the Algerian woman penetrates a little further into the flesh of the Revolution.

But it was from 1956 on that her activity assumed really gigantic dimensions. Having to react in rapid succession to the massacre of Algerian civilians in the mountains and in the cities, the revolutionary leadership found that if it wanted to prevent the people from being gripped by terror it had no choice but to adopt forms of terror which until then it had rejected. . . .

A time came when some of the people allowed doubt to enter their minds, and they began to wonder whether it was really possible, quantitatively and qualitatively, to resist the occupant's offensives. Was freedom worth the consequences of penetrating into the enormous circuit of terrorism and counter-

terrorism? Did this disproportion not express the impossibility of escaping oppression?

Another part of the people, however, grew impatient and conceived the idea of putting an end to the advantage the enemy derived by pursuing the path of terror. The decision to strike the adversary individually and by name could no longer be eluded. All the prisoners "shot and killed while trying to escape," and the cries of the tortured, demanded that new forms of combat be adopted.

Members of the police and the meeting places of the colonialists (cafés in Algiers, Oran, Constantine) were the first to be singled out. From this point on the Algerian woman became wholly and deliberately immersed in the revolutionary action. It was she who would carry in her bag the grenades and the revolvers that a *fidaï* would take from her at the last moment, before the bar, or as a designated criminal passed. During this period Algerians caught in the European city were pitilessly challenged, arrested, searched. . . .

Carrying revolvers, grenades, hundreds of false identity cards or bombs, the unveiled Algerian woman moves like a fish in the Western waters. The soldiers, the French patrols smile to her as she passes, compliments on her looks are heard here and there, but no one suspects that her suitcases contain the automatic pistol which will presently mow down four or five members of one of the patrols.

We must come back to that young girl, unveiled only yesterday, who walks with sure steps down the streets of the European city teeming with policemen, parachutists, militiamen. She no longer slinks along the walls as she tended to do before the Revolution. Constantly called upon to efface herself before a member of the dominant society, the Algerian woman avoided the middle of the sidewalk which in all countries in the world belongs rightfully to those who command.

The shoulders of the unveiled Algerian woman are thrust back with easy freedom. She walks with a graceful, measured stride, neither too fast nor too slow. Her legs are bare, not confined by the veil, given back to themselves, and her hips are free.

The body of the young Algerian woman, in traditional society, is revealed to her by its coming to maturity and by the veil. The veil covers the body and disciplines it, tempers it, at the very time when it experiences its phase of greatest effervescence. The veil protects, reassures, isolates. One must have heard the confessions of Algerian women or have analyzed the dream content of certain recently unveiled women to appreciate the importance of the veil for the body of the woman. Without the veil she has an impression of her body being cut up into bits, put adrift; the limbs seem to

lengthen indefinitely. When the Algerian woman has to cross a street, for a long time she commits errors of judgment as to the exact distance to be negotiated. The unveiled body seems to escape, to dissolve. She has an impression of being improperly dressed, even of being naked. She experiences a sense of incompleteness with great intensity. She has the anxious feeling that something is unfinished, and along with this a frightful sensation of disintegrating. The absence of the veil distorts the Algerian woman's corporal pattern. She quickly has to invent new dimensions for her body, new means of muscular control. She has to create for herself an attitude of unveiled-woman-outside. She must overcome all timidity, all awkwardness (for she must pass for a European), and at the same time be careful not to overdo it, not to attract notice to herself. The Algerian woman who walks stark naked into the European city relearns her body, reestablishes it in a totally revolutionary fashion. This new dialectic of the body and of the world is primary in the case of one revolutionary woman.[6]

But the Algerian woman is not only in conflict with her body. She is a link, sometimes an essential one, in the revolutionary machine. She carries weapons, knows important points of refuge. And it is in terms of the concrete dangers that she faces that we must gauge the insurmountable victories that she has had to win in order to be able to say to her chief, on her return: "Mission accomplished . . . R.A.S."[7]

Another difficulty to which attention deserves to be called appeared during the first months of feminine activity. In the course of her comings and goings, it would happen that the unveiled Algerian woman was seen by a relative or a friend of the family. The father was sooner or later informed. He would naturally hesitate to believe such allegations. Then more reports would reach him. Different persons would claim to have seen "Zohra or Fatima unveiled, walking like a . . . My Lord, protect us!" The father would then decide to demand explanations. He would hardly have begun to speak when he would stop. From the young girl's look of firmness the father would have understood that her commitment was of long standing. The old fear of dishonor was swept away by a new fear, fresh and cold—that of death in battle or of torture of the girl. Behind the girl, the whole family—even the Algerian father, the authority for all things, the founder of every value—following in her footsteps, becomes committed to the new Algeria.

Removed and reassumed again and again, the veil has been manipulated, transformed into a technique of camouflage, into a means of struggle. The virtually taboo character assumed by the veil in the colonial situation disappeared almost entirely in the course of the liberating struggle. Even Algerian women not actively integrated into the struggle formed the habit of abandoning the veil. It is true that under certain conditions, especially from 1957 on,

the veil reappeared. The missions in fact became increasingly difficult. The adversary now knew, since certain militant women had spoken under torture, that a number of women very Europeanized in appearance were playing a fundamental role in the battle. Moreover, certain European women of Algeria were arrested, to the consternation of the adversary who discovered that his own system was breaking down. The discovery by the French authorities of the participation of Europeans in the liberation struggle marks a turning point in the Algerian Revolution. From that day, the French patrols challenged every person. Europeans and Algerians were equally suspect. All historic limits crumbled and disappeared. Any person carrying a package could be required to open it and show its contents. Anyone was entitled to question anyone as to the nature of a parcel carried in Algiers, Philippeville, or Batna. Under those conditions it became urgent to conceal the package from the eyes of the occupier and again to cover oneself with the protective *haïk*.

Here again, a new technique had to be learned: how to carry a rather heavy object dangerous to handle under the veil and still give the impression of having one's hands free, that there was nothing under this *haïk*, except a poor woman or an insignificant young girl. It was not enough to be veiled. One had to look so much like a "fatma" that the soldier would be convinced that this woman was quite harmless.

Very difficult. Three meters ahead of you the police challenge a veiled woman who does not look particularly suspect. From the anguished expression of the unit leader you have guessed that she is carrying a bomb, or a sack of grenades, bound to her body by a whole system of strings and straps. For the hands must be free, exhibited bare, humbly and abjectly presented to the soldiers so that they will look no further. Showing empty and apparently mobile and free hands is the sign that disarms the enemy soldier.

The Algerian woman's body, which in an initial phase was pared down, now swelled. Whereas in the previous period the body had to be made slim and disciplined to make it attractive and seductive, it now had to be squashed, made shapeless and even ridiculous. This, as we have seen, is the phase during which she undertook to carry bombs, grenades, machine-gun clips.

The enemy, however, was alerted, and in the streets one witnessed what became a commonplace spectacle of Algerian women glued to the wall, on whose bodies the famous magnetic detectors, the "frying pans," would be passed. Every veiled woman, every Algerian woman became suspect. There was no discrimination. This was the period during which men, women, children, the whole Algerian people, experienced at one and the same time their national vocation and the recasting of the new Algerian society.

Ignorant or feigning to be ignorant of these new forms of conduct, French colonialism, on the occasion of May 13, reenacted its old campaign of

Westernizing the Algerian woman. Servants under the threat of being fired, poor women dragged from their homes, prostitutes, were brought to the public square and *symbolically* unveiled to the cries of *"Vive l'Algérie française!"* Before this new offensive old reactions reappeared. Spontaneously and without being told, the Algerian women who had long since dropped the veil once again donned the *haïk,* thus affirming that it was not true that woman liberated herself at the invitation of France and of General de Gaulle.

Behind these psychological reactions, beneath this immediate and almost unanimous response, we again see the overall attitude of rejection of the values of the occupier, even if these values objectively be worth choosing. It is because they fail to grasp this intellectual reality, this characteristic feature (the famous sensitivity of the colonized), that the colonizers rage at always "doing them good in spite of themselves." Colonialism wants everything to come from it. But the dominant psychological feature of the colonized is to withdraw before any invitation of the conqueror's. In organizing the famous cavalcade of May 13, colonialism has obliged Algerian society to go back to methods of struggle already outmoded. In a certain sense, the different ceremonies have caused a turning back, a regression.

Colonialism must accept the fact that things happen without its control, without its direction. We are reminded of the words spoken in an international assembly by an African political figure. Responding to the standard excuse of the immaturity of colonial peoples and their incapacity to administer themselves, this man demanded for the underdeveloped peoples "the right to govern themselves badly." The doctrinal assertions of colonialism in its attempt to justify the maintenance of its domination almost always push the colonized to the position of making uncompromising, rigid, static counterproposals.

After May 13, the veil was resumed, but stripped once and for all of its exclusively traditional dimension.

There is thus a historic dynamism of the veil that is very concretely perceptible in the development of colonization in Algeria. In the beginning, the veil was a mechanism of resistance, but its value for the social group remained very strong. The veil was worn because tradition demanded a rigid separation of the sexes, but also because the occupier *was bent on unveiling Algeria.* In a second phase, the mutation occurred in connection with the Revolution and under special circumstances. The veil was abandoned in the course of revolutionary action. What had been used to block the psychological or political offensives of the occupier became a means, an instrument. The veil helped the Algerian woman to meet the new problems created by the struggle.

The colonialists are incapable of grasping the motivations of the colonized. It is the necessities of combat that give rise in Algerian society to new attitudes, to new modes of action, to new ways.

## Appendix[8]

On the Algerian earth which is freeing itself day by day from the colonialist's grip, we witness a dislocation of the old myths. . . .

There is not occupation of territory, on the one hand, and independence of persons on the other. It is the country as a whole, its history, its daily pulsation that are contested, disfigured, in the hope of a final destruction. Under these conditions, the individual's breathing is an observed, an occupied breathing. It is a combat breathing.

From this point on, the real values of the occupied quickly tend to acquire a clandestine form of existence. In the presence of the occupier, the occupied learns to dissemble, to resort to trickery. To the scandal of military occupation, he opposes a scandal of contact. Every contact between the occupied and the occupier is a falsehood.

NOTES

Translated by Haakon Chevalier.

1. We do not here consider rural areas where the woman is often unveiled. Nor do we take into account the Kabyle woman who, except in large cities, never uses a veil.

2. *Djellaba*—a long, hooded cloak.—TRANS.

3. One phenomenon deserves to be recalled. In the course of the Moroccan people's struggle for liberation, and chiefly in the cities, the white veil was replaced by the black veil. This important modification is explained by the Moroccan women's desire to express their attachment to His Majesty Mohammed V. It will be remembered that it was immediately after the exiling of the King of Morocco that the black veil, a sign of mourning, made its appearance. It is worth noting that black, in Moroccan or Arab society, has never expressed mourning or affliction. As a combat measure, the adoption of black is a response to the desire to exert a symbolic pressure on the occupier, and hence to make a logical choice of one's own symbols.

4. The *haïk*—the Arab name for the big square veil worn by Arab women, covering the face and the whole body.—TRANS.

5. Attention must be called to a frequent attitude, on the part of European women in particular, with regard to a special category of evolved natives. Certain unveiled Algerian women turn themselves into perfect Westerners with amazing rapidity and unsuspected ease. European women feel a certain uneasiness in the presence of these women. Frustrated in the presence of the veil, they experience a similar impression before the bared face, before that unabashed body which has lost all awkwardness, all timidity, and become downright offensive. Not only is the satisfaction of supervising the evolution and correcting the mistakes of the unveiled woman withdrawn from the

European woman, but she feels herself challenged on the level of feminine charm, of elegance, and even sees a competitor in this novice metamorphosed into a professional, a neophyte transformed into a propagandist. The European woman has no choice but to make common cause with the Algerian man who had fiercely flung the unveiled woman into the camp of evil and of deprivation. "Really!" the European women will exclaim, "these unveiled women are quite amoral and shameless." Integration, in order to be successful, seems indeed to have to be simply a continued, accepted paternalism.

6. The woman, who before the Revolution never left the house without being accompanied by her mother or her husband, is now entrusted with special missions such as going from Oran to Constantine or Algiers. For several days, all by herself, carrying directives of capital importance for the Revolution, she takes the train, spends the night with an unknown family, among militants. Here too she must harmonize her movements, for the enemy is on the lookout for any false step. But the important thing here is that the husband makes no difficulty about letting his wife leave on an assignment. He will make it, in fact, a point of pride to say to the liaison agent when the latter returns, "You see, everything has gone well in your absence." The Algerian's age-old jealousy, his "congenital" suspiciousness, have melted on contact with the Revolution. It must be pointed out also that militants who are being sought by the police take refuge with other militants not yet identified by the occupier. In such cases the woman, left alone all day with the fugitive, is the one who gets him his food, the newspapers, the mail, showing no trace of suspicion or fear. Involved in the struggle, the husband or the father learns to look upon the relations between the sexes in a new light. The militant man discovers the militant woman, and jointly they create new dimensions for Algerian society.

7. R.A.S.—*Rien á signaler*—a military abbreviation for "Nothing to report."

We here go on to a description of attitudes. There is, however, an important piece of work to be done on the woman's role in the Revolution: the woman in the city, in the *djebel*, in the enemy administrations; the prostitute and the information she obtains; the woman in prison, under torture, facing death, before the courts. All these chapter headings, after the material has been sifted, will reveal an incalculable number of facts essential for the history of the national struggle.

8. This text [here excerpted, Ed.] which appeared in *Résistance Algérienne* in its issue of May 16, 1957, indicates the consciousness that the leaders of the National Liberation Front have always had of the important part played by the Algerian women in the Revolution.

Part 4

# *Like a Film*

## Theatrical Dispositions

## Julia Kristeva
# Modern Theater Does Not Take (a) Place

1. As a constructed model of a system of signs, semiology is a theory of the existent. Modern theater does not exist—it does not take (a) place—and consequently, its semiology is a mirage.

2. To say that modern theater does not take place implies first that the speaking animal has reached a point in its experience which signifies that its only inhabitable place—locus—is language *(le langage)*. Since no set or inter-play of sets is able to hold up any longer faced with the crises of state, religion, and family, it is impossible to prefer a discourse—to play out a discourse—on the basis of a scene, sign of recognition, which would provide for the actor's and audience's recognition of themselves in the same Author. The Golden period of the Greek (or Classical) community failed to materialize in the twentieth century within existing theatrical communities, among totalitari-ans, fascist happenings, and sociorealist productions. As its only remaining locus of interplay is the space of language, modern theater no longer exists outside of the text. This is not a failure of representation (as is often said), because nothing represents better than language *(la langue)*—that privileged fabric of identification and fantasy. Rather, it is a failure of de-monstration, of the theater as de-monstration. Severed from its intralinguistic production *(le langage)*, this de-monstration can do nothing but chain itself to the normative ideologies to which the failure of contemporary social sets, and perhaps, even the failure of the human race, affixes itself. Faced with the technocratic explo-sion, this is a failure to constitute a communal discourse of play (interplay). Mallarmé was the first to recognize this situation when, cognizant of the unfurling of the Symbolist theater, he turned towards "music" and "letters." Or when he imagined the book-theater, which was never meant to have any other place than in the archivist's records, destined for the incinerator. The surrealist attempts to rekindle hope in a communal representation of play within the space of a theater—even Artaud's attempts—are only transient, more or less tragic or debilitating, seeking to dodge the Mallarméan state-ment. In short, Mallarmé asserts first, the disappearance of the sacred—of the communal sacred—the absence of a sacred locus that is always the locus, the place, of theater; and second, he asserts the eventual retreat of this sacredness

into language *(la langue)*. Proof: the post-Mallarméan survivors of the modern theater are fantasies deprived of a public, while the most advanced experiments in writing address themselves uniquely to the individual unconscious, without speculating on the fantasies of the larger group.

3. Nevertheless, when a significance in play—interplay—does manage to come to light through an irresistible scopic drive (i.e., to see, to act, to know), it currently undergoes two fates: either it does without language *(le langage)*, and, like the double of Artaud's theater, implements color, sound, and gesture—painting, dance, music in the syncretic work of the silent theater; or, it speaks a discourse of verisimilitude, made up of stereotypes and edged with debility, as Beckett and Ionesco knowingly did, as any self-respecting director hints as doing with a malice that aims at putting the text in quotes so that it thus becomes a reported discourse, a quotation from an outdated code, feeble, just good enough to make some communal sign, but debased. Or like so many modern playwrights who innocently bury themselves in it with the condescending boredom of the sparse audience as their only consolation.

4. The first of these two modes, the silent theater of colors, sounds, and gestures, sends the subject back to that region of the structure of the speaking being where a lethal drive operates, a drive of forgetfulness or of death, which I have called the *semiotic (le sémiotique)*. Threshold of identity and of language *(le langage)*, edge of primal repression, absence of the difference which makes sense, and thus, absence of sexual difference, primary narcissism. Two variants emerge from the articulation of this space in language—in the *symbolic* (which even if it remains silent is still undeniably present in any undertaking): the first, more schizophrenic, which transforms into metaphor the sound-color-gesture distribution by the theme of *death;* the second, more paranoid, which transforms the arrangement of sound-color-gesture into metaphor through the theme of passage toward action—toward the act—by the theme of *madness.*

Independent American cinema seems to provide the best illustration of the first variant. In his film *Wave Length,* Michael Snow works toward a representation which is no longer the result of editing. No more psychological, ideological, or narrative sequences; almost no more words either. Rather, there is above all a play on *colors;* an infinite differentiation in chromatic wavelength (color to black and white, gradual return to color), focused on the same filmed object (a loft, a body). At the same time, a play on *sounds,* swelling and slowly dying, thus paralleling the increase and decrease in chromatic effect. All this make it seem that the projection of *time* of the sequences is nothing but a mad race behind objects of invariably mistaken identity, a

time which has nothing to do with the a-chronic time of representation which dissolves itself and recreates itself over again (this second "time" is closer to Freud's famous a-temporality in the unconscious). The only event within this semiotic limit of the representable (and thus of meaning and of time) is death; language is present only to proclaim through a woman's mouth that the body of the man is henceforth a corpse; words spoken to us while, in effect, we experience a never-addressed but nonetheless present death; it enters through the retina, across an infinitely contracted or infinitely expanded wavelength. For we accompany death by following the progressive extinction of the visible field; the camera focuses on a photo of ocean waves, and by approaching closer and closer, it transforms visual perception into tactile perception: chiaroscuro becomes a sharply jagged surface before blackness erases everything, thus coinciding with death. Theater/cinema (I will come back to this difference) of cruelty, to use Artaud's term, for according to him and in this kind of presentation, cruelty is a technique: "cruelty is above all lucid, a kind of rigid control."[1]

How can we think this economy? We know that any signifying practice involves a partial recovery and a relative independence of the two extremes of the signifying function $S_2$ (semiotic) and $S_1$ (symbolic). In the type of representation which I just described, $S_2$ encompasses $S_1$, but this inclusion remains outside of the representation. The symbolic (the meaning), which is included in the interplay of color-sound-gesture (the semiotic), remains foreign to them, does not name them, does not comment upon them: when it pronounces itself, when it names itself, this meaning is nothing but a solitary signifier, uniquely and ultimately "death."

5. The second variant of the silent theater—a production through a minute semiotic assemblage of the acting-out and of "madness"—is without doubt best typified by the theater of Bob Wilson. Whether it is the deaf man with his surrealist reminiscences, Queen Victoria, Stalin, or Einstein, there emerges the identity of a representation, but only as a blurred ensemble, the identity of a precise arrangement of sound, gesture and color. Like traces of a rhythm which the content will only summarize, like the lines of force underlying the conflict which Einstein was already teaching to his students, traces of a perpetually blurred and faulty signifiable articulate themselves on stage; *lektonic* traces in sound, gesture, color. That they be carried by a lethal drive here does not prevent, contrary to the preceding variant, an interplay of acting elements *(actants),* and therefore, of signified elements *(signifiés)* from manifesting itself. The discovery of an object (by the deaf man's sight) or of a scientific object (by Einstein), the exercise of power, etc., thus appear as acts of violence, as bursting forth, as enjoyment *(jouissance)* which has finally arrived

from this lethal drive, infinitely repeatable as aphanisis and aphasia. Therefore, we have an acting-out—a passage toward *the* act—such that no act, no identity nor character is taken for granted but rather, remains problematic as crisis, as catastrophe. Whence the fact that the only real character in this representation is the Madman, no longer the comic and reassuring Crazyman of the Carnival, but the madman-truth of each utterance, neither tragic nor comic, the Madman as necessary element of the spoken, as threshold from aphanisis to enjoyment, from aphasia to action, from repetition to No.

The representation of this economy necessitates a theory of catastrophe: each specular-spectatorial identity is a passage, fold, threshold between at least two spaces ($S_1$ and $S_2$).

6. Less explicit experiments on the same psychosemiotic plane use the same economy: the theater, dance, and cinema of Yvonne Rainer, for example. What is represented here as "catastrophic" does not take on the identity of the Madman, but of the contestatory Other (the other sex). "Feminist" theater, "psychedelic" theater, "black" theater; they all draw from the same structure in order to effect a more directly social and political project.

7. These two variants of a radical experiment show first that it is henceforth impossible to separate "theater" from "cinema." Reconstruction of the subjective space experienced by our modernity demands recourse to all means of representation, and therefore, to film, to explore the limits of the representable, and in order to include the visual in the acoustic or the gestural. This new subjective space in search of itself through, among others, the two structural variants which I have just outlined, in effect profoundly modifies the way in which contemporary man sees, listens, acts. The old cinema/theater distinction disappears, a new coalescence begins to emerge . . . "Listen to what you see; act out what you hear . . ." Here, the work of Connie Bently asserts itself; for Bently, film is gaining a more and more dominant role, to the point where, perhaps one day, it will eliminate theater, if not become definitively integrated into it.

These two variants indicate also that the stage/audience separation, which weighed so heavily on the theater of the preceding generation (because it froze identities which were thereafter unacceptable), is merely a superficial problem; the new locus of representation no longer develops out of a mechanical mixture of actors and audience, but by a different articulation of the semiotic and symbolic elements, through the pursuit of a different syncretic assemblage (like the two examples given above) where the crises of the speaking would be recognizable.

8. Thus, two spaces (of explosive inclusion and of catastrophe) appear to me to have emerged in contemporary American experiments with representation. Can we, however, call them the beginnings of a modern replica of the classical notion of the "sacred"? In any case, it is evident that these spaces constitute or harbor a new subject, which only a particular socioeconomic context can favor. Aided by the development of productive forces, this socioeconomic context lends itself easily to a certain power whose abuses we know only too well, but which, rather than polarizing itself when faced with an Opposition, tolerates multiple oppositions instead. Therefore, polytopical in power, polylogical in discourse: a multitude of stories (histories) and spaces where totalitarianism cannot extend its grasp (a tactic which only reinforces partisan dogmatism) but rather, where it is weakened by a plurality of loci and discourses. Thus, it is within this overwhelmingly Protestant society that the necessarily instinctual and maternal "repressed" makes its return, asking for new spaces, and therefore, new representations to enjoy. Process analogous to that which occurred in Europe during that virgin and Jesuit explosion which gave rise to the Baroque.

The fact that the United States is proposing a radically new locus of representation today implies also and finally that a new political body is growing here; a supple subjectivity, finding its catharsis in the deepest psychic clouds, capable of seeing and thus of abre-acting its death and its catastrophes, and thus of facing the ever-present constraints of power in society with less resentment, and thus, less dogmatism.

For if modern theater does not take (a) place, it is only as of late, as a new subject and a new society, here and especially in France, are running up against too many archaic constructs (economic and ideological). This obliges playwrights and actors either to play complacently with the verisimilitude of an antiquating society's antiquating fantasies (a narcissistic and debilitating accommodation), or, in the best situations, to develop a technical arsenal of "alienation" (the "Ontological Hysteric Theater" of Richard Foreman), of Brechtian distance, thus keeping the audience's lucidity removed from a criticizable discourse or ideology, all the while waiting for the coming of a "place": the remaking of language.

## NOTES

Translated by Alice Jardine and Thomas Gora.

1. Antonin Artaud, *The Theater and Its Double,* trans. Mary Caroline Richards (New York: Grove Press, 1958), 102.

# Jean-François Lyotard
## The Tooth, the Palm

1. Theater places us right at the heart of what is religious-political: in the heart of absence, in negativity, in nihilism as Nietzsche would say, therefore in the question of power. A theory of theatrical signs, a practice of theatrical signs (dramatic text, mise-en-scene, interpretation, architecture) are based on accepting the nihilism inherent in representation. Not only accepting it: reinforcing it. For the sign, Peirce used to say, is something which stands to somebody for something. To Hide, to Show: that is theatrality. The modernity of our fin-de-siècle is due to this: there is nothing to be replaced, no lieutenancy¹ is legitimate, or else all are; the replacing—therefore the meaning—is itself only a substitute for displacement. Take two places A and B; a move from A to B means two positions and a displacement; now declare that B comes from A, you are no longer taking B's position positively, affirmatively, but in relation to A, subordinated to A, itself absent (gone by, hidden). B is turned into nothingness; as an illusion of presence, its being is in A; and A is affirmed as truth, that is to say absence. Such is the apparatus of nihilism. Is theatrality thus condemned? By repeating this apparatus in its specific reading, semiology continues theology, the theology of the death of God, of structure, of critical dialectics, etc.

2. Displacement (Freud's *Verschiebung* or *Entstellung*) is an energy transfer, Freud said an economic process; the libido invests this or that region of the body's surface (which turns inward to its "internal organs" also); it establishes itself there, in position A; it moves; it settles elsewhere; in position B. Shall we say B represents A? In his *Petite anatomie de l'image*, Hans Bellmer takes this example: I have a toothache, I clench my fist, my nails dig into the palm of my hand. Two investments of the libido. Shall we say that the action of the palm represents the passion of the tooth? That it is a sign of it? Is there no possibility to reverse one and the other, a hierarchy of one position over the other, power of one over the other? For anatomical and physiological sciences, for re-flexology, and for any reflexion, the answer is yes, of course. In the move of the libido, no irreversibility is possible; the erotic-morbid body can function in all directions, can go from the clenching of the palm to that of the jaw, from the fear (imagined?) or a father or mother to obesity (real?) or ulcer (real?) of the stomach. This reversibility from A to B introduces us to the destruction of the sign, and of theology, and perhaps of theatrality.

3. Reversibility is part of our social, economic, ideological experience of modern capitalism, which is ruled by a simple law: value. In precapitalistic economy, the product, production, consumption (which are not even separated as distinct spheres) are related as signs or as sign-making activities to positions deemed original or preexisting: the object, work, the destruction or circulation of objects are thought of within a Mystique or within a Physics, being there by and for another thing. Part of Marx's work perpetuates this semiotic theory of precapitalist economy, notably by using the category of use-value (of commodities, but especially of labor power). But the present experience of growth economy teaches us that so-called economic activity has no anchoring in an origin, in any position A. Everything is exchangeable, reciprocally, only under the conditions inherent in the law of value: work is no less a sign than money, money no more than a house or car, there is only a flux metamorphosing into billions of objects and currents—such a teaching from political economy must be compared to what libidinal economy teaches us: both political economy and libidinal economy in so much as they shape our modern life, support criticism and the crisis of the theater. A semiology would inhibit the crisis and gag the criticism.

4. Reading Zeami's treatises in R. Sieffert's translation, and at the same time Artaud and Brecht, whose analyses and concurrent failures still dominate today's theater, I am learning how theater, put at the place where displacement becomes re-placement, where libidinal flux becomes representation, wavers between a semiotics and an economic science. In the first books of the Fushi-kaden, the earliest (c. 1400), Zeami multiplied discontinuities; he divided up the life of the actor into periods, the year into seasons, the day into moments; mimicry into types, the repertory into genres of nô (of waki, of ashura, of women, of the real world . . .), the diachrony of the theatrical show in units (kyôgen, nô), assembled according to an unchangeable sequence jo-ha-kyû, the stage space into places ascribed to such and such a role and to such and such a moment in the action, the sound space into regions, the mimicry into poses, the very public itself into categories, etc. This material is every semiologist's dream; everything is discrete and coded, each unit of one order referred to a unit of another and of all other orders; the whole game seems governed by the two principles of the primary of signification (iwâre) and of the search for the greatest agreement (sôô). To fully realize the sign system, the actor himself had to disappear as presence; wearing a mask, his hands hidden, when playing women's roles; the flower (fleur) of the performance was conceived as absolute interpretation, that is to say, noninterpretation; and when playing the role of madmen without a mask, he would underline the difficulty of performing madness by allusions to possession, therefore imitating the

possessor-demon, without however falling into the expressionism of facial features "whereas there is no necessity to imitate the facial expression; it happens however that in changing one's usual expression, one composes his countenance. That is the intolerable sight." Intolerable in that it makes visible the invisible, it confuses bones with skin, substance with secondary effects, it violates the hierarchy of social and corporal spaces distanced into front and back, into illusion and reality. The extreme nihilism lurking in Buddhism is what pushes this semiotics to its limit, transforming the signs into signs of nothing, of the nothing that is between the signs, between A and B; said Zeami, it is in the intervals between the actions he performs, be they spoken, sung, danced or mimed, thus in moments when he is doing nothing, that the actor is truly a sign, signifying the very power of signifying which is a deviation and a void: puppet. Zeami cited in this connection a zen formula about puppets which referred the Westerner to book 7 of the *Republic*.

5. However the semiotics of Zeami seems traversed, sometimes thwarted by a very different drive, a libidinal drive, a search for intensiveness, a desire for potency (isn't it necessary to express *nô* as potency, *Macht*, might, in the Nietzschean sense, in the same sense that Artaud takes *cruauté?*). The name of flower *(fleur)* is given to the search for the energetic intensification of the theatrical apparatus. The elements of a total "language" are divided and linked together in order to permit the production of effects of intensity through slight transgressions and the infringement of overlapping units. The signs are no longer looked at in their representative dimension, they don't even represent the Nothing any more, they do not represent, they permit "actions," they operate as the transformers, fueled by natural and social energies in order to produce affects of a very high intensity. In this way, we can understand the appearance (a little later) in Zeami's work of the themes of the unusual, of the fluidity and the unpredictable effectiveness of acting, of the uncalculable significance of seizing the right moment: above all the fact that the flower *(fleur)* of interpretation is nothing, is only effervescent *(shoiretaru)*. The well-tried procedures *(kojitsu)*, which correspond to the unity of a culture which is also a cult, thus make room for a flux in motion, for a displaceability, and for a kind of effectiveness by means of affects, which belong to libidinal economy.

6. The hesitation of Artaud was the same as that of Zeami. But it leaned the other way. Artaud sought to destroy not so much the Italian, i.e. European Renaissance, theatrical apparatus, but at least the predominance of articulated language and the suppression of the body. In this way he expected to rediscover a libidinal efficiency of the performance: "power," "underlying energy," the power to displace the affects which work by the displacement of well-

ordered units; "the secret of the theater in space is dissonance, the discrepancy of voice timbers and the dialectical deconcatenation of discourse." Here is evidence of something very closely approaching libidinal economy;[2] "in the ardor of life, in the lust of life, in the unreasoned impulse of life, there is a sort of initial meanness, the desire of Eros is a cruelty because it burns contingencies, death is cruelty, resurrection is cruelty, transfiguration is cruelty, because in all directions and in a circular and closed world, there is no room for true death, because ascension is a tearing away, because the closed space is teaming with life, and because every stronger life passes through other lives, thus devouring them in a massacre which is transfiguration and a positive good." But on the way to this generalized dissemiotization, Artaud stopped and what stopped him was nihilism, religion, (perceptible even in this *Lettre sur la cruauté*). For intensities to function, he had to manufacture a "tool" which would again be language, a system of signs, a grammar of gestures, of hieroglyphics." That is what he thought he found in Eastern theater, particularly in Japanese and Balinese. Thus he remained a European, he repeated the "invention" of an agreement between the body and the senses, he repeated the great discovery of the uniting of the Eros-libido with the libido as death-wish, he repeated his "ethnographic" mise-en-scène here on the Eastern stage. But the Eastern schoolmaster, no less nihilistic than his Western pupil, had to also "invent" the paradise, whether Buddhist or any other, of non-duality. In this way the mutilation that Artaud is fleeing comes back to him by way of Balinese hieroglyphics. To hush the body with the writer's theater, dear to bourgeois Europe of the nineteenth century, is nihilistic; but to make it speak the lexicon and syntax of mime, song, dance, as the *nô* does, is again a way of annihilating it; a body completely transparent, skin and flesh of the bone which is spirit, untouched by all displacement, events, libidinal denseness. Not to mention that modern Europe does not have at its disposal any *kojitsu,* any certified means of conveying the affects; it wants signs and speaks of them at the very moment that it lacks them. This is why Artaud put more emphasis on the sacred than did Zeami.

7. Will the theater have to limit itself to a critical function? the only one allowed by the crisis of modernism? That was Brecht's solution. To him, it is not enough for the movement of the hand to make a silent allusion to the toothache, effectiveness is defined as a process of understanding or of realization, that is to say a process of appropriation, of espousing the cause (position A). The theater aims at making us recognize that there exists a structure connecting the tooth and the fist, connecting such and such a behavior of Mother Courage to such and such an infrastructure, and such and such another behavior to such and such an ideology. The theatrical effectiveness,

defined as knowledge, is mediated by "conscience." "Conscience" is, in fact, a precise language apparatus, Marxist materialism: this apparatus of language, in its turn, introduces into Brechtian playwriting and scenography, a complex apparatus no less precise, that Brecht defines as distanciation. Distanciation appears to be an extreme case of nihilism, the actor performs such and such an action in such and such a situation, but his text, his acting, and the whole mise-en-scène take hold of this action in order to show that it could be another: "to act out all the scenes in terms of other possible scenes." This is a process that reduces its object to nothing, much as the recounting of a witness on the street corner, far from actualizing the accident distanciates it through discourse. Here Brecht can also call upon Eastern theater (especially Chinese): "it is evidently a matter of repetition by a third party of a process of a description admittedly artful. The artist shows (representing someone in a rage) that this man is beside himself, and he points to completely external signs that prove it (for example, taking a lock of his hair between his teeth and biting it off). But no nihilism can realize itself, all nihilism must remain religious; where there is a gap between A and B (the *nihil*), there must also always be the link between A and B (to connect it, the *religio*). What performs as religion in Brecht is the language apparatus of Marxism: the whole theatrical effectiveness which he anticipates, relies upon a system of beliefs, not only the belief that there exist sociological determinations that correspond to economic structures, but the belief that these determinations form the deep lexicon and grammar of historical passions, that they produce and govern the displacement of affects and the investments of the theatrical audience. That is why this theater is called epic theater. But ours is no longer a time of the epic any more than of tragedy or of savage cruelty. Capitalism destroys all the codes, including the one that gives industrial workers the role of the historical hero. The Marxism of Brecht = an epic grafted onto a critique. After a century of International Congresses and half a century of Socialist States, we must say: the graft has not taken, neither as dramaturgy, scenography, nor as world politics. Marxist semiotics is as arbitrary in the theater as is any other semiotics for correlating the performer and the performed and to allow the communication of the audience with itself through the mediary of the stage.

8. Alienation itself, a nihilistic, religious, and again Marxist category, must be thought through affirmatively. The importance of alienation is not that it points out the distance from an origin, from a lost nature, its importance is in the way Marx analyzed it in the introduction to the *Contribution critique de l'économie politique* in the *Grundrisse* in (the unpublished) chapter 6 of *Kapital I:* as indifference of man toward his work and of work toward its man, of money toward that which it can buy and of the commodity toward its mone-

tary counterpart (and its possessor). This indifference is the experience of the predominance of exchange value. We must stop thinking of it as the loss of something, the loss of the difference, that is to say of qualification, craft, quality, usage, meaning, agreement, possession. Rather let's think of it positively, this indifference leads to libidinal economy, to a direct linking without representation of the political economy with libidinal economy. The theory of value puts us potentially into a non-hierarchical circulation, where the tooth and the palm no longer have a relationship of illusion and truth, cause and effect, signifier and signified (or vice versa), but they coexist, independently, as transitory investments, accidentally composing a constellation halted for an instant, an actual multiplicity of loops in the circulation of energy. The tooth and the palm no longer mean anything, they are forces, intensities, present affects.

9. An energetic theater would produce events that are effectively discontinuous, such as the acts noted randomly on slips of paper themselves being lots, drawn by John Cage and proposed to the interpretors of *Theater Piece*. Likewise what this theater needs, instead of *sôô*, of agreement between dance, music, mimicry, words, seasons, time, the public, and nothing, is rather the independence and the simultaneity of noises-sounds, of words, body arrangements, images that characterize the coproductions of Cage, Cunningham, Rauschenberg. By eliminating the sign relation and its hollowness, one makes the power relation (hierarchy) impossible, and consequently, what becomes also impossible is the so-called domination of the playwright + metteur en scene + choreographer + stage designer over the so-called signs and also over the so-called spectators.

10. So-called spectators, because the notion of such a person or such a function is itself contemporary with the predominance of the re-presentation in social life; and specifically of what the modern West calls politics. The subject is a product of the performance apparatus, it disappears when the apparatus disappears.

11. As for the theater as place, this affirmative thinking of alienation implies not only the bankruptcy of the hierarchized relation stage/house, but that of the hierarchized relation of inside/outside. For all theater is an apparatus duplicated at least once sometimes more than once; *Hamlet, Marat-Sade, La Prochaine fois je vous le chanterai*: it could be reversed, it could be displaced; actors playing in the wings, the audience seated on stage) thus made up of two limits, of two barriers filtering the coming and going energies; one limit (1) which determines what is "exterior" to the theater ("reality") and what is

"interior," a second limit (2) which, on the inside, disassociates what is to be perceived and what is not to be perceived (underneath, stage lights, wings, chairs, people . . .). Criticism, involved in the new theater, addressed itself essentially to the problem of the second limit (2), as staging and architectural experiments prove. But the crisis is now that of the first limit (1); stage + house/"outside." It is a selective limit, par excellence; sounds, lights, words, eyes, ears, postures (and therefore also in capitalism, the wallets) get sorted out so that what is a libidinal displacement may yield to the re-presentative re-placement of performance. On the "outside," the toothache, on the "inside," its representation by the clenching of the fist. But the business of an energetic theater is not to make allusion to the aching tooth when a clenched fist is the point, nor the reverse. Its business is neither to suggest that such and such means such and such, nor to say it, as Brecht wanted. Its business is to produce the highest intensity (by excess or by lack of energy) of what there is, without intention. That is my question: is it possible, how?

## NOTES

Translated by Anne Knab and Michel Benamou.
1. A pun is here intended; *lieu-tenant* = place holder.—TRANS.
2. See Lyotard, *Libidinal Economy,* trans. Iain Hamilton Grant (Bloomington: Indiana University Press, 1993).—ED.

# Josette Féral

# Performance and Theatricality: The Subject Demystified

Depending on one's choice of experts, theater today can be divided into two different currents which I shall emphasize here by referring to a remark of Annette Michelson's on the performing arts that strikes me as particularly relevant to my concern:

> There are, in the contemporary renewal of performance modes, two basic and diverging impulses which shape and animate its major innovations. The first, grounded in the idealist extensions of a Christian past, is mythopoeic in its aspiration, eclectic in its forms, and constantly traversed by the dominant and polymorphic style which constitutes the most tenacious vestige of that past: expressionism. Its celebrants are: for theater, Artaud, Grotowski, for film, Murnau and Brakhage, and for the dance, Wigman, Graham. The second, consistently secular in its commitment to objectification, proceeds from Cubism and Constructivism; its modes are analytic and its spokesmen are: for theater, Meyerhold and Brecht, for film, Eisenstein and Snow, for dance, Cunningham and Rainer.[1]

Rather than question this classification and the insufficient consideration it gives to men of the theater like Craig or Appia, and to theatrical practices as varied as those of A. Boal's guerrilla theater, Bread and Puppet's political theater, and the experiments of A. Benedetto, A. Mnouchkine, the TNS, the San Francisco Mime Troupe, and Mabou Mines, I should like to make my own use of it to account for the phenomenon of performance as it has appeared in the United States and Europe over the past twenty years.

Inherited from surrealist practices in the twenties, as RoseLee Goldberg has shown in her book, *Performance,*[2] artistic performance enjoyed quite a boom in the fifties, especially in the wake of the experiments of Allan Kaprow and John Cage. Conceived as an art form at the juncture of other signifying practices as varied as dance, music, painting, architecture, and sculpture, performance seems paradoxically to correspond on all counts to the new theater invoked by Artaud: a theater of cruelty and violence, of the body and its drives, of displacement and "disruption,"[3] a non-narrative and non-representational theater. I should like to analyse this experience of a new genre in hopes of revealing its fundamental characteristics as well as the

process by which it works. My ultimate objective is to show what practices like these, belonging to the limits of theater, can tell us about theatricality and its relation to the actor and the stage.

Of the many characteristics of performance, I shall point to three that, the diversity of practices and modes notwithstanding, constitute the essential foundations of all performance. They are first, the manipulation to which performance subjects the performer's body—a fundamental and indispensable element of any performing act; second, the manipulation of space, which the performer empties out and then carves up and inhabits in its tiniest nooks and crannies; and finally, the relation that performance institutes between the artist and the spectators, between the spectators and the work of art, and between the work of art and the artist.

1. *First, the manipulation of the body.* Performance is meant to be a physical accomplishment, so the performer works with his body the way a painter does with his canvas. He explores it, manipulates it, paints it, covers it, uncovers it, freezes it, moves it, cuts it, isolates it, and speaks to it as if it were a foreign object. It is a chameleon body, a foreign body where the subject's desires and repressions surface. This has been the experience of Hermann Nitsch, Vito Acconci, and Elizabeth Chitty. Performance rejects all illusion, in particular theatrical illusion originating in the repression of the body's "baser" elements, and attempts instead to call attention to certain aspects of the body—the face, gestural mimicry, and the voice—that would normally escape notice. To this end, it turns to the various media—telephoto lenses, still cameras, movie cameras, video screens, television—which are there like so many microscopes to magnify the infinitely small and focus the audience's attention on the limited physical spaces arbitrarily carved out by the performer's desire and transformed into imaginary spaces, constituting a zone where his own emotional flows and fantasies pass through. These physical spaces can be parts of the performer's own body magnified to infinity (bits of skin, a hand, his head, etc.), but they can also be certain arbitrarily limited, natural spaces that the performer chooses to wrap up and thus reduce to the dimensions of manipulable objects (cf. Christo's experiments with this technique).[4]

The body is made conspicuous: a body in pieces, fragmented and yet one, a body perceived and rendered as a *place of desire,* displacement, and fluctuation, a body the performance conceives of as repressed and tries to free—even at the cost of greater violence. Consider, for example, the intentionally provocative scenes where Acconci plays on stage with his various bodily products. Such demonstrations, which are brought to the surface more or less violently by the performer, are presented to the Other's view, to the view of others, in order that they may undergo a collective verification. Once this exploration of the body, and therefore of the subject, has been completed,

and once certain repressions have been brought to light, objectified, and represented, they are frozen under the gaze of the spectator, who appropriates them as a form of knowledge. This leaves the performer free to go on to new acts and new performances.

For this reason, some performances are unbearable; those of Nitsch, for example, which do violence not only to the performer (in his case, a violence freely consented to), but also to the spectator, who is harassed by images that both violate him and do him violence.[5] The spectator has the feeling that he is taking part in a ritual that combines all possible transgressions—sexual and physical, real and staged; a ritual bringing the performer back to the limits of the subject constituted as a whole; a ritual that, starting from the performer's own "symbolic," attempts to explore the hidden face of what makes him a unified subject: in other words, the "semiotic" or *chora* haunting him.[6] Yet this is not a return to the divided and silent body of the mother, such as Kristeva sees in Artaud, but instead a march ahead toward the dissolution of the subject, not in explosion, scattering, or madness—which are other ways of returning to the origin—but in death. Performances as a phenomenon worked through by the death drive: this comparison is not incidental. It is based on an extensive, conscious practice, deliberately consented to: the experience of a body wounded, dismembered, mutilated, and cut up (if only by a movie camera: cf. Chitty's *Demo Model*), a body belonging to a fully accepted lesionism.[7]

The body is cut up not in order to negate it, but in order to bring it back to life in each of its parts which have, each one, become an independent whole. (This process is identical to Buñuel's in *Un Chien andalou,* when he has one of the characters play with a severed hand on a busy road.) Instead of atrophying, the body is therefore enriched by all the part-objects that make it up and whose richness the subject learns to discover in the course of the performance. These part-objects are privileged, isolated, and magnified by the performer as he studies their workings and mechanisms, and explores their underside, thereby presenting the spectators with an experience in vitro and in slow motion of what usually takes place on stage.

2. First the manipulation of the body, *then the manipulation of space:* there is a functional identity between them that leads the performer to pass through these places without ever making a definitive stop. Carving out imaginary or real spaces (cf. Acconci's *Red Tapes*), one moment in one place and the next moment in the other, the performer never settles within these simultaneously physical and imaginary spaces, but instead traverses, explores, and measures them, effecting displacements and minute variations within them. He does not occupy them, nor do they limit him: he plays with the performance space as if it were an object and turns it into a machine "acting upon the sense organs."[8] Exactly like the body, therefore, space becomes existential to the

point of ceasing to exist as a setting and place. It no longer surrounds and encloses the performance, but like the body, becomes part of the performance to such an extent that it cannot be distinguished from it. It *is* the performance. This phenomenon explains the idea that performance can take place only within and for a set space to which it is indissolubly tied.

Within this space, which becomes the site of an exploration of the subject, the performer suddenly seems to be living in slow motion. Time stretches out and dissolves as "swollen, repetitive, exasperated" gestures (Luciano Inga-Pin) seem to be killing time (cf. the almost unbearable slow motion of some of Michael Snow's experiments): gestures that are multiplied and begun again and again *ad infinitum* (cf. Acconci's *Red Tapes*), and that are always different, split in two by the camera recording and transmitting them as they are being carried out on stage before our eyes (cf. Chitty). This is Derrida's *différance* made perceptible. From then on, there is neither past nor future, but only a continuous present—that of the immediacy of things, of an *action taking place*. These gestures appear both as a finished product and in the course of being carried out, already completed and in motion (cf. the use of cameras): gestures that reveal their deepest workings and that the performer executes only in order to discover what is hidden underneath them (this process is comparable to Snow's camera filming its own tripod). And the performance shows this gesture over and over to the point of saturating time, space, and the representation with it—sometimes to the point of nausea. Nothing is left but a kinesics of gesture. Meaning—all meaning—has disappeared.

Performance is the absence of meaning. This statement can be easily supported by anyone coming out of the theater. (We need think only of the audience's surprise and anger with the first "stagings" of the Living Theater, or with those of Robert Wilson or Richard Foreman.) And yet, if any experience is meaningful, without a doubt it is that of performance. Performance does not aim at *a* meaning, but rather *makes* meaning insofar as it works right in those extremely blurred junctures out of which the subject eventually emerges. And performance conscripts this subject both as a constituted subject and as a social subject in order to dislocate and demystify it.

Performance is the death of the subject. We just spoke of the death drive as being inscribed in performance, consciously staged and brought into play by a set of freely intended and accepted repetitions. This death drive, which fragments the body and makes it function like so many part-objects, reappears at the end of the performance when it is fixed on the video screen. Indeed, it is of interest to note that every performance ultimately meets the video screen, where the demystified subject is frozen and dies. There, performance once again encounters representation, from which it wanted to escape at all costs and which marks both its fulfillment and its end.

3. In point of fact, the artist's relation to his own performance is no longer one of an actor to his role, even if that role is his actual one, as the Living Theater wanted it to be. When he refuses to be a protagonist, the performer no more plays himself than he represents himself. Instead, he is a source of production and displacement. Having become the point of passage for energy flows—gestural, vocal, libidinal, etc.—that traverse him without ever standing still in a fixed meaning or representation, he plays at putting those flows to work and seizing networks. The gestures that he carries out lead to nothing if not to the flow of the desire that sets them in motion. This response proves once again that a performance means nothing and aims for no single, specific meaning, but attempts instead to reveal places of passage, or, as Foreman would say, "rhythms" (the trajectory of gesture, of the body, of the camera, of view, etc.). In so doing, it attempts to wake the body—the performer's and the spectator's—from the threatening anesthesia haunting it.

> It seems to me that all of us here are working on material, rearranging it so that the resultant performance more accurately reflects not a perception of the world—but the rhythms of an ideal world of activity, remade, the better in which to do the kind of perception we each would like to be doing.
>
> We are, then, presenting the audience with objects of a strange sort, that can only be savored if the audience is prepared to establish new perceptual habits— habits quite in conflict with the ones they have been taught to apply at classical performance in order to be rewarded with expected gratifications. In classical performance, the audience learns that if they allow attention to be led by a kind of childish, regressive desire-for-sweets, the artist will have strategically placed those sweets at just the "crucial" points in the piece where attention threatens to climax.[9]

This technique accounts for the "selective inattention" that Richard Schechner speaks of in *Essays on Performance*.[10] No more than the spectator, though, is the performer implicated in the performance. He always keeps his viewing rights. He is the eye, a substitute for the camera that is filming, freezing, or slowing down, and he causes slides, superpositions, and enlargements with a space and on a body that have become the tools of his own exploration.

> In our work, however, what's presented is not what's "appealing" (the minute something is appealing it's a reference to the past and to inherited "taste")—but rather what has heretofore not been organized by the mind into recognizable gestalts; everything that has heretofore "escaped notice." And the temptation each of us fights, I think, is to become prematurely "interested" in what we uncover.[11]

This situation is all the more difficult for the spectator since performance, caught up as it is in an unending series of often very minor transformations, escapes formalism. Having no set form, every performance constitutes its own genre, and every artist brings to it, according to his background and desires, subtly different shadings that are his alone: Trisha Brown's performances lean toward the dance, Meredith Monk's toward music. Some, however, tend in spite of themselves toward theater. Acconci's *Red Tapes,* for example, or Michael Smith's *Down in the Rec Room.* All of this goes to show that it is hard to talk about performance. This difficulty can be seen also in the various kinds of research on the subject, often in the forms of photo albums recording the fixed traces of performances that are forever over, with the few critical studies of the subject tending toward historicism or description. Here we touch upon a problem identical to one presented by the theater of non-representation: how can we talk about the subject without betraying it? How can we explain it? From descriptions of stagings taking place elsewhere or existing no longer, to the fragmentary, critical discourse of scholars, the theatrical experience is bound always to escape any attempt to give an accurate account of it. Faced with this problem, which is fundamental to all spectacles, performance has given itself its own memory. With the help of the video camera with which every performance ends, it has provided itself with a past.

If one judges from everything that has thus far been said about performance, it certainly seems difficult to ascertain the relationship between theater and performance. And if we turn to the statements of certain performers, that relationship would even seem to be, of necessity, one of exclusion. Michael Fried writes to that effect: "theater and theatricality are at war today, not simply with modernist painting (or modernist painting and sculpture), but with art as such—and to the extent that different arts can be described as modernist, with modernist sensibility as such."[12] Fried sets forth his argument in two parts:

1) The success, even the survival, of the arts has come increasingly to depend on their ability to defeat theater.
2) Art degenerates as it approaches the condition of theater.[13]

How is such a statement to be explained, let alone justified? If we agree with Derrida that theater cannot escape from representation which alienates and undermines it, and if we also agree that theater cannot escape narrativity (all the current theatrical experiences prove as much, except perhaps for those of Wilson and Foreman, which already belong to performance), then it would seem obvious that theater and art are incompatible. "In the theater, every form

once born is mortal," Peter Brook writes in *The Empty Space*.[14] But as I have just stated, performance is not a formalism. It rejects form, which is immobility, and opts, instead, for discontinuity and slippage. It seeks what Kaprow was already calling for in happenings thirty years ago: "The dividing line between art and life should remain as fluid and indistinct as possible and time and space should remain variable and discontinuous so that, by continuing to be open phenomena capable of giving way to change and the unexpected, performances take place only once."[15] Are we very far from what Artaud advocated for the theater, or from what the Living Theater and Grotowski, following Artaud, have demanded as the model for theater's renewal: the stage as a "living" place and the play as a "one time only" experience?

That performance should reject its dependence on theater is certainly a sign that it is not only possible, but without a doubt also legitimate, to compare theater and performance, since no one ever insists upon his distance from something unless he is afraid of resembling it. I shall not attempt, therefore, to point out the similarities between theater and performance, but rather show how the two modes complement each other and stress what theater can learn from performance. Indeed, in its very stripped-down workings, its exploration of the body, and its joining of time and space, performance gives us a kind of theatricality in slow motion: the kind we find at work in today's theater. Performance explores the underside of that theater, giving the audience a glimpse of its inside, its reverse side, its hidden face.

Like performance, theater deals with the imaginary (in the Lacanian sense of the term). In other words, it makes use of a technique of constructing space, allowing subjects to settle there: first the construction of physical space, and then of psychological space. A strange parallel, modeling the shape of stage space on the subject's space and vice versa, can be traced between them. Thus, whenever an actor is expected to ingest the parts he plays so as to become one with them (here we might think of nineteenth-century theater, of naturalist theater, and of Sarah Bernhardt's first parts), the stage asserts its oneness and its totality. It is, and it is *one*, and the actor, as a unitary subject, belongs to its wholeness.

Closer to us, in experiences of present-day theater (experimental theater, alternative theater)—here we might think of the Living Theater's first experiments, or, more recently, of Bob Wilson's)—the way theatrical space is constructed attempts to make tangible and apparent the whole play of the imaginary as it sets subjects (and not *a* subject) on stage. The processes whereby the theatrical phenomenon is constructed as well as the foundation of that phenomenon—an extensive play of doubling and permutation that is more or less obvious and more or less differentiated depending upon the specific director and aims—thus become apparent: the division between actor and

character (a subject that Pirandello dealt with very well); the doubling of the actor (insofar as he survives after the death of the text) and the character; the doubling of the author and the director (cf. Ariane Mnouchkine); and lastly, the doubling of the director and the actor (cf. Schechner in *Clothes*). As a group, these permutations form different projection spaces, representing different positions of desire by setting down subjects in process.

Subjects in process: the subject constructed on stage projects himself into objects (characters in classical theater, part-objects in performance) which he can invent, multiply, and eliminate if need be. And these constructed objects, products of his imagination and of its different positions of desire, constitute so many "a"-objects for him to use or abuse according to the needs of his inner economy (as with the use of movie cameras or video screens in many performances). In the theater, these "a"-objects are frozen for the duration of the play. In performance, on the other hand, they move about and reveal an imaginary that has not been alienated in a figure of fixation like characters in the classical theater, or in any other fixed theatrical form. For it is indeed a question of the "subject," and not of characters, in today's theater (Foreman, Wilson) and in performance. Of course, the conventional basis of the actor's "art," inspired by Stanislavski, requires the actor to live his character from within and conceal the duplicity that inhabits him while he is on stage. Brecht rose up against this illusion when he called for a distancing of the actor from his part and a distancing of the spectator from the stage. When he is faced with this problem, the performer's response is original, since it seems to resolve the dilemma by completely renouncing character and putting the artist himself onstage. The artist takes the position of a desiring—a performing—subject, but is nonetheless an anonymous subject playing the part of himself on stage. From then on, since it tells of nothing and imitates no one, performance escapes all illusion and representation. With neither past nor future, performance *takes place*. It turns the stage into an event from which the subject will emerge transformed until another performance, when it can continue on its way. As long as performance rejects narrativity and representation in this way, it also rejects the symbolic organization dominating theater and exposes the conditions of theatricality as they are. Theatricality is made of this endless play and of these continuous displacements of the position of desire, in other words, of the position of the subject in process within an imaginary constructive space.

It is precisely when it comes to the position of the subject, that performance and theater would seem to be mutually exclusive and that theater would perhaps have something to learn from performance. Indeed, theater cannot do without the subject (a completely assumed subject), and the exercises to which Meyerhold and, later on, Grotowski subjected their students

could only consolidate the position of the unitary subject onstage. Performance, however, although beginning with a perfectly assumed subject, brings emotional flows and symbolic objects into a destabilized zone—the body, space—into an infrasymbolic zone. These objects are only incidentally conveyed by a *subject* (here, the performer), and that subject lends himself only very superficially and partially to his own performance. Broken down into semiotic bundles and drives, he is a pure catalyst. He is what *permits* the appearance of what *should* appear. Indeed, he makes transition, movement, and displacement possible.

Performance, therefore, appears as a primary process lacking teleology and unaccompanied by any secondary process, since performance has nothing to represent for anyone. As a result, performance indicates the theater's *margin* (Schechner would say its "seam"), theater's fringes, something which is never said, but which, although hidden, is necessarily present. Performance demystifies the subject on stage: the subject's being is simultaneously *exploded* into part-objects and *condensed* in each of those objects, which have themselves become independent entities, each being simultaneously a margin and a center. Margin does not refer here to that which is excluded. On the contrary, it is used in the Derridian sense of the term to mean the frame, and consequently, what in the subject is most important, most hidden, most repressed, yet most active as well (Derrida would say the "Parergon").[16] In other words, it refers to the subject's entire store of non-theatricality. Performances can be seen, therefore, as a storehouse for the accessories of the symbolic, a depository of signifiers which are all outside of established discourse and behind the scenes of theatricality. The theater cannot call upon them as such, but, by implication, it is upon these accessories that theater is built.

In contrast to performance, theater cannot keep from setting up, stating, constructing, and giving points of view: the director's point of view, the author's toward the action, the actor's toward the stage, the spectator's toward the actor. There is a multiplicity of viewpoints and gazes, a "density of signs" (to quote Barthes)[17] setting up a thetic multiplicity absent from performance.

Theatricality can therefore be seen as composed of two different parts: one highlights performance and is made up of the *realities of the imaginary;* and the other highlights the theatrical and is made up of *specific symbolic structures.* The former originates within the subject and allows his flows of desire to speak; the latter inscribes the subject in the law and in theatrical codes, which is to say, in the symbolic. Theatricality arises from the play between these two realities. From then on it is necessarily a theatricality tied to a desiring subject, a fact which no doubt accounts for our difficulty in defining it. Theatricality cannot *be,* it must be *for* someone. In other words, it is *for the Other.*

The multiplicity of simultaneous structures that can be seen at work in performance seems, in fact, to constitute an authorless, actorless, and directorless *infratheatricality*. Indeed, performance seems to be attempting to reveal and to stage something that took place before the representation of the subject (even if it does so by using an already constituted subject), in the same way that it is interested more in an action as it is being produced than in finished product. Now, what takes place on stage comprises flows, accumulations, and connections of signifiers that have been organized neither in a code (hence the multiplicity of media and signifying languages that performance makes use of: bits of representation and narration and bits of meaning), not in structures permitting signification. Performance can therefore be seen as a machine working with serial signifiers: pieces of bodies (cf. the dismemberment and lesionism we have already discussed), as well as pieces of meaning, representation, and libidinal flows, bits of objects joined together in multipolar concatenations (cf. Acconci's *Red Tapes* and the fragmentary spaces he moves about in: bits of a building, bits of rooms, bits of walls, etc.). And all of this is without narrativity.

The absence of narrativity (continuous narrativity, that is) is one of the dominant characteristics of performance. If the performer should unwittingly give in to the temptation of narrativity, he does so never continuously or consistently, but rather ironically with a certain remove, as if he were quoting, or in order to reveal its inner workings. This absence leads to a certain frustration on the part of the spectator, when he is confronted with performance which takes him away from the experience of theatricality. For there is nothing to say about performance, nothing to tell yourself, nothing to grasp, project, introject, except for flows, networks, and systems. Everything appears and disappears like a galaxy of "transitional objects"[18] representing only the failures of representation. To experience performance, one must simultaneously be there and take part in it, while continuing to be an outsider. Performance not only speaks to the mind, but also speaks to the senses (cf. Angela Ricci Lucchi's and Gianikian's experiments with smell), and it speaks from subject to subject. It attempts not to tell (like theater), but rather to provoke synaesthetic relationships between subjects. In this, it is similar to Wilson's *The Life and Times of Joseph Stalin* as described by Schechner in *Essays on Performance*.[19]

Performance can therefore be seen as an art form whose primary aim is to undo "competencies" (which are primarily theatrical). Performance readjusts these competencies and redistributes them in a desystematized arrangement. We cannot avoid speaking of "deconstruction" here. We are not, however, dealing with a "linguistico-theoretical" gesture, but rather with a real gesture, a kind of deterritorialized gesturality. As such, performance poses a challenge

to the theater and to any reflection that theater might make upon itself. Performance reorients such reflections by forcing them to open up and by compelling them to explore the margins of theater. For this reason, an excursion into performance has seemed not only interesting, but essential to our ultimate concern, which is to come back to the theater after a long detour behind the scenes of theatricality.

## NOTES

Translated by Terese Lyons.

1. Annette Michelson, "Yvonne Rainer, Part One: The Dancer and the Dance," *Artforum* 12 (January 1974): 57.

2. RoseLee Goldberg, *Performance: Live Art, 1909 to the Present* (New York: H. N. Abrams 1979).

3. Luciano Inga-Pin says this in his preface to the photo album on performance, *Performances, Happenings, Actions, Events, Activities, Installations* (Padua: Mastragiacomo-Images 1970).

4. By wrapping up cliffs and entire buildings in their natural surroundings, Christo isolates them. He thus simultaneously emphasizes their gigantic size and negates it by his very project, and estranges his objects from the natural setting from which he takes them (cf. photo no. 48 in the illustrations to Inga-Pin).

5. The performances of the Austrian artist Hermann Nitsch were inspired by ancient Dionysiac and Christian rites adapted to a modern context designed to illustrate in a practical fashion the Aristotelian notion of catharsis through fear, terror, or compassion. His *Orgies, Mysteries, Theater* was performed on numerous occasions in the seventies. A typical performance lasted several hours. It began with loud music followed by Nitsch ordering the ceremonies to begin. A lamb with its throat slit was brought into the midst of the participants. Its carcass was crucified, and its intestines removed and poured (with their blood) over a naked man or woman lying beneath the animal. This practice originated in Nitsch's belief that humanity's aggressive instincts had been repressed by the media. Even ritual animal sacrifices, which were so common among primitive peoples, have totally disappeared from modern experience. Nitsch's ritual acts thus represented a way of giving full rein to the repressed energy in man. At the same time, they functioned as acts of purification and redemption through suffering. (This description is based on the discussion found in Goldberg, *Performance*, 106.)

6. These notions are borrowed from Julia Kristeva, *Revolution in Poetic Language* trans. Margaret Waller (New York: Columbia University Press, 1984).

7. "Lesionism" refers to a practice whereby the body is represented not as an entity or a united whole, but as divided into parts or fragments (cf. Inga-Pin, *Performance*, 5).

8. Ibid., 2.

9. Stephen Koch, Richard Foreman, et al., "Performance, a Conversation," *Artforum* 11 (December 1972): 53–54.

10. Richard Schechner, *Essays on Performance Theory, 1970–1976* (New York: Drama Book Specialists, 1977), 147.

11. Koch, et al., "Performance, a Conversation," 54.

12. Michael Fried, "Art and Objecthood," *Artforum* (June 1967), rpt. in *Minimal Art,* ed. Gregory Battcock (New York: E. P. Dutton, 1968), 139.

13. Ibid., 139–41.

14. Peter Brook, *The Empty Space* (New York: Atheneum, 1968), 16.

15. Allan Kaprow, *Assemblage, Environments, and Happenings* (New York: H. N. Abrams, 1956), 190, quoted in *Performance by Artists,* ed. A. A. Bronson and Peggy Gale (Toronto: Art Metropole, 1979), 193.

16. See Jacques Derrida, *The Truth in Painting,* trans. Geoff Bennington and Ian McCleod (Chicago: University of Chicago Press, 1987).

17. Roland Barthes, "Baudelaire's Theater," in *Critical Essays,* trans. Richard Howard (Evanston, Ill.: Northwestern University Press, 1972), 26.

18. See Donald W. Winnicott, *Playing and Reality* (New York: Tavistock Publications, 1971).

19. Schechner develops the idea of "selective inattention" in his discussion of Wilson's *The Life and Times of Joseph Stalin* (Schechner, *Essays on Performance Theory,* 147–48): For the December, 1973, performance . . . at the Brooklyn Academy of Music's opera house, the Le Perq space—a room of about 150 feet by 80 feet—was set up with tables, chairs, refreshments: a place where people went not only during the six 15-minute intermissions but also during many of the acts of Wilson's seven-act opera. The opera began at 7 P.M. and ran more than 12 hours. . . . The behavior in the Le Perq space was not the same throughout the night. During the first three acts the space was generally empty except for intermission. But increasingly as the night went on people came to the space and stayed there speaking to friends, taking a break from the performance, to loop out of the opera, later to re-enter. About half the audience left the BAM before the performance was over; but those who remained, like repeated siftings of flour, were finer and finer examples of Wilson fans; the audience sorted itself out until those of us who stayed for the whole opera shared not only the experience of Wilson's work but the experience of experiencing it.

# Régis Durand

## The Disposition of the Voice

*The voice is never represented: it represents, it is the act of*
*a presence which represents itself*

—D. Vasse

*Theater is the art of playing with division, by introducing*
*it into space by means of dialogue.*

—M. Blanchot

This is a recorded message. Yet it does not reproduce my voice, the voice that I hear, myself, as I speak to you now, as I am writing this paper. It represents it, yet it does not re-present it. It does not record it for future representation, it puts it on record, for future reference.[1]

The voice, meanwhile, does and does not become silent. It cuts its groove, trace, into the text of which I am saying that, in this particular case, it represents the voice. Were I to read the text in front of you, pretend I am speaking it for the first time, the situation would be reversed. I would be voicing, giving voice to, a text written prior to the performance, the very text I am writing at this minute.[2] And even if I was pretending to improvise—having for instance learned my text by heart—my voice would only be an instrument, second to the written text, and I would be in the same relation to it as an actor to his lines. But even then, as Rosolato indicates, the voice would hardly be a mere instrument. It would produce its own effects, have its own resonances.[3] The voice has to do with fantasy *(le fantasme)* and myth, but it is perhaps in the dramatic metaphor that we can attempt to anchor some remarks on the apparatus *(dispositif)* called the voice: remarks that, by holding together several levels of attention, would aim at complicating the issue a little.

I

Nothing is closer to me than my voice: the consciousness of the voice is consciousness itself.[4] "Phonic signs ('acoustical images' in Saussure's sense, or the phenomenological voice) are heard by the subject who proffers them in

the absolute proximity of their present. The subject does not have to pass forth beyond himself to be immediately affected by his expressive activity. My words are 'alive' because they seem not to leave me: not to fall outside me, outside my breath, at a visible distance; not to cease to belong to me, to be at my disposition 'without further props.' "[5] The voice is present, presence itself. Freedom itself, too, and freedom of the language: a discourse which does not have to borrow its signifiers from the world, and hence is never in danger of being dispossessed of them.[6] Absolute presence: the words exist as they are spoken, then vanish in thin air leaving no trace of signifiers behind, no body, leaving us in the immediate presence of the signified. Self-presence, "apparent transcendence" of the voice.[7] *Auto-affection:* from myself to myself. I do not even have to speak to you, as long as I hear myself. I do not even have to *speak:* I can sing, scream, mutter, speak to myself in silence.

But if I speak, something else takes place: the voice itself can only be immediate presence inasmuch as language, the phenomenological "body" of the signifier, seems to fade away at the very moment it is produced: an absence for a presence. But *speech* differs. In speech we can never say that the body of language is totally absent. It absents itself, yet it leaves a trace. It is at best present-absent. For speech is not voice. It is a voice that has run over and through language: "a wading through language, a wading that occurs inside as well as outside of the body."[8] And language like any system of meaningful signs, is something other than pure presence. It differs, and it *defers:* dif-fer*a*nce is the spacing-out, the constitutive delay and insistence, that which will not be denied its temporality and its power of deferment, what happens when the voice runs through the body of language, becomes speech and writing *(ecriture)*.

The voice is inextricably bound up with bodies: the body of language, the body of the speaker. "Between body and language."[9] The voice belongs to the body, is *produced* by it. It is one of those emissions of the body which, in Freudian psychology, play such an important part in the structure and mani-festation of desire and fantasy: "the products of an underground operation, of a metabolism which, once they have fallen out, become objects distinct from the body, without its qualities of sensitivity, reaction and excitability, and which acquire a value which interests the desire of the other.[10] Lost objects, *a* objects in Lacanian terminology.

The voice speaks of the body: of its dualities (interior/exterior, front/back, eye/ear, etc.). It speaks of the unconscious drives and fantasies. *Trieb:* drift, drive. The voice has to do with flows and desires, not with meaning. It belongs to the realm of what Barthes calls *signifiance,* that is to say signification *before* it coalesces, before it emerges, of signification nascent, floating. That is why the

voice cannot really be apprehended through "scientific" discourse. The most "extreme" manifestations (silence, scream) of the voice dramatize this metaphoric relation to the unconscious drives.[11] However, let us not be mistaken about it, if the voice gives access to metaphorical representations of drives, it is only through the logic of a system of signifiers which act as "desire traps."[12]

## II

"*Between* body and language": it is hard to conceive of a voice without a reference to a signifier, and in particular to language.[13] Yet, conceived it must be, as music and poetry, marginally, show us. Cage, Mauricio Kagel, Dieter Schnebel, de-construct "silence" and speech to free music from the fetters of the signifier's organization. A-verbal musical voice, "silence-voice," which allows us to listen to sound rather than sense, to the inchoate exploration of sound untamed by syntax (Daniel Charles has shown the parallel with Heidegger's definition of *Ursprache*).[14]

The voice has to do with loss, fall from the body. Yet it also has to do with the return to origins, to the dream of an *Ur*-language, a corporeality of language which Vico, Heidegger and Norman O. Brown celebrate. The voice, in this respect, is regressive. Mythically, it aspires to an original state, that of the "first men," before they became enslaved by words, when they were "entirely immersed in the senses, buffeted by passions, buried in the body."[15] Individually, being an expansion of the body and a metaphor of fantasy, the voice follows fantasy's regressive pattern, and gives expression to traces of unconscious desires and constructs dredged up from the past.

The voice goes back, and forth: a go-between, an intermediary.[16] A transmitter that makes dual, dialectical relations possible, on all levels: linguistic in general (the problem of enunciation: the "voice" of the verb): analytic, "as it leads through myth and fantasy, toward the superego with its judgments of 'interior' voice, and beyond it toward the id and its drives."[17]

In-between, because it can only be defined as "the relationship, the distance, the articulation between subject and object, the object and the Other, the subject and the Other.[18] In-between organism and organization, the body biologic and the body politic, "so that neither the biological body nor the body of language could possibly be conceived without it, in spite of the fact that it belongs properly neither to the one nor to the other.[19] Passage, tunnel, passing-through *(traversée)*. Enigma: "Enigma because it can be construed neither as the locus of presence, nor as the knowledge *(savoir)* of representation. It is the unceasing relation between the two, which cannot be reduced to either of the two orders it articulates, precisely *because* it articulates them."[20]

III

The philosophical status of the voice is complex and involves a series of oppositions and enigmas. Is that what gives it its special appeal, its fascination (both as a "real" production and as a critical concept)? We indicated that the voice was always anchored in desire, and more precisely that its effect was to situate the subject in the desire of the other. There is no such thing as a neutral voice, a voice without desire, a voice that does not desire me. If there was, it would be an experience of absolute terror. But even as it is, and even though it may charm, the voice frightens and disturbs. Is it because the voice gives us nothing to *see,* because it has no mirror-image? Speaks of loss, of an absence? But it also brings pleasure, an unparalleled ecstasy. How is it that some voices hold us spellbound, come through mouth, record, or print to haunt and thrill? Because the voice affirms that ecstasy is possible, can be attained through discourse. It tells me that I too can attain it, that I am not forever excluded from it, that some sort of ecstasy *(jouissance)* is to be had in the attainment of my self-image.[21] The voices that thrill us allow us to apprehend their power of dissociation. They themselves are not concerned with diction, expressive effect. They let something through which has to do with origin and loss, and the determination of a space where ecstasy is possible. Beyond words, the heterogeneity of signifiers, the voice determines an enclosure, ambitus. There it keeps watch over signifiers and over the signifier of signifiers (the Phallus in Lacanian parlance). This "transcendental signifier" is that which guarantees the unity of signifier and signified, underneath and beyond all signified-effects *(effets de signifié)*. Thus, as Derrida shows, the danger of returning to a metaphysics of "pure presence," of the immediate is always lurking when one discusses the voice.[22]

IV

Is there then no way we can help being brought round full circle? Daniel Charles sees a possibility of approaching the problem differently, through the later works of Bachelard and Heidegger: the voice as the "vertical connection" between Earth and Sky, that which establishes instant relation between contraries (Bachelard speaks of "the androgynous moment"). Charles, after Cage, interprets verticality as *intensity*. A vertical connexion which is an experience of pure time, "time degree zero," a yet unstructured time.[23] From those remarks we conclude that a meta-(or para-) discourse on the voice has (at least) two vanishing points. We would be tempted to say

that one is more theoretical, the other more geared to performance and creation, except that it would not be quite true (the so-called theoretical aspect becomes performance, performance is always a theoretical statement). If, however, for clarity's sake, we decide to distinguish between them, we turn to the work of Gilles Deleuze and Jean-François Lyotard for the theoretical vantage point. Their work is sufficiently well-known to make a discussion here unnecessary. Gilles Deleuze's contribution to the question of the voice is indirect but essential; it is to be found in the concept of nomadism, in the critique of depth (and height) and the freeing of surfaces which he conducts in *Logique du sens* and *L'Anti-Oedipe*.[24] With that, Deleuze has given us powerful instruments to reexamine the function of the voice. A passage on nomadism, for instance, quoted by D. Charles, appears to be analogous to the shift in intensity, the abrupt and static vertical connection which the voice effects: "The nomad is not necessarily somebody who moves: there are travels in which one does not move, travels in intensity, and even from a historical point of view nomads are not those who move like migrants, on the contrary they are those who do not move, and who start nomadizing in order to stay in the same place and free themselves from codes."[25] Another concept which serves in Deleuze's work to describe the ability to free oneself from codes is what he calls humor. That too is relevant to our study: "For if irony implies the coextensiveness of being with the individual, or of the I with representation, humour implies that of sense and nonsense; humour is the art of surfaces and replicas *(doublures)*, of nomadic singularities and of the aleatory point which is always being moved, the art of static genesis, the knowledge of pure event or 'the fourth person singular'—signification, designation and manifestation being suspended, depth and height abolished."[26]

J-F. Lyotard has carried further the research into shifts of intensities, decoding and recoding of flows *(flux)* with direct relevance to drama and voice. Lyotard has written little on drama itself (apart from "The Tooth, the Palm"), but many of his analyses bear on theatricality *(la théâtralité)* and how avant-garde music, painting, and criticism can subvert that concept on which the Western theory of representation rests. The key words again are shifts, jumps in intensity; errance, mobility; *dispositif* (sometimes translated as apparatus but better rendered perhaps as *disposition*). Lyotard makes us aware that drama, vocal music, the cinema, whatever their particular aesthetics, are complex systems, screens, filters, apparati designed to capture and transform energy. The essay on drama mentioned is a radical critique of dramatic theory and practice based on signs and semiotics, on the representative value of signs, and it is a plea for a "theater of energies" *(un théâtre énergétique)*.[27]

V

That the voice will be an essential element of such a theater hardly needs to be emphasized. What is perhaps worth another brief turn of the screw is the consequences of the medium itself of the theoretical forays I have so sketchily surveyed. It will have been noted that the voice we refer to is a migratory notion: now a vocal production, now a psychoanalytic concept, now a kind of metaphorical support for pure time, mobility, intensity (a name perhaps for the unnameable?). Conversely and symmetrically, this volatile concept plays havoc with the clear distinctions between media and genres, as well as between reality and representation. Roland Barthes in *Le Plaisir du texte* speaks of "writing aloud" *(l'écriture à haute voix)* as the hallmark of the radical shift we have been approaching by a devious path. The last paragraph of his book is worth quoting in full since it does more than introduce us to the last rung of our spiral:

> *Writing aloud* is not expressive. . . . It is carried not by dramatic inflections, subtle stresses, sympathetic accents, but by the *grain* of the voice, which is an erotic mixture of timbre and language, and can therefore also be, along with diction, the substance of an art: the art of guiding one's body (whence its importance in Far Eastern theaters). Due allowance being made for the sounds of language, *writing aloud* is not phonological but phonetic: its aim is not the clarity of messages, the theater of emotions; what it searches for (in a perspective of bliss) are the pulsional incidents, the language lined with flesh, a text where we can hear the grain of the throat, the patina of consonants, the voluptuousness of vowels, a whole carnal stereophony: the articulation of the body, of the tongue, not that of meaning, of language. A certain art of singing can give an idea of this vocal writing; but since melody is dead, we may find it more easily today at the cinema. In fact, it suffices that the cinema capture the sound of speech *close up* (this is, in fact, the generalized definition of the "grain" of writing) and make us hear in their materiality, their sensuality, the breath, the gutturals, the fleshiness of the lips, a whole presence of the human muzzle (that the voice, that writing, be as fresh, supple, lubricated, delicately granular and vibrant as an animal's muzzle), to succeed in shifting the signified a great distance and in throwing, so to speak, the anonymous body of the actor into my ear; it granulates, it crackles, it caresses, it grates, it cuts, it comes: that is bliss *[jouissance]*.[28]

This beautiful page, in its allusion to drama, cinema, and voice, summons the name of Marguerite Duras, novelist, dramatist, director and filmmaker. It is toward her and the fascinating quality of her work that this whole commentary has been directed from the start. Yet I shall say relatively little about her and content myself with having led you to the door. Like many other people,

I was jolted into awareness of the importance of what she is doing by her film, *India Song* (and its twin or ghost film, *Son nom de Venise dans Calcutta désert*). *India Song* (the text and the film) quite literally *effects* something new in the use of voice and dramatic space.

Duras's use of voices has to do with memory and loss of memory (*l'oubli*). We learn from G. Rosolato that the voice "gives physical manifestation to ancient images reconstituted by an *evocation* from fantasies. It (the voice), being an extension of the body as diversified as the face, becomes the depositary of the desires and intentions of a past, which give it its singularity."[29] M. Duras explicitly conceives *India Song* as just such a dream of voices and desires: "The voices do not address the spectator or reader. They are absolutely autonomous. *They speak among themselves. They do not know they are being heard.* The story of that love, the VOICES knew it, or read about it, a long time ago. Some of them remember it better than others. But none of them really remembers it, and none has quite forgotten it either. One never, at any time, knows *who those* VOICES *are.* Yet, by the way they have, each of them, of having forgotten or of remembering, they make themselves known to us more deeply than through their identity."[30]

In her "Notes for the Theater about Setting," M. Duras emphasizes the creative—or destructive—power of her conception of voices and the immediate consequences on scenic space: "The setting should be both that of loss of memory and that of vacillating memory, that is to say a place with incidents of light, points of intense luminosity, holes of darkness, breaks . . . a place which one enters via the memory and loss of memory of the women, of the voices."[31] The voices, then, are from the start the element through which the text and the film come to life. It would take a separate study to analyze the workings of the voices as generative principle. But it is interesting to note how M. Duras worked with her actors in order to destroy the traditional relation of actor to voice, of voice to spectator/reader. In a discussion with Xavière Gauthier, M. Duras explains how she avoids the "abject proximity" of direct sound. She often has the actors record their lines so that when they play their scene, they can hear their own voice returning to them (M. Duras says *revenant,* which also means a ghost).

XG: They listen to their own voice?

MD: Yes, while they were acting, they listened to their own voice.

XG: That again must have something to do with death. Their voices are like voices from beyond the grave *(revenante)*.

MD: Yes, but I don't know whether it is not also concerned with cinema itself. There was something in silent cinema which has been lost forever. There is something trivial, vulgar in direct sound.

XG: In realism?

MD: Yes, the inevitable realism of direct sound, and the dishonesty it represents. So you see, when they speak and hear their own words, the words have infinitely more echoes. I mean, while they are suppposed to be speaking their words, at the very same time, they could be saying something entirely different. The field opens up, the field of speech opens up infinitely wide. I think that's what it is, and because of that, everything takes on a dual dimension."[32]

Those voices, those which return to us from before, from another time, are radically cut off from our demand, our need to fasten on to them and invest them with our desire. They will never give us satisfaction. They don't have a body (the speakers are never seen, or at least, never seen *while* they are speaking). They are *off,* unstable, always somewhere else. Yet, like a powerful current, they leave marks. They burn. Although they are without a visible body, they are profoundly physical. Although they will not acknowledge *our* desire, they are voices of desire. The drama of the two female voices, in particular, is intensely sensual. Here perhaps is the best actualization of what Barthes calls "writing aloud." Not only the grain, the stereophony of the flesh, but the powerful currents, gusts, shudders of desire which run through the voices.

A new relation is established between sound and image, an amplification of the space *between* them. (M. Duras has carried the exploration even further in *Son nom de Venise,* in which the same sound track as in *India Song* is used on different images, mainly shots of deserted places, perhaps some of the locations used in *India Song*). The voices in *India Song* are not simply an aid to, a commentary on, the images. They disrupt the images, shatter them. Scenes and voices do not coincide, the words are not spoken by the bodies present on the screen. It is they (the bodies) which seem a creation of the voices. M. Duras transforms the use of off sound. Those voices are no longer *expressive* of something (the interiority of a subject, the knowledge or the consciousness of a central intelligence). What is challenged is not only the primacy of character and image, but also the more modern variations on it, in order to substitute a different logic: the logic of memories *other* than the writer's: "The voices do not speak to the spectator or the reader. They are totally autonomous. They speak between themselves."

Because of this different logic and circulation of desire, *India Song* is perhaps the first cinematographic and textual disposition of *another* scene, in which reader/spectator, writer/director, text/film, characters/actors are equally implicated, equally affected; where no central, omnipotent subject pulls the strings, orders and reorders. With all the importance it is given, it is a wonder that the voice does not become a fetish. But it never does: desire runs from

one object, one "person" to another, carrying danger and death to all (including the viewer). M. Duras renounces fixed narrative space, in order to explore what literally cannot be said: not the mystical unknown or attainable, but what is always taking place on another scene, in between words, elsewhere. In her exploration I see the most radical attempt to date to deconstruct "theatrical" space (the "depth" J-F. Lyotard talks about), filmic and narrative order (hierarchy of images and sound, linearity of images, the role of bodies and voices), to alter the relation between writer, word, and reader, to cancel, displace the subject as referent. That she effects through a profound reconsideration of the "affectiveness" of the voice. The question she asks is: What happens when voices are freed from the conventions of what E. Benveniste calls "written-spoken" discourse, in order to become something that literally does not concern you, even though it affects you deeply? Marguerite Duras approaches the exploration of pure desire, pure intensity and horror, allowing us to hear some echoes of what Maurice Blanchot calls the "neutral" voice, "a voice that one could describe as outside discourse, outside language":

> Within the neutral space of narrative, the speech bearers, the subjects of actions—those who used to be called characters—fall into a relation of non-identification with themselves: something is happening to them which they can only invest by divesting themselves of their power to say "I," and what is happening to them has always already happened to them: they can only account for it indirectly, as the loss of memory of themselves, that loss of memory which introduces them into the present without a memory which is that of the narrating voice.[33]

## NOTES

Translations of quoted passages are my own, unless otherwise indicated.

La voix n'est jamais représentée, elle est l'acte d'une présence qui se représente. (Denis Vasse)

Le théâtre est l'art de jouer avec la division en l'introduisant dans l'espace par le dialogue. (Maurice Blanchot)

1. Guy Rosolato, "La Voix," *Essais sur le symbolique* (Paris: Gallimard, 1969).
2. John Vernon, "Language and Writing," *American Review,* 22 (1975).
3. Rosolato, "La Voix," 287–88.
4. Jacques Derrida, *Of Grammatology,* trans. Gayatri Chakravorty Spivak (Baltimore: Johns Hopkins University Press, 1974), pp. 19 ff.
5. Jacques Derrida, *Speech and Phenomena,* trans. David Allison (Evanston, Ill: Northwestern University Press, 1973), 76.

6. Derrida, *Of Grammatology,* 168.

7. Derrida, *Speech and Phenomena.*

8. Vernon, "Language and Writing," 215.

9. Guy Rosolato, "La Voix entre corps et langage," *Revue Française de Psych-analyse* 1974, 1, 75–94.

10. Ibid., 78.

11. Daniel Charles, "John Cage ou la voix symbole du temps," *L'autre scène* 10 (1975).

12. Rosolato, "La Voix entre corps et langage," 93–94.

13. Ivanak Stoianova, "La Voix-silence et le corps," *L'autre scène,* 10: 37–44.

14. Charles, "John Cage," and "Nature et silence chez J. Cage," *Le Langage* (Neuchatel: Bâconnière, 1966).

15. Norman O. Brown, *Closing Time* (New York: Random House, 1973), 73.

16. Rosolato, "La Voix entre corps et langage," 294–99.

17. Ibid., 302.

18. Denis Vasse, *L'Ombilic et la Voix* (Paris: Seuil, 1975), 14.

19. Ibid., 21.

20. Ibid., 215.

21. Charles Bouazis, "L'Excellence de la voix," *Essais de la semiotique du sujet* (Bruxelles: Editions Complèxe, 1977).

22. Jacques Derrida, "The Purveyor of Truth," *Yale French Studies* 52 (1975) (a translation of "Le facteur de la verité," originally in *Poètique* 21).

23. Charles, "John Cage," 35.

24. Gilles Deleuze, *The Logic of Sense,* trans. Mark Lester with Charles Stivale (New York: Columbia University Press, 1990). (In particular "26th Series of Language," and "27th Series of Orality").

25. Gilles Deleuze, "Pensée nomade," in *Nietzsche aujourd'hui?* (Paris: U.G.E., 1973), 176 (quoted by Charles, "John Cage," 36).

26. Deleuze, *The Logic of Sense,* 141.

27. Jean-Francois Lyotard, "La Dent, la paume," in *Des Dispositifs pulsionnels* (Paris: U.G.E., 1973). [See the translation included in this volume—Ed.]

28. Roland Barthes, *The Pleasure of the Text,* trans. by Richard Miller (New York: Hill and Wang, 1975), 66–67.

29. Rosolato, "La Voix entre corps et langage," 83.

30. Marguerite Duras, *India Song* (Paris: Gallimard, 1973), 147.

31. Duras, in *Marguerite Duras* (Paris: Albatros, 1975).

32. *Marguerite Duras,* 80–81.

33. Maurice Blanchot, *L'Entretien infini* (Paris: Gallimard, 1969), 564 [Dans l'espace neutre du récit, les porteurs de parole, les sujets d'action—ceux qui tenaient lieu jadis de personnages—tombent dans un rapport de non-identification avec eux-mêmes: quelque chose leur arrive, qu'ils ne peuvent ressaisir qu'en se désaisissant de leur pouvoir de dire "je," et ce qui leur arrive leur est toujours déjà arriveé: ils ne sauraient en rendre compte qu'indirectement, comme de l'oubli d'eux-mêmes, cet oubli qui les introduit dans le présent sans mémoire qui est celui de la parole narrante.]

# Contributors

**Louis Althusser** was Secrétaire at the Ecole Normale Supérieure, Paris, where he taught until 1980. He died in 1990. His studies pioneered the poststructuralist revision of Marxist theory and provided a theoretical basis for political debate in France. His published works include *For Marx, Reading Capital,* and *Lenin and Philosophy and Other Essays.*

**Hélène Cixous** directs the Women's Studies Program at the University of Paris VIII (Vincennes at St. Denis). She has taught at Columbia University, Cornell University, Dartmouth College, and Yale University, among others. Cixous is author of almost fifty novels and plays, including *Portrait de Dora,* directed by Simone Benmussa, *La prise de l'école de Madhubaï,* directed by Giorgio Strehler, and many collaborations on the colonial condition with Ariane Mnouchkine and the Théâtre du Soleil of Paris, including *Indiade* and a recent piece on the French Resistance, *Manne.* Cixous is a very influential feminist theorist whose critical work includes the manifesto, "The Laugh of the Medusa," and *The Newly Born Woman,* written with Catherine Clément.

**Gilles Deleuze** was Emeritus Professor of philosophy at the University of Paris VIII at Vincennes/Saint Denis until his death in 1995. His numerous monographs on aesthetics and philosophical texts include *The Fold* on Leibniz, *Expressionism in Philosophy* on Spinoza, *Coldness and Cruelty* on Sacher-Masoch, as well as his two-volume study on the relation of Bergson's theses of perception to cinema and its history, *Cinema 1: The Mouvement-Image, Cinema 2: The Time-Image.* His essay on Carmelo Bene, included here, outlines some of the major points of his influential collaborations with Félix Guattari on the subjects of capitalism, schizophrenia, and minority representation, published in *Anti-Oedipus, A Thousand Plateaus,* and *Kafka: Toward a Minor Literature.*

**Jacques Derrida** is Director of Studies at the Ecole des Hautes Etudes en Sciences Sociales, Paris, and Professor of Humanities at the University of California at Irvine. He is former Director of the Collège Internationale de la Philosophie and has taught at The Johns Hopkins University, Yale University, and Cornell University. His philosophical and literary development of the post-Heideggerian philosophy of deconstruction include *Speech and*

*Phenomena, Of Grammatology, Writing and Difference, Dissemination, Positions, Margins of Philosophy, Memoires for Paul de Man, Spurs, Glas,* and *Specters of Marx.* His illuminating essays on aesthetics, art, and architecture can be found in *Truth in Painting, Memoires of the Blind, Psyche,* and *Aporias.*

**Régis Durand** is Director of Studies at the University of Lille III and served as Director of the Centre d'Etudes et de Recherches Nord-Américaines et Canadiennes. His essays on theater, the novel, and critical theory appear in *Myth and Ideology in American Culture* and *La Relation théâtrale. La Part de l'ombre* contains his more recent work in photographic theory and criticism.

**Frantz Fanon** was born in Antilles, educated in Paris as a psychiatrist, and was named, in 1953, Director of Algeria's largest psychiatric hospital, the Hospital at Blida-Joinville. In his book, *Black Skin, White Masks,* he broke new ground in linking the discourse of psychoanalysis to the colonial condition. His essay included here is taken from his 1959 book on the Algerian condition, *A Dying Colonialism,* which paved the way for his insightful studies of colonialism and revolution, *Toward the African Revolution* and *The Wretched of the Earth.*

**Josette Féral** is Professor of Theater at the University of Quebec at Montreal. Her essays and interventions have played a leading role in the feminist theorization of performance and dramatic practice. She is editor of *Jeu* and author of *La Culture contre l'art.*

**Michel Foucault** held the chair of the History of Systems of Thought at the Collège de France until his death in 1984. He also taught at the University of California at Berkeley and at universities throughout the world. His work on the archaeology of knowledge and the histories of madness, prison, and sexuality revolutionized Western historical thought and provided the conceptual framework for "new historicism" in literary studies. His books include *The Order of Things, The Archaeology of Knowledge, The Birth of the Clinic, Discipline and Punish,* three volumes of *The History of Sexuality, Power/ Knowledge,* and *Language, Counter-Memory, Practice.*

**René Girard** is Andrew B. Hammond Professor of French at Stanford University, previously teaching at SUNY Buffalo and The Johns Hopkins University. His prolific writing develops his theories of the triangularity of desire, the scapegoat, and originary violence. His books include *Deceit, Desire, and the Novel, Violence and the Sacred, Theater of Envy, To Double Business Bound, Scapegoat,* and *Things Hidden since the Foundation of the World.*

**André Green** is a former Professor of Psychiatry at University College, London, and past President of the Société Freudienne de Paris. His post-Lacanian readings have redefined the affect, the masochism of tragedy, and the narcissism of life and death. His books include *The Tragic Effect, On Private Madness, Hamlet et "Hamlet," Narcissisme de vie/Narcissisme de mort, Discours vivant,* and a recent study of Leonardo de Vinci, *Révélations de l'inachèvement.*

**Luce Irigaray** holds a research position at the Centre Nationale de la Recherche Scientifique, Paris, and has taught at the Ecole des Hautes Etudes en Sciences Sociales and the University of Montreal, among others. She has made major contributions to several areas of French intellectual theory, including feminist theory, philosophy, literature, linguistics, and psychoanalysis. The publication of *Speculum of the Other Woman* had considerable impact on international feminist thought and has been followed by numerous books such as *This Sex Which Is Not One, Ethics of Sexual Difference, Sexes and Genealogies,* and most recently, *Thinking the Difference: For a Peaceful Revolution.*

**Julia Kristeva** holds a chair in linguistics at the University of Paris VII and is a regular visiting Professor at Columbia University. Kristeva is one of the leading female voices in French literary criticism, psychoanalysis, linguistics, and political theory. As a practicing analyst, she has played an important role in defining the theory and pedagogy of French psychoanalysis. Her books include *Revolution in Poetic Language, Powers of Horror, Desire in Language, Love Stories.* She is also a writer whose novel, *The Samourais,* loosely describes recent French intellectual life.

**Philippe Lacoue-Labarthe** is Director of Studies in philosophy at the University of Strasbourg and has taught at the University of California at Berkeley. Lacoue-Labarthe is a leading voice in contemporary French philosophy and has collaborated in the direction of conceptual productions of the National Theater of Strasbourg and the Strasbourg Opera. He was a founding member of two of the most influential French philosophical working groups of the 1970s and 1980s, the Groupe de Recherches sur les Théories du Signe et du Texte and the Centre de Recherches Philosophiques, which published two important collections, *Rejouer le politique* and *Le Retrait du politique.* In addition he has coauthored two books with Jean-Luc Nancy, *Literary Absolute* on German romanticism, and *Title of the Letter* on Jacques Lacan. Lacoue-Labarthe's monographs include *Typography, Heidegger, Art, and Politics,* and *Portrait de l'artiste en général.*

**Jean-François Lyotard** is Distinguished Professor of French at Emory University and has taught at The Johns Hopkins University, the University of California at San Diego, and the University of California at Irvine. He was a founding member and Director of the Collège Internationale de la Philosophie, and is Emeritus Professor of Philosophy at the University of Paris VII at Vincennes/ St. Denis. His daring and innovative thought on psychopolitical discourse, the sublime, the avant-garde, and postmodernism is included in a large number of monographs, including *The Differend, Libidinal Economies, The Postmodern Condition, Just Gaming, Peregrinations,* and *Duchamp's TRANS/formers.*

**Louis Marin** was Director of Studies at the Ecole des Hautes Etudes en Sciences Sociales, Paris, until his death in 1992. Marin also taught at the University of California at San Diego, The Johns Hopkins University, SUNY Buffalo, Cornell University, and others. He played a pivotal role in promoting the semiotics and theory of representation in relation to art, utopia, and literature. He specialized in reading texts and images of the seventeenth century. His numerous monographs include *Utopics, The Portrait of the King, La Critique du discourse, To Destroy Painting, Food for Thought, Des pouvoirs de l'image, Lectures traversières, De la représentation.*

**Timothy Murray** is Professor of English at Cornell University. A former editor of *Theatre Journal,* he is the author of *Theatrical Legitimation: Allegories of Genius in Seventeenth-Century England and France, Like a Film: Ideological Fantasy on Screen, Camera, and Canvas,* and *Drama Trauma: Specters of Race and Sexuality in Performance, Video, and Art* (forthcoming), and coeditor with Alan Smith of *Repossessions: Psychoanalysis and the Question of Early Modern Culture* (forthcoming).

# Index

Williams, Linda, 24n. 33
Willis, Sharon, 3
Wilson, Robert, 9, 241, 247, 279, 292,
    294, 295, 296; *The Life and Times of
    Joseph Stalin,* 298, 300n. 19
Winnicott, D. W., 136, 300n. 18

Woolf, Virginia, 242
Wulf, Christoph, 10

Zeami, Motokiyo, 283–84
Zeno, 220, 225
Žižek, Slavoj, 25n. 43